RE
WOMEN PATRONS

DEDICATED TO THE MEMORY

OF MY MOTHER
EVE BARTON 1908–92

AND OF MY FATHER
THOMAS HOOKEY 1911–96

❀

AND GIVEN WITH LOVE
TO MY DAUGHTER NELL

RENAISSANCE WOMEN PATRONS

WIVES AND WIDOWS IN ITALY
c. 1300–1550

Catherine King

MANCHESTER
UNIVERSITY PRESS

Manchester and New York

distributed exclusively in the USA by St. Martin's Press

Published by Manchester University Press
Oxford Road, Manchester M13 9NR, UK
and Room 400, 175 Fifth Avenue, New York, NY 10010, USA

Distributed exclusively in the USA by
St. Martin's Press, Inc., 175 Fifth Avenue, New York, NY 10010, USA

Distributed exclusively in Canada by
UBC Press, University of British Columbia, 6344 Memorial Road,
Vancouver, BC, Canada V6T 1Z2

British Library Cataloguing-in-Publication Data
A catalogue record for this book is available from the British Library

Library of Congress Cataloging-in-Publication Data applied for

ISBN 0 7190 5288 2 *hardback*
0 7190 5289 0 *paperback*

First published 1998
05 04 03 02 01 00 99 98 10 9 8 7 6 5 4 3 2 1

Typeset in Hong Kong
by Graphicraft Typesetters Limited
Printed in Great Britain
by Bell & Bain Ltd, Glasgow

CONTENTS

PLATES

PREFACE

In this book women patrons are called by the name of their paternal family, where known, followed by reference to the name of their husband's family, except when translating inscriptions.

Biblical references are to the Vulgate. Latin texts may be looked up in *Biblia sacra iuxta vulgatam clementinam*, Rome, 1956, while English translations will be found in *The Jerusalem Bible*, London, 1966. Where the Vulgate version quoted in inscriptions or other sources differed from that of modern editions I provide the translation.

Where known, information on the size and media of works is given in the captions to the plates.

ACKNOWLEDGEMENTS

I am grateful to the Research Committee of the Open University and to its successor, the Research Committee of the Faculty of Arts at the Open University, for funding travel required for researching this book. I am most grateful to Osvaldo Böhm of Venice, who have kindly permitted me to reproduce works here, the copyright for which they own, without payment.

I thank all the friends and relations who have encouraged me in my quest over a decade, and the colleagues, especially from the Women in the Humanities Research Group of the Faculty of Arts at the Open University, who have assisted me to develop the questions posed in this book through inviting me to give seminars or lectures on this topic. I note in particular: 'Widows as patrons 1480–1550 in Italy', delivered at the Art Historians' Conference, London, 1989; 'Medieval and Renaissance matrons, Italian-style', delivered at the conference on Medieval Women: Art, Literature and Spirituality, York, 1992; 'Margarita Pellegrini and the Pellegrini Chapel', delivered at the Art Historians' Conference, Birmingham, 1994; 'Women as patrons in the Italian Renaissance', delivered at the University of Hertfordshire, 1995; and 'Women and courtesans in High Renaissance Rome', delivered in Cambridge, 1996. Their comments have been gladly received.

Colleagues have generously found examples of women's patronage for me and helped where translation defeated me. I acknowledge their roles individually in the notes. In particular, Dott.ssa Luisa Bassi gave me advice on the transcription of wills written in the dialect of the Veneto.

Kathleen Caustin, my aunt, and Clive Baldwin, Senior Editor, Arts, The Open University, have kindly read the manuscript and given critical advice. They both gave me their valuable time when I needed it.

My copyeditor, Richard Wilson, has helped to improve the manuscript in innumerable ways though, as always, I am responsible for any remaining omissions or faults. I thank him for his work on this text.

INTRODUCTION

In 1492 the Prior of the Augustinian monastery of San Niccolò in Foligno had an inscription placed on an altarpiece made for his church by a wealthy local widow named Donna Brigida di Michele, who had contracted the altarpiece before her death. In the inscription, the Prior asked viewers to decide who had acquired the more merit in producing the altarpiece they saw before them – the painter, or Donna Brigida, who caused it to be done.

> To the reader – The noble Donna Brigida, now dead, willed that this work be painted – a spectacle extremely pleasing to God. If you seek to know the author's name, it is Niccolò L'Alunno of Foligno – beautiful crown of its territory. In 14[92] he put the finishing touches. But who is the more worthy of merit, I ask you, critical reader – since Brigida gave the commission, and he the executing hand?[1]

In showing how seriously the role of the female patron in commissioning works of art at this time was regarded, the inscription sets a significant context for this study (Plate 1).

This book is a survey of a group of documented commissions of art and architecture by very well-off laywomen like Donna Brigida – who was a banker's wife, as well as by poorer wives and widows – like the guild-workers' relatives who could only contribute to joint commissions. There are also commissions

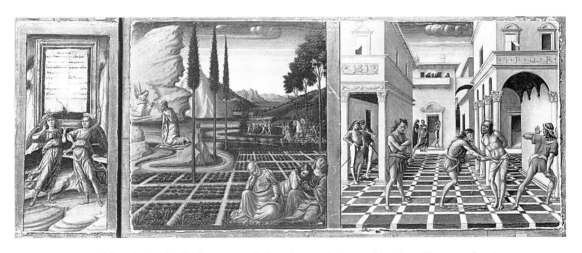

1 Predella of Niccolò di Liberatore, called L'Alunno, *Nativity with saints* (Plate 15), showing two angels holding the dedicatory inscription and two scenes of the Passion of Christ.

by others who were more loftily placed, like the women of patrician families in Naples and Venice – that is to say, laywomen of the social positions below that of female sovereigns and the close relatives of male rulers who were either elected or sovereigns by right of succession, or, as in the case of the Medici at some periods, *de facto* rulers. The book looks at the sorts of things these laywomen were able to commission, and also at the kinds of audiences that they were able to address. In taking objects of study from the fourteenth, fifteenth and sixteenth centuries in Italy, I want to pursue the historical debate concerning the way in which Italian laywomen experienced the 'Renaissance', and what artistic contribution they themselves were able to make to it. With the style-labels of Early and High Renaissance in mind I have taken the cut-off date of 'about 1550'.

As the inscription on Donna Brigida's altarpiece shows, an approach to works of art which emphasises buyers, viewers and users of art is one that matches fifteenth-century notions of the importance of the critical beholder and of the idea that authorship of representations and buildings belongs not only to artists but also to commissioners. It is important to stress these period concepts, because the study of women as patrons does not fit neatly with the chronological and geographical litanies of Renaissance Italian art history as it has developed since the sixteenth century.[2] Looking at male and female patronage entails turning the focus away from the customary concentration on Great Masters and style-labels. However, with masculine consumption it is still possible to proceed chronologically, tracing the contribution of institutions or families to great stylistic changes, and it is also possible to concentrate on different geographical areas, to examine patronage in major cities like Florence, Venice or Rome. Looking at women as buyers of art, however, means finding yet another approach, because from any Italian city between about 1300 and 1550 or so there survives evidence of only a handful of paintings, sculptures or buildings which are proven commissions by wealthy or quite well-off women. It is necessary to move to a mode of analysis which relates to the contemporary social structures in which laywomen operated. The main categories I have selected to create this organisational framework are that of considering the woman's marital status, that of studying commissions by groups of laywomen as opposed to single donatrixes and that of considering commissions for laywomen who were accorded the special privileges of being candidates for canonisation as saints.

In considering the sorts of laywomen capable of commissioning, I present a range of documented case-studies, which suggest something of the repertoire of positions from which laywomen ordered art to be made. A prime factor determining the position from which a laywoman could commission was her marital status – because there was a considerable legal difference between the

wife, who could commission only with the assent and assistance of a husband, and the widow, who had more freedom in law. Accordingly, I have devoted Chapter 2 to wives as patrons and Chapters 3–7 to widows.

However, there are other important differences in a laywoman's position which are of concern both in studying wives and in looking at widows. Her geographical location was certainly of importance. Depending on where the laywoman lived in the Italian-speaking peninsula, she might or might not be required to have a legal guardian to effect her commission. This tended to affect widows more than wives, because wives were expected to have their husbands as their legal guardians. However, the wife of an exile, for example, in some areas would be required to choose such a guardian, but in others would not need to do so, depending on whether she lived under Lombardic or Roman law. Laywomen living in different areas would also be expected to order different kinds of objects, depending on the political regimes holding sway and on the local traditions in general. For example, because there was a long tradition of lawyers having elaborate tombs in Bologna and Padua, a widow living in these areas might feel it appropriate to commission an imposing tomb for her lawyer spouse. The republican ethos in Venice and in Florence discouraged the commemoration of individuals by effigial sculpture, whereas the feudal traditions of Naples encouraged the portrayal of the dead. A woman's social position was often an important factor in her ability to commission, and the hierarchies of social standing varied from city to city and from regime to regime. Under communal government the daughters and wives of great mercantile families would be the elite. Under the government of sovereigns by succession, such mercantile families would take social positions below those of noble rank appointed by the prince, and perhaps below the prince's administrators and legal advisers. Depending on the size of the community in which she lived, the actual prestige she acquired through the roles her father and husband fulfilled would differ. Thus the banker's widow in little Foligno was a more powerful figure in her own area than a banker's widow in the much larger city of Florence might be.

A further question to consider for both wives and widows is that of whether the woman was making a posthumous commission or whether she was alive and able to respond to the exigencies of the actual course of the commission as it unfolded. It is also of interest to think about whether a woman was commissioning as an individual (of course, if as wife, with her husband's assent) or whether she was playing some collaborative role, either to assist the project of an institution like a local convent or a parish church, or to advise a member of her family who was the chief patron.

Then there is the question of whether she was able to commission because she was acting for her male relatives – and this would apply to a wife of a

living exile as well as to a widow commissioning monuments for her son and husband – or if the woman was able to have something made primarily for herself. Although the issue arises more obviously with the widows I look at in Chapters 3–7, the question is worth keeping in mind with regard to the wife. In Chapter 2, for example, we shall find a wife who was a childless heiress building a hospital, convent and church for the salvation of her soul, to compare with a wife with three sons who completed a commission begun by her father for his funerary chapel and adapted it to suit her descendants.

Because of the notion that it was more decorous for women to keep to the private sphere, an important overarching issue is that of whether a woman was commissioning an object which was in the public arena, like a hospital, a church, a church decoration, a chapel (to be used by the general congregation or by a confraternity); or whether she was commissioning something for private use – as in a house. Objects commissioned for private use have not survived in large numbers. What survive better are things women had made for semi-public use, like the family or personal funerary chapel which was visible to all, but belonged to her or to her family. There were also situations in which a woman could commission something for a monastic community which entailed her object being presented to people outside her immediate circle – but still viewers who were a limited group, and selected by her as a particularly devout audience.

Most documented commissions seem to be those of sole donatrixes. However, laywomen did belong to some tertiary organisations which were all-female, and these sororities did occasionally commission objects for their joint use as a female religious society. In Chapter 8 I have compared a commission by such an association of laywomen with a commission funded by a donatrix for a mixed confraternity of tertiaries, because they entailed group patronage, which was otherwise not available to women unless they were a convent community, and also because the sorority or mixed confraternity was an officially constituted religious association with a public face in the parish.

Another important means of categorising these laywomen's commissions is that of the spiritual distinction of a wife or widow. Women who were especially respected for their exceptional devoutness were able sometimes, while they lived, to achieve commissions of unusual prominence using their own wealth or the gifts of men who believed in their sanctity. These pieces of patronage were rare, because laywomen regarded as worthy of sainthood were themselves rare, and such women were not always interested in making buildings or images. However, when they *were* interested, documentation is relatively good, because the events in the life of the woman would have been recorded to create the case for her canonisation. These 'living saints' – *sante vive*, as they were

called, had public prestige unusual for a woman, and a sense of duty to their fellow-citizens in faith well beyond the expected familial scope of most lay-women commissioners. Their public reputation had the further effect of enabling their female relatives to commission objects in their honour which were also sometimes of an unusual nature, beyond the scope of the ordinary laywomen who make up the bulk of the documented commissions I analyse. I have grouped commissions by or for saintly laywomen in Chapter 9.

In conclusion, I have devoted Chapter 10 to a single case-study. This is the commission by Donna Margarita Pellegrini of a funerary chapel for her son and herself from Michele Sanmichele, at San Bernardino in Verona. I argue that this is the most powerful commission by a laywoman who was not a ruler nor the relative of a ruler which I have so far found. Since she was a widow, Margarita Pellegrini controlled the entire commission personally during her lifetime. She could afford to build new from the foundations and to employ an expensively articulated architecture, exquisitely sculpted, rather than the much cheaper painted decoration. She adopted the prestigious form of the centrally-planned edifice for her son and herself, a form otherwise chosen by popes and male bankers for their tombs, and traditionally associated with the commemoration of the martyrdom of a saint. Her building demonstrated the acme of scholarly Renaissance styles in its search for perfect geometrical proportions and the antiquarian accuracy of its classicising membering. After she had commissioned Sanmichele to work for her, local civic and family patrons followed her taste in employing him for their grandest buildings. Because she managed to control the project personally and build something which was in many respects the sort of thing a highly discriminating male patron could have commissioned, I suggest that it was a very special achievement.

Throughout this study I have presented clusters of case-studies in order to provide the information on individual women patrons which allows discussion of how the gender of the commissioner may explain features in a building or representation. The grouping of case-studies also enables analysis of the image or edifice to expand our understanding of the desires of women in buying art, and their rewards as beholders. This book describes the sociological, legal, economic and spiritual conditions in which laywomen could buy and enjoy art and architecture and the part they could play in making the 'Renaissance'. It is a study which has at its heart the feminist enterprise of recovering the histories of women patrons whose concerns may be inferred from their commissions and sometimes from their wills, portraits and inscriptions. With this data it is possible to debate the question as to whether what women commissioned represented acquiescence to masculine notions of the feminine, or, rather, represented their own versions of what was honourable female behaviour.

One question to keep in mind is that of whether works commissioned by laywomen look different to items commissioned by comparable laymen. The answer seems to be that in some cases they do. Where laywomen were commissioning something for their own use, the resulting work would often be marked as feminine. For example, the altarpiece commissioned by Caterina de' Sacchi for the Franciscan Tertiaries of San Bernardino in Verona gives women unusual prominence in presenting the portrait of the donatrix in the centre, including smaller portraits of her female colleagues on the predella and prioritising the foundress of the female tertiaries by having her placed in the position of honour to the left on the altar-panel. However, where the female commissioner was making something solely for a man – such as a tomb for her husband – only the wording of the inscription might indicate her role. In various intermediate situations between these two extremes, where, say, the woman intended to be buried in a son's or husband's funerary chapel, she might stipulate elements referring to the feminine – such as the presence of her own natal heraldry, and perhaps allusion to female saints. However, it should be emphasised that whether the product did or did not look as if it had been made for a woman, the fact that a woman had had it made would have had significance for contemporaries with respect to the propriety of her activities, and has significance for us now in terms of charting the ways in which women went about commissioning because of their legal and educational status and the social rules to which they were expected to adhere.

It is important to compare what laywomen could commission with what their fathers, brothers, sons and husbands could commission. Laymen could commission a greater range of objects for a wider diversity of functions than could women of their rank. Laymen might be given the opportunity to participate in the corporate governmental patronage which created great historical narratives and sculptures to adorn a town hall, or shape civic spaces for spectacle and assembly, complete with items like civic fountains. Such governmental patronage might be influenced very exceptionally indeed by laywomen regarded as living saints (as we shall see in Chapter 9). Laymen could also help to shape the artistic patronage of their guild in a way which was closed to women, because even those guilds which did admit widows did not charge them to oversee commissions on behalf of the guild. This barred women not only from helping to create a guild chapel or a guild hall, but also from participating in the kind of extra responsibility for artistic patronage for key sites like the baptistry and the cathedral undertaken by major guilds in Florence.

Both laymen and laywomen commissioned to help convents and also to assist devout groups of tertiaries and confraternities of which they were members, and both laywomen and laymen commissioned for their families. However,

laymen dominated the patronage of convents, tertiary chapels and confraternities, and they were more prominent in family patronage, too. While both laymen and laywomen might commission personal or family funerary commemorations, it was the men who were more often responsible for the family chapel, and they too were the ones who are documented as having built town palaces and having furnished them for themselves and their male heirs. Heiresses documented as commissioning with the assistance of their husbands to benefit their children – in terms of building and furnishings for the family dwelling – are rare. Widows with sons handed over responsibility for the family palace to the eldest, once he attained his majority, and so might be responsible for domestic architecture for a short spell. Widows without sons had no future family to endow, and were therefore treated as genealogical dead ends. They might make funerary chapels, but had no need to create fine houses – which would enter the patrimony of others at their death.

The way in which women's options were restricted, while men's were free-ranging, is evident also in the gendering of funerary and votive portraiture. Laymen commissioned the full range of effigial sculpture for themselves and other men, depending on their status. These sculptures included full-size effigies resting on top of the bier, seated or standing portraits beneath a canopy, portrait busts in niches and portraits in low relief on floor slabs. A few women commissioned these things for men, but not for themselves. A tiny number of laywomen gave themselves an effigy on a floor slab, or on the side of a tomb chest. No laywoman to my knowledge commissioned a portrait bust for herself or another woman at this period, and laywomen paid for a full-length effigy of a woman as if lying on the top of a tomb only when the woman commemorated was regarded as a saint. A few more laywomen commissioned a painted funerary portrait of themselves (but they still only account for a mere 3 per cent of the surviving painted single votive portraits).[3] From the early fifteenth century onwards, about 97 per cent of single painted votive portraits consist of laymen who had themselves painted full-length, half-length or head-and-shoulders. Laymen had themselves represented as rapt in prayer or gazing boldly out at the viewer. In contrast, laywomen had themselves portrayed as looking away from the viewer, and usually showing only a part of their body. There were, therefore, far fewer women commissioning than men, and their options in commissioning were very restricted in scope.

This pattern of male (open) and female (confined) may be understood in terms commonly employed by anthropologists to interpret how gendered behaviour is displayed in a diversity of societies. In introducing an anthology of articles on the way in which gender differences were represented in a variety of cultures, Sherry Ortner and Harriet Whitehead suggested that everywhere

the masculine is seen as capable of governing society because men can belong to any spheres – whether public or private.[4] Ortner and Whitehead argued that the masculine is regarded as a social chameleon, who has the right to speak for all in his public capacity. Since the masculine is represented as able to take any position, he can claim objectivity and universality. In contrast, the feminine is shown as corralled into a smaller area of activity within this general field, tied to the interests of the family, or her children and herself, and is represented as having partial or sectional views and knowledge. The masculine stands for the unlimited and omniscient, while the feminine is represented as limited in vision and knowledge. Such a model makes sense of the patronage patterns in Italian Renaissance society, where the masculine ranged freely over the public and the private spheres of commissioning, while the feminine was usually confined to the privacy of the family – and even there was restricted in comparison with the masculine. This anthropological model, as discussed by Ortner and Whitehead, suggests that the ideas of the masculine and the feminine inhabiting separate spheres and being defined through clusters of contrasting binaries like passive/ active or emotion/reason (found in the handbooks of conduct considered in Chapter 1) represent a surface fiction of duality. These cloak a more fundamental set of beliefs and practices: that the masculine governs, since he can take un-limited positions, while the feminine is subservient and limited. He can opt to express emotion yet control it with reason. He can choose the path of humility and the contemplative life, or that of active leadership and public admiration. The feminine inhabits a separate sphere which is not separate in the sense that the masculine cannot enter and share it, but, rather, separate in that she is con-fined to it. The system is not one of duality, but rather of a subservient sphere governed by the full powers of mastery.

For these laywomen class distinctions were of great importance. The terms lower-, middle- and upper-class, which are current now, are perhaps best used in some sort of conjunction with the less anachronistic concepts of rank, con-dition, estate, dignity or standing, which stress that we are dealing with social hierarchies which were different to those of industrial societies and which help to remind us that they were also locally particular. The poem by the Florentine Francesco da Barberino, written between 1314 and 1316 and entitled *Reggimento e costumi di donna*, for example, assumed that women of different rank should behave differently to one another, but listed not three or six groupings of women – as in modern classifications of class – but a dozen, divided into four clusters, with some discussion of how great wealth could outweigh lowly occupations or very ancient pedigree could counter poverty. Firstly came queens (*figlia d'imperadore con quelle del re*), then marchionesses, duchesses, countesses, baronesses and daughters of men who bore arms (*cavaliere da scudo*). Francesco

then moved, secondly, to explain that women of poor baronial families might behave both like the daughters of *cavaliere da scudo* and the daughters of judges, and those of doctors and of 'gentlemen' (*altro gentile uomo di cui antichi*). This group was followed, thirdly, by the daughters of burghers or city magnates (*mercatante o uomo di comune*), among them such people as rich guild-workers (*popolare artefici anco ricchi*). Fourthly came the daughters of lesser men like farmers and peasants (*uomo lavoratore di terra*).[5] We may note that for this writer her status was primarily derived from her father, though clearly it was also dependent on whom she married.

Surveying the most recent discussions of the definition of the ruling class in Italian territories, with reference to Venice and Florence, Anthony Molho has argued that it is impossible to define exactly the ruling elite of a city at this period, pointing to the coexistence of families of greater wealth and lesser lineage and those with lesser funds and impeccable genealogies in Venice and in Florence. Consequently he suggests that 'broad and capacious' definitions are preferable to narrower ones.[6] The widows I consider here were of rank just below or well below that of the great personal rulers – whether elected, *de facto*, or inheriting by succession – of large cities or domains. It should be stressed that in many cases where the commission is simply documented by inscription on the work itself, no information on the occupation of the woman's husband or father is available. With regard, however, to cases where more can be deduced, I look at the wives and widows of the lesser nobility, at the consorts of men in the legal and medical professions, at the spouses of soldiers in the service of governments and the partners of merchants and bankers. At the upper end of the range I have included such commissioners as the sister-in-law of a Doge (Donna Marietta Dandolo), a Countess (Contessa Penthesilea Baglioni) who was widow of a *condottiere* but only the first to hold the title, the spouse of a Marshal of the Queen of Naples who was also from one of the Florentine elite families (Donna Andreuccia Acciaiuoli) and a woman (Donna Atalante Baglioni) who might have been the consort of the ruler of Perugia if her husband had not been exiled as a member of the losing branch of the family in a family feud. With Molho's advice in mind, and given that these women came from such diverse locations and such a broad chronological spread, the most that can be said about them in generalisation is that the majority of patronesses about whom information is available were well-off and from the upper ranks of their particular community. Nevertheless, there are some exceptions in commissions deriving from women of lesser rank in, for instance, the altarpiece funded by Donna Fiordelise, the spouse of a Master Potter of Padua (though he *may* have counted as one of the rich guildsmen in Francesco da Barberino's third class bracket), the women of the confraternity of Our Lady in Sant'Antonio Abate

in Perugia, who paid their painter not in money but in kind, and the contribution to a joint commission at Santa Maria Formosa in Venice by the wife of a stonemason.

We would expect there to be different commissioning patterns for women of different rank. Indeed, for example, the women of lower rank seem to have contributed to collaborative commissions rather than to have been able to launch one project themselves. However, there also appear to be some similarities between commissioning women of different rank. For instance, women who were the relatives of men in the legal and medical professions were capable of funding unexpectedly prominent and attention-seeking projects. Such women's commissions could be equivalent to those executed for a member of the minor nobility. This data seems to chime in with the statements by Francesco da Barberino about the way in which the conduct of the daughters of less well-off noblemen might be similar to that of doctors of law and medicine. This is apparent in the comparison between the earliest full-scale, full-size donatrix portrait, which was designed for the Countess Penthesilea Baglioni, and the second in date, which was painted for Donna Lucrezia del Min – whose father was a doctor of law, whose first husband was a doctor of medicine and whose second was a doctor of law. Again, it is something of a surprise to find the widow of a guildsman – the Master Potter of Padua – being able to command a large altarpiece, and indeed one whose design probably influenced compositions made later for the widows of lawyers in the same city. Such instances suggest that factors like great wealth or the education a woman acquired through helping her clever father or her canny husband could sometimes counterweigh the place assigned in the social hierarchy to her father's occupation in determining what she could commission.

Only the most tentative statements can be made about any changes that may have taken place in the powers of wives and widows over this period. The handbooks of conduct studied in Chapter 1 at any rate suggest some continuity in attitudes as to the behaviour of women of these classes. One change, however, seems to have been an increase in the size of dowries, as deduced, for example, by Stanley Chojnacki from data from Venice. The increased dowries seem associated with the increase in the numbers of women being placed in convents rather than being married off.[7] Margaret King relates that whereas there were five convents in Florence in 1350, there were forty-seven in 1552.[8] Gabriella Zarri traced another dramatic increase – this time fivefold in Bologna between 1508 and 1569.[9] This trend implies that there would be fewer wives and widows capable of patronage, but that the few that were left would have been the more powerful. The lack of sufficient data about wives and widows who were patrons makes it impossible to test such a proposition at present.

Given that this was a society in which the feminine was supposed to be very different from the masculine, working for women patrons may well have caused problems for artists trained to employ a tradition of image-making and building geared to men. For example, special care may have been taken in representing saintly or real women for a female spectator. At the same time, working for women could perhaps provide opportunities for invention. Indeed, it will be suggested that the commission by Margarita Pellegrini of a funerary chapel for her son and herself presented Michele Sanmichele with the chance to experiment with a circular design, suited to the modest inhumation customary for children and women, whereas had a man commissioned it for his son and himself, space would have been required to provide the full-size tomb chests expected for male adult burial.

What sort of Renaissance, in terms of art and architecture, were laywomen commissioners able to explore, encourage and use for themselves? The answer seems to be that they were restricted in terms of the kinds of things that they could purchase by comparison with men. In architecture, it was male patrons who financed the majority of centrally-planned chapels and classicising villas, even though women patrons did on occasion take a decisive lead in demonstrating the latest styles, as we shall see in the Villa Badoer-Giustinian at Roncade for Agnesina Badoer (1514) and the Cappella Pellegrini for Margarita Pellegrini (1529–57) (Plates 8–9, 67–70). Some laywomen patrons invested in the making of sculpture in classicising and realistic styles with impressive results, but their commissions were usually not primarily for themselves or other women but rather devoted to the commemoration of male relatives (for example the magnificent double-sided tomb commissioned by Giovanna de' Beccaria in 1429) (Plate 26). Examples like the impressive portal contracted by Agnese Nascimbene (1441–42), the tombs ordered for themselves by Lucretia Andreotti (1484) and Cecilia Ursini (c. 1550) and the sepulchres of saintly women financed by Villana delle Botte (1451) and inscribed by Antonia Rusca (1499) were very much in the minority (Plates 53, 44, 45, 65–6). If women patrons had limited access to the use of marble, they seem to have had no access at all to the other medium which had classicising references – that is, to bronze, which cost roughly ten times more than marble. Nor were women commissioners of status below that of rulers able to purchase images referring to classical mythology or stories from ancient history, with the possible exception of the relief of the month of March shown as a naked wind-god for Agnese Nascimbene and the naked satyrs and nymphs sculpted in the detailing of the Cappella Pellegrini. Excepting the two last examples and the relaxed attitude to naked putti – which were, after all, just babies – as decorative motifs, women consumers seem only to have commissioned portrayals of the nude in the context of religious subject-matter. Here

11

the requirement for nudity would be dictated by the narrative or iconographical conventions associated with the the subjects related to the dedication of a chapel. For example, in the case of the depiction of Christ in his Crucifixion and Entombment nudity would be expected (as designed for Maria Bovolini, *c.* 1360, and Atalante Baglioni, 1507), as it would for images of saints like Onuphrius contracted by Altabella Avogaro (1484), Sebastian, paid for by Oradea Becchetti (1492), Jerome, ordered by Briseide Colla (1523) and the Baptist and Jerome commissioned by Maria Bufalini (1526) (Plates 38, 23, 46, 43, 52, 24). Only the male relatives of these laywomen commissioners might play some part in financing the development of the new Renaissance artistic forms of the bronze medal, or voting an equestrian monument to a successful *condottiere* or the creation of large-scale statuary in the round for the courtyard of their family palace. The women themselves were confined to contributing something to the other fast-developing Renaissance genres, that is to say, the creation of impressive altarpieces and of sepulchral monuments. On such altarpieces and tombs they were responsible for having a Latin, and on one occasion a Greek, inscription placed to express their wishes, or their praise of a male or female relative or to explicate some complex theological argument. Since Savonarola (1491) and Dolce (1547) both assumed that the marriageable woman might have been taught to read Latin, it seems possible that in the later part of the period some female patrons could have understood the inscriptions they had placed on their commissions.

It was largely in terms of commissioning altarpieces, and to some extent in contracting tombs, that women patrons could explore the new Renaissance stylistic effects of realistic-looking portraiture, the illusion of credible pictorial space with objects in it, the production of dramatically convincing narratives and the impression of a moment of action and feeling, in lighting and weather conditions denoting a specific place and time of day. Women patrons, however, seem to have followed behind the pioneering activities of male commissioners, rather than to have led, in using these new effects.

A handful of women patrons commissioned realistic-seeming likenesses of themselves, exploiting the way painters could depict their glances to guide the viewers of their images in devotion. Three truncated portraits (of Altabella Avogaro, 1484; Giulia Muzzarelli, *c.* 1530; and Antonia di Bartolomeo da Urbino, 1565) and one full-length portrait (of Finalteria da Bevagna, 1559) direct our gaze upward to honour the woman's advocate (Plates 46, 49, 50, 18). One three-quarter-length portrait (of Marietta Dandolo, 1547–54) and two full-length portraits (of Penthesilea Baglioni, *c.* 1520, and Lucrezia del Min, *c.* 1530) depict the donatrix with eyes downcast in prayer (Plates 51, 47, 48).

The technique of creating pictorially convincing perspectival space seems to have been welcomed by women patrons, with regard to such early examples

as that of Angellela di Pietro, with its startling evocation of the upper room for the Pentecost (1403), and with special reference to the exploitation of the central point construction to specify the position of the viewer in relation to the portrait of the donatrix herself in votive altarpieces from 1484 onwards (Altabella Avogaro) (Plates 21, 46). Altarpieces for women patrons also often included persons among the holy figures portrayed who appear to exchange admonitory or complicit glances with the viewer, beginning with the very earliest commissions such as that of Elena at Cesi whose image of the Virgin Mary (1308) is made to look at the spectator (Plate 36). Within the field of religious subject-matter female commissioners seem to have been able to command the full repertoire of skill in producing dramatically credible narratives (Atalante Baglioni, 1507) (Plate 23). Some early sixteenth-century examples display to the full the technique of suggesting an instant of movement, mood, weather and time of day (Briseide Colla, 1523–28; Maria Bufalini, 1526) (Plates 52, 24). Such techniques could be used to suggest the thoughts and feelings of the donatrix in an unexpectedly emotional and passionate way (Giulia Muzzarelli, c. 1530) (Plate 49).

How far did these wives and widows show an awareness of the new concepts associated with the Renaissance 'rise of the artist' – entailing the value of personal skill, of scientific and scholarly knowledge, of imagination and of problem-solving in an artist? There are early and later examples of women commissioners allowing artists to emphasise the latters' personal identity in inscribing works (Maria at Ancona, 1257; Angellela di Pietro, 1403; Oradea Becchetti, 1492) (Plates 40, 21, 43). A woman patron could also show some knowledge of fashionable trends in comparing her commission to another already completed and acclaimed, as in the case of the contract of Giulia Brancaccio, who stipulated that her husband's tomb ought to reach the standard of that of Donatello in a nearby church in Naples (1492) (Plate 14). One commissioner recorded her pleasure in artistic attainment when she stated in her will that her chapel was 'very beautiful and laudable' (Margarita Pellegrini, 1529–57) (Plates 67–70). A woman might wish to express her delight in what her artist had made for her by rewarding him well beyond the price she had contracted to pay him. With such enthusiasm Donna Briseide Colla of Parma in 1523 gave Antonio Correggio not only his lodgings in her house and the contracted payment while he was painting her altarpiece, but also a load of wood, some measures of grain and a pig (Plate 52).[10]

One of the main concerns of feminist history has been to recover the lives of silenced women in the past, and much work has been done in investigating the biographies of women artists and writers of the Italian Renaissance. However, this study suggests that a further field of evidence for reconstructing women's concerns is provided by examining their artistic commissions. With

the evidence of images and buildings, of inscriptions, wills and sometimes portraits, it is possible to build up quite a rich picture of the ambitions of individual women, derived from a great variety of social positions. If collecting secure data about laywomen's patronage allows us to discover women hidden from history, it also allows us to debate the feminist question of whether women who commissioned had to conform to the notion of the obedient feminine in order to be allowed to commission at all, or whether some women could use images or buildings to demonstrate their own views on how women should behave. Studying laywomen's patronage can provide evidence of the views of women on their roles which is not otherwise obtainable for such relatively ordinary women – women who did not, after all, write poetry, nor letters to great men, nor paint pictures themselves.

Many female commissions represented conventional expectations of proper feminine behaviour, since they were made in order to commemorate men in the orbit of the family, and ostensibly sought little or no attention for themselves. This was so with the funerary commemorations commissioned by women for their sons (Angellela di Pietro, 1403) (Plate 21). In even more cases women were responsible for commemorating their husbands (Andreuccia Acciaiuoli, 1380–90; Giovanna de' Beccaria, 1429; Giulia Brancaccio, 1492; Antonia di Giovanni Nuti, 1495; Antonia Vespucci, 1523–26; and the Tomacelli widows, 1473–1529) (Plates 20, 26, 13, 14, 27, 28–9). Occasionally the woman would have the dual job of commemorating her husband and father-in-law (Brigida, wife of Michele, 1482; Antonina Tomacelli, 1519; Maria Bufalini, 1526) (Plates 1, 15, 30–1, 24).

Nevertheless, it seems likely that her very activeness in choosing an artist, discriminating over the designs and handling the business, albeit on behalf of dead men, could give her unwonted prominence. Even in this arena of self-deprecation, the woman could make some appearance in the sepulchral inscription as the good wife (Antonina Tomacelli, 1519), or she might have attention drawn to her posthumously by the grateful church authorities for her gift (Brigida, widow of Michele, 1482) (Plates 30, 15). Some women in this position provided for their own commemoration along with that of their men (Filippa de' Benedetti for her brother and herself, 1483–86; Atalante Baglioni for her son, herself and their family, 1507) (Plates 22–3). Furthermore, a commission which started out as entirely concentrated on honouring a dead man might come to refer to the women of the family through new misfortunes intervening while the work was being completed (Margarita Pellegrini for her son, her daughter and herself, 1529–57) (Plates 67–70).

In the unusual circumstances in which a wife and mother built a villa for her children using her father's inheritance, her husband was placed in the

quasi-female position of generational 'go-between', acting primarily for her and their children, since he might enjoy solely the *use* of this villa, not its ownership, and this only if, as a widower, he did not remarry (Villa Badoer-Giustinian at Roncade, *c.* 1514) (Plates 8–9). In this commission the woman was behaving in a conventionally feminine way in acting for her children, but her role as heiress gave her powers closer than normal to those of the male head of the household.

Some women patrons were less conventional in terms of what was expected of the feminine, and put their spiritual and commemorative welfare on the same level as that of their husbands, rather than trailing in the wake of their male relatives (Maddalena Teruncelli, 1440; Fiordelise, before 1525; and Marsia de' Cagli, 1558) (Plates 4, 56, 57). A woman who had no relatives had, of course, no choice in this matter (Francesca de' Ripoi, 1517) (Plate 16).

A tiny handful of women made votive images for themselves including their own portrait. Since only about 3 per cent of votive portraits represented sole laywomen, as Kocks has shown, these women were awarding themselves unusual prominence. Fourteenth- and some fifteenth-century portraits are of diminutive size, but it is important to note that the majority did indeed take the place of honour on the left, normally taken by the donor (Elena at Cesi, 1308; Maria Bovolini, *c.* 1360; Tora di Nardo, *c.* 1375; Smeralda Nelli, *c.* 1480; and Oradea Becchetti, 1492) (Plates 36, 38, 41, 42, 43). Only Muccia of Lucignano (*c.* 1320) remained in the wifely place to the right. Similarly Alixe da Ponte was relegated to the right by the Prior of the monastery of Sant'Andrea when he recorded the building work which she had enabled (1356) (Plates 37, 19).

Women commissioners were able to have representations of themselves as donatrixes with realistically-sized portraits only at a late date by comparison with male donors. Some women only felt able to have a truncated portrait which disclosed merely the head and shoulders (Altabella Avogaro, 1484; Giulia Muzzarelli, *c.* 1530; Antonia di Bartolomeo da Urbino, 1565) (Plates 46, 49, 50). Others awarded themselves a full-length portrait (Penthesilea Baglioni, *c.* 1520; Lucrezia del Min, *c.* 1530) or were regarded as worthy of it by the institution whose commission they had funded (Finalteria da Bevagna, 1559) (Plates 47, 48, 18). Again, however, as with the diminutive portraits, it was the minority of women commissioning realistically-sized votive portraits who took the feminine position on the right (Penthesilea Baglioni, *c.* 1520; Antonia di Bartolomeo da Urbino, 1565) (Plates 47, 50). One commissioner took a three-quarters visible portrait placed on the left (Marietta Dandolo, 1547–54) (Plate 51). Few women seem to have been able to order full-length realistically-sized sepulchral effigies for themselves, and the three examples I have documented were not for the superior position, lying on the top of a tomb chest, but for

placing on a floor slab (Sibilia Cetto, 1418–21; Lucretia Andreotti, 1484) and the side of a tomb chest (Cecilia Ursini, *c.* 1550) (Plates 10, 44, 45). Only when it came to commemorating a woman of spiritual excellence could a female commissioner order (Antonia Rusca, 1499) or play a part in ordering (Villana delle Botte, 1451) a full-size effigy represented as lying on top of a draped bier – an image referring to the type of ceremonial funeral displaying the cadaver which men of temporal achievement were accorded (Plates 66, 65).

Whether for family chapel or a more general audience it seems likely that the votive and funerary portraits rebuffed normal masculine viewing routines, since women could be seen to have ordered representations of themselves which refused idealisation and showed the physiognomy of mature age. On altarpieces women commissioners were taking the power to show themselves in charge not only of their own gaze, but also of the gaze of the spectator. In veristic portrayals for tombs and altarpieces, women might emphasise their status as individuals in a superior realm of spiritual values which demoted temporal notions of feminine attractiveness for masculine consumption.

Although the attention-seeking votive or sepulchral portrait was in some ways so challenging to masculine expectations of the self-effacing feminine, the majority of these portraits were shown in the semi-private context of the family chapel. Where these portraits were primarily displayed to strangers in a church or monastery they were stepping out of the private sphere into the pub-lic arena in a more challenging way (Sibilia Cetto, 1418–21; Marietta Dandolo, 1547–54; Finalteria da Bevagna, 1559) (Plates 10, 51, 18). When women com-missioners created things which would benefit the public cult in a convent or a parish church or improve the health of their city in a hospital, they were veering into territory normally associated with the masculine domain. Although the praiseworthy feminine was defined as self-sacrificing, caring and pious, so that arguably it was conventional to give to the community in this way, the act of taking thought for the general good, with its associations of far-sightedness, magnificence and magnanimity, belonged too much to the public arena to be routinely acceptable from a woman commissioner. The writers of handbooks on female conduct considered that women should be confined to the priv-ate sphere, and if they did wish to do good outside the home, they should be careful not to draw attention to themselves. In common with other societies, as defined by Sherry Ortner and Harriet Whitehead, this was a culture in which

> Women are seen as tending towards more involvement with private and particu-laristic concerns, benefitting themselves and perhaps their children without regard to the larger social consequences, whereas men are seen as having a more universalist orientation as being concerned with the welfare of the social whole.[11]

Women commissioners who gave to those beyond their families could be viewed as acting outside the normal narrow scope of the feminine. Even women who gave small sums towards their local parish to fund works of art might attract admiration from fellow-parishioners (see Margarita, Margarita and Lucia, 1470–72, and Alessandra, Bellezza and Dialta, 1526) (Plates 3, 2). A woman commissioner could have sufficient funds to provide a chapel furthering some aspect of the cult dear to a particular community, for all to use, as when Griseide di Ser Sebastiano donated the Cappella delle Rose to the Franciscans of San Fortunato (1512) (Plate 54). A woman member of a Third Order Secular group could benefit her fellows and thereby achieve public prominence (Caterina de' Sacchi, 1522) (Plate 62). In practice it seems that quite often a woman's commission would have both a private and a public face, and perhaps the former function enabled the patron to achieve the latter prominence in a socially comfortable way. It seems possible, for example, that the *Crucifixion* of Maria Bovolini (*c.* 1360), with its appeal to the citizens of Bassano, and the altarpiece of Oradea Becchetti (1492), with its associated gift of indulgences, had such mixed functions (Plates 38, 43). This was probably the case with the memorial for her beatified mother commissioned by Antonia Rusca (1499) and even to some extent in the chapel made by Elena Duglioli to bury herself and her husband and to house a precious reliquary of Saint Cecilia to be honoured by the general worshipper (1513–17) (Plates 66, 63).

Generosity in giving to the community at large was not the only way in which commissions could achieve a public role unusual for women's works. Most spectacularly the 'living saint' could take a fully political role in being asked to prescribe the ingredients in a visual and dramatic enactment for a mass civic audience, with the very survival of the commune at stake (Margarita Bichi, 1526). More modestly, but with more continuity, laywomen as a body could act in an official capacity to fund something for their own organisation and thereby demonstrate their own institutional existence (the Compagnia della Nostra Donna in Perugia, 1510) (Plates 60–1). Acting alone, a widow might use a votive altarpiece to make a veiled statement of her political allegiances, as did Smeralda Nelli within a city still controlled by the powerful Medici family who had exiled her husband (*c.* 1480) (Plate 42). With an emphasis on cultural rather than political publicity a commission could come to attract the limelight, as the artist responsible gained a reputation and his works came to be written and talked about. This seems to have happened with the Pellegrini chapel, as its architect acquired great fame in her home town during the lifetime of the patron, and as his work entered the written and printed canon of Italian art eleven years after her death in Vasari's *Lives of the Artists* (Margarita Pellegrini, 1529–57) (Plates 67–70). Since, according to the ideology of conduct, women

were not supposed to concern themselves with politics and were not considered as leaders in cultural change, such commissioning was either venturesome from the very start or could come to appear so during the commissioner's lifetime.

Commissioning items which had some sort of public face seems, not surprisingly, to have been difficult for a woman to achieve independently. This study considers, for example, an instance in which a woman acted with her husband to create a hospital (Sibilia Cetto and Baldo Bonafari, 1414–21), a situation where the woman achieved a chapel to encourage the cult of the Annunciation long after her death through the commissioning of the Procurators of San Marco de Citra (Margareta Vitturi, 1427–1530), and the completion of a fine church portal through executors (Agnese Nascimbene, called Bianca, 1441–42) (Plates 10, 17, 53). Indeed, it seems likely that the woman commissioner acting in this unfamiliar sphere might find that only masculine assistance could validate her schemes. The 'double-act' of the funding niece working with the commissioning grand-nephew of the family of the *beata* Villana, in furthering her cult at Santa Maria Novella (1421–51), suggests how effective this could be (Plates 64–5). Such collaborative endeavours, for example with the Compagnia della Nostra Donna at Sant'Antonio Abate in Perugia being joined by their priest in their commission, underline that where evidence is lacking it is a fair assumption that the female commissioner did usually require some masculine assistance.

Did a woman have to 'pass' as the feminine-pleasing-to-men in her world in order to be a patron at all, and did she have to make sure she made conformist representations and buildings suited to her sex? Or was she already flouting the idea of the passive and silent feminine in commissioning in the first place – no matter how many caring hospitals and devout churches she built? Was the fact of her commissioning so disruptive that whatever she made and however carefully she tiptoed around hoping to achieve decorum, the displacements of the normative obviously did show something out of place and unexpected? Were some female commissioners more conventional, while others radically transgressed normative expectations to redefine the feminine?

This book is about women as commissioners and what they could say in their images and their buildings. But it is also about the female spectator and the many and various ways in which she could be prioritised as the viewer in a regime of representation which normally put men first. Such reversals are especially found in the votive images made by women for themselves, which include a portrait of the donatrix who shows the viewer what to look at and privileges any woman spectator by providing a female stepping-stone into the picture.

In asking whether women conformed or were conventional, we need to have some ideas about what conventions of feminine behaviour entailed. In

Chapter 1 we turn to look at a range of advice written by men during the period on the behaviour proper to wives and widows. In some ways this advice explains how wives and widows would have been able to justify their commissioning by reference to what was expected of them. In other ways, however, it provides a sense of the rules which some wives and widows moved away from when patronising the making of buildings, sculptures and paintings.

Notes

1 Filippo Todini and Elvio Lunghi, *Niccolò di Liberatore detto L'Alunno*, Foligno, 1987, fo. 15, recto–verso: 'Ad lectorem. Nobile testata est pingi [domina] Brigida quondam / Hoc opus; O! nimium munera grata Deo. / Si petis auctoris nomen; Nicholaus alunnus / Fulginis patri[a]e pulcra corona su[a]e. / Oct[?] quin[?] centum de millibus anni / Cum manus imposita est ultima vanuerant. / Sed quis plus meruit queso te judice lector / Cum causam dederit Brigida et ille manum?' (Dates are sometimes expressed subtractively, so this may indicate 'eight minus five hundred and a thousand'.) Thanks to Dr Colin Cunningham for advice on the translation.

2 See Jaynie Anderson, 'Rewriting the history of art patronage', *Renaissance Studies: Journal of the Society for Renaissance Studies*, X, 1996, pp. 129–38.

3 Dirk Kocks, *Die Stifterdarstellung in der italienischen Malerei des 13–15 Jahrhunderts*, Ph.D. thesis, University of Cologne, 1971 (figures based on counting up Kocks' examples, tabulated in the Appendix in his survey).

4 Sherry B. Ortner and Harriet Whitehead, *Sexual Meanings*, London, 1981, especially the Introduction, pp. 1–33.

5 Francesco da Barberino, *Reggimento e costumi di donna*, ed. G. E. Sansoni, Turin, 1957, pp. 15–19.

6 Anthony Molho, *Marriage Alliance in Late Medieval Florence*, Cambridge, Mass., 1994, pp. 193–4.

7 Stanley J. Chojnacki, 'Patrician women in Early Renaissance Venice', *Studies in the Renaissance*, XXI, 1974, pp. 176–203.

8 Margaret L. King, *Le donne nel Rinascimento*, Bari, 1991, p. 97.

9 Gabriella Zarri, *Le sante vive: profezie di corte e devozione femminile*, Turin, 1990, pp. 198–91.

10 Girolamo Tiraboschi, *Biblioteca Modenese, o notizie della vita e delle opere degli scrittori, natii [sic] degli stati del Serenissimo Signor Duca di Modena* (6 vols.), Modena, 1781–86, VI, 1786, pp. 267–8: 'la Dama ne fu soddisfatta per modo, che oltre la convenuta mercede, e oltre l'averlo nel tempo che in qual lavoro occupossi, mantenuto in sua casa, gli fece dono, secondo il desiderio del Pittore, di due carri di fasci, di alcune staja di frumento, e di un porco'.

11 Ortner and Whitehead, *Sexual Meanings*, pp. 7–8.

PROPER CONDUCT

There are few direct statements about how women might control or present images and building from this period. However, some guide as to what the rules were is given in the series of treatises on the correct behaviour of maidens, wives and widows, written by men. By analogy, strictures on women's speech and dress can be interpreted as indicating what the content of an image for a woman might be and what appearance she was able to present if she decided on a votive portrait. Advice as to what she should devote her energies to suggest that it was not expected for her to commission with an eye to her own concerns, but rather for the men in her family. Counsel on her public activity points to the boldness of any commissioning she undertook for a public arena and the care with which any portrait of her to be publicly displayed would have had to be calculated. Rulings as to what she should do with her eyes give an idea of what it was socially safe for a woman to be portrayed looking at, perhaps what kinds of images she was supposed to order, and what she was allowed to provide for other viewers. By surveying these handbooks of conduct it is possible to get an idea of what was regarded as correct behaviour against which the activities of commissioning women can be tested, to gauge the extent to which women patrons were conforming to contemporary rulings as to what was proper to the feminine. In doing so, it is important to keep in mind that the tone of the strictures suggests that in reality laywomen were acting in ways which were more independent than the moralists wished. If many women's behaviour did not conform to the handbooks' advice, it may be argued that some of the bolder female patrons considered in later chapters were nonconformists with regard to the advice of the handbooks but behaving in ways which were not so surprising, given the actual conduct of real Italian laywomen

during this period. The handbooks are nevertheless important sources to consider, because they suggest a written tradition of ideal conduct to which laywomen might aspire, which we can contrast and compare with the practical and visual tradition of proper conduct which this book traces in its history of laywomen buying and using art and architecture.

The handbooks of conduct which we draw on are a variegated group of texts. While some were addressed to women, with a relatively conciliatory tone, others were written for men, with stern advice for keeping women in order. There seems to be some class distinction here, with the firmer rulings being composed for merchants (Alberti and Paolo da Certaldo, for instance) and merchant princes (Francesco Barbaro) and the more permissive tone being used for dedicatees who were noblewomen (Trissino). Perhaps this distinction could map on to the behaviour of the women commissioners considered in Chapters 2–10, with women of nobler birth being permitted a rather more public and self-promoting type of art patronage. The handbooks are also variegated in that they were written in a variety of locations and not produced at regular intervals across the period. However, this unevenness is something of a match for a similar patchiness in the evidence of commissioning examined in Chapters 2–10.

Some handbooks deal with all the issues highlighted and include advice on how women were to act (by analogy to commission), what women were supposed to *look like* (how women could have themselves portrayed), what women were allowed to *look at* and how they were supposed to view (how women might be spectators, and of what) and where women could go (the kind of buildings they could make and where their images could be placed). But many treatises only touch on these topics, or cover a few of them. In looking at a selection of these works we shall sample the views of literate men on proper feminine demeanour. Such a study needs to be undertaken with an understanding that men also counselled other men in treatises on how to behave, including such rules as how men of lower rank should behave in the presence of their social superiors (the lowly man, for example, being instructed to stand, while his betters sat, to keep his eyes down, and to speak only when spoken to).

In examining the handbooks it is important to distinguish the advice given to wives from that given to widows. The legal position of a wife was that her will was subsumed under that of her husband, and the assumption in the handbooks was that she should be obedient to her husband and act for his good. Although in matters of conscience she was told to think for herself, she was seen otherwise as behaving well just by doing what her husband instructed. The legal position of the widow was different, because she was regarded as having a considerable degree of independence, and it is the patronage of widows which figures most largely in the case-studies considered in Chapters 2–10.

Although, as explained in Chapter 3, there were some checks on her autonomy, the widow was seen as someone who had to make her own decisions about her conduct. For these reasons we deal with the advice on proper behaviour for wives separately from strictures describing the correct demeanour of widows.

Wives

There are a number of shared assumptions in these pieces of masculine advice on the correct behaviour of the wife – varied though they are. One is that the virtue of husbands was different to the virtue of wives. Husbands were seen as worthy through cultivating a strong presence outside the house to protect and enhance the patrimony as well as governing the domestic domain. Women's virtue consisted in their chastity and their active care for their consorts' household. Where husbands could exercise virtue in both public and private, wives were to do good only in the privacy of the home. Wives were thought of as obeying their husbands in all things except when it came to matters of conscience, and the wife was supposed to put her husband first in all her considerations. Differences between men and women in marriage did not imply any binary relation of equals, but positioned the wife as the inferior member of the pair. The husband's proper government of the wife extended to physical reproof, and covered vetting her appearance, her way of speaking and what she looked at.

This was a system in which the husband was regarded as the discriminating viewer who scrutinised his wife inside and outside the home. He was the critical observer, and she was the object of his examination. As a viewer, her gaze was primarily to be restricted to the privacy of the house, or, if in company, she was told to look at her husband with admiration, or at the ground. She was not supposed to look about her freely in public. As a speaker she was to reply modestly if spoken to, but otherwise remain silent. As wife she was to *watch herself* to make sure she pleased her husband, dressing with a moderation which would ensure that she was not noticed in public either for her showiness or her carelessness. It is important to realise that both in an early text like that by Francesco da Barberino (about 1300) and a later text like that by Nevizzano (about 1520) the notion of what was public space included any parts of the house where she could be seen by outsiders – that is, the courtyard, the doorway, the windows and balconies, and perhaps even the public rooms. It also, of course, meant the public arenas of the street, the square and the church.

In giving advice on the education of women around 1315, the Florentine lawyer and poet Francesco da Barberino, in his long vernacular poem *The Rule and Customs of the Lady*, emphasised that it was unnecessary to educate

women who were destined to be wives in the way appropriate to those who were to become nuns. In his view, therefore, the laywoman did not need to be well lettered. While women of the upper classes needed to learn how to sew and cook in order to amuse themselves and govern the household knowledgeably, women of lower condition needed to be able to sew, weave and cook for their household directly.[1] On her wedding-day the wife to be was to appear timid and shy, with her eyes downcast.[2] In order to represent herself as passively feminine, at the marriage ceremony, she was not to give her hand freely to her husband, but to wait so as to give the effect of the ring being forced on to her. Once in her husband's house, she should speak only when spoken to, and respond briefly, in a low voice and timidly.[3] The wife was to concentrate entirely on serving her husband – to the extent of looking only at him, as Barberino ordered: 'Abstain from looking at all – save him.'[4] The scopic double standard is underlined by the way in which the poet told the wife never to let her own eyes stray to look at another man, but that if her husband looked at another woman, she was to pretend not to notice, and hope his mood would change.[5]

According to another Florentine, the merchant Paolo da Certaldo, writing in Italian about 1365, women needed marriage to stabilise and control their giddy behaviour, for 'without a man to control her conduct, the woman is in great danger, because she is very empty and unstable'.[6] In his treatise entitled the *Book of Good Customs*, he stated that the wife needed watching constantly by her husband to ensure that she worked hard, and that it was more dangerous to grant a woman leisure than it was to a man. He should often come back to the house and keep his wife in a flutter of apprehensiveness for his approval.[7] The husband was the master who made the critical surveillance – indeed, Certaldo told the husband to lock the house from outside if he went out at night, so that he would always know who left or entered his house.[8] For Certaldo the priorities of the wife and the husband were very different. Whereas the wife was to make her husband the centre of her attention, the husband was told to give priority to his sons and only then to consider his wife, and after her, his friends.[9] The lowly position of the wife is emphasised in the proverb which Certaldo quoted with approval: 'Good horses and bad horses want the spurs; good wives and bad ones want a master and the stick.'[10] The qualities to be valued in a wife were those of serviceableness in the household, propriety in any public place, and piety in church.[11]

A later Florentine treatise dedicated in 1416 by Cardinal Giovanni Dominici to Donna Bartolommea degli Alberti dwelt more extensively on the conduct of the good wife. The recipient of his advice, which was written in Italian, was the wife of a Florentine man who had been exiled, so that she had unusually

heavy burdens of responsibility. Like Paolo da Certaldo, Fra Dominici advised that the wife should never be idle, but spend her time at prayer or at work with her hands. Like his predecessor he stressed that the wife should obey her husband in all things, and give him priority – so she was to consult her husband before helping and caring for her parents or her sons or her daughters, let alone other needy people outside the family.[12] Dominici considered that wives could buy or make things for the ornament of a church service and for the fabric of the church itself, in order to do good works for their salvation, but although their souls belonged to God, they were to be completely ruled by their husbands in body and goods and therefore needed their permission for such devout gifts.[13] The only exception to the rule of wifely obedience was with regard to her duty to consult her own conscience, were he to command her to commit a mortal sin, and also in, for example, not working on feast days and in attending church on the major feasts and Sundays, even if her husband ordered her to do the opposite.[14] Only the wife's duty to obey God's commands overrode her duty to obey her husband.

Dominici made clear that the wife was responsible for the devout education of her young children, and although he considered that only the boys needed to be taught to read and write, he gave detailed advice on what sort of pictures she should have in the house to instruct girls and boys: 'The first thing is to have in the house paintings of holy boys and young virgins.' For boys one should have images of the Virgin Mary with Christ in her arms, and a little bird or a pomegranate in his hand. A good motif would also be the suckling Christ or Christ sleeping in his mother's lap. Another good image would be the Baptist himself as a small child, wearing camel-skin. He also mentions the subject of the Massacre of the Innocents. For little girls the mother should choose images of the Eleven Thousand Virgins and of Saints Agnes, Cecily, Catherine and Elizabeth, because these women offer good role-models for loving Christ, hating sin and avoiding bad company. He adds that in church the wife should be careful not to let her children admire paintings covered in silver and gold in preference to older, more revered ones, which were smoke-blackened.[15]

Like previous writers Dominici considered that the wife belonged to the privacy of the family house, and should not go out unless her husband told her to. As with other handbook authors, he did not conceive of the wife walking about her city as an ordinary, tranquil and even edifying exercise. Instead he plunged into an image of disorder as he wrote of the dangers of her going out to the pub or the bar (*albergare*).[16] The confinement of the wife's gaze is made explicit in his advice that although in the country she might look to her heart's content at the beauties of God's creation (in the trees, the sky and the flowers), in the city she had to lower her eyes and fix them on the ground.[17]

At the same date, in 1416, Francesco Barbaro wrote a Latin treatise on choosing a wife, entitled *On Marital Matters*. His checklist of good wifely qualities stressed that above all things she should be modest.[18] Although he was a Venetian patrician, he wrote this in Florence. The conventional stricture that she should be silent except when spoken to, then moderate in her reply, was trotted out, and Barbaro added that wives should watch themselves every day in the mirror, so as to cogitate on what matronly dignity and gravity required of their appearance to achieve decorum.[19] Such suitable dress meant for him an appearance which struck no individual note, because it was neither too exquisitely choice nor too carelessly negligent.[20] As in other treatises, the ideals of female quietness, modesty and the suppression of any independent self-expression were linked with the notion that the wife should remain in the private sphere. The writer proposed that men were naturally equipped through strength of body and mind to defend the home, while the imbecility (*imbecillitas*) of women fitted them to look after the household contents.[21] Wives were to follow the moods of their husbands, 'joyfully congratulating when things go well and giving comfort in adversity'.[22] Barbaro revealed his sense of the danger of women who look freely about them when he defined an immodest woman as one with wandering eyes (*evagatio oculorum*).[23] Luxurious clothing was to be avoided, as it would encourage the woman to roam about the city to show off her finery – and the customs of Egyptian patricians of forbidding their wives to wear shoes was approved as a way of confining them to the home. Wives were not to be thought of as walking about the streets but of *wandering* (*evagandi*) – so that wandering feet are compared to the dangers of wandering eyes.[24] Barbaro explained that for a woman to make speeches in public was as shocking as if she was to take all her clothes off for everyone to see her body. Behind this comparison lay the idea that while it was proper for a wife to appear naked to her own husband and speak freely to him, such things were for his eyes and ears only. Neither her opinions nor her naked body should be aired and seen in public.[25] Rather, taciturnity in a woman could not be too much admired.[26] Originally dedicated to Lorenzo di Giovanni de' Medici on the occasion of his marriage, the notions in this treatise were still current more than a century later, for even in the mid sixteenth century Italian translations were being published.[27]

In his vernacular treatise *On the Family* written during the 1430s and 1440s, the Florentine Leon Battista Alberti presented an evaluation of the wife based on her use to men – in terms of her capability as child-bearer and her trustworthiness as a man's helpmeet. In this role she needed to be modest, obedient, neat, hardworking and cheerful.[28] Like the other treatise writers Alberti considered that the woman should concentrate on running the house. She should

not spend her time gossiping outside it, but try to be taciturn – for quiet and guarded utterance was the ornament of a wife.[29] Like Francesco Barbaro, Alberti dwelt on the notion of separate spheres, linking it to theories of sexual difference in order to explain the dominance of the husband over home and business and the confinement of the wife to the house. Whereas the wife was timid and gentle by nature and therefore suited to look after the household, the husband was bold and firm and could therefore defend his fatherland, his religion and his family.[30]

The subordination of the wife and the concept of natural difference between men and women is explicit also in the treatise by the Franciscan Fra Cherubino of Siena. This was written in the vernacular, entitled the *Rule for Married Life*, and composed some time before his death in 1484.[31] In it he outlined the contrasting duties of the husband and the wife in the marriage. He explained that the husband had a primary duty to provide his wife with teaching, instructing her in the words of the Paternoster, the Ave Maria and the Credo. Secondly, it was his duty to correct her. He argued that the wife was a weak and defective creature (*fragile e difettuosa*) whom her husband needed to put right either with words or with blows. He should commence with tactful words: 'don't say "you're crazy", but rather, say "you have spoken like one of those silly and foolish women"'.[32]

If she would not listen to reason, blows, a beating or a real thrashing might be necessary.[33] Thirdly, he had a duty to feed and clothe her, not unlike his duties to a child, an apprentice or a servant.[34] Conversely, he outlined the duties of the wife. In his view it was the first duty of the wife to fear her husband's displeasure and to obey any of her husband's commands which were not contrary to the commands of God.[35] Secondly, she had a duty to serve and care for him.[36] Thirdly, she owed a duty to admonish him. But whereas the husband could use physical violence and brusque words (*parole bruschi*) to the woman, the wife was told to entreat him to improve his ways: 'You should sweetly and pleasantly exhort and cajole him to improve, saying, "My Lord, My Master, what you did was wrong – I pray you not to do it any more".'[37]

In this asymmetrical pattern of reciprocal duties the wife is seen as possessing some judgemental and decision-making abilities, but associated with relatively weak powers: of refusal to do something wrong herself and of persuading, rather than forcing, her husband to avoid sin. Such advice proved popular, as Fra Cherubino's treatise was often reprinted in the next two centuries.

About half a century later, a little before 1520, Giovanni Nevizzano, a Professor of Law at Turin, wrote a Latin treatise on marriage called the *Nuptial Forest*.[38] Nevizzano rehearsed the familiar theory that wives ought to serve their husbands, who rightly controlled their goods as well as their bodies – down to

deciding whether they were allowed to wear a nightgown in bed or not.[39] He repeated the idea that they should be kept busy in the house and should 'not associate with one another, nor wander about the town, nor travel'.[40] He quoted a saying which reveals contemporary expectations as to the places where married women were to be safely seen, and something of the current derisive views on wives: 'Women are saints in church, demons in the house, magpies at the door, owls at the window and goats in the garden.'[41]

In explaining the aphorism, Nevizzano said that no one denies that women are more devout and merciful than men; hence their sanctity in church. But in the house a woman scolds the servants like a devil, and at the door – when she is buying things from pedlars – she chatters like a magpie, while at the window she calls like an owl, for she may not go out into the piazza. Nevizzano side-stepped the presumably lascivious implications in the comparison between the wife and the goat in the garden, by saying women everywhere like gardening – even in pots and window-boxes, if they have no ground by their house – and that one man does more damage in a garden than three women – except menstruating ones, whose effusions kill plants.[42]

Like Francesco da Barberino, at the beginning of the period, Nevizzano did not think the wife needed to be well educated. Although he believed that her knowledge should be helpful to her husband whether in her literacy or in her rational care of the family, he thought that it could be dangerous to marry a learned woman, because she might wish to dominate and 'because letters are instruments of luxury and are more of an elegant ornament than a necessity to an honest woman'.[43] Nevizzano followed previous authors like Alberti and Francesco Barbaro in emphasising the doctrine of sexual difference, but he did not use it solely to show the wife in a weaker light. Rather he suggested that the prudent wife might wean a husband away from his vices. In explaining women's potential for superior virtue Nevizzano cited the example of Judith's victory over Holofernes, as represented in the statue before the Palazzo della Signoria in Florence, as an example of the defence of the fatherland, and stated that 'it is said that women are more pious than men, so that they are considered to gain access to salvation more quickly'.[44] This is presumably a development of the duty of the wife to admonish her husband, on which Fra Cherubino da Siena had dwelt.

In an Italian treatise entitled *Most Praiseworthy Teachings Belonging to Honourable and Virtuous Married Life* published in Venice in 1547, the Venetian Lodovico Dolce also emphasised the feminine goodness of the wife and stressed another way in which this quality assisted the breadwinner, recalling the early fifteenth-century advice of Francesco Barbaro that the wife would show her love of her husband by matching her moods to his:[45]

The wife can be the restorer of the husband, to whom he is grateful when sadness overtakes him – as sometimes happens. After any hard mental work, she should make recreation for him, with some sweet motto or pleasing story, and especially when he betakes himself to the house to get away from the clamour of court affairs or of civic business, she should make home a tranquil and restorative place to rest in – like a good hostel after a long journey.[46]

The treatise reiterated the tough regime of the wife outlined by earlier handbooks, such as the commonplace that the wife and the husband should be one body, of which he is the head.[47] There is little sense of the wife as a separate being, with volition, since no part of her body or mind is to be kept secret from her husband.[48] Naturally the wife ought to obey her husband, and, as Fra Cherubino da Siena had advised a century before, she was told to bear it patiently when he beat her.[49] The wife should seek to please her husband and should value silence. She was to consider neither the wealth nor the status she had brought to the house, but only her honesty, chastity, kindness, virtue, obedience and her duty in caring for domestic matters.[50] As usual, the wife was to behave very cautiously when she was outside the house, acting with gravity and honesty and taking care to look at no man.[51] Dolce justified the subordination of the wife with reference to the familiar doctrine of sexual difference. The husband is said to be harder-working than the wife and strong enough to deal with the outside world, while the woman is weaker, but can passively conserve the things which her husband has acquired in the house which he shelters and guards overall.[52] Accordingly, husbands should deal with public affairs and women should not seek to know anything of the republic.[53] Dolce repeated the advice on the importance of the wife meeting her spiritual obligations – and the way these duties to God had priority over the commands of her husband.

Despite variations, there are some common assumptions running through these treatises – of wifely confinement to the home and obedience to the husband. These notions were not a matter of surface advice on manners, but rather locked in at the deepest level with the pronouncements of canon law. So the Dominican Archbishop of Florence, Antonino Pierozzi, who was declared Saint Antoninus, wrote a frequently-printed compendium of canon law between 1440 and 1459, within which was a section on marriage. His preface rehearses the rules covered by the handbook-writers. The wife was to obey her husband in all honest and allowable actions and, for example, could therefore only give alms or gifts by his permission. The wife should shun public spaces: 'She ought but rarely to wander around outside the home . . . and she should not go leaping about in the piazza, nor stand telling stories and murmuring in the doorway, nor talking at the window . . . and she should go outside the house only to church, and then she should not go by herself.'[54]

The only explicit advice on what the wife could commission was given by Dominici, who approved of her paying for religious furnishings for church and of her ordering images for the home to encourage piety and good behaviour in her children. The general import of the handbooks is that any art patronage would be expected to take place by permission of the husband, that commissions in which the goodness and piety of the wife benefited the husband spiritually would be encouraged, as well as ones which were aimed to benefit his lineage. Indeed, according to the handbooks it is hard to think of the wife possessing the subjecthood to speak or act as an individual at all. If commissions followed the rules suggested for her appearance, we would expect her to take some middle way between extremes such as the 'exquisite' and the 'careless' of Francesco Barbaro, so as not to attract undue attention and risk the embarrassment of her husband. Presumably qualities which were felt to represent her matronly dignity and gravity would be required.

Widows

I turn now to gauge the conventions which were to be negotiated by widows in buying art and architecture.

Among the writers on female conduct widows were regarded more highly than wives. Because of a widow's abstention from sex and the possibility of leading a life of abstemiousness by herself, she was considered to be living in a state in which she could be more virtuous than a wife whose chastity consisted in keeping herself for one man. For example, Archbishop Antonino Pierozzi declared that although the state of marriage was honourable, canon and divine law praised the state of widowhood as the more perfect.[55] In the vacuum of obedience to a living man created by death, the treatise-writers fell back on counselling the widow to concentrate instead on the higher role of serving God. All the writers agreed on the need for the widow to abstain from sexual activity, for her not to frequent public spaces and to shun the limelight, acting modestly and not attracting attention for any singular behaviour. Within this ideology of conduct, however, there was some flexibility about how the widow should live in order to achieve a chaste, modest and private existence. Some writers outlined a more severe routine including practices such as solitude, abstinence from social and bodily pleasures, prayer, penitence, silence, the doing of good works and the giving of alms, an emphasis on plainness in dress and also self-education in scriptural knowledge, so as to set a good example or teach others in her charge. Other writers – and this seems to be especially true of the sixteenth-century ones – advised a gentler regime, concerned that too

much piety, lack of social contact and hardship might lead to eccentric behaviour and appearance, and that the widow could become intolerant, censorious and lose her feminine amiability. There was clearly some room for interpretation as to how the widow should conduct herself.

Although the theoretical model of the widow was not much different to that of the wife, there is also a sense of the widow as quite a powerful figure for the stated reason of her experience and the unstated reason of her relative freedom from the close control of a man. Indeed, about 1365, Paolo da Certaldo had advised, 'do not take a widow for a wife, because you will never satisfy her, and she will always compare you with her first husband'.[56] The widow was thought capable of judging a man and finding him inadequate.

The Florentine Francesco da Barberino, writing in about 1315, had devoted part of his didactic poem to those women who remain widows, offering them comforts in the shape of personifications of Constancy, Hope and Consolation, and the promise of eventual Happiness and Joy. The young childless widow was advised to spend at least a year in the house of her husband as a widow and then, if her family wished, she was to remarry. If she was of middle age, what she did was dependent on what sort of woman she was – whether she was young in heart (in which case she might want to remarry), or whether she preferred to remain without a husband. An older widow should live honourably in the house of her husband or her own house.[57]

Although, he wrote, many widows wore make-up when they went out – to vie with their female neighbours, to please their lovers, or so everyone would say what beautiful women they were – Barberino stated that a widow who washed in water and wore a veil was really beautiful.[58] The widow with children should, in his view, stay with them, educating them so that 'they are friends of reason and justice, and walk in the way of God', appointing officials to help her organise the household, and guarding and increasing the wealth of the family.[59] The widow was warned never to speak to a man alone, except priests and monks, not to go out often on to the streets, nor sit constantly at her windows. She was told to dress plainly, keep company with mature women, ignore dances and other vanities, lament, pray for and speak well of her husband, and keep offering plenty of alms for her and her husband's souls.[60] Barberino's parting words pointed to his concept of the widow as one who must be contained out of sight, or at least be as inconspicuous as possible, as he advised her: 'Lock your doors early in the evening, open them late in the morning, and watch carefully that you do not shut the serpent in the house.'[61]

The elegant Latin poem addressed by Antonio Loschi to the scholarly widow Maddalena Scrovegni of Padua in 1389 also stressed that the widow belonged

to the private sphere and should lead a life of intense modesty, frugality and chastity. For reasons which the writer does not make explicit, she is also given to penitence. The ideal of the widow as so self-effacing and self-mortifying that she is socially invisible is represented by erudite personifications and learned exemplars. Loschi elevated the tone by allegorising the private *studiolo* of Maddalena in her father's house as a Temple of Chastity in Scythia – the land of the Amazons. Loschi signified this feminine Chastity as remote, placed very high, dwelling in white marble and seated on a glass throne. He described her as dressed in widow's garments, and so as to let it be understood that she showed true modesty in withstanding great temptations, she was represented as being in the flower of her age, with her beauty untouched.[62] Carved in stone were exemplars of Chastity in the form of Lucretia, Hippolytus, Hermione, Penelope and Arethusa. Tending the fire of Vesta, Maddalena was placed at the centre of a system of concentric circles and guarded by the personifications of Penitence, Continence and Virginity, while her protector, Frugality, beat off the advances of Cupid. At her feet sat the twins Pudor and Verecundia (Candour and Natural Modesty).[63]

A few years later, at the beginning of the fifteenth century, the Florentine Cardinal Giovanni Dominici stated that both the maiden and the widow should devote themselves to divine service, and encouraged the widow by explaining that she could be superior in piety because of her experience of the vanities of the world and her development of endurance through her role in marriage.[64] Dominici offered two exemplars for the widow – the Prophets Judith and Hannah. He presented a wishful picture of the Old Testament widows. Even though Judith was noble, rich and beautiful and had many relations, she always stayed in her room fasting, praying and wearing a hair shirt. She had only gone out in public once, and that was for divine glory and for the salvation of her people, when she showed herself in attractive clothing to her own people and to strangers. Only such a widow, said Dominici, having returned to the merit of chastity, could have vanquished the human enemy, because she had conquered the ancient serpent of temptation in herself. (In the Bible the Prophet Judith had gone out to the camp of the enemies of her people and had killed the enemy general after having made him drunk and, rather problematically for Dominici, beguiled him with her beauty.) The Prophet Hannah remained in the temple day and night, well into her seventies, sacrificing to God, like Judith. In this way, according to Dominici, she earned the hundredfold harvest of virginity because she received the Christ child in her arms when the Virgin Mary brought him to the priest. According to the Bible she had begun to proclaim the coming of Christ as redeemer to all she met once she had seen Him as a baby in the temple.[65]

Dominici commanded a severe regime for the contemporary widow and quoted Saint Paul in his support: 'the widow who enjoys delights is dead' (1 Timothy 5.6). She should distance herself as far as possible from comfortable couches, fine underclothes, pleasant tastes and delicate foods or nutritious things to eat, delicious wines, spices, beautiful clothing, trailing garments, dances, worldly songs and music outside churches. She should avoid weddings, banquets, vain behaviour, going where there are men, even when these are relatives, going to *feste*, or travelling about ('running around the earth' (*discorrer per la terra*)). This, explained Dominici, is not the behaviour of someone whom Jesus Christ would like to take as his wife. The widow should embrace solitude, prayer, discipline, weeping, religious music and confession – as long as it did not entail too many friendly talks with clerics. She was to practise almsgiving and acts of mercy, but only in so far as this could be done without danger or giving a bad example to others.[66] He seems here to be thinking about the possible danger to the reputation of the widow if she got to know the sinful or the poor sufficiently to help them, and also the danger of attracting attention through her gifts. As far as education was concerned, Dominici advised that the widow concentrate on the holy scriptures and its interpreters, and should not seek to inform herself on astronomy or knowledge of classical literature.[67] To follow this discipline of life, he wrote, provided the solaces of the saintly widow.

In the fundamental area of food and drink Dominici merely advised the older widower not to drink wine every day, so as to keep as healthy as a peasant, whereas the older widow was to follow Job and live off bread, herbs and water – and sometimes a little fish. She was to be a female hermit.[68] Here is a model of sensory and social deprivation, of constricted movement, where even good works have warning signals placed round them because they could take the widow into the public sphere. He envisaged the possibility of the widow building churches, monasteries and hospitals, which were all acceptable alms to God, as long as the widow realised that it would always be better to repair an existing foundation – if there was one in her area – rather than to found a new one.[69] Better, he said, that she do good by stealth rather than place her coat of arms on such a gift to the community. Most importantly, she should always consider that while it was good to paint churches to the honour of God and endow them with rich vestments and vessels, or commission murals with gold and fine blue, it would be wrong to neglect the living poor.[70]

At the end of the fifteenth century the Florentine Dominican friar Girolamo Savonarola also took the Prophet Hannah as the ideal for the widow – only this time devoting the whole of his vernacular *Book on the Widow's Life* (1491) to exploring her example. He praised her single-minded devotion to God in deciding to remain a widow, and disparagingly listed the less laudable motives

of widows who refuse remarriage to be desire for social respect, love of their son, love of possessions or fear of having a worse husband than the first.[71] Although such worldly widows might in his view live 'honestly and be reputed as venerable mothers', they still could not command the respect due to followers of the Prophet Hannah.[72] Savonarola explained that Hannah was to be emulated in three ways: firstly, in her practice of solitude; secondly, in her abstinence; and thirdly, in her prayer. Armed with these powers she was able, once she had seen the Christ child, to add a fourth element to her regime of piety – her teaching of all those who wished to know of the redemption of Israel. In suggesting a teaching role for the widow, Savonarola seems at first glance to offer an unusually positive avenue to the widow for an active devoutness. But the treatise proceded to corral her didactic role in ways that confined it to the deferential feminine, recalling the instruction of Fra Cherubino da Siena to the wife – to admonish her husband politely.

Savonarola commanded solitude for the widow, explaining that the woman could not hope to turn from carnal thoughts if she was continually with people. She was to read the lives of the saints and avoid familiarity with members of the household, let alone strange men. She was to keep necessary contact with priests and friars to a minimum, and not to wander about the city from church to church, nor seek to receive visits and be given beads and images (corone and immagine) by such men.[73]

He also told the widow to abstain from the superfluous delights of corporeal sensations. Saint Paul's admonition that the widow who enjoys the delights of the world is dead to God was repeated. In Savonarola's view the sense of taste came first, so indulgence in food and drink should be avoided. Second came sight, so that she needed to be abstinent about whom she looked at and how:

> Especially in churches and other public places you can attract scandal to yourself and to your kin, for I assure you that a great deal can be known from her eyes about the virtue of a lady and the sobriety of her lifestyle. Whence speaks the Prophet in Ecclesiasticus [26.9]: 'fornication in a woman can be known from the way she raises and lifts up her eyes', and therefore the widow ought always to look down and lower her eyes to the ground, wherever she is, and especially when she is in the view of men, and with great modesty and seriousness she should raise her gaze according to the place she is in and the person with whom she is speaking.[74]

Third came the sense of hearing and speech. The widow should avoid pernicious and useless speech, and especially calumny and gossip. Above all she was not to speak much of herself. Fourth came the sense of smell, and so the widow needed to avoid libidinous scents. Women may tell you that they put beautiful-smelling powders and oils on clothes and linen to keep them from

deteriorating, wrote Savonarola, but this is unnecessary. Finally came the sense of touch – the sense which Savonarola considered most dangerous of all: 'Because the pleasure of touching is most violent and bestial, and blots out all reason whence many women and men have fallen only through a touch of the hand.'[75]

Finally, Savonarola warned that the widow must not enjoy delightful things in the imagination either, but rather she was to bend her thoughts towards God.

As well as solitude and abstinence, the widow should embrace prayer and holy meditation. Although it was more the office of women to be silent and learn with humility, the widow who devoted herself to prayer was in a position, following the Prophet Hannah, to teach those who wished to know of redemption about the Saviour. Savonarola emphasised that women were prohibited from preaching publicly, but that they might teach *secretamente* – privately. The widow who instructed had to be well informed on the Ten Commandments, the articles of faith and the *buoni consigli* (the latter may mean the Beatitudes or Christ's commandment to love one another). For her knowledge she was to rely on reading in Latin or Italian if she had been taught grammar, and in any case on her own experience.[76] Savonarola defined the kind of instruction methods she should use as suitably passive and he hedged it about with strictures regarding the status of her listeners. To her betters she could only use her passive example and she might correct them only when they requested, or if their behaviour was such as to render her the moral superior. Even then she still had to employ humility and tact. To her equals – persumably other women of her rank – she could use not only her example but also humble reproof, entreaty and censure – though still in a charitable way, without making a show of authority. With her inferiors (her own and her relatives' children, and the servants) she could use all these approaches and back them up with threats and even blows, yet she was supposed to retain a saintly humility throughout in her heart.[77]

If Savonarola's treatise largely conjured up the image of a widow who lived like a secular nun, a more permissive tone was produced in the treatise by Giovanni Giorgio Trissino of Vicenza entitled *Concerning the Life that a Lady who is a Widow Should Live*, composed in Italian and published in Rome in 1524. This may be because it was dedicated to a noblewoman – Margarita Pia Sanseverino – whose patronage Trissino desired to retain. It may also be because he was thinking of a widow of rather higher status than that addressed in the treatise of Savonarola. Trissino began by stressing the widow's rights and her spiritual equality with males as a woman. He spoke of her as a free woman 'who is not subject to a husband, a father or any other man'.[78] And he encouraged her with the thought that she was born, like all humans, as a man in soul, and just happened to have been placed in a female body.[79] Trissino's treatise was reprinted in Venice in 1530 and in 1549.

Like his predecessors, Trissino offered the widow the life of privacy in her household and virtuous behaviour, educating her children and guarding their inheritance. He explained that, rather than seek beauty, the widow should seek glory. However, the widow's glory was to be acquired through good works and good behaviour, rather than daring deeds. Where the masculine qualifications for glory would be active public achievements, Margarita Pia was offered the passive feminine path, in which Trissino told her the greatest of good works is *pudicitia* – that is, the qualities of modesty, chastity and honour. In fact he advised her explicitly *not* to seek public power and precedence (*signoria e maggioranza*). For the widow, in Trissino's argument, good works were virtually collapsed into good behaviour, and the treatise prescribed a feminine character which is moderate, unobtrusive and amiable. Trissino adapted the masculine list of the Four Cardinal Virtues, leaving out the active virtue of Fortitude or Bravery and substituting for it the feminine virtue of Tolerance. The widow therefore had to practise Prudence, Temperance, Justice and *Tolerance*.[80]

Trissino did not approve of excessive devoutness – 'going about with bent head, lips pursed, attending all the services of the church and saying the Paternoster all day at home'.[81] As Dominici had advised, good should be done by stealth and piety should be quietly observed. In contrast with Savonarola, he did not approve of isolation. Although she should not go to too many weddings and *feste*, the widow should enjoy the company of the good women of her city – while being very careful never to be seen talking to men of bad reputation. Trissino devoted much space to telling the widow how she might talk, and she was warned that 'the slightest action, or freedom and audacity in speech, leads to suspicion of a less than honest life'.[82] She was to guard against unseemly laughter and speaking too boldly, for the one was the sign of a light mind and the other of a furious spirit.[83] 'Silence . . . is the great ornament of women. I do not mean that you should be mute, but that you should not speak except at the right time, and that you should seek always to be serious, honourable and charming in your speech.'[84]

Trissino forbade the widow to discuss war or affairs of state and warned her not to reveal her innermost thoughts, nor speak impulsively without thinking. She was to be approachable, rather than arrogant, and needed to avoid being argumentative and difficult to please. She was not to complain about her problems, but to appear benign, delightful and serene. This is an area in which a slight change of tone is perhaps apparent. From early on, writers on wives had stressed the importance of kindness (for example Francesco Barbaro) and cheerfulness (for instance Alberti). With the handbooks of Dominici and Savonarola, rather sterner qualities were emphasised for the widow. However, Trissino's advice to the widow to be so good-tempered and Dolce's counsel – considered

next – that she should always look benign and amiable, could represent the idea of the continuity of the good and charming wife transposed to the life of the widow.

Trissino ended with the advice to show moderation in dress and in her furnishing of her household:

> In appearance and clothing I praise what is ornate because this shows care, but not flaunting nor painted, because while ornate dress is a sign of careful thought, the latter sort of appearance represents a light and not very chaste mind. Equally, too little care in her appearance in a lady is a sign of foolishness.[85]

In the house too the widow was not to have an abundance of superfine things, nor yet to lack basic necessities, for the former showed intemperance, while the latter indicated lack of prudence.[86] Indeed, in speech, laughter, dress and furnishing her house, the watchword was to take the middle path, so as to avoid being noticed, and to cloak personal feelings with the impression of feminine serenity. The treatise goes to the heart of masculine anxiety about maintaining feminine difference. For at the same time that Trissino demanded that widows keep up the appearance of amiability (where the male is differentiated as capable of showing wrath and anger in public), he feared the very cultivation of feminine duplicity. For he urged, impossibly, 'never have in you anything of the double and feigning . . . never have one thing on your lips and another closed in your breast'.[87]

The imperative contradicted his previous instruction – that she must never reveal her innermost thoughts. This anxiety about what a woman might really be thinking, doing and planning could be acute in a masculine regime which not only insisted on the feminine as self-consciously controlled appearance, but also conceived the Christian person as a site of continuous interior struggle, where soul and spirit fought with body and selfish desires. Ideally for Trissino – and as we shall see next, with the advice of Dolce – the widow was to internalise the docility, responsiveness and modesty required of her feminine persona to the point of no longer being aware of acting a part.

As well as writing on the behaviour of wives, Dolce had also written on the conduct of widows in *The Most Praiseworthy Instruction of the Honourable and Virtuous Life of the Widow*, published in Venice in 1547. Following the views of Cardinal Dominici, Dolce asserted that the state of widowhood, when a woman had acquired knowledge and experience, was more pleasing to God than that of the wife or the maiden. Recalling the words of Francesco da Barberino, Dolce spoke first of the proper period of mourning and then advised the young childless widow to remarry so as to avoid calumny, but the widow with children should remain loyal to her husband's memory and look

after his children.[88] He provided various exemplars from ancient history of such loyalty to one man, and also a bestiary suggesting she emulate the diligence of the bee, the assiduity of the ant, the faithfulness of the dog and the loyalty to one mate supposedly practised by turtle-doves and pigeons.[89]

Dolce explained that commissioning a splendid tomb for her husband was of no use to the dead, whereas alms to support widows and orphans in hospitals on his behalf would be useful to the living.[90] Recalling the advice of Dominici, Dolce counselled her to take Christ as her husband. As with other handbooks on behaviour, one gets the impression that the widow has only exchanged obedience to and fear of her husband for her duty to the Divine Spouse. With a glance in the direction of Savonarola, Dolce ordered her to lead a 'vita honesta e casta' through fasting, praying and sincerely removing herself far from the delights of the world.[91] Like Dominici and Savonarola, he suggested as her exemplar the Prophetess Hannah.[92]

From practices of piety Dolce moved to her household cares. The widow needed to rule her household and family well, spending plenty on the education of her sons, conserving the estate and living moderately. However, Dolce was alert to the dangers that such responsibilities might put her in – of contact with public affairs:

> And because to run the household one enters into many transactions which are not appropriate for a lady, like buying, selling, receiving payments, dealing with judgements and soliciting advocates, and doing business that takes up the whole day and is a skill, the widow should choose an efficient and trustworthy man to whom she should commit the burden of this management.[93]

Ideally, this man should be a brother or father.

Dolce, as we have come to expect, laid down strict rules as to the behaviour of the widow. She should associate only with men who were relatives and with women of good reputation, and she should have a female companion (ideally her mother or mother-in-law or an old friend). She was to avoid luxurious food and wine and dress well in a moderate way, leaving the house solely to attend church, avoiding the houses of friends and relatives and not attending *feste* or weddings.[94] As in Trissino's treatise, the widow was told that her piety was also to be moderate, that she should confess only once or twice a year, read religious books, and certainly not show off her sanctity, as some do who think more of seeming than being devout. Giving alms and doing good works were to be hidden, and prayer should be confined to her own room.[95]

The widow was to think carefully before she spoke, and never speak evil of anyone, nor ever get angry. She was never to speak of public issues like government and war – 'the latest news from the piazza, like the business of the

King and the deliberations of the Princes' – but to concentrate on the private concerns of her household and spiritual matters.[96] Despite her confinement, however, Dolce, like Trissino, struck a new note in expecting her to maintain a blithe and happy expression on her face, although he closed his treatise with the conventional encomium of the Prophet Judith.[97]

He signalled a further change in advising that marriageable women should have some breadth of literacy. As well as knowing how to govern a household, how to cook, spin and weave, how to adorn a room and make a bed, she should also, in his view, read widely in Latin and Italian, as long as the content was not lascivious, and as long as she did not attempt Greek.[98] Nevizzano had, in contrast, agreed with Francesco da Barberino in shunning learned women, while Dominici and Savonarola had desired her well-informed – but solely on a diet of scriptural books. The treatise by Dolce suggested that a Renaissance husband could have liked a woman who appreciated his conversation – should he range over the ancient Roman and Greek historians and poets as well as Dante and Petrarch in the vernacular and such modern Latin writers as Vida. Possibly the image of the well-informed lady represented in *The Courtier* by Castiglione (1528) had some effect on the educational advice for women of humbler social position.

The handbooks were virtually silent about widows commissioning works of art. As I have noted, Giovanni Dominici advised her to buy images for her household so as to instil piety in her children, to fund the rebuilding and repair of churches, hospitals and monasteries, rather than creating new foundations in her name, and to decorate churches only as long as she gave generously to those in need. Dolce was more negative in suggesting that it was better to help the poor than to commission a tomb for her husband, though he implied that she might perhaps fund hospitals for widows and orphans in his name.

Some inferences can be drawn about the views of these writers on widows' commissioning. It seems likely that the widow would be advised to get an agent to act for her, and that even if she did deal directly with artists, she would not be supposed to do so alone. It seems that all writers were concerned for the widow to display her chastity in every action, and that she should be devout, modest and not attract attention. For all authors, her appearance in public, except at church, was to be minimal. There was, however, some conflict between these priorities when it came to the possibilities of devout practices attracting personal fame and entailing some public prominence in the church. Where the wife's dilemmas about conduct were easily solved by appeal to the authority of her husband, the advice to the widow to live a devout life and obey God might allow her to search out her own way to some degree. Some authors – like Dominici and Savonarola – advised her to educate herself spiritually, to

practise self-denial and influence people around her. For other authors adherence to the heroic regimes of such women as the Prophets Hannah and Judith held dangers. They preferred the widow to make moderation her watchword, looking well turned-out without extravagance, appearing serene and amiable rather than penitent and censorious, and furnishing her house decently – though not luxuriously. Perhaps by analogy commissioning widows would need to patronise schemes which were well funded without being either too extravagant or too mean. According to these authors her piety too should be moderate (Dolce, for example, suggests she confess just twice a year), and she should avoid excessive church-going, any admonitory role or self-advertising practices of prayer, obvious almsgiving and fasting.

When widows commissioned they often acted solely for the good of their male relatives, and were thus presumably conforming to the handbooks' expectations of the self-effacing feminine. However, widows did also commission items for their own spiritual benefit, with or without their own votive portraits. These representations asserted the conventional belief in the spiritual equality of women, but also entailed unusual personal prominence for the individual women. While some schemes were focused on the more private arena of family use in a family chapel, albeit within the public space of the church, others were clearly intended to benefit the general congregation. In such works women were placed in the unusual role of taking the initiative in judging the needs of their community, whether it be for a new hospital or a new chapel, and of exerting the power to give what they deemed was required. Although a few votive portraits showed the widow in a serene manner (Plate 49, for example), others represent the woman in a more severe fashion (Plate 46, for instance). Where portraits were included, the widow took the role, unusual for the sole female outside the home, of exhorting devoutness by example and directing viewers how to look. It seems possible that the emphasis on the importance of piety for the widow could create some space for her action and the expression of her views in public, despite the danger to her honour of immodesty and attention-seeking. In this somewhat flexible area, where devoutness might outweigh modesty, a special place was reserved for laywomen acknowledged as candidates for sainthood in their own lifetimes, whose patronage is discussed in Chapter 9.

Laywomen as viewers and consumers of art

The handbooks emphasise that ordinary wives and widows were not supposed to be discriminating viewers on a par with men. For instance, about 1365 Paolo da Certaldo had advised young women to take the Virgin Mary as their

exemplar. He consequently suggested that the woman should withdraw to the innermost sanctum of the house, and in a revealing metaphor compared the vacuity of a woman without a man to direct her ('la femina è cosa molto vana') to a vacuous wandering eye ('occhio vano') which looks from one thing to another to choose what it likes:

> She [the Virgin Mary] did not linger outside the house, and she did not go running about here and there, nor up and down, listening to and looking at frivolous men and other vanities, but she stayed closed up, and locked away in a hidden and honest place . . . and she did not behave like an empty and foolish eye which looks around at what it wants and does not want.[99]

For the woman to survey the whole visual field was not interpreted as a preliminary to any measured discrimination or well-thought-out choice, but as a foolish feminine fluttering from one thing to another. Roving eyes were no better than roaming feet for the female.

Women were also used to being the objects of scrutiny and male surveillance in private and in public, not free-ranging critical viewers themselves. In his treatise *On the Excellence and Dignity of Women*, published in Venice in 1526, Giovanni Francesco Capra illustrated the cruelty of the masculine optical regime. Even the church, he wrote, is turned into a theatre where women going about their devotions are treated as a

> new spectacle, and one man will whisper into the ears of another, 'Look at her', and he will reply, 'She looks as if her breasts were bellows full of wind', and a thousand other things which would be superfluous and do little honour to write down, where women silently and modestly, with eyes downcast, attend to no one but to their prayers.[100]

In this regime of representation, women acting as patrons were taking an unusually discriminating role in judging what to show in church or civic space. Furthermore, where women ordered votive portraits they were taking an even more unusual power. Males were supposed to display themselves freely as actors in both public and domestic space. In contrast, women were likely to be construed as more or less attractive objects, to be acted upon by the masculine viewer. Women commissioning votive portraits could perhaps contest these conventions by having their gaze direct that of the viewer around the composition and also by presenting themselves as *not* concerned to look attractive. They were nevertheless carefully conventional in the sense that they chose to be shown in their altarpieces with their eyes downcast in prayer, or averted, to gaze upwards at the saint or saviour in whom they put their trust. When it came to managing the gazes of the painted or sculpted persons in their representations, however, there was more flexibility. The woman commissioner could have an

image designed which used the direct gazes of male or female protagonists in her representation to make challenging eye-contact with spectators, including herself as viewer, at her behest. For example, the way Raphael turned the painted Magdalene to look at the viewer in the altarpiece of Saint Cecilia for Beata Elena Duglioli is especially striking (Plate 63). In considering the significance of such exchanges of the glance it is important to think of the audience for which the woman patron was commissioning, over and beyond the primary fact that the artist was aiming to satisfy her.

Presenting images to all-women audiences would allow a woman to escape the masculine scrutiny of her portrayal as the attractive object of his sight. Apart from this, the woman might commission in a particular way for an all-woman audience. One example is the fresco decoration made by Donna Finalteria da Bevagna for the nuns' choir at Sant'Anna in Foligno, which, although it did not entail a votive portrait, showed Saint Lucy holding a pair of eyes which gaze at the viewer between narrow lids, on a dish (Plate 55). But women often aimed their commissions at mixed audiences. Occasionally in this situation the image prioritised the female gaze. For example, an altarpiece commissioned by Caterina de' Sacchi for the Tertiaries of San Bernardino in Verona used her own portrait to lead the eye from one saint to the next in the altarpiece – putting Saint Elizabeth of Hungary first (Plate 62). Sometimes the image commissioned by a woman might be aimed at a men-only gaze, as for instance in the high altar for Sant'Andrea in Padua commissioned by Marietta Dandolo (Plate 51). This showed herself and a companion beside the Magdalene, who was represented as the first witness of the Resurrection. Here a chain of women – from the patron, to her companion, to the Magdalene – embodied faith in Christ, for a choir of Dominican friars.

The dominant conventions represented masculine and feminine as inherently different, with the female as the subordinate term in the pair. This may be seen as linked to the systems of binaries – of the many pairs of opposing qualities used in all discourses to describe and account for the world. These systems of meanings in which the feminine is always assigned the relatively weaker quality so as to secure the dominance of the masculine were maintained by the rules of ecclesiastical and secular institutions and their integral discourses of power. While male commissioners and artists did dominate all these regimes of representation, some women patrons arguably pushed at the conventional definitions of the feminine. These regimes of representation were developing and changing themselves. They were also, in some senses, contradictory or mutually inconsistent. In a system set up for a normative masculine, if a woman avoided infringing one set of strictures about what a woman should do, she might well transgress in another way, obtaining a prestige unusual for the feminine through

reference to some other discourse or system of meanings. In periods where masculine-dominated discourses themselves multiply, alter and radically or slightly contradict one another, as in the cultural ferment we call the Renaissance, there could be some spaces for women commissioners to create unorthodox meanings.

In some cases women commissioners seem to be consciously transgressing within the rules of a single discourse or system of meanings. I suggest that this was happening when women patrons took over the position of honour to the spectator's left for their votive portraits, which was accorded to a man when man and wife were portrayed on an altarpiece. In contrast, a woman commissioner might be very careful *not* to perpetrate some unfeminine act according to one discourse, but thereby inadvertently acquire an abnormal superiority for the feminine. Possibly the patron welcomed the symbolic windfall. For example, a widow might wish to have on an altarpiece a portrait of herself which emphasised her age and plainness, so as to state her adherence to her dead husband and her rejection of the vanities of the world, but this could allow her to slide away from the feminine role of attractive object and over on to the symbolic territory of the venerable male actor, represented warts-and-all, as the wise governor and discriminating judge of what he surveys.

For example, it will be suggested that Margarita Pellegrini set out consciously in the Cappella Pellegrini to make a funerary chapel for her young son and herself which was highly conventional in that it did *not* entail full-size tombs for her young son or herself, on the basis that full-size tombs were the privilege only of adult men of her class (Plates 67–70). However, this modest decision meant that her project particularly suited the latest central-plan designs, and in particular the most prestigious ground plan of all: the circular. By reference to the newest, fast-developing Renaissance architectural theories, experimenting with the revival of antiquity, decorum in one discourse could come to be indecorous for the feminine in another. Margarita Pellegrini ended up – perhaps without really intending it from the start – with a funerary chapel which was proper for a woman in one way, but too progressive and exemplary (in terms of stylistic innovation) for her gender, in other ways, and indeed more suited to the finest taste of male leaders in her society: of popes and bankers.

Where women were constructed as belonging to the modest, the private and the domestic, and advised to do good by stealth, we shall take the extent to which women patrons could provide costly, grand and public images and edifices for their cities as some index of women asserting an unexpected prominence. Where women were advised not to draw attention to themselves, it seems that the commissioning of votive portraits made claims of individual spiritual worth for which the writers of the handbooks did not prepare the reader. Where

women were not expected to be well educated, commissions which showed scholarly distinction – such as a wealth of erudite inscriptions – would have been unusually prestigious for the feminine. Where women were not regarded as enlightened pioneers in thought, contracts which allowed a leading artist to demonstrate the latest artistic ideas placed the woman patron in the unfamiliar role of furthering general development and progress in art. In the following chapters, which look at a sequence of case-studies, some attempt has been made to distinguish groups of commissions regarded as relatively conformist from those which seem, in the light of this survey of the handbooks of conduct, to have been rather more unconventional.

Notes

1 Barberino, *Reggimento e costumi di donna*, pp. 15–19.

2 *Ibid.*, p. 59: 'esser temente e vergognosa, cogli occhi chinati, fermi li membri e sembri paurosa'.

3 *Ibid.*, p. 69: 'non dimandi, ma s'è domandata risponda brieve, basso e pauroso'.

4 *Ibid.*, p. 89: 'ch'ogni suo guardo s'astenga da tutti, fuor che da lui'.

5 *Ibid.*, p. 89: 'che s'essa s'accorge ch'esto suo marito ad alcun'altra donna o damigella volgesse gli occhi o desse intendimento, finga ciò non veder in questo tempo'.

6 Paolo da Certaldo, *Libro di buoni costumi*, ed. Alfredo Schiaffini, Florence, 1945, p. 105: 'La femina è cosa molto vana e leggiere a muovere, e però quand'ella sta sanza il marito sta a grande pericolo.'

7 *Ibid.*, pp. 105–6: 'torna spesso in casa, e provedi i fatti tuoi, e tielle in tremore e paura tuttavia. E fa sempre ch'abbiano che fare in casa, e non si stieno mai: chè stare la femina e l'uomo ozioso è di grande pericolo, ma più è di pericolo a la femina.'

8 *Ibid.*, p. 114: 'Sempre mai l'uscio de la tua casa fa che si serri la notte a chiave, acciò che di notte niuno non esca e non entri in casa tua che tu non sappi.'

9 *Ibid.*, p. 128: 'il primo si è quello de l'anima tua, il secondo si è quello de' tuoi figliuoli, il terzo si è de la tua donna, il quarto si è da uno amico a l'altro'.

10 *Ibid.*, p. 137: 'Buoncavallo e mal cavallo vuole sprone; buona donna e mala donna vuol signore, a tale bastone.'

11 *Ibid.*, p. 133: 'La donna dee [*sic*] essere sollecita in casa, e onesta fuori, e divota in chiesa.'

12 Giovanni Dominici, *Regola del governo di cura familiare*, ed. D. Salvi, Florence, 1860, p. 58: 'non ne cavo nè parenti nè figliuoli nè figliuole, salve se tuo marito tel comandasse'.

13 *Ibid.*, p. 59: 'cose s'appartengono alla divina laude, e liciti ornamenti ecclesiastici'.

14 *Ibid.*, p. 91: 'ordinandoti tu guadagnassi male, di fare quello che non è lecito . . . non obedire'.

15 *Ibid.*, pp. 131–3.

16 *Ibid.*, p. 87: 'Esso sia el signore e tu la serva . . . Tu non puoi dormire se non dove esso vuole, e non puoi vegghiare fuori del letto dov'egli è . . . e molto meno andare di notte albergare fuori di casa.'

17 *Ibid.*, pp. 46–7: 'Abbi aperti gli occhi al cielo, alle selve, alla foresta, al' fiori e a tutte cose ti possono infiammare del Creatore; nelle città e dove sono chi può peccare o far peccare, gli occhi bassi e fissi nella terra.'

18 Francesco Barbaro, *De re uxoria*, Paris, 1513, fo. xxii, recto: 'omni tempore coniuges modestia prae se ferant'.

19 *Ibid.*, fo. xxiii, recto: 'Appelate coniunctissimis respondeat modestissime'; and fo. xxii, recto: 'Quotidie speculentur et cogitent quod dignitas matronatum: quod seviritas [*sic*] postulet: ne quod decoris ab eis desideret.'

20 *Ibid.*, fo. xxiiii, recto: 'Attamen nec nimis exquisitus nec neglectus admodum probabitur sed quod decorum servaverit.'

21 *Ibid.*, fo. xxvii, verso.

22 *Ibid.*, fo. xix, verso: 'Nam et secundis in rebus gratulatio iocunda: et in adversis consolatio est.'

23 *Ibid.*, fo. xxii, recto: 'evagatio oculorum . . . levitatis vanitati semper coniuncta sunt'.

24 *Ibid.*, fo. xxiiii, verso: 'saepissime per totam urbem discurrere. Quodcirca sapienter Aegyptiis mulieribus ne calceis patriciis uterentur interdictum est: ut evagandi licentia cohiberetur.'

25 *Ibid.*, fo. xiii, recto: 'sed ne sermones quidem mulieris publicos esse conveniet. Nec enim minus huiusmodi foeminae vox quam membrorum nudatio verenda est.'

26 *Ibid.*, fo. xxiii: 'Taciturnitas ipsa satis commendari non potest.'

27 See Francesco Barbaro, *Prudentissimi et gravi documenti circa la elettion della moglie*, Venice, 1548.

28 Leon Battista Alberti, *I libri della famiglia*, ed. G. Mancini, Florence, 1908, pp. 103–4.

29 *Ibid.*, pp. 212–13.

30 *Ibid.*, pp. 202–3: 'gli uomini ànno da natura l'animo rilevato e più che le femine apto con arme e consiglio a propulsare ogni adversità quale premesse la patria, le cose sacre, o e nati suoi. Et l'animo è dell'uomo asai più che quello delle femine robusto et fermo a sostenere ogni impeto de' nemici, e sono più forti alle fatiche, più constanti negli afanni, et ànno gli uomini ancora più onesta questa licenza uscire pe' paesi altrui acquistando et [coa]dunando de' beni della fortuna. Contrario le femine, quasi tutte si vegono timide da natura, molle, tarde, et per questo più utili sedendo a custodire le cose, quasi come la natura, così provedesse al vivere nostro, volendo che l'uomo rechi a casa, la donna lo serbi. Difenda la donna serrata in casa le cose e sè stessi con otio, timore et suspitione. L'uomo difenda la donna, la casa e suoi, e la patria sua, non sedendo, ma exercitando l'animo, le mani con molta virtù per sino a spandere [spender] il sudore e il sangue.'

31 Fra Cherubino da Siena, *Regole della vita matrimoniale*, in G. Carducci, *Scelta di curiosità letterarie inedite o rare dal secolo XIII al XVII*, ed. C. Negroni and F. Zambrini, Bologna, 1888.

32 *Ibid.*, p. 12: 'non disse tu se' una pazza, ma disse tu hai parlato quasi come una delle folli e stolte femmine'.

33 *Ibid.*, p. 11: 'percussione, o vero battitura e flagellamento'.

34 *Ibid.*, p. 15: 'debbi provedere a tutte le necessità dell'anima e corpo della moglie'.

35 *Ibid.*, p. 18: 'debbi stare sempre in paura', but p. 20: 'se il marito ti comanda cosa che sia contro alla legge di Dio, non gli debbi ubbidire'.

36 *Ibid.*, p. 21: 'debbi servire a tutto quello che è necessario'.

37 *Ibid.*, p. 23: 'lo debbi dolcemente e piacevolmente esortare e confortare che non lo faccia più . . . messer mio, signore mio, la tale cosa fate ch'è peccato; priegovi, che non facciate questo più'.

38 Giovanni Nevizzano, *Sylvae nuptualis libri sex*, Venice, 1573 (although the preface speaks of an edition in 1520, the first recorded publication is Paris, 1521).

39 *Ibid.*, p. 167 and p. 309: 'nec possunt tenere camisiam in lecto invito marito'.

40 *Ibid.*, pp. 301, 309: 'mulieres non conversantur, non vagantur, non peregrinantur'.

41 *Ibid.*, p. 401: 'Mulieres in ecclesia [sunt] sanctae, in domo daemones, bubones in fenestris, picas in porta, caprae in hortis.'

42 *Ibid.*, pp. 402–4.

43 *Ibid.*, p. 118: 'Doctrina et scientia mulieris visa est viris prodesse et labores eorum alleviasse tam in scribendo et tenendo rationem curae familiaris quam fidelius et magus secrete', and p. 215: 'Mulierem doctam ducere periculosum est . . . quae instrumenta luxuriae sunt, elegantius quam necesse est probae mulieri.'

44 *Ibid.*, p. 317: 'Virtus pietatis dicitur inesse plus mulieribus quam viris et ideo illae dicuntur citius salvari quam viri.'

45 Lodovico Dolce, *Ammaestramenti pregiatissimi che appartengono alla educatione e honorevole e virtuosa vita virginale, maritale e vedovile*, Venice, 1622 (first published Venice, 1547).

46 *Ibid.*, p. 93: 'Grato ristoro adunque nelle tristezze che alle volte sopravengono, o doppo alcuna fatica di mente, farà al marito l'esser ricreato dalla moglie con qualche dolce motto, o piacevole novelletta: e massimamente quando o dalli strepiti del palazzo, o dalle onde de' negotii civili, a casa, come ad albergo di quiete, et a porto di gratissima consolatione si riconduce.'

47 *Ibid.*, p. 90: 'un corpo solo'.

48 *Ibid.*: 'sotto un solo tetto . . . in un solo letto'.

49 *Ibid.*, p. 79: 'onde la femina obbedisce al maschio lo accompagna, lo accarezza, et sostiene con molta patientia d'esser battuta da lui'.

50 *Ibid.*, p. 91: 'la prudente moglie non istimar suo dote, danari, bellezze, o nobiltà, ch'ella porti seco in casa del marito, ma la honestà, la castità, la bontà, la virtù, la obbediaenza, la diligenza nel governo la famiglia'.

51 *Ibid.*, p. 106: 'con la sua famiglia si ritrovi nella propria casa'.

52 *Ibid.*, p. 101: 'per esser la femina più debole, di conservar nella casa le cose acquisite'.

53 *Ibid.*, p. 102: 'non cercar di saper quello, che si tratta nella Repubblica'.

54 Saint Antonino, Archbishop of Florence, *Tractatus de sponsalibus*, Lyons, 1511, fo. e vii, recto: 'Debet esse rara in discurrendo extra domum . . . non debet esse in plateis ad tripudianum, in ostio domus ad confabulandum vel murmurandum, in finestra ad procandum . . . prodire extra domum nescia nisi cum ad ecclesiam conveniret, et tunc non sola.' The earlier editions were published in 1474, 1477 and 1480.

55 *Ibid.*, fo. g vii, recto: 'iura canonica et divina plus fave[n]t viduitati q[uam] matrimonio ut statui perfectiori'.

56 Certaldo, *Libro di buoni costumi*, p. 160.

57 Barberino, *Reggimento e costumi di donna*, pp. 131–2.

58 *Ibid.*, p. 132: 'Ai, com'è bella vedova colei che sol lo velo la cuovre e l'acqua lava.'

59 *Ibid.*, pp. 133–5: 'amici di ragione e di giustizia, e che caminin per la via di Dio'.

60 *Ibid.*, pp. 137–8: 'prieghi sovente per il suo marito . . . parli di questo passato come più puote in suo laude e onore'.

61 *Ibid.*, p. 138: 'Faccia serrar le suo porti per tempo, e tardi avrire, e cautamente guardi che non s'inchiuda lo serpente in casa.'

62 Margaret L. King, 'Goddess and captive: Antonio Loschi's epistolary tribute to Maddalena Scrovegni', *Medievalia et humanistica*, X, 1988, p. 122: 'habitus quidem primo vidualis eligitur, et integra pulchritudo in etate florida, ut intelligi detur magnos contra stimulos veram pudicitiam experiri'.

63 *Ibid.*, pp. 103–27.

64 Dominici, *Regola del governo di cura familiare*, p. 104: 'nobile, ricca, bella giovane, graziosa e molto imparentata, la quale stava sempre in camera sempre in diguini, sempre orava, e il ciliccio portava alle carni sue'.

65 *Ibid.*, p. 105: 'Nomina il nuovo Testamento Anna santa fatta profetessa la quale ben sessanta anni perseverò nel tempio dì e notte, di se sacrificando a Dio nel modo che di Iudit è detto qui di sopra.'

66 *Ibid.*, pp. 105–6: 'atti di misericordia quanto sanza pericolo o malo esemplo d'altri'.

67 *Ibid.*, p. 83: 'non di sapere il corso di Saturno, o innamoramenti di Piramo o di Giove, fa' la Scrittura Santa e suoi dottori sieno la luce'.

68 *Ibid.*, pp. 105–6, 185.

69 *Ibid.*, p. 122: 'Così si possono spendere i beni in fabbricare chiesa, monasteri, spedali, maritar fanciulle, liberar prigioni, vestir mal vestiti . . . se vuogli spendere quantità di danari, più ti consiglio rifacci una chiesa guasta . . . o spedal rifiutato per povertà . . . che fabbricar di nuovo . . . e tu n'a[v]rai più premio, perchè a[v]rai minor fama nel mondo.'

70 *Ibid.*, p. 125: 'Dipigner chiese ad onor di Dio, e dotarla di ricchi vestimenti e vasi . . . ma vestire donna Eva d'oro o fino azzurro dentro nel muro e la figliuola di carne vera lasciar morir di freddo o mancar di fame, non è ragionevole.'

71 Girolamo Savonarola, *Libro della vita viduale*, Florence, 1491.

72 *Ibid.*, fo. a 6, recto: 'per amore di figluoli o per amore di roba o per non trovare peggio del primo marito, o perche cosi gli da la sua natura et pero secondo la oppinione del mondo vivano onestamente e siano reputate matre venerande, nientedimeno non sono ancora di quelle alle quale noi vogliamo parlare'.

73 *Ibid.*, fos. b 6, recto – c 2, recto.

74 *Ibid.*, fos. c 3, verso – c 4, recto: 'Maxime nelle chiese et luoghi pubblici altrimenti dara scandolo asse medesima et al proximo suo avisando vi che molto si conosce a gli occhi la pudicitia della donna e la gravita della sua vita. Onde dice el savio nello Ecclesiastico: la fornicatione della donna si conosce nella elevatione e extollentia degli occhi suoi, et pero sempre la vedova e in ogni luogo e maximamente nel conspecto delli huomini debbe deprimere et abbassare li occhi in terra et con grande modestia e gravita elevarli secondo che richiede illuogo e la persona con chi parla.'

75 *Ibid.*, fos. c 5, verso – c 6, verso: 'Perche la dilectatione delle tocchate e vementissima et subita et absorbe la ragione. Onde molte donne et molti huomini sono chaduti solamente per toccharsi la mano.'

76 *Ibid.*, fo. d 4, recto: 'li articoli della fede; e dieci commandamenti e buoni consigli . . . nelli libri volgari leggendo o latini se hai imparato grammaticha'.

77 *Ibid.*, fos. c 8, verso – d 6, verso.

78 Giovanni Giorgio Trissino, *De la vita che die tenere una donna vedova*, Rome, 1524, fo. A ii, verso: 'donna libera, si richiedono, la quale non sia ne a marito, ne a padre, ne ad altri, suggetta'.

79 *Ibid.*, fo. A iv, recto: 'primamente devete considerarae voi essere nata homo, di anima e di corpo composta'.

80 *Ibid.*, fos. B i, recto – B iii, verso: 'the greatest good work is *pudicitia*'.

81 *Ibid.*, fo. B i, verso: 'vanno col capo torto, e con le labbra chiuse, e stanno a tutti le officii de la chiesie e sempre per la casa dicono pater nostri'.

82 *Ibid.*, fo. B i, verso: 'un minimo atto, un parlar libero, et audace fare suspitione di meno che honesta vita'.

83 *Ibid.*, fo. B iii, recto: 'Guardarsi dal riso disconvenevole, e dal parlar troppo audace; che' l'uno è segno di mente leggiera, e l'altro di animo furibondo.'

84 *Ibid.*, fo. B iii, verso: 'Il tacere . . . è il grande ornamento de le donne. Non pero voglio, che siate mutola; ma che non parliate, se non quando il tempo rechiede; e che cerchiate sempre di serbare gravità, honestà, e giocondità.'

85 *Ibid.*, fo. B iv, verso: 'Ne l'habito vostro poi, lodo l'essere ornata, ma non sfoggiata, ne lisciata, che l'habito ornato è segno di compositi costumi, le foggia e li lisci di animo leggiero e non molto pudico; si come la troppo incultezza dela donna è segno di dapocagine.'

86 *Ibid.*, fo. C ii, recto.

87 *Ibid.*, fo. C iv, recto: 'non havere in voi niente di doppio, e di finto . . . ne tenere una cosa pronta ne la lingua, et un altra chiusa nel petto'.

88 Dolce, *Ammaestramenta pregiatissimi*, pp. 116–17.

89 *Ibid.*, p. 118: 'Api, formiche, cani, pecore, tortore, et colombe a chi assomigliati et loro proprietà.'

90 *Ibid.*, p. 123: 'i marmi, i bronzi, gli ori, gli intagli, i grandi epitaphi, et le statue . . . a morti inutili . . . s'impiegasse utilmente opere di carità nelle . . . vedove o miseri orfani alli spedali'.

91 *Ibid.*, p. 125: 'gli ornamenti veri della vedova essere i digiuni, le orationi e la vita sincera e lontana de tutti i diletti del mondo'.

92 *Ibid.*, pp. 125–6: 'in astinenza et orationi, dì et notte menava la sua stanca vita'.

93 *Ibid.*, p. 128: 'Et perche a ciò fare, vi entrano di molte attioni, nelle quali la Donna non si può trovare; come in comperare, in vendere, in riscuotere, in comparar ne giudicii, sollecitare Avocati, e si fatti negocii, che intravengono tutto die, è mestiero ch'ella si elegga huomo sufficiente et fedele a cui commetta il peso di questo maneggi.'

94 *Ibid.*, pp. 128–30: 'benche ella habbia disposte le perle et panni allegri; non la consiglierei però a usare il cilicio o drappo troppo rigido'.

95 *Ibid.*, pp. 130–1: 'più apprezzi l'effetto, che nome, sobrietà'.

96 *Ibid.*, p. 131: 'Le novelle delle piazze come d'i maneggi d'i Re, delle deliberatione d'i Principi.'

97 *Ibid.*: 'scopri sempre un'amabile piacevolezza, e hilarità nella fronte' (for the example of Judith, see pp. 133–4).

98 Dolce, *Ammaestramenti pregiatissimi*, pp. 16–29: she might read the Bible, the Church Fathers, Plato, Seneca, Cicero, Livy, Sallust, Suetonius, and among the poets, most of Virgil and Horace, Prudentius and the modern writers Petrarch, Dante and Vida.

99 Certaldo, *Libro di buoni costumi*, pp. 170–1: 'Ella non stava fuori di casa e non andava discorrendo né giù né su né qua né là, né udendo né guardando gli uomini vana, né l'altra vanità, anzi stava rinchiuso e serrata in nascoso e onesto luogo . . . non fece come l'occhio vano che vede quello che vuole e che non vuole.'

100 Giovanni Francesco Capra, *Della eccellenza e dignità delle donne* (first published Venice, 1526), ed. Maria Luisa Doglio, Rome, 1988, p. 67: 'come si fossero ne' teatri a mirari qualche novo spettacolo e l'uno a l'altro insusurarsi all'orecchie dicendo: "Vedi mona", tale, "Quella pare con quelle poppe che paiono dui mantici che gonfiano", e mille altre cose che saria soverchio e farse poco onore a scriverle, dove le donne tacite e vergognose con gli occhi bassi non ad altro attendono, che a' suoi paternostri.'

WIVES

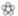

A small number of wives seem to have been capable of some sort of patronage. These wives needed the consent and the administration of their husbands of their dowry and any inheritance, except in the case of wives whose husbands were in exile, bankrupted or deemed through crime or insanity incapable of directing their wives' possessions. A wife owned her dowry and any inheritances and could dispose of them in her will or, with her husband's concurrence, during her lifetime. Because of the way in which the husband acted for the wife, documentation is rarely sufficient for us to infer much about her role in any artistic enterprise. However, we shall consider three case-studies exploring the way in which two wives commissioned art and architecture with their husbands. The earliest entails the building of the largest hospital in Padua by the childless couple, the heiress Donna Sibilia Cetto and Ser Baldo Bonafari, between 1414 and Donna Sibilia's death in 1421. The second is the completion of the funerary chapel of Don Girolamo Badoer at San Francesco della Vigna in Venice by his sole heir Donna Agnesina, wife of Don Girolamo Giustinian, in 1508. The third case-study looks at the subsequent building of the castellated villa at Roncade near Treviso by Girolamo Giustinian on behalf of its owner, his wife, Agnesina Badoer.

It seems that one way of being required to commission was for a married woman without any brothers to be ordered by her father to complete some enterprise for him as his heiress. This happened in the case of Agnesina Badoer on the demise of her father in 1495. In obeying her father the wife fulfilled the expected role of dutiful daughter. Another situation licensing a wife to commission might occur where she had an inheritance of her own and no direct heirs. With her husband's assent she might then spend her possession justifiably

on their joint spiritual welfare in a funerary chapel or a charitable enterprise. This was the case with Sibilia Cetto, when she turned to building a hospital in Padua in 1414. When an heiress had male children, the fact that her inheritance remained her possession until her death and was controlled by her will meant that where her husband improved her property in her lifetime, that building remained hers as patron, even though her husband administered the commission. In fact, Agnesina Badoer was patron of the Villa Giustinian-Badoer from 1495 onwards in these circumstances. In this position a wife was placed in a powerful role by the will of her father, which dictated that his possessions should remain hers until her death and be subject only to her will. Therefore the heiress could be an important commissioner. It is suggested, however, that it was the childless heiress who was the more prestigious patron, because she could benefit her community on a grand scale. For this reason the three longer case-studies comprising the majority of this chapter have been arranged in ascending order of public prominence, looking at the family-orientated commissioning of Agnesina Badoer first and the magnanimous civic patronage of Sibilia Cetto last.

Before turning to these three major case-studies, tracing the control of very wealthy heiresses over large building enterprises, we shall look briefly at a few other commissions which throw light on the other social, religious and legal situations in which wives could participate in the making of art and architecture. These instances show them in a variety of relatively weak positions, whether because they had to rely on executors to carry out their desires or because they were only contributing to schemes organised by others. Women who were not wealthy in their own right could take collaborative roles in commissioning. It seems likely that they may have taken part in discussions of items contracted by their husbands, though evidence of this does not appear to survive. They could also, with the assent of their husbands, contribute to commissions initiated by another institution, like their local church, and perhaps play some part, by the power of the purse, in shaping the scheme. It seems possible, for example, that the women who donated sums for a mural in their parish church of San Giacomo at Spoleto in the early sixteenth century were wives, rather than widows. This scheme was painted by Giovanni di Pietro, called Lo Spagno, and entailed the adornment of the apse with a *Coronation of the Virgin with angels and Saints Apollonia and Lucy* (Plate 2). During the autumn of 1526 groups of individual donations were made, among them, by a few women, Madonna Alessandra, Bellezza da Nofrio and Dialta de Butio – the last specifying, 'I am paying for the figure of Saint Lucy.'[1] Married women could also belong to a sorority and contribute to a joint commission, as they did for the altarpiece of the sorority of Nostra Donna at the church of Sant'Antonio Abate

in Perugia in 1510 (see Chapter 8). These wives were able to act in their life-times with the consent of their husbands, but in other cases a wife might use her last will and testament to have something made after or very close to the time of her death. A woman might, with her husband's permission, specify that some of her inheritance or dowry, or both, be spent posthumously, on a funerary commemoration for her. To the extent of her specifications in the will, and, one surmises, her discussions with her executor, she could be thought of as controlling the work to some extent – though he would be the person who made the decisions. It seems possible, for example, that a panel from Montevarchi, deposited in the Uffizi, which shows the Madonna and child and four saints with the donor and a boy, at the feet of Saint Antony, could be a wife's posthumous work, because the panel is inscribed: 'This panel was made by Tommaso from San Piero of San Marco for the soul of Mona Filippa his wife and her dead, 14[?]3.' The date was probably either 1423 or 1413, given the stylistic characteristics of the painting.[2] Such commissions have so far proved difficult to document.

Wives' wills could also contribute to projects outside the family sphere, as did those of three wives of the parish of Santa Maria Formosa in Venice between 1470 and 1473. With their 'promissory notes' of money to come, these women helped to fund the painting of the high altar for their parish church. The desire for their support in his commission may have led Andrea da Sole, the parish priest who organised the painting of the three panels by Bartolomeo Vivarini, to take account of their wishes in some respects. The original silver altarpiece had been stolen in 1470, and Andrea da Sole promptly set about accumulating sufficient promises of funds from will-makers in his parish to help to replace the panel. Since he was a qualified notary as well as a priest, he was able to act as notary for the gathering of his testamentary subscription list. In December 1470 he recorded the will of Lucia, wife of the master mason Vito, who donated 5 ducats. In September he wrote down the will of Margarita, wife of Giacomo da Sebenico, who gave 3 ducats for the making of the altarpiece, and in March 1473 he inscribed the will of Margarita, wife of Giovanni da Corfù, detailing the forthcoming gift of 12 ducats and two hangings to put before the altar. Later in 1473 these three wives were joined by a widow – Regina – and a painter called Master Giorgio, all wishing to contribute to the cost of the project, which was so expedited that it was finished during this same year, when the painter signed and dated it. Although it seems likely that the fund was also swelled by direct donations, testamentary gifts were obviously of importance to the fund-raiser, because he was still ensuring that parishioners were mentioning the project in their wills well into the year in which the paintings were finished, so that even the 2 ducats of the painter Giorgio were still worth pursuing in August 1473.

The main subject-matter of the altarpiece commissioned by Andrea da Sole for his church was the Madonna della Misericordia, who is portrayed as drawing her cloak protectively round a circle of kneeling worshippers (Plate 3), while the side wings represented the meeting of Joachim and Anne – the parents of the Virgin – and the birth of their baby child, Mary. This subject was eminently

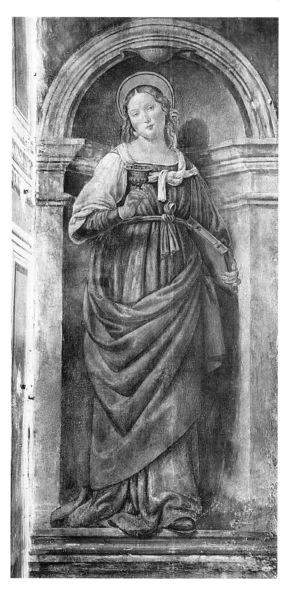

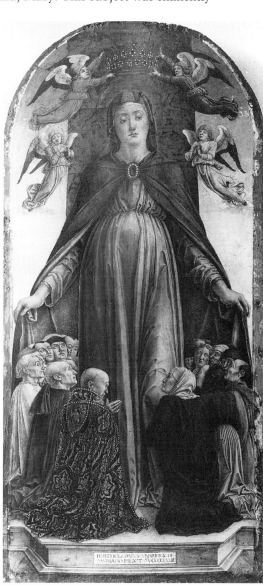

2 Giovanni di Pietro, called Lo Spagno, Saint Lucy, from the *Coronation of the Virgin with angels and Saints Apollonia and Lucy*, 1526, fresco, San Giacomo, Spoleto.

3 Bartolomeo Vivarini, *Madonna della Misericordia*, 1473, wood, 146 × 71 cm., Santa Maria Formosa, Venice.

suited to the dedication of the church to the Virgin, but, at the same time, the emphasis on the role of Saint Anne was geared to appeal to women, since she was a saint with special concern for childbirth. In addition, the choice of the Madonna della Misericordia allowed the painting to contain portrayals of the devout which might call to mind the kinds of people who had made the commission possible, without necessarily being intended to record specific portraits of them. To the left, in the place of honour, is a cluster of clergy and other men with a kneeling priest in the foreground, while to the right is a curve of seven kneeling women and one man. It seems likely, therefore, that the need to attract funding from wives might have had some bearing on the kind of image they were being asked to support.[3]

In theory, wives might have the capacity to commission if their husband was insolvent, since at this point they could administer their dowry, which could not be used without their consent to pay off his debts.[4] Where the husband was absent or placed in a weak position through insolvency, or his will declared invalid through crime or madness, a wife could have some independence. But in fact, so far no evidence has emerged of wives in these positions with the wealth and – even more important perhaps – the social prestige to commission works of art, given the opprobium of madness and the censure of crime in their menfolk.

Wives might be asked to commission when their husbands were in exile, since their dowries and their inheritances were exempt from the fines placed on the rest of the estate. Indeed, wives could administer the estates of their exiled husbands. Later in this chapter we examine the way in which Sibilia Cetto in Padua was able, as the wife of an exile, to launch an important commission while her husband was in Venice. In her case the legal documents recorded that she was 'acting on her own behalf with her husband absent': a formula which emphasised that she was able to act with some independence.

So far the commissions we have glanced at show wives in a weak position, either because they were participating in a small way in a larger scheme controlled by others or because they had to rely on the executors of their wills to do their bidding. A wife, however, could be in a stronger position when she commissioned an entire project in her lifetime with her husband's agreement. It seems likely that she would need to be quite wealthy in her own right, and would need to emphasise that she was benefiting her husband as well as herself. A beautiful and lavish instance of this was the commission by Maddalena dei Teruncelli for the life-size statue of the Virgin and Child, probably from a pupil of Rainaldino di Pietro da Francia, for the church of Santa Maria dei Servi in Padua, about 1440 (Plate 4). This is a superb, weighty sculpture of enormous dignity and charm, representing the Christ child blessing in the arms of his

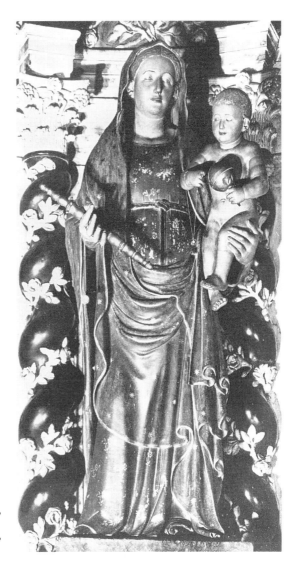

4 Attributed to a follower of Rainaldino di Pietro da Francia, *Madonna and Child*, *c.* 1440, painted marble, 169.5 cm. high, Santa Maria dei Servi, Padua.

amiable mother.[5] The statue displayed the skill of the artist conspicuously in the deep undercutting of the Virgin's robe and in the treatment of the baby as a separate form. The life-size statue compares quite closely with the Madonna and Child carved by Rainaldino di Pietro da Francia for the Confraternity of Saint Antony at the basilica of Sant'Antonio in Padua in 1396.[6] Like that at Sant'Antonio, the statue commissioned by Maddalena dei Teruncelli is vividly painted. Although the original tabernacle sheltering this statue is lost, we can perhaps get an idea of its appearance by comparison with that of the Confraternity of Saint Antony, which is still *in situ*. The comparison with the group

ordered by the Confraternity suggests that Maddalena was making a gift which would benefit the congregation in general, rather than being more narrowly focused on a personal chapel. It seems likely that its present location in the middle of the liturgical south wall, strategically opposite the entrance from the street, is close to its original position.[7]

Maddalena's husband, Galvano Lattuga, was one of the executors chosen by Sibilia Cetto to complete her commission in building the hospital, convent and church of San Francesco which we consider later in this chapter. He was well qualified for this job because he was an administrator for the Bishop of Padua in charge of building work being carried out by the Florentine sculptor Nanni di Bartolo. Earlier he had also been employed by members of the da Carrara dynasty.[8] In 1443 Maddalena gave the Prior of Santa Maria dei Servi a wooden house and three fields as the endowment for masses for her chapel. The notary recorded that

> she had had made and fabricated from her own personal goods, in the said church of Santa Maria dei Servi, a chapel with columns, canopy and altar which was dedicated to the honour of the glorious Virgin Mary, mother of God, with a stone image of the Virgin with her son blessing in her arms, and this chapel is placed in the middle of the body of the church of Santa Maria dei Servi for the salvation of the souls of the said Donna Maddalena and of the said Don Galvano there present, agreeing and consenting.[9]

Maddalena was buried in front of the chapel 'where were the arms or shield of those who had funded the said chapel'.[10] This was a very grand adornment for a woman to provide for the church, bound to attract the prayers of the faithful to honour the Virgin Mary, far beyond the funerary commemoration of Maddalena or Galvano, but publicly associated with her husband and socially licensed by the fact that she had no direct male heirs with the right to expect as large an inheritance as possible.

The funerary commission of Maddalena Teruncelli entailed an expensive sculpture in a monumental framing devoted to the spiritual needs of herself and her husband. As our first major case-study shows, a woman who was the sole heir of her father could actually be given the responsibility for the commissioning of an elaborately sculpted chapel – in this case by her father on his behalf. From this case-study we now turn to dwell in greater detail on the three commissions by the very richest heiresses which comprise the main body of this chapter.

In 1495 Donna Agnesina Badoer was asked by her father Girolamo di Giacomo Badoer in his will to complete his funerary chapel at San Francesco della Vigna in Venice with an elaborate sculpted altarpiece. In obeying her

father's wishes she could be seen as conforming to the role of the dutiful daughter, yet a lavishly funded commission attracted prestige unusual for a woman, and displayed the types of judgement and taste expected more usually of the son, not the daughter. At the time of the death of her father Agnesina was widowed with one baby son, since her husband had died in 1494.[11] However, by the time the will was *proved* in 1497, she had been married a second time, to Girolamo Giustinian, and her baby son seems to have died. She consequently fulfilled the patronage of her father's chapel as a wife, between then and about 1508. In doing so she transformed the commission, to make it not only a commemoration of her father, her mother and herself, but also a funerary chapel suited to the burial of her second husband and their children. Since her husband had to administer or assent to the funding and contracting of the enterprise, it may be argued that we are simply seeing him taking advantage of the situation to gain a share in the chapel. However, there is good evidence that Agnesina regarded the primary purpose of the chapel to be for her natal family. After the death of her second husband in 1532, Agnesina wrote two wills (in 1534 and 1542), and in both she asked to be buried in 'our chapel of the *Badoer* family'. When she came to place the dedicatory inscriptions in the chapel during her widowhood, she put the inscription tablet and shield of her natal family in the place of honour to the left of the altar, and referred to her husband with the Giustinian coat of arms on the right-hand side.[12]

The chapel of Agnesina's father, Girolamo Badoer, was to the left of the high-altar chapel in the old church of San Francesco della Vigna in Venice. He was an important citizen who had held high office twice as one of the Magistrates of the Grains and had shown an interest in commissioning sculptures of exquisite quality, having ordered reliefs of a Madonna and Child and Saint Jerome for the tombs of his father and uncle in San Francesco della Vigna, and also, with his fellow-magistrates, commissioned the Madonna della Biade for the Palazzo Ducale.[13] His daughter therefore had a helpful role-model to follow in terms of sculptural patronage. That his new funerary chapel at San Francesco was at least structurally completed by 1495 is suggested by the way his wife Donna Michaela Michiel spoke in her will of 'the tomb which has been made at San Francesco della Vigna by my husband Don Girolamo'.[14] In his will Girolamo instructed 'my most beloved Agnesina' to make a marble altarpiece with 'Saint Antony in the middle wearing the habit of Saint Francis. Saints Jerome and Michael next on the sides. Saint Agnes [and] Saint Benedict next. The Madonna above. And let it be made beautiful, and do not consider the expense.'[15]

What Agnesina actually made (Plate 5) was necessarily different from these instructions, because by the time she had probate, she had a new husband called Girolamo Giustinian, and her father's will had been made on the assumption

55

that he was benefiting her and her baby son Benedetto. Agnesina's first husband had also been called Benedetto – Benedetto di Antonio Badoer, and presumably belonged to the same family of the Badoer as Agnesina. The 1495 will had left everything to Agnesina and after her death to his grandson, little Benedetto. Therefore it must be presumed that in 1495 her father thought he was instructing Agnesina to complete what would remain an exclusively Badoer family chapel.[16]

Agnesina, presumably with the counsel of her new husband, modified the iconographical scheme envisaged by her father to take account of the unforeseen changes. Saint Jerome was substituted for Antony in the centre. This honoured the name of her second husband *and* her father together. For the predella, which had not been mentioned in the will, they chose small scenes from the life of Saint Jerome.[17] They omitted Saint Benedict completely, presumably because he was the patron saint of her dead first husband and the now dead son.[18] Saint Antony was demoted from the centre of the altarpiece to the far right. Since Antonio was the name of Agnesina's brother who had died in 1484, it seems possible that her father in 1495 had wanted to allude to his dead male heir by giving Saint Antony the key position. In the new scheme, Agnesina celebrated her father and her new husband. Saint James was now added to the right of Jerome, possibly to honour the patron saint of her paternal great-grandfather, Giacomo. Saints Agnes and Michael were taken over from her father's original plan; since they referred to the patron saints of Agnesina and her mother Donna Michaela, they were given the places of honour to the left (Plate 6).[19] As instructed, Agnesina placed a Madonna in the upper part of the altarpiece.

Agnesina's first scheme was itself modified during her lifetime. This was because the whole church was rebuilt between 1534 and 1553 by Jacopo Sansovino. By this time Agnesina was again a widow, since her second husband died in 1532. In the chapel now there are two inscriptions placed by her as widow. To the left she dedicated the chapel to her father and her uncle:

> Agnesina heir of her father Girolamo Badoer (who was the son of Sebastiano) and heir of her great-uncle Girolamo (who was the son of Giacomo) placed this memorial as a testimony to their special devoutness, considering their contributions through their sanctity of living and their reliability and wisdom in the administration of the Republic in matters private and public.

To the right she dedicated it to her dead husband:

> Agnesina, daughter of Girolamo, had this made as a monument to her like-minded husband and to their heirs: to Girolamo Giustinian, son of Antonio, Senator of the greatest prudence, and renowned integrity, who fulfilled the office of Procurator of San Marco in a very praiseworthy fashion, living only 62 years, 10 months and 19 days.

Perhaps significantly Girolamo was spoken of in these inscriptions as her 'like-minded husband' ('coniugi unanimi'), in order to emphasise that he was in full accord with her actions.[20] In representations of husband and wife it was usual to show the woman's heraldry to the right and the man's to the left, but Agnesina reversed the positions to claim the chapel as that of the Badoer, with the arms of her paternal family in the place of honour, because this was initially her father's funerary chapel.

The original sculptural decoration of the chapel was taken down and re-erected in the same position relative to the presbytery, but with additions and modifications to fit the new structure which were organised by her son Marcantonio (Plate 7).[21] In the present chapel Agnesina's altarpiece has been placed within a tabernacle, whose frieze contains reliefs of the Crucifixion and the Lamentation. On the front of the altar is a large relief of the Last Judgement. Along the side walls are a series of reliefs with busts of twelve prophets and the four evangelists; on each side wall are two evangelists and six prophets. Above on either wall are eight reliefs narrating the life of Christ. The chapel is exquisitely panelled with marble and now has a barrel-vault. In her will of 1498 Agnesina stated that the entrance of the chapel was installed according to her father's wishes, but that the middle and the end still needed to be finished.[22] By the time she wrote a codicil to this will in 1509 she no longer needed to mention the chapel, so she had presumably completed it. While it seems likely that from a stylistic point of view the sculptures presently in the chapel were made about the same time by members of the Lombardo workshop, the fact that Agnesina's father had also paid for a new sculpted choir for San Francesco before his death has led to plausible suggestions that the reliefs of the evangelists, prophets and the life of Christ came from the dismantled choir and were placed in the Badoer chapel by Agnesina's son during the rebuilding of the church.[23]

The creation of the funerary chapel by Agnesina Badoer was a highly prestigious act for a wife to have undertaken. Although in some sense it was in the private sphere because it was a family chapel, it was publicly prominent in a much frequented church, and the inscriptions made clear who was responsible for the work. We look next at a commission which was created by the heiress Agnesina and her husband, only this time it entailed the building of a villa for family occupation at a site owned by the Badoer on the mainland. Such a commission fully met the expectation that a mother should work to benefit her family and her household, and since it was designed within the protection of a walled enclosure, emphasised the privacy of its owner in a decorous way.

The same Agnesina Badoer who commissioned most of the sculpted decorations for the Badoer chapel owned what was to be called the Villa Giustinian

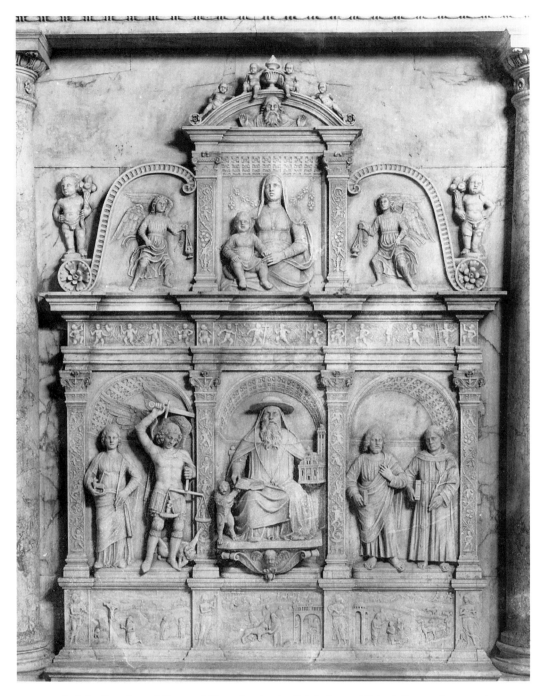

5, 6 Attributed to a follower of Pietro Lombardo, *Saints Agnes, Michael, Jerome, James and Antony*, marble altarpiece, 1497–1508, Cappella Badoer-Giustinian, San Francesco della Vigna, Venice. *Facing:* detail.

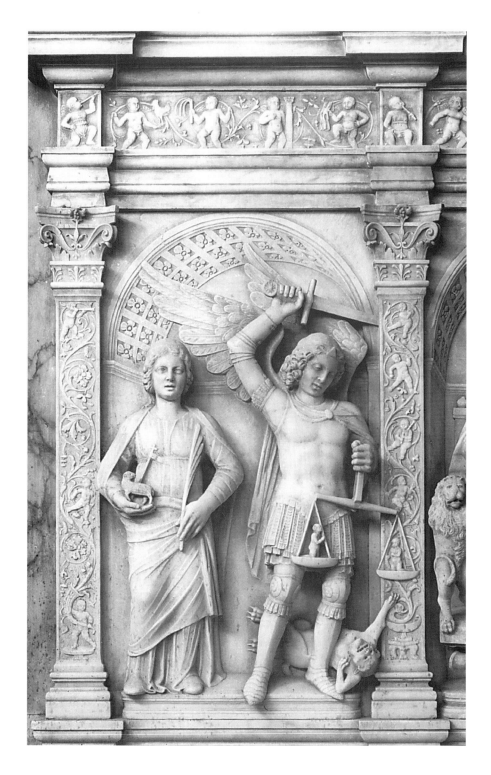

at Roncade, near Treviso, which her husband had built around 1514 (Plates 8–9). While it cannot be thought of exactly as a villa commissioned by Donna Agnesina, it is worth considering because it points up the way an heiress stopped her husband from patronising in the fully separate and secure way normally expected of the masculine. The villa belonged to her as heir to her father and was subject to her will in all her testaments, as well as being listed separately as her property in tax returns. Since her husband administered her estate and owned the profit from it, he could be thought of as having managed the building of the villa, but cannot be regarded as patron in the conventional masculine position of wholly controlling what he designed for himself and his male successors. This villa was built on her land, possibly on the foundations of a medieval castle, and as soon as he had built and paid for it, it became hers to control. Girolamo's income on his own account was very small in comparison with Agnesina's, since he owned just one house in Venice, whilst Agnesina had a house in Venice, several on the mainland, the court at Roncade, numerous grain and sawmills and a copper foundry.[24]

It may well be that Girolamo Giustinian saw himself in some sense as creating this *villa in castello* on his own. Certainly others saw it as his – for example Pietro Bembo in 1529, who called it 'the villa of Hieronimo Giustinian, the Procurator'.[25] In the 1514 tax return, however, he listed the villa among her possessions as 'a large court at Roncade which is still not half done', even though he went on to say that 'it will be for my own use'.[26] By 1514 he had the confidence of having three sons. Nevertheless, at this point, her will of 1498 and her codicil of 1509 still stood: that only her direct heirs should inherit her possessions; that otherwise her estate would revert to the collateral branch of the Badoer; and that Girolamo might have solely the income of the estate and only as long as he did not remarry.[27] Girolamo was therefore 'patron' of a building which did not belong to him, and whose fate was out of his control. At the same time, as the married heiress, Agnesina could not act on her own. It might be seen as a token of the duality of its making that there is a tabernacle on each of the two towers flanking the entrance of 'the court at Roncade' – one on the right with the heraldry of the Badoer, and one on the left with the shield of the Giustinian. When Girolamo came to fill out the property-tax statement in 1514 he began in the first person – 'I give notice', but then went on to list what *we* are paid ('a nui').[28] It may be that a married heiress produced a situation in which the husband might sometimes have to think in terms of acting in the first person plural; in this commissioning situation the feminine was not wholly subordinate to and dependent on the masculine will.

According to the research of Carolyn Kolb-Lewis, the Villa Badoer-Giustinian is the earliest surviving *villa in castello* in the Veneto. What Agnesina

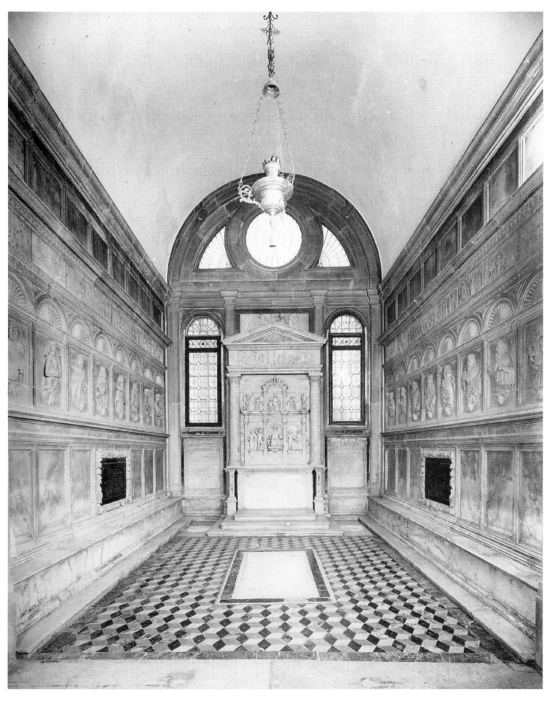

7 General view, Cappella Badoer-Giustinian, San Francesco della Vigna, Venice, *c.* 1490–1508, modified 1534–53.

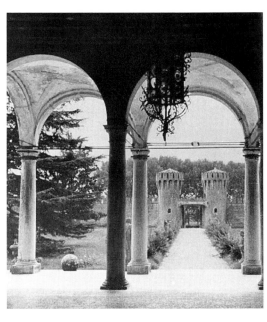

8 View of the castle gate with the villa seen through the portal, Villa Badoer-Giustinian at Roncade, near Treviso, 1514.

9 View of Villa Badoer-Giustinian castle gate from inside the portico of the villa.

called her 'Castel de Ronchade' consisted of a nearly square walled enclosure surrounded by a moat, with towers flanking the gate and on the four corners.[29] The *castello* was symmetrical about the central axis of the entrance gate, with what a contemporary map called the *palazzo* for the owners in the centre, and two separate wings on either side for stabling animals and storing produce, called *barchesse*. The design of the *palazzo* was also exactly symmetrical, with suites of rooms arranged to left and right of a central hall, prefaced by a two-storied portico with a classicising triangular pediment. Kolb-Lewis proposed an attribution to the Venetian architect Tullio Lombardo, and stressed that in the concern for symmetry, clarity and the effect of fortification, it could be compared only with the *barco*.[30] This was the now partially demolished fortified villa built by Caterina Corner, Queen of Cyprus, at nearby Altivole, near Asolo. However, the *villa in castello* at Roncade was smaller than the *barco*, and it was the administrative centre for the Badoer estate rather than a regal pleasure retreat. Kolb-Lewis summed up:

> The Giustinian compound constitutes the first surviving example of a Renaissance rural courtyard in the Veneto and the first known appearance of symmetrical *barchesse* delimiting the agricultural part of the court: the palace appears to be the earliest sixteenth-century villa surviving in the Veneto, and its design with a

symmetrical portico is at least forty years ahead of the adoption by Palladio of such a scheme . . . the crowning pediment which projects above the cornice line of the building may be the first on a domestic building in all of Italy.[31]

Kolb-Lewis pointed out that the castle walls were not functionally defensive, since they were only 45 centimetres thick, and considered rather that the villa referred symbolically to the feudal and princely residences of medieval Italy. She was somewhat puzzled by such a reference, since the Venetian Republic disapproved of its citizens assuming any such pretensions, and concluded that the 'Castel de Ronchade' used the motifs of the fortress as 'an image of seclusion'.[32] This suggestion seems to be a very helpful one. The reference to the castellated villa of the dowager Queen Caterina Corner could relate to the fact that it was designed to be a decorous enclosed residence in the event of Agnesina's widowhood. Both these *ville in castello* are reminiscent of the famous fortified Benedictine convent for women of San Michele extra at Verona.[33] Whereas the normal male patron could anticipate that his widow would only be granted income of part of his estate, withdrawing from the patriarchal residence, and that his sons would control the inheritance immediately at his death, Agnesina's father had stipulated that any grandson would inherit only *after* her death. Indeed, Agnesina did survive Girolamo for over a decade. In her will of 1534 she declared that her 'Castel de Ronchade', mills, copperworks, gardens, orchards and her house at Siega were not to be divided, sold nor leased but to be maintained by her three sons equally and to pass to their sons. Failing sons, she willed that her daughters were to inherit the *villa in castello*.[34]

With her numerous progeny, Agnesina Badoer threw her energies into building up the estate she intended to leave them, ensuring that they had an admirable chapel in Venice and an impressive villa on the mainland as a centre from which to administer her agricultural holdings. But an heiress who had no children could consider other options which would take her commissioning outside the sphere of the private and familial and into the public arena of creating a civic and monastic institution in a way which drew attention to her personal generosity and piety. It is because the commissioning of buildings to accommodate such a public institution represented the peak of patronage for a wife that I have left the administration by Baldo Bonafari for Sibilia Cetto of the erection of the hospital of San Francesco in Padua to the very last.

The most impressive example of charitable expenditure by a married woman without male heirs is the hospital, church and monastery of San Francesco at Padua, funded entirely on the property and through the wealth of Sibilia Cetto and managed by her lawyer husband. She used her fortune from her father to build this great enterprise employing a triangular area in the centre of the city covered with houses belonging to her. The eighteenth-century map of della

Valle shows a hospital to the south of the church of San Francesco which had been much developed since the early fifteenth century, but it does at least suggest the grandeur of the whole enterprise (Plate 10). This area was bounded by the present Via del Santo, the Via San Francesco and the Via Galilei. Between 1414 and 1418, with Baldo administering the enterprise, and then as widow until her death in 1421, Sibilia built the church and convent of San Francesco and the adjacent hospital with linked courts for men and women, and its own chapel.

The large square cloister and the colonnaded wing flanking the south aisle and apse of the church may mark the sites of the male and female quarters respectively. One segment of wall remaining beside the south aisle of the church arguably represents something of the original appearance of the hospital, and the entrance to the hospital over whose door may be seen the word 'IHESVS' is also thought to relate to the original scheme (Plate 11).[35] The cloister of friars retains its fifteenth-century aspect, although the wing flanking the church was taken down when the church was radically reshaped in the sixteenth century. As planned by Sibilia and Baldo, a portico supported on columns runs across the facades of the convent, church and hospital all along the Via San Francesco, to express their unity as one project. In her will of 1421 she spoke of the new tomb which had been constructed at the convent church of San Francesco, for herself and her second husband.[36] The monument survives at the church of the present main hospital in Padua, Santa Maria della Neve, having been removed from its original position on the paving in front of the high altar of her church (Plate 12). As we know from comparisons with other fourteenth- and early fifteenth-century tombs in Padua, the floor tomb was a relatively modest memorial, associated with the burial of other Paduan lawyers and their female relatives. Baldo seems to be dressed for his profession, while Sibilia wears the corded robe of a Franciscan nun, which she had asked to be buried wearing. As the pavement of the church was not laid until 1419 and Baldo had died in 1418, it seems likely that Sibilia had organised the new sepulchre.

As related by Sylvana Collodo, Sibilia was born about 1350, and was the daughter of the rich merchant, moneylender and property-owner Gualperto Cetto of Padua and Benedetta, the daughter of a prominent lawyer. Sibilia was married for the first time in about 1370 to a Doctor of Law, Bonaccorso Naseri, who held the eminent position of councillor to Francesco I da Carrara, ruler of the city, and whose family lived in the *contrada* or ward of Santa Margherita. In 1388 when the Visconti captured the city, Bonaccorso collaborated, and was consequently hanged in the Piazza dei Signori in 1390 when the da Carrara returned to power. Since there were no children, it was Sibilia's right, as widow, to receive back her dowry of 1,100 lire and the very large inheritance,

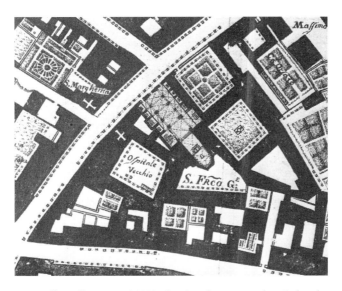

10 Della Valle map *c.* 1765?, showing the convent, hospital and church of San Francesco.

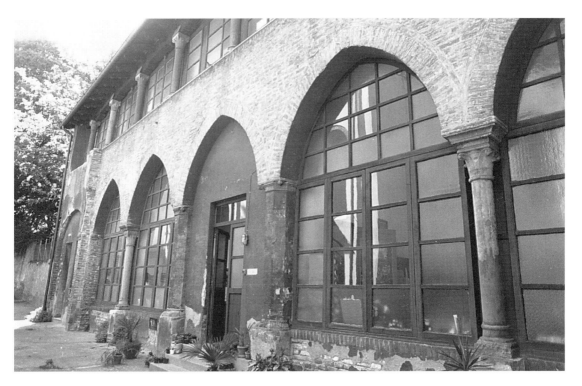

11 Part of original hospital facade with portico supporting the balcony, 1414–30, San Francesco, Padua.

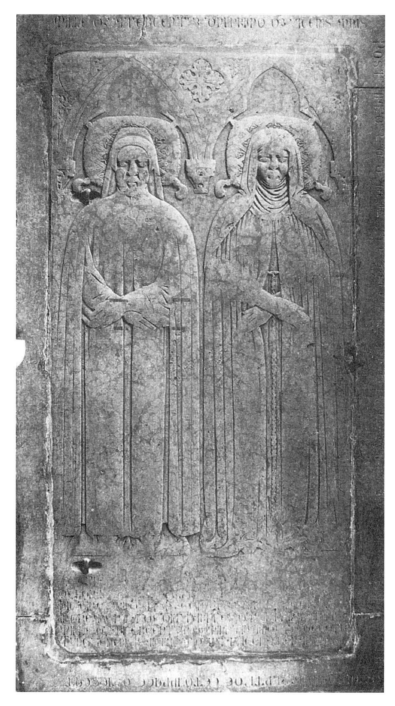

12 Tomb slab of Sibilia Cetto and Baldo Bonafari, 1421, Santa Maria della Neve, the hospital chapel, Padua.

equivalent to 6,800 ducats, which she possessed as sole heir of her father. Her father-in-law had taken refuge in Venice, and having been pardoned in 1392, began the legal procedure of trying to get his family's possessions in Padua, but Sibilia's claim was recognised in the same year by the Paduan authorities, and as an exile, all his immovable goods were passed to her. However, this transaction still did not cover the full sum owed her, and she therefore filed a claim in the Venetian court for the return of the houses in the Venetian district of San Barnaba where the Naseri lived, but which had been bought using her father's money.[37] In 1393 she married a Doctor of Canon and Civil Law, Baldo Bonafari, who acted as her procurator.[38] Arguably Sibilia's success in litigation related to her legal acumen, derived from having lawyers for a grandfather and both husbands. Giovanni Naseri contested her acquisition of his Paduan property and willed his 'rights' on to his only surviving child, Caterina. Sibilia initiated a legal struggle with Caterina, who was, however, murdered by her husband. But Caterina had made a will in 1396, leaving three-quarters to the poor and one quarter to the Venetian Benedetto Trevisan, giving him the right to buy the houses in San Barnaba at a concessionary rate. Caterina had made Benedetto and the Procurators of San Marco de Ultra her executors. The legal contest continued until the late fifteenth century, although the hospital never did obtain the Venetian houses which Trevisan had bought immediately after the murder of Caterina.

In 1392 Sibilia got control over the numerous houses in the *contrada* of Santa Margherita, on which she eventually had the hospital, church, chapel and convent built. But as she remarried in 1393, she might still have expected children. However, in 1405, when she made her second will, she was considering the benefit of an already established hospital, and had had no children.[39] In this testament she deposed that she be buried in her father's tomb at Sant' Antonio in the habit of a clarissan, and left a large legacy to this church and to the Ospedale Albarella of Padua run by Third Order female Franciscans.[40] Within about a year she must have decided to found her own hospital, because in 1407 she had already received the concession from the Venetian *Podestà* and Captain of Padua that the hospital she was about to build, with an endowment of up to 10,000 ducats, would be tax-exempt, 'acting for herself, and for her absent husband' ('agente per sè e per il marito assente').[41]

The turning-point, then, seems to have been in the years following the Venetian invasion of Padua in 1405, which threatened to bolster the case of Caterina's heirs. Since Baldo was a counsellor to the da Carrara, he left Padua in 1406 for Venice when the Venetians took over power in Padua. Pardoned along with all the other exiles by the Venetian government of Padua, he returned in 1413, having spent his period in Venice fighting Sibilia's case in the

Venetian courts. His return coincides with the beginning of the actual construction of the hospital, with the confirmation by the Doge (1413) of fiscal exemption, and the permission of the Bishop of Padua (1414). Presumably Sibilia and Baldo had decided, in about 1406, that the creation of the largest and most central hospital in Padua, built by pulling down the houses which were still related to the dispute, promised to confirm her legal position in a way which would be very difficult to reverse, and could provide both of them with a sound spiritual investment as well.[42]

As analysed by Giulio Bresciani Alvarez, in the autumn of 1414 the Prior of the College of Jurists laid the foundation-stone of the hospital on the site opposite Santa Margherita, where space was made available by demolishing and adapting two of Sibilia's houses, two houses willed for the project by Donna Tomassina Cesso, and buying three others. In August 1414, the master stonecutters Giacomino da Milano, Gabriele di Francescino and Berto di Zeno had contracted to provide a huge quantity of cut stone for the hospital.[43] In November 1414 Baldo contracted for a large quantity of wood for joinery to be delivered in batches during the next two years. The majority was to be larch, a wood, John Florio explained in his Italian–English dictionary, which 'will not rot nor fire consume'.[44] These larch beams were of considerable dimensions, the greatest length specified being that of sixty beams each 34 *piedi* or about 12 metres long. Many shorter pieces of fir were also provided. In December 1414 Masters Matteo da Ravenna, Cristoforo of Zeno and Giovanni of Francesco, all wallers, signed a contract with Ser Baldo agreeing 'to make the walls of a hospital with arcades [*porticali*] made with balconies [*podiolis*] that are to encircle the hospital completely at ground and first-floor level'.[45]

Some time before Baldo's death in 1418 a contract was signed with two carpenters working as partners, Antonio da Zigyo and Domenico detto Ruzzante, for all the stairs, windows and door-frames, ceilings and floors for the part of the hospital designated for women on both ground and first floor. The partners promised 'to do the very best following the discretion and will of Ser Baldo and to make the work beautiful and polished with the plane, within and without, from every viewing-point as shall seem to the discretion of good men who are well informed'.[46] The contract dwells both on the decorative detailing which was to be given in the cornices of the ceilings and mouldings for the door and windows, and on functional matters. Thus the partners promised 'to make toilet-seats in the lavatories upstairs and downstairs with separate cubicles divided with wooden partitions so that one cannot see from one into another'.[47]

We know from a summary of this contract, dated 1418, that there were to be four lavatories on the upper floor and four on the lower.[48] The small rooms (*camare pizole*) – presumably for individual patients – were to be well lit (*ben*

alumenà) and also to be compartmented one from another 'as far as the communal kitchens upstairs and downstairs', suggesting that the female section was divided from the men's by kitchens on the ground and first floors. Since this contract promised that the ceilings of these rooms were to be like those of the men and that the cistern, with capitals and columns of fresh stone, was to be 'like the wells in the cloister of the hospital of the men and better and similar', it seems that the men's hospital was completed before the women's, and that their cloisters were separate.[49]

From these documents we get the impression of concern for a strong, fireproof structure, with maximum air and light and a care for patients' privacy in the bedroom and the bathroom. There is also a concern that the hospitals for the men and the women should be beautiful wherever one looked, with best-quality stone, well-polished, and with well-planed wooden mouldings to decorate door- and window-frames and the cornices. It seems possible that the arcades and balconies encircled the outer and the inner facades of the hospital, and indeed it has been suggested that a segment of the outer wall with its portico and balcony survives in the court on the liturgical south side of the present church (Plate 11).[50]

In order to build the church and the convent, three houses belonging to Sibilia were knocked down, another was bought, and a strip of vacant land along the present Via San Francesco was purchased. With the site ready in December 1416, Ser Baldo contracted Maestro Nicolò Gobo to build the church, the cloister of the friars and the portico outside.[51] By April 1418 he was contracting the carpenters Maestro Antonio di Francesco and Maestro Domenico detto Ruzzante for the roofing and all the hanging lamps for the chapels. After his death in 1418 Sibilia proceeded with the work so that by February 1419 the pavement of the church was being laid, and she was able to buy altar-cloths and vestments for the ceremony of consecration, which took place in June 1421.[52] The church was a simple hall church, cross-vaulted and containing three altars, a high altar and two small altars (*altari pizoli*). In order to separate the religious from the congregation, there was a screen (*mezamento*) consisting of three arches, with the small altars set into the side arches and the central arch leading to the choir and presbytery.[53] On this screen were placed both a podium for reading the epistles and gospels and a pulpit 'for preaching when it may be necessary'.[54] On the liturgical north wall were three chapels and a sacristy, provided with intercommunicating doors. The sixteenth-century reshaping enclosed this first church inside a grander three-aisled and transepted building. However, the friars' cloister survives in something of the form in which it was contracted in 1416 on three of its sides, with octagonal piers alternating with columns on the ground floor and an upper order of columns

supporting a trabeation of wood. The 1416 contract had also specified a portico to front the cloister, church and hospital. It was to have cross-vaults, be supported with columns of cut stone, and have 'beautiful cornices of terracotta to give a beautiful appearance to the outside of the portico', as well as having spandrels adorned with tondi.[55] In her will Sibilia instructed her executors to bring the remaining work to completion, and by about 1460, when Michele Savonarola wrote his description of the monuments of Padua, he could pronounce San Francesco as 'certainly a great church' (*templum quidem magnum*).[56] In token of her concern for the completion of her project, four of the seven witnesses for her last will were makers of her buildings, the stonecutters Francesco Muraro and Pietro dal Dente Murarius, and two woodcarvers, Giacomo and Antonio Marangon.

Sibilia's desire as commissioner is somewhat shrouded by Baldo's administration of her wishes, and emerges clearly only in the will of 1405, then during his exile of 1406–13, and finally at the time of her second widowhood from 1418 to 1421. From her testament of 1405 we learn of her interest in the Franciscan order and in funding a hospital, while her efforts during Baldo's exile focused on acting in his absence to spend her dowry and inheritance on the hospital project. After his death Sibilia seems to have felt unsure of the willingness of the College of Jurists to act as patron of the hospital, and therefore in 1419 she gave privileges to the Confraternity of Santa Maria della Carità, which she had planned to benefit in her 1405 will. She granted them meeting-rooms in the hospital, a chapel in the church of San Francesco and the right of ten members to be patients at any one time. In her will of 1421 she stated that the Confraternity should be patron of her hospital, if the College of Jurists refused. Sibilia also had to resolve the problem that the Franciscan community who were designated to care for the church of San Francesco had informed her that they were unable to reconcile their monastic routine with tending the souls in her hospital. Consequently she had to apply to Pope Martin V to let her make another church or oratory within the hospital for a secular priest and find living space for him – permission for which was granted in 1420.[57] In her 1421 will, Sibilia named the patients of the hospital as her heirs. To complete the building she chose six men 'in whom she had the utmost confidence'.[58] As each died she ordained that their responsibilities would be taken over by members of the College of Jurists, which would act as patron. Silvana Collodo states that Sibilia gave her hospital unusual autonomy with respect to the lay and ecclesiastical authorities of Padua, perhaps to insulate it from Venetian influences, with pressure from the Venetian heirs of Caterina in mind.[59]

As related in Chapter 1, the Florentine Giovanni Dominici had advised that wives should confine their almsgiving to modest gifts of church ornaments, and

only widows should fund larger gifts such as the building of a church or convent or hospital. Even then it would always be better to take the self-effacing role of contributing to an existing foundation than to create a new one solely linked with her generosity.[60] With the consent and the administration of her husband, Sibilia actually went well beyond the commissioning scope envisaged by Giovanni Dominici, to create a church and a convent and a hospital with about a hundred beds, making decisive changes to the appearance and institutions of the city, with a public presence and magnanimity not expected of the feminine. However, she balanced this boldness with a concern for conformity in her commissioning of a tomb before the high altar of San Francesco for herself and her husband. Where Francesco Datini of Prato, also the founder of a great charity, who died in 1410, had his tomb placed before the high altar of San Francesco in Prato in solitary state, and his wife Margherita was buried as a Dominican tertiary at Santa Maria Novella in Florence, Sibilia put her spouse beside her to represent the relative status which even a great benefactress needed to acknowledge.[61]

In this handful of commissioning wives, the factor allowing a woman to be the more prominent and powerful patron in the public sphere seems to have been not so much her social status nor even perhaps her wealth, but rather the question of whether she had male heirs or not. Maddalena Teruncelli was childless and married to a counsellor of the da Carrara and administrator to the diocese. Sibilia Cetto was childless, married two legal doctors and inherited a vast fortune from her merchant father. Arguably, Agnesina Badoer had the higher social position as a member of the Venetian nobility, whose husband was a Procurator of the Republic, whose father was a magistrate in charge of grain supplies for Venice, and who planned for the situation in which her son Marcantonio should be bought a cardinalate in her will of 1534.[62] However, she had direct male heirs. Sibilia's lack of heirs meant that she was socially licensed to use her fortune in the most prominent public way for charitable purposes. In contrast, Agnesina was expected to act as a good caretaker and improver of her possessions to enhance the patrimony. However, in 1498, when she wrote her first will at the beginning of her second marriage, Agnesina had fully intended that if she did die without heirs her estate was to fund the building of a hospital in Venice for forty patients, dedicated to Saint Jerome, with a church and a house for a Prior who would govern it.[63] Chiming in with the advice of writers like Dominici and Dolce, Sibilia's deed in 1414 and Agnesina's will in 1495 suggest some continuity in the commissioning horizons for wealthy childless wives.

All the wives we have looked at needed a facilitative husband. Wives had the negative power of being able to stop their husbands from alienating their

71

dowry or inherited property, but at the same time, if they did wish to use their possessions positively for any purposes, they had to have the agreement and co-operation of their husbands. In this sense, the commissioning powers of the wife required partnership, whereas the patronage of a married man using *his* possessions could, while always taking place in the collaborative context of the family, be more autonomous.

Notes

1 Fausta G. Sabatini, *Giovanni di Pietro, detto Lo Spagno*, Spoleto, 1984, pp. 268–9, 389: 'pago per la figura de sancta Lucia'.

2 Uffizi, Florence, Deposito 1363: *Madonna and Child and four saints with donor as man and his son at the feet of Saint Antony* – from Montevarchi, 1413 or 1423. Inscribed: 'Questa tavola fece fare Maso di San Piero di San Marco per l'anima di mona Filipa sua don[n]a e di suoi morti an[n]o MCC . . . XIII die X Agosto' (Kocks, *Die Stifterdarstellung in der italienischen Malerei des 13–15 Jahrhunderts*, pp. 196, 435).

3 Thanks to Dr Kate Lowe for telling me about this example in Gustav Ludwig, 'Archivälische Beitrage zur Geschichte der venezianischen Malerei', *Jahrbuch der preussischen Kunstsammlungen*, XXVI, 1905, Beiheft, pp. 15–18. The documents recorded only four donatrixes and one donor, not seven women and one man, as on the right-hand side of the Madonna della Misericordia.

4 Julius Kirshner, 'Wives' claims against insolvent husbands in late medieval Italy', in *Women of the Medieval World*, ed. Julius Kirshner and Suzanne F. Wemple, Oxford, 1985, pp. 257–303. For wives during exile, see Susannah Foster-Baxendale, 'Exile in practice: the Alberti family in fifteenth-century Florence, 1401–1428', *Renaissance Quarterly*, XLIV, 1991, pp. 720–56.

5 Wolfgang Wolters, *La scultura veneziana gotica, 1300–1460* (2 vols.), Venice, 1976, II, pp. 61, 211–12, Figure 386: modern polychrome, right hand of Madonna restored.

6 Catherine E. King, 'The arts of casting and carving', in *Siena, Florence, and Padua: Art, Society, and Religion, 1280–1400*, ed. Diana Norman (2 vols), New Haven and London, 1995, I, Plate 120, p. 114.

7 O. Ronchi, 'Notizie da documenti inediti del secolo XV intorno alla chiesa dei Santa Maria dei Servi', in *La chiesa e il convento di Santa Maria dei Servi*, Padua, 1937, pp. 20–8.

8 Claudio Bellinati, 'Ospitale Sancti Francisci. Contributo alla storia della carità e dell'assistenza religiosa nell'ospedale di San Francesco a Padova (xv–xvii secolo)', in Associazione Culturale Francescana di Padova, *Il complesso di San Francesco Grande in Padova: storia e arte*, Padua, 1983, pp. 13–30 (p. 22).

9 ASP, Notario Daniele de Porcigli, 2007, fos. 114–15, 22 July 1443: Record of the will of Maddalena made at the church in front of the altar of Saint Jerome: 'Egregia et honesta domina magdalena filia quondam teruncelli di Padua et uxor legitima dicti Dom. galvano latuge fecerit facere et fabricare de suis propriis bonis in decta ecclesia sanct[a]e mariae servorum capellam cum colupnis arcu et altari quae dedicata sub vocabulo et ad honorem gloriose Virginis ymagine lapidea cum filio suo benedicto in brachiis quae capella disposta in medio corporis dectae ecclesiae sanctae mariae servorum ut per remedio animarum suarum salutis dictae dominae magdalenae et dicti dom. galvani ibidem presentis volentis et consentis.'

10 Ronchi, 'Notizie', p. 27: 'ubi erat arma seu signum ipsorum qui fundaverunt dictam capellam'.

11 Thanks to Dr Jaynie Anderson for pointing out this example to me. See Douglas Lewis, 'The sculptures in the chapel of the Villa Giustinian at Roncade and their relation to those in the

Giustinian chapel at San Francesco della Vigna', *Mitteilungen des Kunsthistorischen Institutes in Florenz*, XXVII, 1983, pp. 307–52, especially pp. 311–12, 318–19.

12 Carolyn Kolb-Lewis, *The Villa Giustinian at Roncade*, Ph.D. thesis, New York University, 1997, pp. 17, 239: 'I wish to be buried in our tomb of the *Badoer* family which is in our chapel in the church of San Francesco della Vigna, near the sacristy' ('voglio sia sepulto nella nostra archa da cha Badoer che e nella nostra capella').

13 Lewis, 'The sculptures in the chapel of the Villa Giustinian at Roncade', pp. 309–10. The magistracies were in 1476–77 and 1481–82. The Madonna della Biade is dated 1481 and attributed either to the studio of Pietro Lombardo or of Giovanni Buora.

14 *Ibid.*, p. 316. She was the daughter of Antonio Michiel and granddaughter of Francesco Michiel.

15 Anne Markham-Schulz, 'The Giustiniani chapel and the art of the Lombardi', *Antichità viva*, XVI, 1977, pp. 27–44, especially p. 40, n. 8: 'sia fato uno altar in dita giesia de S. Francesco dala banda del inchiostro de marmore. S. Antonio in mexo del abito S. Francesco. S. Jeronimo. San Michael apreso dale bande. Santa Agnese, S. Benedeto apreso. Maddona de sora. E sia fato belo e non se vardi a spexia.'

16 Markham-Schulz, 'The Giustiniani chapel and the art of the Lombardi', p. 40, n. 11: 'mia figlia amatissima agnexina volio sia mia universal eriede et dapoi la sua morte lasso a beneto fi[gli]o di dita agnexina la mia casa granda da stacio e in Santa Iustina'.

17 Lewis, 'The sculptures in the chapel of the Villa Giustinian at Roncade', p. 310. The dedication inscriptions state that the chapel was also for another Girolamo who was the author of the fortune which she had had from her father, her great-uncle Girolamo.

18 See Kolb-Lewis, *The Villa Giustinian at Roncade*, pp. 288–9, for the family tree. Agnesina did not refer to her son Benedetto in any wills, so he must have died very early.

19 Michaela made her last will in 1504; see Markham-Schulz, 'The Giustiniani chapel and the art of the Lombardi', p. 41.

20 The epitaph to the left reads 'HIERONIMO BADUARIO SEBAST. F. ET HIERONIMO BADUARIO IAC. F. VIRIS ET SANCTITATE VITAE ET IN REPUB. ADMINISTRANDA CONSILIO AC FIDE CUM PRIVATIM TUM PUBLICE. FRUCTUOSIS AGNESINA BADUARIA HAERES PATRI MAGNOQUE PATRUO OPTIME MERITIS SUAE IN ILLOS PIETATIS TESTIMONIUM H.[ANC] M.[EMORIAM] P.[ONIT].' The epitaph to the right reads: 'HIERONIMO IUSTINIANO ANT. F. SENATORI SUMMA PRUDENTIA ET INTEGRITATE CLARO S. MARCI PROCURATIONEM ADEPTO PERQ. OMNEIS FERE URBANAS DIGNITATEIS MULTA CUM LAUDE VERSATO QUI VIXIT ANN. LXII MEN. X DIES XVIIII AGNESINA BADUARIA HER. F. CONIUGI UNANIMI SIBI POSTERISQ. SUIS F[ACIENDAM] C[URAVIT]'.

21 Markham-Schulz, 'The Giustiniani chapel and the art of the Lombardi', p. 28. Marcantonio's will of 1533 stated that the chapel was not yet complete.

22 Lewis, 'The sculptures in the chapel of the Villa Giustinian at Roncade', p. 320.

23 *Ibid.*, pp. 317–26; Markham-Schulz, 'The Giustiniani chapel and the art of the Lombardi', pp. 28–39; and John Pope-Hennessy, *Catalogue of Italian Sculpture in the Victoria and Albert Museum*, London, 1964, pp. 351–78, Figures 374–5, attributed to Giovanni Buora (accession numbers A58 and A59 (1951)). It is likely that two putti in the Victoria and Albert Museum, holding shields with the Badoer and Giustinian arms, were originally from this scheme (the present inscriptions on the chapel with the reference to the Badoer on the left and the Giustinian on the right suggest that the putti would be placed with the Badoer arms to the left and the Giustinian arms to the right – reversing the present display positions in the museum).

24 Kolb-Lewis, *The Villa Giustinian at Roncade*, p. 244.

25 *Ibid.*, p. 17.

26 *Ibid.*, pp. 244–5: 'uno cortivo grande con diverse abitation lo qual ancora no e mexo fato sara per mio uxo'.

27 *Ibid.*, pp. 237–8.

28 *Ibid.*, pp. 13, 245: 'per mio nome come per nome di Agnesina Badoer . . . a nui'.

29 *Ibid.*, p. 241 (1534).

30 *Ibid.*, pp. 45–6, 88, 96. For the *barco* see, for example, Luciana Piovesan, 'Il barco della regina Cornaro', *Storia di Asolo*, XVI, 1980, pp. 36–198.

31 *Ibid.*, p. 69.

32 *Ibid.*, p. 28.

33 P. Simoni, *Antica mappa di San Michele Extra*, Verona, 1981, *passim*. The monastery had been founded in the twelfth century and was a fortified convent.

34 Kolb-Lewis, *The Villa Giustinian at Roncade*, pp. 19, 241–2.

35 Bellinati, 'Ospitale Sancti Francisci', pp. 23–4.

36 *Ibid.*, p. 21.

37 Sylvana Collodo, 'Religiosità e assistenza a Padova nel Quattrocento. L'ospedale e il convento di San Francesco dell'Osservanza', pp. 31–58, in Associazione Culturale Francescana di Padova, *Il complesso*, pp. 31–2.

38 Bellinati, 'Ospitale Sancti Francisci', p. 17.

39 Collodo, 'Religiosità e assistenza a Padova nel Quattrocento', p. 33. Baldo had one illegitimate son.

40 *Ibid.*, pp. 32–3.

41 *Ibid.*, p. 33.

42 Bellinati, 'Ospitale Sancti Francisci', p. 14.

43 Associazione Culturale Francescana di Padova, *Il complesso*, Appendix II, p. 209. The list began with fifty columns of Montemurlo stone of the highest quality, well worked and polished, of a height between 6 and 7 *piedi* (at least 2.13 m.) including the bases, shafts and capitals and with a diameter of one span (32 cm.). These would be brought to the house of ser Baldo and cost 7½ ducats each, including helping to position them. They then promised to make fifty corbels (*mensole*) or more or less according to what would be needed to go with the great pillars on the ground floor, well worked and of the size commensurate with these pillars, made from stone from Nanto, at the rate of 8 *soldi* for each one. Next they would deliver fifty mouldings (*moeyonos*) of stone from Monselice costing 8 *soldi* each of the measurements given by Ser Galvano Lattuga. They promised to provide fifty corbels for the rafters out of stone from Monselice well worked at 10 *soldi* each. They also promised to deliver large loads of stone from Monselice and Rezzago for the framing of all the doors and windows.

44 Giulio Bresciani Alvarez, 'Il cantiere dell'ospedale, del convento e chiesa di San Francesco in Padova. Note sulla scuola della Carità e l'oratorio di Santa Margherita', in Associazione Culturale Francescana di Padova, *Il complesso*, pp. 59–108 (especially pp. 61–2), and Appendix III, p. 210.

45 *Ibid.*, Appendix IV, pp. 210–11: Contract made between Baldo da Piombino and Masters Matteo da Ravenna, Giovanni da Lendinario and Cristoforo da Verona. The Masters promised Baldo 'to make the walls of a hospital with arcades [*porticali*] made with balconies [*podiolis*] that are to encircle the hospital completely at ground and first-floor level, and also to make as the foundation of the said walls, pillars built from three square stones [*quarellis*], two-and-a-half, two, one, and a half, and thence above ground built from two stones and a half, and from two, and from one-and-a-half, and from one and from a half stone; and to make octagonal pillars giving them Greek stones [*lapides grecos*] hardened in the furnace, which are octagonal; and to make doors, windows, hearths and passages and vaults at ground level and the vaults for the balconies; and to place smooth and moulded stonework according to the needs of the said works and to the customs of the city of Padua, and to make the rafters and planks exactly joined' ('facere muros unius hospitalis cum porticali fiendo cum podiolis quo ire debeat circumcirca dicta hospitalia sive dictum hospitalem superius et inferius; et facere fundamenta dictorum murorum pilastros de tribus quarellis, de duobus et medio,

de duobus, de uno, e de medio et ab inde super terram de duobus lapidibus et medio, et de duobus, et de uno et medio, et de uno, et de medio lapide; et facere pilastros ad *octos* [*sic*] cantonos dando eis lapides grecos factos ad fornacem ad octo cantonos et facere ostia fenestras lares et caminos et voltos subtus terram et voltos podiolorum et ponere planos et guercios secundum necessaria dictis laboreriis et secundum consuetudinem civitatis Padue et asaldare bordonales et trabes dicti laborerii').

46 *Ibid.*, pp. 212–13: 'fare secondo che meyo serà et apparerà a discretion et volontate del dicto misser Baldo et fare lavoriero bello et pollio piollà dentro et de fuora in hogni luogo de vista che se vederà a discretion de boni homini intendenti'.

47 *Ibid.*, pp. 212–13: 'Item fare de socto et de sora ay necessarij comuni i schagni cum buxi de legname divixi et sarà da l'un al'altro si che no se possa vedere da l'uno buxo a l'altro et cet.'

48 *Ibid.*, p. 214.

49 *Ibid.*, p. 213: 'compartij da uno là et da l'altro per fin la coxina comuna de socto et de sora . . . sicome sta i pozuli de l'inchiostro de lo spealle de l'omini et meyo et similmente'.

50 Bresciani Alvarez, 'Il cantiere dell'ospedale', p. 62.

51 Bellinati, 'Ospitale Sancti Francisci', p. 20.

52 Collodo, 'Religiosità e assistenza a Padova nel Quattrocento', p. 35; and Bresciani Alvarez, Associazione Culturale Francescana di Padova, *Il complesso*, pp. 211–12, for the document.

53 Bresciani Alvarez discusses the first church ('Il cantiere dell'ospedale', pp. 69–81).

54 *Ibid.*, p. 70.

55 Bresciani Alvarez, Associazione Culturale Francescana di Padova, *Il complesso*, pp. 76, 211: 'cum belle cornixe de pria cocta per dare bella vista de fura al dicto portegale'.

56 Bresciani Alvarez, 'Il cantiere dell'ospedale', p. 76.

57 Bellinati, 'Ospitale Sancti Francisci', pp. 14–15.

58 Collodo, 'Religiosità e assistenza a Padova nel Quattrocento', p. 35.

59 *Ibid.*, p. 36.

60 Dominici, *Regola del governo di cura familiare*, pp. 59, 122.

61 Iris Origo, *The Merchant of Prato: Francesco di Marco Datini*, London, 1957, pp. 339–40. Margherita died in 1423.

62 F. Schröder, *Repertorio genealogico delle famiglie confermate nobili nelle provincie venete* (2 vols.), Bologna, 1972, I, p. 55. See Kolb-Lewis, *The Villa Giustinian at Roncade*, p. 241, for the mention of the cardinalate.

63 Lewis, 'The sculptures in the chapel of the Villa Giustinian at Roncade', pp. 228–9.

WIDOWS
AND THE LAW

Most commissioning women in secular society were not wives, but widows. The widow had a measure of independence in that she had some control over her dowry and any inheritance, would usually receive income from her husband's estate and could contract an artist, and indeed sue him if he failed to complete the work as promised. Widows represented quite a large percentage of society; in fact, about a quarter of women in Florence in 1427.[1] Widows tended to be older women, because younger ones were persuaded to remarry to form new dynastic alliances for the men controlling their natal families. Young widows were, in contrast, either women who were so rich that their father or brothers wanted to inherit from them, or they were mothers of young male children who had been entrusted to bring them to maturity safely for their husband's family.[2]

Of these types of widow, only the rare heiress would be likely to be head of her separate household. A young childless widow would be sent back to her father's house and her dowry would also return to her father.[3] In some cities, as for instance in Florence, a fatherless and childless widow would still not be in control of her possessions. Thus Antonino, Archbishop of Florence, in his treatise on marriage composed in the fifteenth century, stated that a widow without children whose father was dead would receive her dowry, but that it would be held under the guidance of a male guardian appointed by her.[4] The younger widow with small children might well live in the orbit of her husband's family, and, even if she was head of the household for a while, would cede headship to her eldest son at his majority. Older widows would often live in their son's household, or more rarely in the house of their son-in-law, and were usually pressurised to keep their dowry intact and not to extract it from the patrimony of their marital family.[5] In law, as Thomas Kuehn has pointed

out, all a woman's children, female and male, had equal rights to a share of this dowry, so that in practice a widow may not have felt free to spend on any large scale, or if she did, might have needed to justify her commission as an investment benefiting her children – such as creating a family chapel.[6] Few were living in the independence of Margarita, the widow of the Pistoian legist Cino da Pistoia, who, at her husband's death in 1336, gained control of the new house he had had built on the site of her dowry house as administrator of her dowry possession and, by his gift in the will, all the household effects, except his books.[7]

According to the research of Christiane Klapisch-Zuber, for instance, out of the wealthiest households from the city of Florence in 1427, only 2 per cent of tax returns were headed by the names of widows, and this situation was even worse when it came to wealthy widows living in the countryside around Florence. If a widow was less well-off she would have more chance of heading a separate household in the city of Florence, where in 1427, 14 per cent of households were headed by a widow. But if such a widow lived in the country, her chances of independence were halved.[8] Many cities laid down limits on the amount of estate or goods that a man might leave his wife. For example, in 1499, the Cremonese forbade a husband to leave his widow more than one quarter of the usufruct of his estate and more than the equivalent of 25 Imperial pounds.[9] Such statutes were intended to safeguard the patrimony for the eldest son. Widows tended not to be well-off, because they would not inherit large amounts unless there were no direct male heirs, and the dowry which they had been given was small in comparison with the possessions of the patrimony. Even if a woman inherited from her father because she had no brothers, her male cousins frequently cast a rapacious eye on her possessions and thought it worthwhile to litigate. For instance, in 1547 we find the only daughter of the Perugian painter Mariano di Ser Austerio fighting her cousin in a lawsuit in which he disputed her father's will.[10] Nor would the dowry have increased much in value during the marriage, because the husband had the right of taking the profit from it where, for example, the dowry consisted of land or houses which were rented. Indeed, widows were often classed as *miserabili* – those too poor to be taxed.[11] Most widows were, therefore, old, indigent and dependent.

The widow had more chance than a married woman to commission art and architecture, but in many cities she still did not have the same autonomy as a man, because she was required to have a legal guardian or *mundualdus* (the Latin term) *or mundualdo* (the Italian word) to validate her legal activities. It is important to remember that the legal guardian was a different institution to that of the guardian of the child, and while the mother could be appointed guardian or *tutrice* in this sense, only a man could be the legal guardian or

mundualdus. This *mundualdus* could be any adult male. According to the research of Antonio Pertile, the *mundualdo* system derived from Lombard law and was in force everywhere except in those places which adhered to Roman law, such as Venice, Treviso, Friuli, Belluno, Genoa, Verona, Vicenza and Rome – where he found women free of the *mundualdus*.[12] As Thomas Kuehn has pointed out in his studies of the situation in Florence, the workings of and variations in the *mundualdus* system in different Italian cities awaits clarification.[13] For instance, although Naples adhered in other respects to Roman law, it had adopted the practice of requiring a *mundualdus* in order to provide 'the assistance of a person of authority' for a woman or a minor.[14] It is evident that there were considerable changes during this period in local conditions, when, for example, Venetian legal practices eschewing the *mundualdus* were adopted in territories conquered by the Republic, or when, for instance, cities came under the power of Florence, where, in 1415, it had been declared that the *mundualdus* would be required in all areas subject to Florentine control.[15] The way the *mundualdus* system worked also seems to have varied from city to city. For example, in Florence, the widow who wished to sell or will anything needed the consent either of her *mundualdo* or of two or three of her close male relatives, and in many cases the presence of a judge to validate the alienation of her property.[16] Pertile listed similar conditions in Corsica, Chieri (in 1311), Bergamo, Ferrara, Lucca (in 1539), Sassaro in Sardinia (in 1316), Modena, Mantua, the Marches, Trieste (in 1550), Valtellina and Milan, providing dates for presence of the rule only in some cases.[17] Local variations could be very idiosyncratic. Thus Pertile noted that in Pisa in 1537 a childless woman who was twenty or over and with or without a husband could alienate all her dowry without a *mundualdo*; a widow with children could alienate half her property without a *mundualdo*; while a married woman with children could only alienate one quarter of her dowry property without a *mundualdo* (wives usually had their husband as *mundualdo*).

It would be interesting to gauge how the use of the *mundualdo* in different areas affected women commissioning art and architecture, and especially whether women could be more independent in areas following Roman law. The use of the *mundualdo* might have made commissioning more difficult and cumbersome, and it also encapsulated belief in the inadequacy of a woman's decision-making capacities, since what Kuehn terms the Florentino-Lombardic law did not consider that women had the legal persona to act without a *mundualdus*. This contrasted with the situation in both Roman and Canon law, according to which it was assumed that an individual woman had the full personal capacity of will – most importantly, for instance, in taking vows to enter marriage or a convent life or to dissolve a marriage.[18] However, it has been shown by

Kuehn that Florentine widows could choose their *mundualdi*, that they were often not men who were their relations, and, he inferred, would not have been able to pressurise the woman.[19] In addition, Elaine Rosenthal has pointed out that in about a fifth of the fifteenth-century notarial documents she examined the names of Florentine *mundualdi* were added *after* the deed had been drafted, flouting the rule that the *mundualdus* was supposed to be present to allow the woman to act. She concluded that the *mundualdus* was sometimes a legal fiction.[20] Any such study, however, of the effects of the *mundualdus* on commissioning awaits a sufficient body of documented examples from different areas and more comparative studies by legal historians.

When it came to the woman's ability to sue an artist if he defaulted, the woman might again not be in the same position as the man. Here, too, the situation varied from city to city. As laid down, for instance, in the statutes of Florence: 'no woman may act for or defend herself in civil cases, although she may respond to questions if these are put to her as necessary by adversaries'.[21] In Lucca, however, in 1539, a woman was allowed to stand in judgement acting for and defending herself in all situations, whether married, widowed or never married, as long as she was eighteen years or over.[22] Equally the rules concerning the emancipation of men from the power of their fathers were different to those relating to women. As explained by Enrico Besta, emancipation was automatic when a man or woman assumed high office, took monastic vows or accepted adult baptism having a father who was not a Christian. Otherwise, with men, emancipation from the father's control took place either when the son left off living under his father's roof, or when he reached a certain age – which varied from city to city (for example, it was twenty at Bologna and twenty-five in Modena), or before that time by the father freeing the son by legal act.[23] But a woman was never emancipated while her father lived, no matter how many times she married or how old she was. The only way a woman could be free of her father's legal control was by his formal resignation of that power. While her father lived, only emancipation gave a woman the legal status as an individual separate from her father to undertake contractual obligations, stand as a legal party in an arbitration, write a will or choose her place of burial without his permission – some or all of which she would need to do if she wanted to commission art or architecture. (Of course in cities where the *mundualdus* system was in force, the emancipated woman *still* needed the *mundualdus* to make her a full legal persona, but in other places emancipation gave her autonomy.) As pointed out by Kuehn, emancipation was given by fathers who considered that it would benefit the family.[24] Indeed later we shall see that an important patron of Michele Sanmichele in Verona – Margarita Pellegrini – was emancipated by her father in 1529 so that she could independently make

79

a will leaving him a huge fortune consisting of the inheritance of her dead husband. In other words, when we look at a commission by a widow containing an inscription or donatrix portrait, but where no documentary evidence is available, we may be seeing a design which the widow commissioned with her father's consent, or one which she contracted as an emancipated woman alone – with or without a *mundualdus*. In this way as in others, then, the position from which the widow stated her will and acted and exerted her artistic taste differed fundamentally from that of a male patron.

Within these strictures widows were nevertheless expected to act with sagacity and independence if the survival of the patrimony depended on them, as illustrated in the correspondence of the Florentine Alessandra Macinghi Strozzi with her eldest son, who was in exile following the loss of her husband in 1425. Over two decades, she was in charge of the education of a family of young children in Florence and of administering the business of her sons as they came of age and were exiled. In her letter to her eldest boy telling him of her decison to marry off her daughter Caterina in 1447, for example, she evinces considerable self-possession in announcing her strategy and in deploying her money and his (half and half) to provide the dowry.[25] As stressed by Elaine Rosenthal, even in Florence women could be selected as guardians of their children, acted as executors of wills, managed large households, including estates, and occasionally were named as legal procurators and arbitrators, despite the fact that this was in theory legally incorrect.[26] Such social expectations may help to explain why the few women who did find themselves in positions where it was appropriate to commission, often seem to have done so with shrewdness and acumen. Although in their day-to-day lives they were ready to stay permanently in the background, they were schooled, like understudies, to take the management of affairs on behalf of the family at a moment's notice if necessary.

The kinds of art that widows had made related both to their limited social expectations and their narrow financial scope. The emphasis seems to be on the commissioning of funerary monuments, usually for a husband or a son. When widows commissioned sculpted effigies of the grander sort – busts or full-length figures in the round – they did so for their men. Widows did, however, order portraits of themselves, but in the form of painted altarpieces which included portraits of them as the donatrix. Whereas the tomb portraits of their men might celebrate the active life, the donatrix portraits of the widow were able to state her hopes for personal salvation and her piety, but not her individual career achievements. Sometimes a widow would overstep expectations as to the private and family-orientated character of a woman's interests to fund something which enhanced the cult in general, like a chapel for anyone to worship in, or a beautifully carved church door, or the mural decoration

for the facade of a church, or the building of a convent or a hospital. Such a magnanimous woman would need to be bereft of direct male heirs to be able to act in this outgoing manner. Usually the stress was on making art for family commemoration and (as far as the surviving evidence is concerned) the concern was for wholly religious purposes.

In Chapters 4–7 the different kinds of widows' commissioning have been grouped according to what may be deduced about the degree of control the female commissioner was able to exert over her scheme; how far her commission was designed for a wider public than her family; how far it asserted her spiritual needs rather than those of her relatives; and the extent to which she drew attention to herself through inscriptions or a portrait or both. In selecting these criteria it is assumed that the feminine was normally represented in this culture as dependent and relative in her actions rather than independent, as private rather than public, as working for the well-being of her family, not herself, and as opting for discreet silence and modest obscurity rather than appearing before the gaze of the crowd.

Accordingly, Chapter 4 considers widows who had to act posthumously through writing more or less detailed wills, sometimes in conjunction with legal contracts previously negotiated with an artist. In such situations the widow was in the hands of her executors, who were usually men. Although these posthumous commissions could be very varied in type and widows thought of ingenious ways of ensuring their desires, such patronage was fundamentally weak because the woman could not respond pragmatically to the circumstances of the commission as it developed. Chapter 5 considers widows commissioning during their lifetimes, and thus in control of their enterprises, but who were fulfilling the servicing and auxiliary role expected of the feminine, of commemorating their husbands, or their sons, or, indeed, their fathers-in-law. Chapter 6 discusses widows who put their own spiritual concerns first, and commissioned funerary altarpieces in their own lifetimes, containing their own votive portraits. These images presented the widow to the gaze of all who used a church, asserting her individual hope of salvation. Chapter 7 looks at widows who were also feminine in an assertive way not envisaged by the writers of the handbooks of social conduct, because they too put themselves first, but used inscriptions rather than portraits in their commissions to demonstrate their authorship of a work.

Notes

1 Christiane Klapisch-Zuber, *Women, Family and Ritual in Renaissance Italy*, Chicago, 1985, pp. 120–1. In Florence in the early fifteenth century, for example, half the female population over sixty, 45 per cent of women over fifty and 18 per cent of women over forty were

widows. Looking at the statistics rather differently later in the century, for example according to Molho, *Marriage Alliance in Late Medieval Florence*, p. 413, the 1480 *catasto* showed that there were 9,964 women not yet married, 7,193 wives, 1,245 widows and 438 females of unknown marital status out of 18,840 females in Florence.

2 Klapisch-Zuber, *Women, Family and Ritual in Renaissance Italy*, pp. 120–1.

3 Antonino, *Tractatus de sponsalibus*, fo. g vii, verso.

4 *Ibid.*

5 C. Klapisch-Zuber and D. Herlihy, *Les Toscans et leurs familles*, Paris, 1978, p. 61; Nino Tamassia, *La famiglia italiana*, Milan, 1911, pp. 325, 344–5.

6 Thomas Kuehn, *Law, Family and Women: Towards a Legal Anthropology of Renaissance Italy*, Chicago, 1991, p. 206. (This reprints his earlier article, 'Cum consensu mundualdi: legal guardianship of women in Quattrocento Florence', *Viator*, XIII, 1982, pp. 309–33.)

7 S. Ciampi, *Vita e poesia di Messer Cino da Pistoia*, Pisa, 1813, pp. 145–6. The universal heir was Cino's nephew, since he and Margarita had had no children.

8 Klapisch-Zuber, *Women, Family and Ritual in Renaissance Italy*, p. 120.

9 Tamassia, *La famiglia italiana*, p. 335.

10 F. Briganti, 'Un ignorato dipinto di Mariano di Ser Austerio', *Bollettino della Deputazione di Storia Patria per l'Umbria*, XV, 1909, p. 372.

11 Klapisch-Zuber and Herlihy, *Les Toscans et leurs familles*, p. 75.

12 Antonio Pertile, *Storia del diritto italiano dalla caduta dell'Impero Romano alla codificazione* (6 vols.), Turin, 1896–1903, III, pp. 239–40, especially n. 37: Pertile found women free of the *mundualdus* in Venice, Friuli, Genoa, Verona, Vicenza, Rome and Belluno.

13 Kuehn, *Law, Family and Women*, p. 235.

14 Camillo Tutini, *Dell'origine e fundazione de' seggi di Napoli*, Naples, 1754, p. 68.

15 Kuehn, *Law, Family and Women*, pp. 214–15.

16 Pertile, *Storia del diritto italiano*, III, p. 240.

17 *Ibid.*, n. 43.

18 Kuehn, *Law, Family and Women*, pp. 215–16.

19 *Ibid.*, p. 236.

20 Elaine G. Rosenthal, 'The position of women in Renaissance Florence: neither autonomy nor subjection', in *Florence and Italy: Renaissance Studies in Honour of Nicolai Rubenstein*, ed. P. Denley and C. Elam, London, 1988, p. 377.

21 Pertile, *Storia del diritto italiano*, III, p. 243, n. 51: 'Nulla mulier potest in causa civili agere vel defendere [se] per se ipsam. Possit tamen respondere positionibus si requisita fuerit ad hoc per adversarium' (Statutes of Florence, II, 9).

22 *Ibid.*, pp. 243–4, especially n. 55. In general, women's testimony was much less likely to be taken seriously than that of men. For instance, in Venice, where one man's witness was sufficient, the evidence of two women was required. In Sassari, when witnesses were required for a will, the presence of two women equalled that of one man, and when it was a question of the disposal of a dowry, three female witnesses were needed if a man was not available.

23 Enrico Besta, *La famiglia nella storia del diritto italiano*, Milan, 1962, p. 205.

24 Kuehn, *Law, Family and Women*, pp. 205–6.

25 Molho, *Marriage Alliance in Late Medieval Florence*, pp. 128–9.

26 Rosenthal, 'The position of women in Renaissance Florence', pp. 375–7.

COMMISSIONING
FROM THE GRAVE

Widows could commission quite a wide variety of items by means of writing more or less detailed wills, sometimes also signing contracts with artists when the widows were close to their deaths. In some cases the widow was employing part of her husband's estate to commemorate him, as we shall see with the sculpted tomb for her husband ordered in 1492 by Donna Giulia Brancaccio of Naples and the painted altarpieces required by Donna Brigida in 1482 and Donna Antonia Nuti in 1495 for their husbands in Foligno. In other cases the widow might allot her own inherited or dowry wealth to be spent on a funerary commemoration for herself in the form of a tomb chest and an altarpiece, as we find with Donna Francesca de Ripoi in Florence in 1517. Some widows donated all their possessions to further more public-spirited and grander schemes. This was done by Donna Margarita Vitturi in 1455 in order to build a chapel honouring the Annunciation for the people of Venice, and by Donna Finalteria da Bevagna in 1559 to pay for monastic buildings in Assisi. It is significant that the widows we look at in this chapter had no sons. As explained by Pertile, there were often controls on the proportion of her possessions, especially her dowry, that a widow could will away from her family for a funerary commission or some charitable endowment. Pertile's examples suggest the kinds of restrictions in various cities and towns in the peninsula. For instance in Florence the widow with sons could not will any of her dowry away from them at all. In Rome and in Naples she had a little more scope, and she might will just a tenth of her dowry away from any children, while in Belluno and Valsesia she could dispose of a quarter of her dowry if she had children. However, in Domodossola she could do as she wished with half of her dowry. But in Lucca, even if she had no children, she could only will three-quarters away from her

other relatives.[1] The commissions studied in this chapter confirm the likelihood that widows with children would not be able to command lavish commissions from the brink of the grave.

Even where widows left sums to enable commissions to be fulfilled, they did not necessarily stipulate exactly how they should be spent. For example, Donna Isabetta, who was the mother of a monk at Sant'Elena in Venice, left 200 ducats to be spent on the *fabbrica* or building of his newly built church in 1440. With this money it was recorded in 1441 that her son Fra Tommaso da Venezia had commissioned an altarpiece providing for her funerary commemoration and including her patron saint, Saint Elizabeth, figuring prominently, and that he had donated expensive altar-cloths.[2] But while we may guess that Donna Isabetta would have spoken to her son of her desires, the firm evidence is that he, not she, decided how to spend the money. Such weak posthumous commissioning was probably quite common. It also occurred in 1495, when Donna Antonia Nuti died leaving instructions for her brother to commission a funerary altar for her husband. This resulted in Niccolò di Liberatore being paid for a Coronation of the Virgin with Saints Antony Abbot, George and the Franciscan Bernardine of Siena, contracted by Pierangelo di Giovanni Nuti (Plate 13). The patron explained that this painting was for the chapel of his brother-in-law Giovanni Antonio Marini, detto Il Guercio da Foligno, in the church of San Niccolò, Foligno.[3] The choice of Antony presumably referred to the name of her husband.

To ensure that the widow had some measure of control, one strategy was to contract the work some time before her death. This was the case, for instance, with another commission aimed at commemorating a husband, this time entailing an expensive wall tomb designated by Donna Giulia Brancaccio del Glivoli for the soldier Tommaso Brancaccio Imbriachi in the chapel of San Jacopo (at present the Cappella di San Domenico) at San Domenico, Naples (Plate 14). Following his death Donna Giulia Brancaccio del Glivoli signed the contract in 1492 with the sculptor Maestro Jacopo della Pila. She specified that the sepulchre should be completed in eight months, that it should include an effigy of her husband in full armour, that her arms and his should be placed on either side, that good-quality stone and Carrara marble should be employed, and that it should be in no way inferior to the tomb of Cardinal Brancaccio in the nearby church of Sant'Angelo, carved by Donatello. To ensure his compliance she had had him make a drawing which was in her possession.[4] The inscription on the tomb itself stated that she had had to design the tomb because her husband had died unexpectedly without time to plan his own memorial: 'For the Magnificent soldier Tommaso Brancaccio of Naples who when dying had not considered his tomb, Giulia Brancaccia took care of his sepulchre for the most

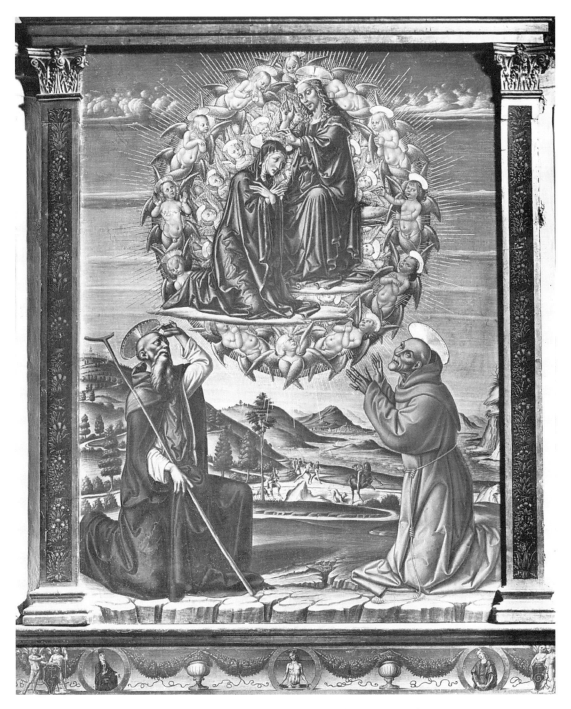

13 Niccolò di Liberatore, called L'Alunno, *Coronation of the Virgin with Saints Antony, Bernardine and George*, 1495, panel, San Niccolò, Spoleto.

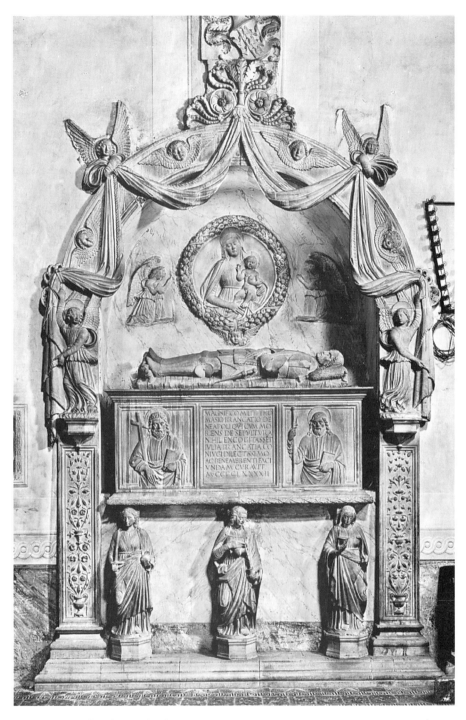

14 Jacopo della Pila, Tomb of Tommaso Brancaccio, 1492–1500, San Domenico, Naples.

beloved and worthy spouse, 1492.'[5]

Donna Giulia designed a monument which would commemorate her husband via a full-size effigy of him resting on his bier, and ordered a relief of the Virgin and Child to be placed above him to represent his hope of merciful treatment at the last. On the tomb chest are roundels showing Saint James holding a pike – presumably representing the Saint James who had been martyred by being chopped to bits – as a suitable patron for a soldier, and Saint John Evangelist with the cross and his gospel.[6] This tomb chest is supported by caryatid figures of Justice, Temperance and Prudence. Her husband's arms were placed on the apex of the tomb and according to Filangieri were repeated to the right of his effigy, while hers were carved to the left.[7] Donna Giulia seems to have died in the same year as she signed the contract, and one of her heirs was still quibbling about payment in 1500, saying the monument was defective, but since the fight was about paying the remaining third of the agreed price, it seems that Donna Giulia's enterprise had been at least two-thirds advanced at her death.[8]

The widows we have looked at so far relied on relatives to follow their wishes (on a son, a brother, and in the case of Donna Maria some sort of relation, because the quarelsome heir was a Brancaccio), but the wealthy widow was often isolated from close relatives, by definition, and in such cases she had to consider shrewdly whom to trust. In the case of Donna Brigida, relict of the banker Michele di Niccolò Picche of Foligno, we have a widow who had her own and her husband's riches to dispose of in 1482, and who intended to give it all to various churches and monasteries in the city of Foligno. Consequently she needed to thwart any ideas her husband's nephews might have to claim their uncle's money, and she therefore chose two prominent male citizens as her executors: the Councillor of the city, Francesco Varini, and the nobleman Ser Luca di Ser Viviano da Foligno. As such a lavish benefactress (for example, she left the cathedral 700 ducats for stained-glass windows), she created a climate in which the combined ecclesiastical forces of Foligno were intent on keeping the benefit of the will. In the event her will was indeed contested by her husband's two nephews, but they had lost their case by 1492.

What survives from Donna Brigida's careful calculations is the magnificent funerary altarpiece which she initiated between 1478 and 1482, and which was completed by her executors in 1492. Like Donna Maria Brancaccio, Donna Brigida exerted strong control over this artistic enterprise by signing the contracts for her chapel well before her death. Like the posthumous commissions of Donna Antonia and Maria, this project also centred round the irreproachably feminine role of honouring one's husband. The chapel was dedicated to Saint Nicholas of Bari in the church used by Donna Antonia, San Niccolò, which

was itself dedicated to the Augustinian Nicholas of Tolentino. In 1478 she commissioned Giovanni and Stefano di Roffinelli to make the altar and the vault and Ugolino di Gisberto to fresco it. Finally she contracted Niccolò di Liberatore to paint the altarpiece in 1479. She promised to pay 135 ducats for the general preparation of her chapel and 180 ducats for the altar-panel. The altar-panel was, however, not complete at her death in 1482, so in her will she endowed the chapel with the conspicuous sum of 400 ducats and entrusted her executors with the task of seeing the work through to 'the true perfection it ought to have'.

The altar-panel is a large one with a centrepiece devoted to the Nativity, with the Resurrection above it (Plate 15). In tribute to the patron of her chapel, Donna Brigida chose to have Saint Nicholas of Bari painted on our left, while on the right she had the name-saint of her dead husband, Michael. Since he was Michele di Niccolò, the patron saint of the chapel could refer to her father-in-law's funerary commemoration. This was a complex polyptych, so she was also able to honour twenty other saints including the patron saint of the church, the Augustinian Saint Nicholas of Tolentino. Only one female saint was given pride of place on the centrepiece – the Augustinian Saint Monica. However, female saints were more numerous in the smaller images adorning the piers on either side.[9] In addition the predella featured depictions of mourning women in the scenes of the Way to Calvary and the Crucifixion. It is of great importance that an inscription was placed on the leftmost panel of this predella, beside a scene of the Agony in the Garden. It is painted as if it were a sheet of parchment held by two angels, and it asks the viewer who can read Latin to decide who has acquired the more merit in producing the altarpiece they see before them – the painter, or Donna Brigida who caused it to be done. The inscription is transcribed and translated in the Introduction to this book (see p. 1 and Plate 1). It seems likely that this was placed here at the wish of the Prior of San Niccolò, who was able to renew the contract of 1479 with Niccolò di Liberatore when the will was proved in 1492. The first contract had (sensibly) included a drawing of what Donna Brigida's panel would look like, and, given that the price agreed with her was retained, it seems likely that the altarpiece envisaged by her was virtually the same as the one received by the Prior.[10] Perhaps the additional inscription was a mark of the respect felt by the churchmen of Foligno for such a benefactress.

While Donna Brigida attained local fame for her generosity, her funerary chapel was focused not on herself but on her husband and father-in-law – from whom presumably the bulk of the money she planned to give away derived. Some widows, however, did commission posthumously for their own entombment. This was so with the widow Donna Francesca de Ripoi, whose will in 1517

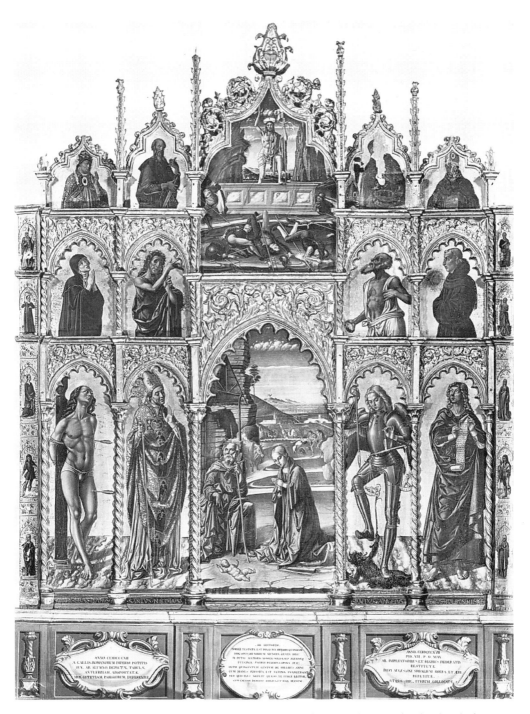

15 Niccolò di Liberatore, called L'Alunno, *Nativity with saints*, altarpiece for the chapel of
Saint Nicholas, 1492, panel, San Niccolò, Spoleto.

envisaged a tomb chest for herself and an altarpiece. Like Donna Brigida, Donna Francesca too employed an executor who was not a relative – in her case the Prior of the hospital of Santa Maria Nuova in Florence. But whereas every move made by Donna Brigida's executors was no doubt scrutinised by her fellow-citizens, Donna Francesca was without family in Florence and her executor was able to take over her testamentary commission for his own family's advantage. Francesca was a Spanish noblewoman, widow of the 'Magnificent gentleman Don Aloisi de Ripoi of Valencia and daughter of the Magnificent gentleman Don Benedetto Falchone Catalan'. Since she did not begin to negotiate her commission and sign a contract before her death, her affairs were entirely in the hands of the Prior.

In 1517 Donna Francesca added a codicil to her will stipulating that she wanted a funerary chapel and burial chest in Ognissanti in Florence which should be dedicated to Saint John the Baptist at a cost of 100 florins, to be completed within two months of her death. Her heir – the Prior Leonardo Buonafé – duly fulfilled her wishes, but with various additions, and at the expense of a further 100 florins of his own money he made a family chapel to leave to his nephews Giovanni and Riniero and their male descendants. Indeed, a document of 1520 recorded that he had solely *his* coat of arms painted on the frame of the altarpiece.[11] Leonardo contracted the painter Rosso Fiorentino in January 1518, about nine months after Francesca's death, to make the altarpiece at a fee of 25 florins, representing the Madonna and Child with Saints John the Baptist, Jerome, Leonard and Benedict. The Baptist was given the position of honour on the Virgin's right, following Donna Francesca's decision about the dedication of her chapel, and Saint Benedict was chosen as the patron saint of Ognissanti. But although the reason for the choice of Saint Jerome is not clear, Saint Leonard was there for the prior, and there was no mention of her coat of arms marking the commission. As David Franklin's research showed, the Prior finally rejected the Rosso panel for this spot, changed the specification to Rosso from Benedict to Antony Abbot and from Leonard to Stephen, sending the resulting panel elsewhere (Plate 16). For the chapel of Francesca de' Ripoi he ordered yet another panel from Ridolfo Ghirlandaio, showing the Virgin and Child with Saint John the Baptist and Romuald.[12] It seems likely that *their* chapel was complete by 1525, since Prior Leonardo stated in that year that he personally had provided additional funds to pay for the priest officiating in the chapel and that the funerary masses were to be for himself as well as for Donna Francesca.[13]

These commissions were all completed within a relatively short time of the demise of the women concerned. But a widow could even control a design created long after her death to some extent, if she went about it shrewdly.

Through a long-term investment managed by an institution, a widow of medium fortune could obtain a spectacularly expensive work of architecture. In this way Margarita Vitturi, a merchant's widow of Venice, managed the altruistic feat of having a chapel built to encourage devotion to the Annunciation beside San Michele in Isola, Venice (Plate 17). Margarita made her will in 1427, soon after

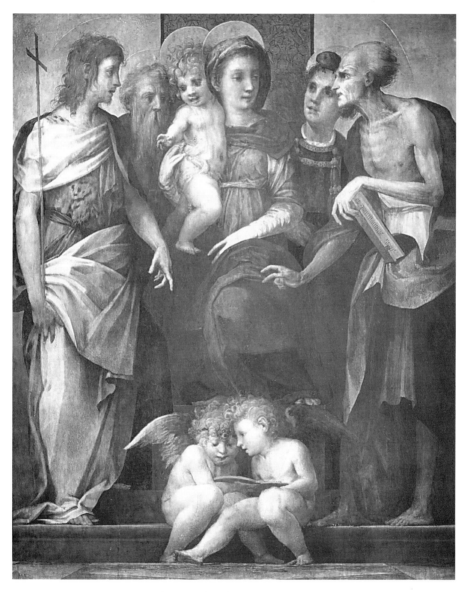

16 Rosso Fiorentino, *Madonna and Child with saints*, 1518, panel, 172 × 141 cm., Uffizi, Florence.

91

17 Guglielmo de' Grigi, Chapel of the Virgin Annunciate, for Margarita Vitturi Emiliani, 1526–30, San Michele in Isola, Venice.

her husband Giovanni Emiliani died. While her husband did not belong to a notable Venetian family, her own family were citizens of Venice and belonged to the elite, according to Schröder.[14] She chose as her executors the Procurators of San Marco de Citra (who were officers responsible for work outside the church of San Marco itself). Without forgetting her only child, Lucrezia, she nevertheless decided to place the value of most of her estate in the Camera degli Imprestiti or public loan of Venice at her death until a sufficient sum had accumulated to pay for the building of the chapel.[15] The investment was therefore made at her death in 1455. Although a sufficient sum was available by about 1500, the procurators had difficulty in finding a site at the first choice she had specified in her will, beside San Francesco della Vigna, where she was buried. They then transferred the scheme to her second choice of location, which was beside the church of San Michele in Isola, where her husband was

buried. Here they were able to obtain a very cramped space to the left-hand side of the church, looking at the facade, and in 1526 they hired Guglielmo de' Grigi to build it.

In her will Donna Margarita had made very precise stipulations as to the features which the chapel had to possess in order to fulfil the functions she wanted it to serve and the number and dedications of the altars she wanted. Given the tiny site, this gave the architect a difficult problem. She had stipulated that there had to be one entrance door from the street or canal which would be open for the passer-by whenever the church was open for worship. There was also to be an internal door leading from the nave of the church which would likewise be open at all times. Secondly, she specified that there were to be three altars, with the main one dedicated to the Annunciation, while the others would be dedicated to the Nativity and the Adoration of the Magi. (In the event the architect placed the altarpiece representing the Annunciation directly opposite the main entrance to the chapel from the waterside.) When she wrote her will Margarita could not have conceived that the architect would solve the problem with a domed centrally-planned building, nor the florid classicising style in fashion in a hundred years time. Presumably, given the building conventions of the early fifteenth century in Venice, she envisaged a rectangular plan with plenty of room to dispose the two doors and the three altars and allow a prime position to be given to the altar of the Annunciation. Even when it was completed in 1530, it was the first chapel of such a form to be built in Venice. In fact, a rectangular chapel was impossible in this location, and Guglielmo de' Grigi made a six-sided ground plan which maximised the space available for the two doors and three altars required by the patron, and he made a false door to give symmetry. Rather than painted altarpieces, he designed ones sculpted in relief. Margarita had hoped that the chapel would have been at the church of San Francesco della Vigna, where she chose to be buried in the habit of the Clarissans. Her devout aspirations were also signalled in her will by payments to send a priest on pilgrimage both to Assisi and to Jerusalem, and her touching bequest of 15 ducats to buy a dress for the statue of Saint Clare at the church of Santa Chiara in Venice. Perhaps most devoutly of all, she planned to make a building which would enhance the cult and offer a general spiritual benefit to the people of Venice in a form she would never see with her bodily eyes. Over the public entrance to her richly adorned chapel built in the latest classicising form, the procurators placed this inscription explaining how it had come to exist: 'According to the will of the matron Margarita Emiliani of notable piety, the Procurators of San Marco de Citra saw as faithfully as possible to the building from its foundations, 1530.'[16]

The chapel of Donna Margarita was an imaginative piece of patronage. If

the amazing mode of commissioning she invented was weak in the sense that she had to leave so much to the chances of the future, it was very strong in its outgoing dynamic, in the insistent detailing of the will and in sheer daring – not exactly conventional feminine traits. With such a strategy a widow could get round the relative poverty of women's fortunes and accumulate funds to have elaborate architecture and sculpture which they normally could not afford, and by sound investment she could remove her funds from the minds of contemporary nephews, brothers and uncles, who would be dead long before a fortune worth litigating for had accumulated.

A widow might also use her will to occasion the commissioning of something even grander than the chapel of the Annunciation at San Michele in Isola. But in giving to an institution which would be using her money to build for its own purposes, she was unlikely to be able, or even to desire, to exert much control over the appearance of the work she paid for. For example in 1559 the Franciscan community of Santa Maria degli Angeli near Assisi recorded that it was receiving a large inheritance from Donna Finalteria of Bevagna, daughter of Meneco [Domenico] di Calamo da Bevagna and widow of Ser Bonifacio di Luciano da Bevagna.[17] Although she had two nephews who might have expected to inherit, Donna Finalteria preferred to pay for the building and decoration of the refectory at this convent called della Porziuncula, as well as other monastic building work. As the place where Saint Francis died on the plain below Assisi, it was a focus for pilgrimage and only a few miles from her home town. The decoration of the refectory with a large mural of the Crucifixion was completed by 1561, and the painter Dono Doni placed a portrait of her kneeling to the left venerating the Cross, in the position of the donatrix (Plate 18).[18] This portrait is on the same scale as that used for the figures in the main scene. The mural is the only decoration in the room and fills one of the walls, ensuring that the donatrix had maximum attention. The painter was probably acquainted with Donna Finalteria, since paintings which she had commissioned earlier for two female monasteries in Foligno are attributed to him (see Plate 55).

It could have been the decision of the friars to have Donna Finalteria portrayed here, following a convention for rewarding a generous donatrix. For example, a relief over what was the entrance to the hospice of the monastery of the Padri Eremitani of Sant'Andrea in Isola, by the Lido of Venice, displays a votive portrait of a veiled woman, Donna Alixe da Ponte, who had endowed the monastery in her will (Plate 19). The rectangular carving represented Saint Andrew as a tall standing figure in the centre with the smaller kneeling woman to the right, but pride of place, kneeling on the left, was taken by the Prior of the Eremite Fathers who had been able to have the work done as a result of Donna Alixe's gift: '1356 in the month of June, Brother Marchio Minoto, the

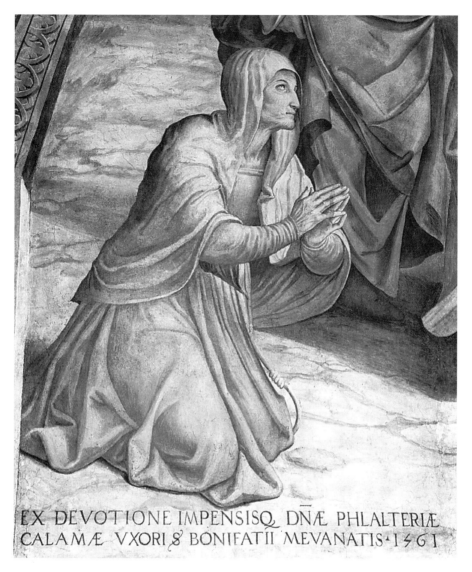

EX DEVOTIONE IMPENSISQ DÑÆ PHLALTERIÆ
CALAMÆ VXORIꝓ BONIFATII MEVANATIS·1561

18 Dono Doni, *Crucifixion with the donatrix Finalteria da Bevagna*, 1559–61, Santa Maria
degli Angeli, Assisi.

Prior of Sant'Andrea of the Lido, had this work done. Madonna Alixe da Ponte
left this possession to the said monastery.'[19] The inscription does not make clear
whether Donna Alixe was a wife or a widow, but the relief suggests a pre-
cedent for the appearance of the portrait of Donna Finalteria in the all-male
refectory of the Franciscans at Santa Maria degli Angeli.

It is not clear whether the refectory mural was commissioned after or before

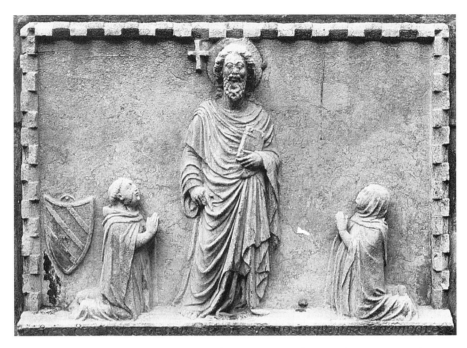

19 Relief showing Saint Andrew, the Prior of the monastery of Sant'Andrea, Venice, and Donna Alixe da Ponte, 1356, Corte Sant'Andrea, Isola di Sant'Andrea, Venice.

the death of Donna Finalteria. The will recorded in 1559 could have acted as a guarantee of funds forthcoming in the way we have already seen used by the parish priest of Santa Maria Formosa in Venice when he wished to make his subscription list for the altarpiece of Bartolomeo Vivarini (see pp. 50–1 above and Plate 3). The fact that the monastery finally registered her testamentary bequest only in 1566 and the sale of her houses for the enormous sum of 2,573 florins another year later suggests that their patroness may not have died until 1566. Alternatively there may have been a dispute over the will conducted by her nephews to explain the long delay before her will was effected. Through making an institution her executor and beneficiary, then, the widow might achieve unusually prestigious commemoration in terms of portraiture as the donatrix.

In conclusion, widows could contract commissions and start off the work, having written a will which ensured that funds were forthcoming for the completion of the project following their deaths. They could also leave sums in their wills for relatives or institutional executors to spend, having specified more or less in the will how it was to be used and the eventual nature of the commission. Well-off widows designed family funerary chapels in this way, as in the cases of Donna Antonia Nuti, who used her brother as executor of the work, and Donna Brigida, wife of Michele di Niccolò Picche, who appointed two prominent

96

citizens of Foligno to ensure her scheme was completed. They might also plan more altruistic gifts to further the religious life of communities they admired, as in the case of Donna Alixe da Ponte and Donna Finalteria da Bevagna, or to encourage a type of devotion especially dear to them, as in the case of the long-term investment of Donna Margarita Vitturi. In some instances, as with the tomb made by Donna Giulia Brancaccio, widows were making plans for the commemoration of their male relatives, but in others they considered their own spiritual advancement, whether boldly, for the benefit of the wider public, or more modestly for their own burial masses and masses for the dead, as with the Catalan Donna Francesca de Ripoi. Ostensibly posthumous commissioning was weak. Nevertheless, by shrewd choice of executors, detailed contracts or testaments and careful calculation (most absent in the case of Donna Francesca, and most evident in the cases of Donna Brigida, Donna Margarita and Donna Finalteria), widows could achieve impressive results. One particularly wise provision seems to have been to have the artists you had contracted and promised to pay to act as witnesses to your will. In Chapter 2 we saw Sibilia Cetto do this. In Chapter 7 we shall see Agnese Nascimbene have her sculptor as a witness, and in Chapter 10 we find the same strategem adopted by Donna Margarita Pellegrini. In this way the widow could give her artists confidence that they would indeed be paid to complete her enterprise. In Chapter 5, however, we turn to examine widows who were able to complete commissions during their lifetimes, and who could therefore control artistic enterprises directly, but who were still relatively conformist as women because they were fulfilling the auxiliary roles of patronage on behalf of their husbands, their fathers-in-law, their brothers or their sons.

Notes

1 Pertile, *Storia del diritto italiano*, IV, p. 19, n. 29.

2 Sandra Moschini-Marconi, *Cataloghi dei musei e gallerie d'Italia: Gallerie dell'Accademia di Venezia* (2 vols.), Rome, 1955–62, I, pp. 31–2, no. 29; Rodolfo Gallo, 'La chiesa di Sant'Elena', *Rivista mensile della città di Venezia*, V, 1926, pp. 421–90, especially pp. 442 and 490. Gallo reported that an inscription was recorded on the frame: 'GIACOMO MORANZONE A LAVORA QUESTO LAVORIER AN.[NO] DOM.[INI] MCCCCXXXX'.

3 M. Sensi, 'Nuovi documenti per Niccolò di Liberatore detto L'Alunno', *Paragone*, XXXII, 389, 1982, pp. 77–107, especially p. 86. Only the record of the final payment for the panel survives, not the contract or Donna Antonia's will. The predella showed the Virgin and John the Evangelist with the dead Christ. The altarpiece is in its original frame and shows one set of arms, presumably those of the Marini family.

4 Gaetano Filangieri, *Documenti per la storia, le arti e le industrie delle provincie napoletane* (6 vols.), Naples, 1883–91, III, pp. 15–27. It was to cost 140 ducats, and this included the cost of the installation. Of Tommaso Brancaccio, Gaetano Filangieri reported that he knew nothing other than what was reported on the epitaph.

5 Raffaele Maria Valle and Benedetto Minichini, *Descrizione storica, artistica, letteraria della chiesa convento e religiosi illustri di S. Domenico di Napoli dal 1216 al 1854*, Naples, 1854, p. 281: 'MAGNIFICO MILITI THOMASIO BRANCATIO DE NEAPOLI QUI CUM MORIENS DE SEPULTURA NIHIL EXCOGITASSET IULIA BRANCATIA CONJUGI DILECTISSIMO AC BENE MERENTI FACIENDAM CURAVIT MCCCCLXXXXII.'

6 The identity of this saint is probably Saint James the Dismembered, since he sometimes held one of the instruments with which he had been dismembered by the soldiers of the Persian King Bahram, purportedly in the fifth century. Saint James the Greater had the attributes of a pilgrim, while Saint James the Lesser held a flail or stick.

7 Filangieri, *Documenti per la storia*, III, p. 15.

8 *Ibid*., pp. 19, 27. Maria Brancaccio, the heir to half her estate, is documented as alleging in 1500 that the monument was defective ('opus non esse perfectum sed defectivum') and refusing to pay her half share of the the final payment of 50 ducats to the sculptor. After adjudication, she was required to pay 20 ducats, having successfully argued that the sculptor should forgo 5 ducats. The record of the dispute does not name the other heir responsible for completing the commission.

9 These include Saint Catherine of Alexandria and Saint Barbara.

10 Todini and Lunghi, *Niccolò di Liberatore detto L'Alunno*, fo. 15, recto and verso: 'ad veram et debitam perfectionam'; and Sensi, 'Nuovi documenti per Niccolò di Liberatore detto L'Alunno', pp. 82–4. The altarpiece represented, reading from from the top left, a bishop, possibly Augustine, Paul, Peter, a bishop, Monica, the Baptist, Jerome, Nicholas of Tolentino, Sebastian, Nicholas of Bari, Michael and John the Evangelist – and a further ten saints (at least five of whom seem to be female) on the piers.

11 David Franklin, 'Rosso, Leonardo Buonafé and the Francesca de Ripoi altarpiece', *Burlington Magazine*, CXXIX, no. 1015, October 1987, pp. 652–62, especially p. 656.

12 David Franklin, 'Ridolfo Ghirlandaio's altarpieces for Leonardo Buonafè and the hospital of S. Maria Nuova in Florence', *Burlington Magazine*, CXXXV, no. 1078, January 1993, pp. 4–16.

13 Franklin, 'Rosso, Leonardo Buonafé and the Francesca de Ripoi altarpiece', p. 655. Franklin argued that the revised scheme actually painted by Rosso was tailored for the church of Santo Stefano at Grezzano outside Borgo San Lorenzo.

14 F. Schröder, *Repertorio genealogico delle famiglie confermate nobili nelle provincie venete*, II, p. 371: from 1297.

15 Vittorino Meneghin, *San Michele in Isola di Venezia* (2 vols.), Venice, 1962, I, pp. 334–68, gives the full account. Padre Meneghin found it puzzling that Donna Margarita went into such extraordinary detail in her will.

16 The inscription is extant: 'Margaritae Aemilianae testamento matronae pietate insignis Procuratores Divi Marci de Citra fide optima a fundamentis extruendum curaverunt anno MDXXX.'

17 Her gift was recorded as an inheritance on 18 April 1559 by the treasurer at Santa Maria degli Angeli; see F. F. Mancini, *La basilica di Santa Maria degli Angeli* (3 vols.), Perugia, 1990, III, pp. 47–8. He payed off small bequests in 1566, as executor, and sold her houses in 1567 (pp. 48–9). They raised the very large sum of 2,573 florins.

18 For the date see E. Lunghi, 'Osservazioni su Dono Doni', in *Arte e musica in Umbria tra Cinquecento e Seicento. Atti del XII Convegno di Studi Umbri, 1979*, Gubbio, 1981, p. 100. Note, however, that it is dated 1559 in *Pittura in Umbria tra il 1480 e il 1540, premesse e sviluppi nei tempi di Perugino e Raffaello (guida catologo)*, ed. Laura Vasta, Milan, 1983, p. 114.

19 Wolters, *La scultura veneziana gotica*, I, p. 190, 'MCCCLVI DEL MEXE DE CUGNO FRAR MARCHIO MINOTO PRIOR DE S. ANDREA DE LIDO FE FAR QUESTO LAVORIER MADONNA ALIXE DA PONTE SI LASA QUESTE POSESION AL DITO MONASTERIO', 77 × 103.5 cm., still on Isola di Sant'Andrea, in the courtyard, II, Plate 320, Istrian stone. See Flaminio Corner, *Notizie storiche dalle chiese e monasteri di Venezia e di Torcello tratte dalle chiese veneziane e torcellane*, Padua, 1758, pp. 60–4, for some information on the community of Carthusians.

COMMEMORATING
DEAD MEN

Quite numerous commissions were handled by widows on behalf of their dead menfolk in terms of creating funerary monuments or funerary altars for them. Where evidence of these widows' family background exists, we find that they were widows of men who had earned their living in the law and of men whose claim to high status rested on military prowess. This sort of patronage could be prestigious for the widow in terms of her handling matters of business and artistic discrimination on her own, and in acquitting herself well in having her male relative properly honoured. Since the attention was focused on commemorating and mourning the deceased man, her efforts were thoroughly conformist in one sense. However, in those funerary chapels which the widow intended to be used later for her own funerary masses as well as those of her relatives, she might introduce elements such as her coat of arms, or reference to her patron saint, to fit the design for her and their own eventual commemoration. She could also be seen in these situations as creating funerary chapels or monuments which would give prestige to the family and assist her heirs. In such a role widows could feel themselves taking on important dynastic responsibilities.

Widows of men without direct adult male heirs would sometimes be required in their spouse's will to commission a tomb or funerary chapel, or feel that it was socially appropriate to do so, given that they benefited largely from his testament. They might also commission a funerary monument for a son, their father, brother or even for their father-in-law. It is important to stress, however, that widows were by no means automatically assumed to be in charge of their male relatives' commemoration. There was often a man around in the form of another executor of the will or a son-in-law, to act instead of, or with, the widow. For example, in 1337 when the tomb of the Pistoian lawyer Cino

da Pistoia was being planned according to his will, two of his male executors dealt with the sculptors, although his wife, Donna Margarita, survived him, and they had no children.[1] When the childless Roman sculptor Andrea Bregno died in 1503, his funerary monument was put up at Santa Maria sopra Minerva in Rome not by his wife Caterina alone, but jointly by her and the executor of the will, the Pontifical Registrar, Bartolomeo Bolli.[2] When Donna Andriana Signorelli, widow of the Graziani, had an altarpiece of the *Transfiguration* painted for her by Perugino for her chapel in Santa Maria dei Servi al Colle in Perugia, it was her brother Panfilo Signorelli who contracted the painter in 1517 on her behalf – 'pro Domina Andriana'.[3] When the painter and sculptor Perino del Vaga died in 1547, his commemorative portrait bust for the Pantheon in Rome was inscribed jointly by his widow Caterina, his daughter Lavinia and his son-in-law Giuseppe.[4] Even if the widow was put in charge of the commission she might only have the task of completing something her husband had already begun, and would make merely minor adjustments. For instance, with the altarpiece of Matteo Palmieri for San Pietro Maggiore in Florence, the husband had set the commission in train before his death in 1475. His widow, Niccolosa Serragli, confirmed that the painter Francesco Botticini had fulfilled his contract in 1477, and, since she is shown in the altarpiece as wearing widow's weeds, she must have reinstructed the painter as to her votive portrait.[5]

Widows might commission funerary altarpieces as well as tomb monuments for male relatives. They are best considered separately, because the political sensitivities related to effigial sculpture meant that elaborate tombs were made only in some areas of Italy, while altarpieces were in general use.

Funerary altarpieces

Funerary altarpieces provided the setting for the dead masses of the buried man and were wholly or partly geared to his personal requirements and wishes where known. However, if the widow had the task of bringing up a young family of heirs and intended to be buried in the chapel she was making, she had the weightier responsibility of creating a worthy family chapel for the lineage. It was in this role, as mother responsible for two young sons, that Donna Andreuccia Acciaiuoli fulfilled the will, dated 1380, of her husband, Mainardo Cavalcanti, in rebuilding the old choir at Santa Maria Novella in Florence to form a sacristy and funerary chapel dedicated to the Annunciation. As traced by Margaret Haines, the commission entailed the building of a lofty cross-vault, the insertion of a three-lighted window opposite the entrance, the painting of a polyptych placed beneath the window, and the sculpting of a tomb to

one side of the altar, as well as the creation of burial vaults.[6] Since she had married in 1372, her two boys were still quite young, and because her husband was assassinated, he had not himself had time to prepare his family chapel.[7] The 'sepoltura magnifica' which he had ordained seems to have been basically completed by 1390 when she was authorised to appoint a chaplain to officiate at the altar, while a memorandum of the contract for the stained glass is dated 1386. This was a very splendid commission relating to the high status of a woman who was a sister of Cardinal Angelo Acciaiuoli, widow of the military Marshal of the Queen of Naples, and who had been married before to a Count – Francesco di Battifolle.[8] Not surprisingly the Acciaiuoli and the Cavalcanti are listed by Molho as belonging to the inner circle of the most powerful groups in Florence.[9]

The altarpiece is an elaborate polyptych which has been attributed to Giovanni del Biondo, and centres on the event – that of the Annunciation – selected as the dedication for the chapel by Mainardo in his will (Plate 20). The announcement of the birth of the saviour is accompanied by a large gathering of saints on either side of the centre panel, whose names are helpfully inscribed on the base. Above the Annunciation, God the Father is represented as judge surrounded by angels, while the three scenes on the pinnacles show the Flagellation, Crucifixion and Resurrection. The predella emphasises the grief of the Three Maries and Saint John as they lower Christ into the tomb. On either side are the four doctors of the early Church and their modern counterparts in Thomas Aquinas and Bernard. The four evangelists are represented on the piers.

In some ways Donna Andrea did steer the commission in her interests, because she gave prominence to her own patron saint, Andrew, on the far left, and that of her father, Saint James the Greater, to the immediate right of the Annunciation. She seems to have asked for Saint Agatha to be included at the last minute, because whereas the left-hand panel has evenly spaced rows of saints, and only three saints in the front row, some squashing has occurred on the right margin of the right-hand panel. Here the three saints – James, Bartholomew and the Magdalene – are joined by Agatha, whose profile just pokes in at the edge. Although the central event chosen by Mainardo for the altarpiece celebrated the role of Mary, the female saints are otherwise pushed to the right-hand margin of the polyptych, with Saints Lucy, Elizabeth, Catherine, Margaret and Dorothy, in addition to the Magdalene and Agatha. These women are represented as looking demurely towards the Annunciation. Although some of the male saints also look to the centre, others are painted as if gazing boldly out at the viewer. Saints Peter, John the Baptist and Benedict stare at the spectator. So do Thomas Aquinas and Jerome. Most powerfully, above the Annunciation in the centre of the altarpiece, God the Father as judge is painted as looking at

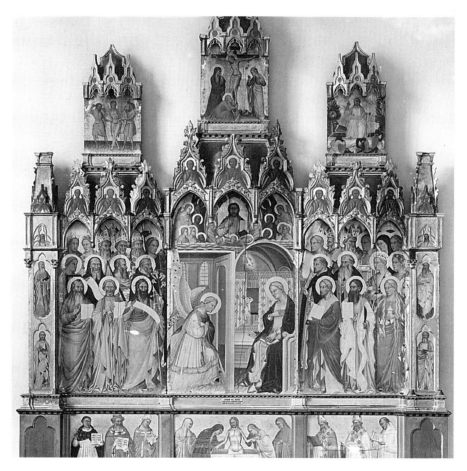

20 Attributed to Giovanni del Biondo, *The Annunciation with saints*, 1380, wood, 406 × 377 cm., Galleria dell' Accademia, Florence.

the beholder too, and he also looks at the viewer from the stance of the Resurrection. While all the female and some of the male saints hold attributes, many of the men also hold scrolls or open books on which are written words from the Bible. Peter, Andrew, James, Bartholomew and Thomas, for example, show us the words of their – the Apostles' – Creed.[10] Thus men possess the power to speak the word of God, and they also scrutinise in judgement. Nevertheless it may have been of significance to the patron that she had her patron saint and that of her father present the words in the Credo which describe the main event on the altarpiece: 'and in Jesus Christ the only son of our Lord, who was conceived by the holy spirit and born of the Virgin Mary'.[11]

The stained-glass window which Donna Andrea also commissioned is still in place, except for the scene of the Nativity of Christ, which has been reglazed.

The scheme appears to have been selected by her and compares the lives of Christ and the Baptist. The recapitulation of the contract between the patron and her glazier, the Vallombrosan monk Leonardo di Simone, is dated 16 November 1386, and recorded that he would be responsible for the initial outlay on glass, tin, lead and expertise. She, however, would provide the ironwork, the copper and the scaffolding. The subject-matter was not specified, but referred to as 'those stories pleasing to Madonna Andrea'.[12]

Donna Andreuccia Acciaiuoli's commission placed the requirements of her husband and her sons foremost, playing down her own interests, with the inscription on her husband's tomb praising his life in the service of Queen Joanna, and stating self-effacingly that the chapel 'was made', using the passive voice – 'Haec extructa fuit fabrica clara Deo' ('This impressive building was constructed in honour of God'). However, there were elements which announced her presence. An inscription below the window proclaimed her contribution, 'coniunx olim Mainardi' ('wife of the dead Mainardo'). The arms of her family, the Acciaiuoli, were painted on the piers of the altarpiece beneath the Cavalcanti arms and, according to Offner, at one time on the front of these piers, too. However, the Cavalcanti insignia outnumbered the Acciaiuoli, since their shield was placed nine times on the scenes at the apex of the polyptych as well. Stanley Chojnacki's analysis of the testamentary habits of Venetian patricians in the fifteenth century points to the way in which women were socially positioned to think of themselves as belonging to more than one family group: Chojnacki noted that women's wills tended to benefit both their spouse's family and also their kin by birth, while those of men concentrated on natal relations only.[13] Such patterns could suggest the attitude of a woman like Andreuccia Acciaiuoli in placing her father's and her husband's arms on the panel and including the patron saints of herself and her father on her husband's altarpiece. In the event, both her sons predeceased her, and in her will of 1411 she asked to be buried with them, leaving 200 florins for the further mural decoration of the chapel.[14]

Where Donna Andreuccia planned a family chapel for the future, many commissioning widows were by definition the last of their line and created self-consciously valedictory images. Such a widow might search for subject-matter which would sum up her particular sense of loss. Thus a Perugian woman whose husband Pietro and young son Giovanni were both to be mourned, thought of the scene of the Pentecost. In this event it was customary to place Saints Peter and John on either side of the Virgin Mary, receiving the gift of tongues from God. She had the artist paint the apostles' names on their haloes on her altar-panel so that it was easy to identify the patron saint of her husband (Saint Peter), and that of her son (John the Evangelist). The panel she commissioned was completed in 1403, and the inscription states that 'Taddeo di Bartolo of

Siena painted this work which Angellela the wife [or daughter] of Pietro had made for the soul of her son Giovanni.'[15] It was first recorded in the chapel of Saint Thomas, in Sant'Agostino, Perugia, and is still in its original frame (Plate 21). This picture employs a bold perspectival illusion to present the scene of the Pentecost. It shows the moment when Christ handed his ministry on to his apostolic Church to spread the message of salvation to the world. The central figure is that of the Virgin Mary, flanked by the seated apostles receiving the miraculous gift of tongues from the Holy Spirit (which is symbolised by rays of light and the dove). Emphasis is further placed on the mother of Christ because her figure is the focus of the orthogonals provided by the chequered pavement of the setting. On the Virgin's halo are the words 'Mater pulchr[a]e dilectionis' ('Mother of beautiful delight'). A sense of deep space is suggested through the painting of a fictive arch and capitals supposedly behind the arched wooden frame of the altarpiece, and the illusion of a step traversing the base, just inside this frame. Because a high imagined viewpoint has been chosen for the floor of the upper room in which the miracle was supposed to have taken place, the spectators are given the feeling that they can walk into the scene. The painter has imagined different reactions of surprise expressed in the hand-gestures of each apostle, in what is a highly arresting and dramatically engaging image. Although the perspectival conventions used in the altarpiece were to be refined and the effects would become commonplace, they must have made a strong impression when first installed. The subject of the Pentecost was otherwise not often chosen for funerary chapels.[16]

Most commissions were for husbands, and comprised painted altarpieces. So the sculpted altarpiece made by Filippa de' Benedetti for her brother at San Giovanni e Paolo in Venice around 1485 (Plate 22) was unusual. Like Donna Andreuccia, she designed the scheme to include her own commemoration as well, and like Donna Angellela she was the last of her line. Since she and her brother were childless she perhaps felt justified in committing the large sums entailed in commissioning sculptures from her and her brother's possessions. The altarpiece has been attributed by Anne Markham-Schulz to the design of Pietro Lombardo, who, she argued on stylistic grounds, was influenced by the Florentine sculptor Verrocchio. It consists of a triumphal arch with statues of Saints Andrew and Philip to the left and right. These figures are each carved from a single block and were finished with gold and black paint. As intended by Donna Filippa the central, taller arch originally held a fourteenth-century statue of a standing Madonna who was probably shown on a larger scale than the flanking saints. It was this much-revered statue, apparently decked in real clothing through the gifts of the devout, to which Donna Filippa's commission gave a new frame. Above the central arch is a relief of God the Father and

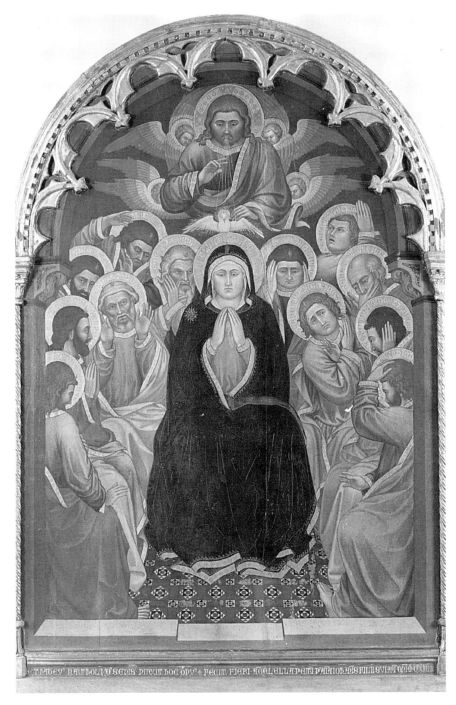

21 Taddeo di Bartolo, *Pentecost*, 1403, tempera on panel, 220 × 147 cm., Galleria Nazionale, Perugia.

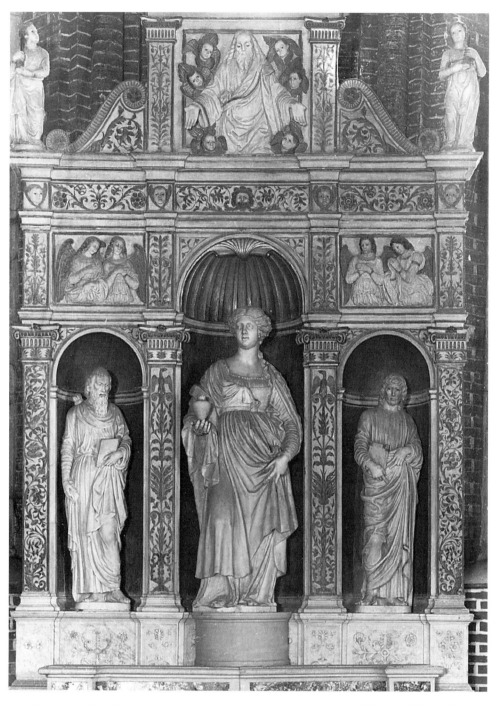

22 Attributed to Pietro Lombardo, Altarpiece with Saints Andrew and Philip, *c.* 1485, marble, San Giovanni e Paolo, Venice.

another showing the Holy Spirit as a dove, while below on either side and above the two apostles are relief panels of angels. In reframing the revered statue, Donna Filippa could benefit the devout community of her city, giving her and her brother's funeral commemoration a public element.

The altarpiece is now in the Chapel of the Virgin, immediately to the right of the high altar, in Santi Giovanni e Paolo in Venice, and the statue of the standing Virgin which was its focus has been replaced by another (of the Magdalene, from Santa Maria dei Servi). However, the original location was before the pier separating this chapel from the one to the right, as you face the high altar. At the original location, on the ground, is still placed the funerary slab of Filippa and her brother Andrea, with its dedication to 'Andrea de' Benedetti da Serico and to Filippa de' Benedetti, his sister'. Donna Filippa di Giovanni Benedetti was from a patrician family, and she had married Ser Gerolimo Businello, who seems to have been alive when she made her first will in 1480. By the time of her second will in 1487 she stated that she had made the tomb for her brother, and she also left money for funerary masses for him, for herself and for her husband. This will, therefore, indicates that her husband had died in the interim. Perhaps she started her commission as wife and finished it as widow, for monastic records show that she began work on the altarpiece in 1482. When she made her third will in 1494 she repeated her previous instructions, speaking of 'the altar which I have had made, where I have buried the body of my most excellent brother Andrea'.[17] Donna Filippa put her brother's patron saint in the place of honour on the left, but she had her own patron sculpted to the right. Since her father had named the brother and sister after two apostles, she could draw on the imagery of their joint commitment to Christ to symbolise her close relationship with her brother in this expensive ensemble.

When a widow's family was politically prominent, her commission might have other kinds of public significance requiring careful thought from the widow. In the case of the *Entombment* completed for Atalante Baglioni by Raphael in 1507 to commemorate her dead son (Plate 23), the widow belonged to the branch of a family who had failed repeatedly to seize control of Perugia from the other branch. Her son had been killed in a faction fight and had been stripped naked after his death and left as a spectacle to the citizens of Perugia, prior to his being taken for burial by his mother and wife.[18] Donna Atalante needed to create a chapel which would represent a humiliating and notorious death in a way which was honourable for the survivors: herself, her daughter-in-law, her four grandchildren and her own mother. Although her son had obtained the patronage of the Chapel of Saint Matthew in the church of San Francesco al Prato before his death, Atalante seems to have decided to avoid referring to a theme connected with this dedication, and chose instead to have

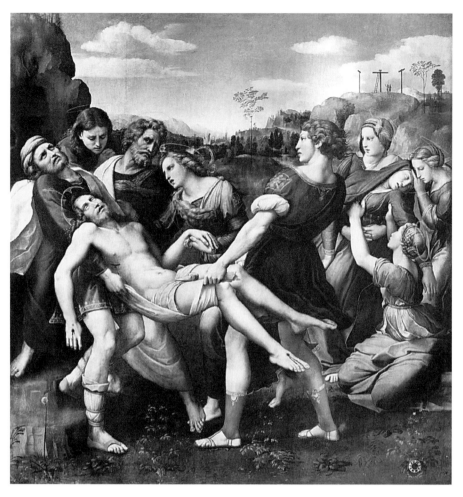

23 Raphael, *Entombment*, 1507, panel, 184 × 176 cm., Galleria Borghese, Rome.

Raphael paint the carrying of the naked body of Christ from the Crucifixion to his tomb, accompanied by mourning women. For the predella she chose the Theological Virtues of Faith, Hope and Charity, placing Charity in the centre, to signify Christ's statement that it was the greatest of the three.[19]

Donna Atalante was of high rank, since her mother was a countess, and she and her husband were both members of the Baglioni, who were the ruling family of Perugia. Atalante Baglioni had married Grifone Baglioni, who was killed in exile in 1477. Her son Federico, called Grifonetto, had been born after his father's death, had married Zenobia Sforza, and was killed in 1500, aged only 23, leaving four children all under 5 years old. Even when the altarpiece was completed in 1507 the eldest grandson was still only 12 years old. Despite

his youth, Grifonetto had already made plans for his funerary chapel, as documented by the research of Vincenzo Ansidei. For in 1499 the Chapter of San Francesco al Prato at Perugia had granted to him the chapel of Saint Matthew, which he accepted in his own name and the name of his mother. He stated that it was for the burial of himself, for Atalante, for *her* mother Angela d'Acquaviva, Contessa di San Valentino, and for their heirs.[20] In her will of 1509, Atalante asked to be buried with her son.[21] In this will she named Zenobia Sforza as future *matrem* and *dominam* (mother and head of the household) of her grandchildren, underlining that she was fulfilling the role of head of the household and overall protector of her daughter-in-law and grandchildren. Atalante left Zenobia the income of her entire estate, 1,000 ducats towards the marriage of her granddaughter Teodorina, and the estate to be divided equally between her three grandsons. A document of 1505 which recorded that Atalante was returning a portion of her dowry to Zenobia stresses that Atalante was in charge of the estate of Grifonetto.[22] These documents indicate why it was Donna Atalante, and not Zenobia, who commissioned the *Entombment* from Raphael, and underline that the commissioning of the funerary chapel, like the writing of the will, looked to the future public reputation and security of her young family.

As often noted, the subject of the Entombment of Christ with the group of mourning women, although customary for a funerary chapel, had especially poignant connotations for the chapel of Grifonetto, his mother, wife and children, given the circumstances of his death. The theme of the three Theological Virtues chosen for the adornment of the frame was more unusual. The fact that, again unusually, they are painted in monochrome, could have met with Donna Atalante's approval because of the reference to the sculpted tombs in which such Virtues customarily supported the effigy. They could hint at the marble monument which Grifonetto could not achieve through valour and statesmanship because of his untimely death. It has been argued by Francesco Santi that a fragment of framing painted with griffins and putti in the Galleria Nazionale at Perugia derives from the frame of the *Entombment*.[23] If this is accepted, the imagery of the griffin could be thought of as alluding to Federico's pet name and to the griffin as the heraldic emblem of the city of Perugia. But as explained by Giovanni Dominici, in his handbook of conduct, dated 1416, it was also an emblem of the widow who guarded her virtue: 'see how the griffin guards gold, defending it with its beak and talons, sustaining terrible wounds and blows, so as not to lose its treasure: so must you sustain every sorrow and pain in this world rather than lose hold of your immortal soul'.[24]

Donna Atalante was a strong widow used to independence, since her father had died when she was in her teens, and she was the only child. Following the

death of her husband after only four years of marriage she had been her own mistress for the rest of her life except for the brief period of her son's majority – being in charge first of her husband's estate and then that of her son.[25]

If Donna Atalante's altarpiece was something of a public-relations exercise on behalf of her heirs, other widows might commission in a rather more detached and dutiful mode. This seems to have been the case when Donna Maria Bufalini commissioned a funerary chapel solely for the use of her husband Antonio Caccialupi and his father Giovanni Battista, at San Salvatore in Lauro in Rome, from Parmigianino and his uncle in 1526 (Plate 24).[26] Her family were originally from Città di Castello, but she was living in Rome because her father and her husband were lawyers in the papal consistory. Maria Bufalini's own allegiances were to her family of birth and her home town. According to her will of 1528, as shown by Mary Vaccaro and Sandro Corradini, Donna Maria was definitely not commissioning with her own funerary requirements in mind, for she specified that she wished to be buried either in the Bufalini chapel dedicated to Saint Bernardine (which had been ordered by her father Nicolò Bufalini from Pinturicchio) in Santa Maria Aracoeli in Rome, or in the Bufalini chapel of her family at Sant'Agostino in Città di Castello – a chapel dedicated to what the will termed 'the Conception'. Donna Maria was, as we might expect, childless. Her husband had no living brothers, and she and her sister-in-law Francesca inherited jointly from Antonio, taking equal shares, as long as Donna Maria did not remarry.[27] She was a woman of considerable substance, because she was the sole heir of her mother Francesca Bufalini, from whom she had inherited a house in the Parione district of Rome which she eventually left to the nuns of Santi Cosma e Damiano. She also owned shops which she willed to nephews and nieces, and she made a further group of nephews and nieces her universal heirs – taking equal shares – including her nephew Riccomanno Bufalini, Bishop of Venafro.[28]

In January 1526 in her house in Rome – six years after her husband's death – Maria contracted Parmigianino and his uncle Pier Ilario to paint 'a panel with the image of the blessed Virgin Mary seated with her son in her arms, and the image of Saint Jerome, Doctor of the Church, and of Saint John the Baptist at the feet of the Virgin, who will be placed in the centre between the said images of Saints Jerome and John the Baptist'.[29] This panel was to be flanked by scenes of the 'Conception of the said Virgin on one side and of Saints Joachim and Anne on the other side painted in the cornices of the chapel, with fine and perfect colours and as much gold on the cornice of the panel as may be required'. Donna Maria was to pay 65 scudi in all, and she handed over a down payment of 30 scudi to the two painters when the parties signed the deal in the presence of the notary. The whole scheme was to be completed

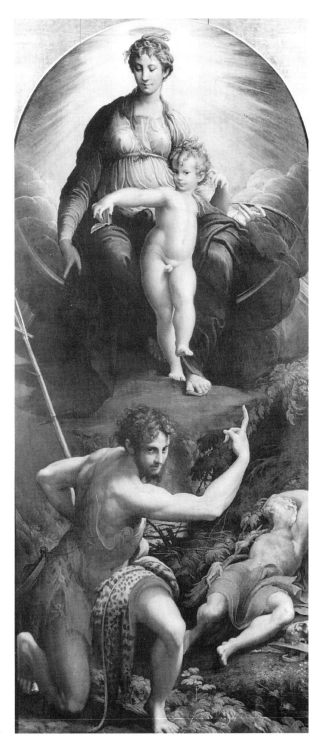

24 Parmigianino, *Virgin
and Child with Saints
John the Baptist and
Jerome*, 1526–28, panel,
343 × 149 cm.
Reproduced by courtesy
of the Trustees of the
National Gallery, London.

111

in six months.[30] In 1527 when Rome was sacked by Imperial troops, both the commissioner and the artists fled. Yet the panel appears to have been complete by then, because in her will of 1528, drawn up in Città di Castello, Donna Maria charged her executors to pay the painter (in the singular) only for framing the panel and putting it into position, as well as giving him the remainder of the fee.[31] During the Sack of Rome, the altarpiece was stored in the refectory of Santa Maria della Pace and was collected long after by one of her heirs, who placed it in the family chapel at Città di Castello. The flanking scenes were presumably in fresco, and were destroyed when San Salvatore was burned down and rebuilt in 1591.[32]

Her husband had buried his father at San Salvatore in Lauro in 1496, and her will implies that she had buried Antonio there too in 1518.[33] Mary Vaccaro suggested that while the Baptist was the name-saint of her father-in-law, Giovanni Battista Caccialupi, this man had also considered Saint Jerome as his spiritual advocate, since a panel is recorded showing Saint Jerome with the inscription 'Giovanni Battista Caccialupi, count and advocate'.[34] In addition, she points out, Jerome was regarded as the advocate in heaven of all legal advocates – being Doctor of the Church – and so he would have been a suitable patron for her father-in-law and her husband, who had been doctors of law as consistorial lawyers. The unprecedented iconography of the sleeping Saint Jerome still invites convincing explanation. Perhaps the idea would be more likely to be permitted by a commissioner who had no spiritual investment in an image of her own, than by a man who hoped that his advocate would be alert at the Last Judgement.[35]

The widows commissioning these altarpieces seem to have been of quite high rank. However, the creation of a sculpted monument for a male relative represented an even more exclusive enterprise, obeying different types of decorum with regard to the use of effigial tombs, depending on the varying political regimes in which the family lived, and also more exclusive to honouring the man himself, with rather less flexibility than the funerary altarpieces when it came to including elements representing the personal interests of the widow.

Elaborate sculpted tombs

As well as altarpieces, a widow would sometimes be required to commission for her husband the kind of sculpted monument which commemorated an active masculine life, and which few women commissioned for themselves. The commemoration of an individual with a stone monument, especially with an

effigy, was a prestigious act, associated with the highest dignity and regarded as more or less decorous depending on the political theory openly advocated in specific parts of Italy. In those areas with communal government, impressive monuments including effigies tended to be discouraged, and might even be considered as presumptuous, while they proliferated in areas where dynastic power supported by a feudal aristocracy held sway.

The monument might consist of a relatively modest floor slab with the effigy of the dead man. A touching example which commemorates a husband and perhaps a small child may be seen in the church of the Incoronata in Naples (Plate 25).[36] This represents the soldier Antonio Orzenello in full armour, with his little baby beside him in its cradle and swathing bands: 'For Antonio Orzenello who with the army of Ferdinand the Catholic excelled greatly in Italy, but at last when the French were besieging Naples, died from fever, his most mournful wife Anna Contreria placed this stone in his memory with love and tears.'[37]

Antonio was only 27 years old and died in 1529. Donna Anna Contreria placed her and his arms on shields flanking the effigy. The format of this tomb was not unprecedented, since there are examples extant from the fourteenth century onwards in Naples showing the dead warrior with a child at his feet. For example, Anna Contreria would have known the example dedicated by a son for his father on the floor of the church of San Lorenzo in Naples and dating from the fourteenth century.[38]

Wall tombs and even virtually free-standing tombs containing an effigy were also occasionally erected by widows. Although such sepulchres tended to be accorded to men of very lofty status, like the patrician soldiers whose widows seem to have been relatively active patrons of this genre in Naples, this type of commissioning could also be undertaken by the widow of a successful lawyer, since there was a tradition of experts in the teaching of law having imposing tombs.[39]

A particularly lavish tomb, for instance, was contracted by Donna Giovanna de' Beccaria of Padua in 1429 to commemorate her husband, Raffaello Fulgosio, a teacher of jurisprudence at Pavia and Padua, who died in 1427 (Plate 26). This tomb was distinguished by her choice of artist, the Florentine Pietro di Niccolò Lamberti, a man who had been working on the sculpture of the facade of San Marco in Venice and was also involved in the sculpture of the tomb of Doge Tommaso Mocenigo. It was also prestigious in its form, since the tomb was designed to be viewed on both sides: it was placed in a bay of the arcade separating the presbytery at Sant'Antonio in Padua from the ambulatory or corridor allowing pilgrims to process around the back of the high altar. The bay has been identified by Anne Markham-Schulz as the third one counting from the left at the rear of the choir, opposite the present chapel of Saint Leonard.[40]

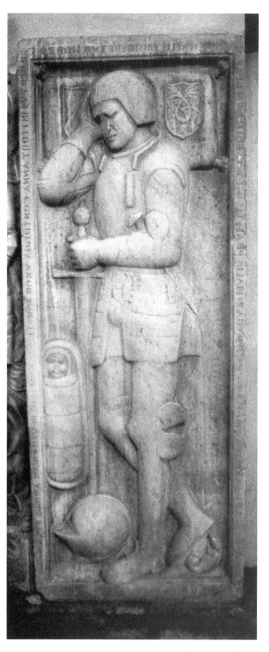

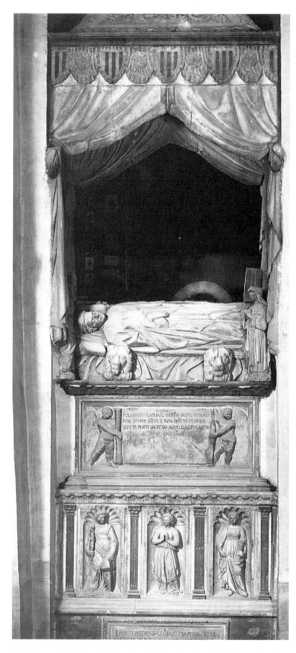

25 Tomb slab of Antonio Orzenello, 1529, Santa
 Maria Incoronata, Naples.

26 Pietro di Niccolò Lamberti, Tomb of Raffaello Fulgosio,
 1429, marble and Ischian stone, Sant'Antonio, Padua.

114

Because it was viewed from both sides, there were two effigies of her husband, each lying on one of the sloping sides of the gabled lid of his tomb. As originally situated, it was also free of the lateral walls of the bay. Since the tomb was near the high altar, it was in a sought-after location too – for which Donna Beccaria paid the friars 500 lire.

When the presbytery was reshaped in 1651, the monument was moved to a new location by the chapel of the Madonna Mora, where the sides were walled in and the canopy modified. In addition, the short columns which lifted the entire structure off the floor were removed. Pietro di Nicolò Lamberti had planned a rectangular base with three niches on both of the long sides on which he was asked in the contract to place 'the six Cardinal Virtues'. On one side are Fortitude, Hope and Faith, with the epitaph of the dead man on the tomb chest above. On the other side are Justice, Prudence and Charity, with three beautifully carved quatrefoils containing reliefs of the Virgin, Christ and the Evangelist. A second epitaph is now inserted into the walling below the south side of the tomb. These epitaphs are repetitive because they were intended for the two sides of the double-sided monument. They used a play on Raffaello's name (*Fulgosus* in Latin), which was connected with the participle *fulgens*, meaning 'glittering' or 'splendid'. For example, the one originally on the ambulatory flank of the tomb reads:

> Raffaello Fulgosio, who deservedly bore the praiseworthy cognomen 'Brilliant' and lies buried in this tomb, deliberated better than anyone on legal matters, and was truly resplendent. He was outstanding in eloquence when he taught civil and canon law. He whose body rests here in peace also exhibited a devout life and the polished manner of one originating in a good family from the urbane city of Piacenza.[41]

Above the two similar effigies of the dead lawyer is a lavish canopy adorned with his coat of arms, sheltering the monument.

As specified in the contract, the tomb employed red marble and white Ischian stone, with white marble being used for the finely polished and detailed quatrefoils. However, in spite of the agreement that the effigies' heads and hands should also be of the more expensive white marble, cheaper Ischian stone was in fact used. Nevertheless, following Donna Giovanna's instructions, Raffaello is shown with a book in his hands and more books at his feet and heads. The contract stated that there should be two figures standing at either end of the bodies, but whether these would be 'persons' (*personarum*) or 'angels' (*angelorum*) would be left to the judgement of the said lady. Donna Giovanna evidently decided that she wanted small figures of lawyers or legal pupils, as if mourners to attend the corpse. The whole red and white structure was originally much more colourful, since she contracted Giovanni di Nicolò Alemagna to

paint it in 1429, and had got him to provide her with a drawing to demonstrate how it would look.[42] Anne Markham-Schulz reported that traces of gold, blue, green, black and flesh-colour are still to be found.[43]

Not surprisingly, the monument seemed to Michele Savonarola, writing his guide to Padua in 1460, 'a superbly decorated sepulchre, worthy of an emperor'.[44] Critics have commented on the way in which Donna Giovanna herself seems to have been responsible for inflating the relatively modest instructions for a tomb in her husband's will into a princely spectacle. For Raffaello asked to be buried at Sant'Antonio, and

> he wished that some honourable place should be purchased where he might be buried and an honourable sepulchre should be made, costing what should seem decent to his executors in agreement with the friars, and that if his executors decided to have his sepulchre made in marble or in stone, he wished that in no way should his tomb be higher than the high altar, but should be lower.[45]

Donna Giovanna made this tomb solely for the burial of her husband, and built an oratory for herself, dedicated to All the Saints, near her house, in the parish church of San Nicolò, where she was buried in 1439.[46]

A wall tomb for a jurist husband, without an effigy, might also be a prestigious monument to be responsible for, in areas like Florence, during the period when ideals of communal government were upheld; and tombs with effigies were considered presumptuous for all but the loftiest statesmen, for clerics and for those of great spiritual distinction. In Florence during the fifteenth century a number of tombs of the wealthiest families, including the Medici and their clients, like the Sassetti, showed the studied austerity of a plain tomb chest without an effigy, where the display of wealth and artistic discrimination has been shifted over from portraiture on to elements of exquisite ornament and the use of expensive materials. It was such an impressively simple tomb chest of polished black marble against a white marble surround that Donna Antonia Vespucci completed for her husband, the successful jurisconsulate Antonio Vanni Strozzi, and placed against the liturgical north wall of Santa Maria Novella (Plate 27). According to Vasari, she commissioned the tomb from the sculptor Andrea Ferrucci da Fiesole, soon after the death of her husband in 1523, and Andrea, who himself died in 1526, had his assistants Silvio Corsini and Maso Boscoli carve the Madonna and the angels respectively.[47] While the inscription refers solely to her husband and the ornament is scattered with the heraldic crescent moons of the Strozzi, Donna Antonia did have her arms placed to the right, while those of her husband's family were to the left, so she presumably planned to be buried here herself. Both the Vespucci and the Strozzi were from Florentine ruling families. The inscription points up the commemoration of a

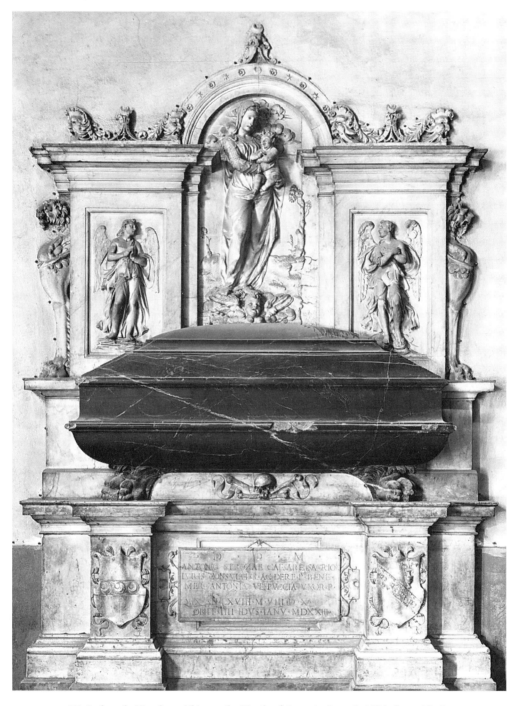

27 Andrea da Fiesole and his pupils, Tomb of Antonio Strozzi, 1526, Santa Maria
Novella, Florence.

117

man who worked 'for the republic': 'To Antonio Strozzi, most expert in imperial and canon law and worthy of merit for his work for the republic, Antonia Vespuccia his wife placed this. He lived sixty-eight years, eight months, ten days, and died on 10 January 1523.'[48]

The imagery of the tomb is that of general hope in resurrection through the merciful intercession of the mother of Christ represented with the Child in her arms. At the same time, the figure of the Virgin and Child is in very bold relief, and both it and the two angels on either side display a conspicuous range of carving techniques, from the ridges of a broad chisel to a high polish for the suggestion of flesh, which draw attention to the considerable artistic energy which has been expended in the sculpture.[49] Although no donor or donatrix is represented, the angels actually take up the poses used for votive figures in joining hands in prayer and in crossing the arms over the breast in adoration, as if to suggest models for the devout honouring the Mother and Child. Within the austere stylistic conventions developed in Florence during the fifteenth century to represent republican ideals, the tomb of Antonio Strozzi could be read as an expression of considerable dignity.

At Naples, in contrast, a large feudal aristocracy produced numerous wall tombs with effigies as part of a routine strategy for openly asserting their noble ancestry and demonstrating the fulfilment of their obligations as soldier, or administrator to the crown, or cleric, which were regarded as the justification of their patrician status, setting them apart from the merchant class.[50] In these conditions, women from the urban aristocracy (the *seggi*), and from the families of barons controlling large territories outside the city and making Naples their headquarters, were occasionally called upon to commission monuments.[51] As analysed by Giuliana Vitale, the nobility exalted the value for the courtier of patrician breeding and individual prowess in both letters and in arms, and they used conspicuous expenditure on the building and decoration of palaces and villas, the conduct of elaborate funerals and the creation of funerary monuments to represent the *splendor* suited to noble status.[52] In this context the wall tomb with an effigy, heraldic shields and an inscription could advertise the personal achievements and the patrician ancestry of the man commemorated. Maria Antonietta Visceglia stresses the way families appropriated chapels in their local church, sometimes for generations, and the way the baronial elite often preferred to place their tombs in the capital (where they had the largest audience) rather than in their estates.[53] In this context the widow bringing up young heirs would be prompt in advertising their patrician genealogy for all to see with a splendid tomb. According to Gérard Delille this was a large shifting elite, with fiefs changing hands through confiscation for disloyalty to the ruler, and when male heirs were lacking – for the rules of succession were relaxed

only in the mid sixteenth century when fiefs were permitted to pass back to a paternal uncle (1532) and to paternal cousins and second cousins (1548).[54] For most of the period then, if sons were lacking, the widow was not likely to be elbowed out of the way by remote relatives of her husband keen to commemorate her spouse and grab the fief, and although she could not consider the future of the dynasty, she would be required to ensure the burial proper to his patrician status.

In San Domenico in Naples, for example, five wall tombs with effigies commissioned by women survive for men of the Tomacelli, the Brancacci and the del Doce families. All celebrate their men as patrician warriors, using variations on forms of monument conventional in the region. Two of them use the inscriptions to commemorate the wife as having lived without discord with her husband. Only one of them (that of Antonina Tomacelli) ensured that she would be buried with her husband – probably reflecting the normal burial patterns for women noted by Visceglia of being interred with their father or mother.[55] The tomb of Tommaso Brancaccio made by Giulia his wife following his death in 1492 has already been considered, where the inscription was used to emphasise that the widow had to make the tomb because her husband had not done so – as if her activities needed explanation (Plate 14).

An example of a tomb made for a husband some time after 1473 in order to establish his patrician status for his young male heirs is to be found in the chapel which had been in the patronage of the Tomacelli family since 1346, and which was dedicated to Saint Catherine of Alexandria, in San Domenico (Plate 28). This was commissioned by a woman who calls herself 'the unhappy wife' (infelix uxor) of Nicola Tomacelli. The monument consisted of a tomb chest on whose lid originally lay the full-length effigy of Nicola, which is at present shifted 90° and sunk into the wall. The effigy displays the armour and the sword which Tutini defined as the privileged dress of the nobility both in the effigy and in the kneeling figure of the dead man carved on a small scale on the front of the tomb chest. Here the dead man is shown praying to the suffering Christ who occupies the central tondo.[56] To either side of Christ are the chief mourners at the Crucifixion – Saint John the Evangelist and the Virgin Mary – while angels support the Tomacelli arms. The inscription explains that the young husband had left the widow with five, presumably young, children: 'Death has snatched Nicola Tomacelli, a nobleman of Naples and strenuous in battle, untimely, from his five children, in the year of our Lord 1473. His unhappy wife, who has done what she can, whom uniquely he loved and with whom he lived without any quarrel, has had this made.'[57] Such a tomb would be an important marker of patrician status for the widow to put down for her sons during their minority.

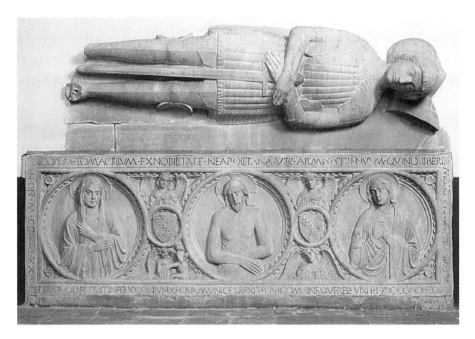

28 Tomb of Nicola Tomacelli, *c.* 1473, San Domenico, Naples.

The second tomb in this chapel, on the left-hand wall, was also commissioned by a Tomacelli widow, but fifty years later, soon after 1529 (Plate 29). This time the widow named herself as Francesca Tomacelli, and erected a monument to her husband, Leonardo Tomacelli. Again the emphasis is on celebrating the noble warrior, worthy of bearing weapons and heraldic arms, though this time with a different stylistic vocabulary. The soldier lies in a more active pose, raised on one elbow, though with closed eyes and the languid limbs denoting the sleep of death. One classicising cherub caresses his head, while another carries a book and douses the torch of life. Rather than a tomb chest, he lies on a shallow bier ornamented with classical Roman armour, as if to suggest the battle trophies put up after victories in ancient Rome. This comparison between ancient valour and modern deeds of arms is pointed up by the presence of a small Roman soldier at the centre of the bier, echoing the pose of the dead man. But these indications of temporal conquests are subordinated to the central relief of Christ's victory over death itself, which is placed at the apex of the monument, and towards which the shape of the monument curves and builds. This victory is couched in military terms through the decision to show Christ's resurrection from the tomb, to the astonishment of the Roman soldiers, who in the biblical accounts had been placed on guard but had fallen asleep. The inscription dwells on the role of the dead man as administrator to the ruler:

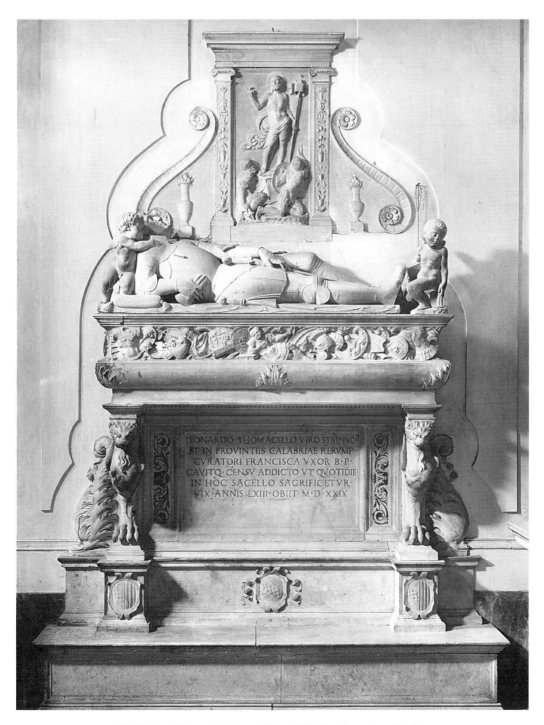

29 Tomb of Leonardo Tomacelli, *c.* 1529, San Domenico, Naples.

For Leonardo, a strenuous man acting as the administrator of the Province of Calabria, Francesca, wife of this worthy person, placed this monument, and she has also made provision from an endowment derived from his estate that a daily mass shall be performed for him in this chapel. He died at scarcely 63 years old in 1529.[58]

The church of San Domenico also contains the chapel originally dedicated to Saint John the Baptist (now honouring Saint Rose of Lima), whose decoration was commissioned by Antonina Tomacelli to commemorate her husband Giovanni Battista del Doce, who died in 1519, and her father-in-law Raynaldo del Doce. Where the declaration of military skills was limited to the two tombs in the Tomacelli chapel, in the del Doce chapel the trophies fill both the tombs and the elaborate architectural articulation of the chapel. For her husband and father-in-law Antonina adapted the Gothic chapel to form a small square *cella*, whose four arches support a dome, employing the Corinthian order. The tomb for her husband (Plate 30) was placed on the right and took the formula of the dead soldier awaiting the promise of the Resurrected Christ which we saw in the slightly later Tomacelli tomb. The tomb for her father-in-law (Plate 31) followed a convention developed in earlier monuments like the Galleazzo Carafa tomb of 1513 in San Gennaro, Naples, which displays the profile-bust of the dead man bordered by military trophies. In the epitaph she emphasised her father-in-law's loyalty to the ruler as a soldier: 'For the best father-in-law, the nobleman Raynaldo del Doce, Antonina Tomacella placed this with many tears. He survived seventy-seven years, and he was a soldier of great integrity who was most trustworthy in the service of King Alfonso I of Naples and acted as the Prefect of his Praesidium.'[59]

Like Maria Bufalini, Antonina Tomacelli seems to have been acting on behalf of her husband to ensure that his father was properly buried. Unlike her, and indeed unlike most women, Antonina sought to be buried with her husband and placed her arms united with his on their tomb. Her inscription acts as a kind of epitaph for herself as well as him, because it allows us to infer the praise of the good wife – the woman who married young and only once and who lived in loving harmony with her man:

This monument commemorates Giovanni Baptista who was from no less than the patrician family of the del Doce, and who achieved glory in arms and displayed the utmost fidelity in the service of the King of Aragon. It was placed by Antonina Tomacella to the best of men, because of the unique and mutual love they bore to one another, as a comfort for her grief, and so that she could guarantee that she, whom he married as a young girl and has lived with him without discord, would at her death be coupled with him in perpetuity. His death took place when he was 62 years, 8 months, and 24 days old; 1519 years from the birth of Christ by the Virgin, on 27 September.[60]

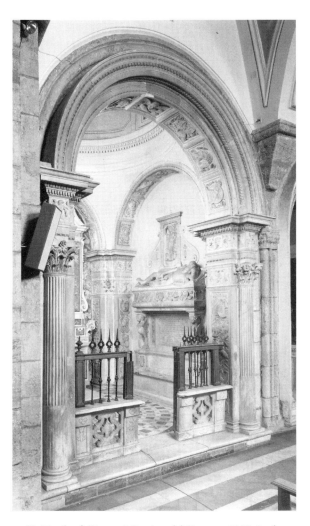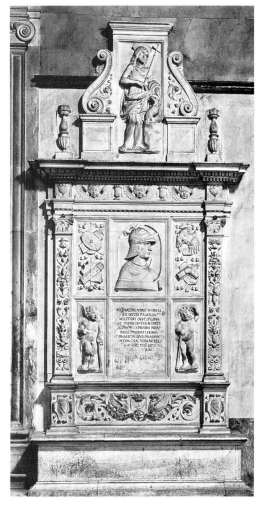

30 Tomb of Giovanni Battista del Doce, *c.* 1519, in the Cappella della Rosa del Lima, San Domenico, Naples.

31 Tomb of Raynaldo del Doce, *c.* 1519, originally in the chapel of the del Doce family, now in the transept, San Domenico, Naples.

Where fiefs died out without direct male heirs, the widow might well be trained to conduct the last rites, as it were, for an honoured dynasty – and might be determined to acquit herself well both in the magnificence of the burial sculpture and in the affectionate sentiments of the inscriptions.

These examples of monuments for patricians in feudal Naples, with their emphasis on effigies and armour, contrast pointedly with the Venetian chapel of the Badoer, who were also members of a large elite of patricians, but in a

republic, where effigial monuments on public display representing the physical and mental strength of individual men were reserved for doges and *condottiere* (see pp. 54–7). Women living in contrasting kinds of political systems in the Italian-speaking peninsula, therefore, such as those of the Venetians and of the Neapolitans, commissioned in widely differing circumstances, with regard to what kind of art and architecture it was deemed appropriate for them to order.

These commissions gave widows the prestige of being patrons with the unusual powers of negotiating with artists, lawyers and the clerics in whose churches their schemes were displayed and used. Some of these projects were entirely devoted to serving the needs of men, as with the funerary chapel commissioned by Donna Maria Bufalini from Parmigianino or the tomb built by Donna Giovanna de' Beccaria for her lawyer husband. Some of them were commissions which were intended to meet the spiritual requirements not only of a dead man, but also of female members of his family and the eventual commemoration of the widow herself. This seems to be the case, for example, with the funerary chapel completed for Donna Andreuccia, Donna Atalante and that of Donna Antonina. Moreover, even in monuments focused on the masculine, inscriptions and the inclusion of her natal heraldry – as in the case of Donna Anna Contreria and Antonia Vespucci – might draw attention to the widow's motives, her commemoration as a 'good wife', perhaps her hopes of remaining a widow rather than remarrying, and could announce her intention to be buried with her husband. Over a long period of widowhood, circumstances could change, and the widow could plan additions to a programme of decoration on her own behalf. This seems to have occurred with the commissioning of Donna Andreuccia Acciaiuoli, for instance, since her sons predeceased her, and she left a large sum in her will for the mural decoration of the chapel in which she desired to be buried with them. It is clear from archival documents that some of these funerary commissions were intended to include the commemoration of females other than the widow, but evidence of such intentions rarely survives on the works themselves.[61] It may, of course, be argued that when, for example, the *Entombment* by Raphael was first in place, it would have been evident that it was related to the funerary ceremonies of Atalante Baglioni and her mother, because of the commemorative masses which took place before the altar, and also in many cases where women were buried, by the presence of epitaphs on the floor of a chapel. Nevertheless, in the commissions I have looked at in this chapter, it was the proper burial of men which was the priority. In the next chapter, however, we turn to look at commissions in which women put themselves first and ordered their own votive self-portraits, and even their own sculpted effigies.

Notes

1 Ciampi, *Vita e poesia di Messer Cino da Pistoia*, pp. 147–53.

2 Gesa Schütz-Rautenberg, *Künstlergrabmäler des 15 und 16 Jahrhunderts in Italien* (Ph.D. thesis, University of Munich), Cologne, 1978, p. 66.

3 See Fiorenzo Canuti, *Il Perugino* (2 vols.), Siena, 1931, II, p. 269, for the document. The altarpiece is in the Galleria Nazionale di Perugia.

4 Schütz-Rautenberg, *Künstlergrabmäler*, pp. 69–70.

5 I inferred this to have been commissioned by a widow in my 'The dowry farms of Niccolosa Serragli and the altarpiece of the Assumption in the National Gallery (1126) London ascribed to Francesco Botticini', *Zeitschrift für Kunstgeschichte*, L, 1987, pp. 275–8; and for confirmation of the attribution and the payment for the altarpiece to Francesco, see Rolf Bagemihl, 'Francesco Botticini's Palmieri altarpiece', *Burlington Magazine*, CXXXVIII, May 1996, no. 1118, pp. 308–14. Thanks to Dr Jane Bridgeman for pointing this article out to me and for further information on widows' dress.

6 Margaret Haines, 'The sacristy of Santa Maria Novella in Florence: the history of its functions and furnishings', in *Santa Maria Novella: un convento nella città: studi e fonti, Memorie domenicane*, XI, 1980, pp. 575–626.

7 Richard Offner and Klara Steinweg, *A Critical and Historical Corpus of Florentine Painting, Section 4, Volume 5, Giovanni del Biondo*, Part II, New York, 1969, pp. 110–14. Here the saints are listed reading from top to bottom and left to right as Minias, Stephen, Nicholas, Donatus, Gregory, Michael, Laurence, Benedict, Paul, Dominic, Andrew, Peter and the Baptist. On the right wing are Thomas, Blaise, Martin, Lucy, Elizabeth, Margaret, Peter Martyr, Antony Abbot, Catherine, Dorothy, Saint James Major, Bartholomew, the Magdalene and Agatha.

8 *Dizionario biografico degli Italiani*, XXII, Rome, 1979, pp. 639–40. She was widowed for the first time in 1369.

9 Molho, *Marriage Alliance in Late Medieval Florence*, pp. 365–75.

10 Offner and Steinweg, *A Critical and Historical Corpus, Section 4, Volume 4*, p. 110. The Baptist displays the text from Matthew 3.3 which asserts his identity as preparing the way for the Lord: 'Hic est enim, qui dictus est per Isaiam prophetam dicentem: Vox clamantis in deserto'. Paul holds his Letters to the Philippians and Romans. Benedict holds Proverbs 4.1: 'Audite filii disciplinam patris . . . custodi praecepta mea et vives', and God the Father John 3.17: 'Non enim misit Deus Filium suum in mundum ut judiet mundum sed ut salvetur mundus per ipsum.' On the predella Ambrose turns his book away from the viewer, but Aquinas offers The Wisdom of Solomon 6.22: 'Quid est autem sapientia et quemadmodum facta sit referam et non abscondam a vobis sacramenta Dei, sed ab initio nativitatis investigabo.' Jerome provides Ecclesiastes 2.12: 'Transivi ad contemplandam sapientiam erroresque et stultitiam'; Gregory displays The Wisdom of Solomon 7.7: 'Propter hoc optavi et datus mihi sensus et invocavi et venit in me spiritus sapientiae.' Augustine presents Psalms 138.6: 'Domine probasti me et cognovisti me; tu cognovisti sessionem meam et resurrectionem meam', and Bernard draws attention to The Song of Songs 4.3: 'Sicut vitta coccinea labia tua, et eloquium tuum dulce sicut fragmen mali punici, ita genua tuae absque eo quod intrinsecus latet.'

11 *Ibid.* Andrew has 'Et in Jesum Christum filium eius unicum dominum nostrum', and James continues with 'Qui conceptus est de Spiritu Sancto natus ex Mariae Virgine'.

12 *Ser Lapo Mazzei, lettere di un notaro a un mercante del secolo XIV, con altre lettere e documenti*, ed. Claudio Guasti (2 vols.), Florence, 1880, II, Appendix 2, pp. 387–8: 'con quelle storie che piaceranno alla detta madonna Andrea . . . sia tenuto il sopradetto don Lionardo diligentemente provedere e dare compimento perfettamente al sopradetto lavorio a dichiarazione del venerabile religioso frate Benedetto dal Pogiuolo, sicché cio che per lui sì dilibera a[ll]'adornezza del sopradetto lavorio s'intenda essere oservato per madonna Andrea e per don Leonardo, chosì del pregio chome d'ogni altra chondizione'. He was joined by a

125

certain Giovanni Rinaldeschi. According to Guasti, Fra Benedetto da Poggiolo was adviser on the cathedral building.

13 Stanley J. Chojnacki, 'Patrician women in early Renaissance Venice', *Studies in the Renaissance*, XXI, 1974, pp. 176–203.

14 Haines, 'The sacristy of Santa Maria Novella in Florence', pp. 578, 582, 587, 590. Both sons – Otto and Carolo – were dead by 1407. She had a daughter called Maria.

15 Francesco Santi, *Galleria Nazionale dell'Umbria: dipinti, sculture e oggetti d'arte di età romanica e gotica*, Rome, 1969, p. 105, no. 84, inv. no. 67: 'Thad[d]eus Bartholi de Senis pinxit hoc opus fecit fieri A[n]gellela Petri pro anima Iohannis filii sui an[n]i d[omi]ni MCCCCIII.'

16 Gail E. Solberg, *Taddeo di Bartolo: His Life and Work*, Ph.D. Thesis, University of New York, 1991, pp. 669–87. Solberg pointed out that describing Angellela as 'of Pietro' could have indicated that she was the *daughter* of Pietro.

17 Markham-Schulz, 'A new Venetian project by Verrocchio', p. 208: 'lo qual altar fezi far dove ho sepulto lo corpo del excellentissimo ser Andrea benedeti mio fradello'.

18 Astur, Baleoneus (Pseud.), *I Baglioni*, Prato, 1964, pp. 135–6.

19 V. Golzio, *Raffaello nei documenti nelle testimonianze dei contemporanei e nella letteratura del suo secolo*, Vatican City, 1936 (1971 reprint), p. 15.

20 Astur, *I Baglioni*, p. 137, n. 1; and Vincenzo Ansidei, *Ricordi nuziali di Casa Baglioni*, Perugia, 1908, p. 50.

21 Astur, *I Baglioni*, p. 153; Ansidei, *Ricordi nuziali di Casa Baglioni*, pp. 44–5. She made the generous bequest of 200 florins to the monastery of Santa Caterina da Siena in Perugia for its building plans and donated sums for the restoration of the funerary chapel of her father-in-law Braccio Baglioni (who had died in 1479) in Santa Maria dei Servi; see also *Dizionario biografico degli Italiani*, V, Rome, 1963, pp. 202–14. It seems that Atalante was an isolated widow, with one living cousin, Andromaca. Her mother was presumably still alive in 1499 when Grifonetto mentioned her as to be buried in the chapel of Saint Matthew.

22 Astur, *I Baglioni*, p. 153.

23 For the presumed frame and the possible lunette of God the Father see Francesco Santi, *Galleria Nazionale dell'Umbria: dipinti, sculture e oggetti dei secoli XV–XVI*, Rome, 1985, pp. 122–3. For the main panel see Paola della Pergola, *Galleria Borghese: i dipinti* (2 vols.), Rome, 1955–59, I, pp. 116–20. For the three Virtues on the predella see Anna Maria Sobell and Fabrizio Mancinelli, 'The Cinquecento', in *Pinacoteca Vaticana*, Milan, 1992, pp. 253–310, especially pp. 266–7.

24 Dominici, *Regola del governo di cura familiare*, p. 75: 'Guarda come grifone guarda d'oro, difendendolo con unghioni and pizichi, sostendendone colpi gravi e mortali, per non perdere suo tesoro che tu sostenga ogni pena e danno temporale innanzi lasci mortalmente l'anima cadere.'

25 Ansidei, *Ricordi nuziali di Casa Baglioni*, pp. 19–44. See p. 44 for the document recording the loss of her father and addressing her as 'Magnifica domina Talanta'.

26 Mary Vaccaro, 'Documents for Parmigianino's Vision of Saint Jerome', *Burlington Magazine*, CXXXV, no. 1078, January 1993, pp. 22–27; and Sandro Corradini, 'Parmigianino's contract for the Caccialupi Chapel in S. Salvatore in Lauro', *Burlington Magazine*, CXXXV, no. 1078, January 1993, pp. 27–31.

27 Corradini, 'Parmigianino's contract', p. 27: 'dum vixit uxorem'.

28 *Ibid.*, pp. 28–9.

29 Vaccaro, 'Documents for Parmigianino's Vision of Saint Jerome', p. 22: 'unam tabulam cum imagine beatae Mariae Virginis sedente cum Filio in brachiis suis et imagine beati Hieronimi doctoris Ecclesiae et beati Ioannis baptistae in pede Virginis a medietate dictarum imaginum sanctorum Hieronimi et Ioannis Baptistae'.

30 Corradini, 'Parmigianino's contract', pp. 28–9: 'necnon imaginem Conceptionis eiusdem beatae Virginis ab uno latere et imaginem sanctorum Iohachim et Annae ab alio latere in cornicibus

cappellae cum coloribus finitis et perfectis et auro in cornice tabulae quantum requiratur infra sex menses proxime futuros pro pretio scutorum sexaginta quinque auri solvendorum'.

31 Vaccaro, 'Documents for Parmigianino's Vision of Saint Jerome', p. 27.

32 *Ibid.*, p. 22.

33 Corradini, 'Parmigianino's contract', p. 28.

34 Vaccaro, 'Documents for Parmigianino's Vision of Saint Jerome', p. 23.

35 Mary Vaccaro reported that another of Parmigianino's patrons, Elena Baiardi, who was the widow of Francesco Tagliaferri, also commissioned an altarpiece – the famous *Madonna del Collo Lungo* – from the painter, for the chapel of her husband, according to the indications in the will of Francesca Tagliaferri, which she has found (*ibid.*, p. 23, n. 9).

36 Carlo Celano, *Notizie del bello, dell'antico, e del curioso della città di Napoli*, ed. Atanasio Mozzello, Alfredo Profeta and Francesco Paolo Macchia, Naples, 1970, p. 1466.

37 Cesare d'Engenio Caracciolo, *Napoli sacra*, Naples, 1623, pp. 479–81, recorded the inscription without further information: 'Antonio Orzenello qui cum militia Ferdin[andi] Cath[olici] multa in Italia praestisse[t] tandem cum Neapolis a Gallis obsideretur morbo correptus interiit Anna Contreria uxor moestiss[ima] saxum hoc in memoriam amoris et lachruma[rum] posuit. XXVII anno salvationis MDXXVIIII die III Novembris.'

38 A tomb slab in the baptistry of Naples cathedral, for example, shows a warrior with a child, and belonged to a member of the Caracciolo family. However, much of the inscription is abraded. See Conway Library, Courtauld Institute negative A/76/2233; and compare this with a tomb slab in the apse of San Lorenzo, Naples, dated 1346, for Guglielmo Obrusaco with his baby, commissioned by his son Berterando and now in the presbytery of San Lorenzo, Naples.

39 See for example Renzo Grandi, *I monumenti dei dottori e la scultura a Bologna (1267–1348)*, Bologna, 1982.

40 Anne Markham-Schulz, 'Reversing the history of Venetian Renaissance sculpture: Niccolò and Pietro Lamberti', *Saggi e memorie di storia dell'arte*, XV, 1986, pp. 9–61, especially p. 24.

41 Wolters, *La scultura veneziana gotica*, I, pp. 240–2. The epitaph originally on the altar side reads: 'FULGOSUS RAPHAEL VIRTUTEM IASPIS UTROQUE IURE STUPORE TANTUS QUAM FAMA QUANTUS ET ORBIS SCRIPTIS MORTE VACAT TAM PARVO CLAUDITUR ANTRO ANNO DOMINI MCCCCXXVII.' The epitaph on the other side, which I translated in the text, reads: 'EMERITE PREDIGNA GERENS COGNOMINA LAUDIS FULGOSUS RAPHAEL CONDITUR HOC TUMULO CONSULUIT NEMO MELIUS FULSIT QUI DOCENDO CAESAREAS LEGES IURAQUE PONTIFICIUM CLARUIT E[L]OQUIO QUEM BLANDA PLACENTIA FORMA ET GENERE INSIGNEM MENTE PIUMQUE TULIT CORPUS HIC IN PACE QUIESCIT.'

42 Vittorio Lazzarini published both the contracts in 'Il mausoleo di Raffaelle Fulgosio nella Basilica del Santo', *Archivio veneto-tridentino*, IV, 1923, pp. 147–56.

43 Markham-Schulz, 'Reversing the history of Venetian Renaissance sculpture', pp. 47–9.

44 Wolters, *La scultura veneziana gotica*, I, p. 240, quotes Savonarola's description in the *Libellus*, p. 34: 'in templo sepultus iacet apud altare maius in superba ornata arca nimis et, ut uno claudam verbo, imperatoria Raphael Fulgosius Placentinus'.

45 *Ibid.*, I, p. 241: 'et voluit quod ematur aliquis locus honorabilis ubi sepeliatur et honorabilis sepultura facit et expendatur in ea secundum quod condecens fuerit et convenire poterunt commissari sui cum ipsis fratribus; et si commisari sui deliberavint archam fieri debere marmoream vel lapideam, voluit quo nullo modo archa altior sit quam mensa altaris, sed inferior'.

46 Giacopo Salomonio, *Urbis patavinae inscriptiones sacrae et prophanae*, Padua, 1701, pp. 126–7. She endowed it with the gift of her house and 30 ducats annually to pay for a daily mass for her soul.

47 Vasari, *Vite*, IV, p. 481, and J. Wood Brown, *The Dominican Church of Santa Maria Novella at Florence*, Edinburgh, 1902, p. 118.

48 The epitaph on the tomb reads: 'D.O.M. [? Deo optimo maximo] Antonio Strozae caesarei sacrique iuris consultiss.[imo] ac de re p.[ublica] bene mer.[enti] Antonia Vespuccia uxor p[osuit] vix anni LXVIII menses VIII dies X obiit IIII Idus Ianuarius MDXXIII.'

49 Giovanni Francesco Gamurrini, *Istoria genealogica delle famiglie nobili toscane et umbre* (first published 1668–85), Bologna, 1972 (5 vols.), IV, p. 101, described Antonio as Ambassador of the Florentine Republic to the papacy in 1512.

50 Everardo Gothein, *Rinascimento nell'Italia Meridionale*, trans. Tommaso Persico, Florence, [1915] 1985, pp. 3–45.

51 Tutini, *Dell'origine e fundazione de' seggi di Napoli*, pp. 2, 148. Tutini explained that the *seggio* was a district of the city governed by noble families who were accorded their privileged status because of the administrative reponsibilities they shouldered for public affairs.

52 Giuliana Vitale, 'Modelli-culturale nobiliari a Napoli', *Archivio storico per le provincie napoletane*, CV, 1987, pp. 27–103.

53 Maria Antonietta Visceglia, 'Corpo e sepoltura nei testamenti della nobiltà napoletana: XVI–XVII secolo', *Quaderni storici*, L, 1982, pp. 583–614.

54 Gérard Delille, *Famille et propriété dans le royaume de Naples XV–XIX siècle*, Paris, 1985, pp. 29–36, 58, 89. The other family possessions could be willed to whom the testator pleased.

55 Visceglia, 'Corpo e sepoltura', p. 604.

56 Tutini, *Dell'origine e fundazione de' seggi di Napoli*, p. 148.

57 Valle and Minichini, *Descrizione storica*, p. 386: 'NICOLAUM THOMACELLUM EX NOBILITATE NEAPOLITANA VIRUM ARMIS STRENUUM QUINQUE LIBERIS MORS IMMATURA ERIPUIT ANNO DOMINI MCCCCLXXIII CETERUM QUOD POTUIT INFELIX CONIUNX QUAM UNICE DILEXIT QUI CUM SINE QUERELA VIXIT HOC CONDI FECIT.'

58 *Ibid.*, p. 390: 'LEONARDO TOMACELLO VIRO STRENUO ET IN PROVINCIIS CALABRIAE RERUMQUE CURATORI FRANCISCA UXOR B.[ENEMERENTI] P.[OSUIT] CAVITQUE CENSU ADDICTO UT QUOTIDIE IN HOC SACELLO SACRIFICETUR VIX ANNIS LXIII OBIIT MDXXIX.' According to Valle and Minichini the arms with which the Tomacelli were joined on the tomb were those of Aragon.

59 Engenio Caracciolo, *Napoli sacra*, p. 278: 'RAYNALDO VIRO NOBILI EX DUCIS FAMILIA MILITARI DISCIPLINA ET VITAE INTEGRITATE ALFONSO PRIORI NEAP. REGI PROBATISSIMO AC PRAESIDII EIUS PRAEFECTO ANTONINIA TOMACELLA SOCERO SUO OPT.[IMO] MULTIS CUM LACHRYMIS POSUIT VIX ANNI LXXVII.'

60 Valle and Minichini, *Descrizione storica*, p. 193: 'IOANNI BAPT. EX PATRITIA DUCUM FAMIL. NON MINUS APUD REGES ARAGON ARMOR GLORIA QUE FIDEI PRAESTANTIA CLARISS. ANTONINA TOMACELLA MUTUAE CHARITATIS CAUSA UNICUM TOT LACRYMARUM SOLATIUM VIRO OPTIMO EX SUO MONUMENTUM POSUIT CAVITQUE NE PRAETER SE QUISQUE INFERATUR UT QUI PUELLULA NUPSERAT ET QUAE CUM SINE IURGIO SEMPER VIX[IT] POST FATA QUOQUE PERPETUO COPULETUR INTERCEPTUS MORTALITATE ANNO AGENS LXII MENS VIII DIES XXIIII E VIRGINEO PARTU MDXIX V CAL. OCTOBR.'

61 It is possible that a commission dated 1510 by Griseide, wife of Ser Sebastiano of Montefalco, was made for her daughter Franciscina as well as her husband. The panel is attributed to Tiberio d'Assisi, and shows *The Madonna del Soccorso* (now in the Pinacoteca Communale, from the church of San Francesco, Montefalco, tempera on panel, 293 × 167 cm.); see C. B. Festi, *Francesco Melanzio da Montefalco*, Milan, 1973, pp. 124–5. It is inscribed 'GRISEYDA SER BASTIANI FECIT FIERI PRO ANIMABUS DICTI SER BASTIANI TARQUINI PERITEY [PERITEI] ET FRANCISHINE A.D. MDX.' The altarpiece showed a mother begging help of the Virgin to protect her child from the Devil, and the Virgin responds by beating the Devil with a club. For 'francishine' see Chapter 7, n. 11 (p. 199).

CHAPTER SIX

SELF-PORTRAITS

Widows did occasionally initiate attention-seeking representations, making votive images which included their own portraits as donatrixes. Such images might represent thanksgiving for prayers being answered or hopes for their prayers to be answered in the future, especially with reference to their hope of heaven. There existed a very long tradition in Italian art of female and male votive portraits, beginning, as shown by Ingo Herklotz, with Late Antique Christian images which themselves derived from pagan votive representations. In these Antique examples the donatrix was often shown on a small scale by comparison with the larger figures of the divine beings she honoured.[1] According to the survey of votive portraits by Dirk Kocks, however, during the early Middle Ages Italian donors and donatrixes were frequently shown on the same scale as the divine figures with whom they were placed in a picture or mosaic. However, Kocks argued, it became most common in the fourteenth century, except for a few examples he noted in Venetian painting, for the donor or donatrix to be represented as of small size relative to the other painted figures.[2] With the development of scientific perspective in Florence from the early decades of the fifteenth century, and spreading rapidly elsewhere, however, it became usual once more for artists to represent the donor, or the donors with their wives, on a large scale. The example of the donor and donatrix of the Lenzi family depicted as realistically-sized figures kneeling on either side of the Trinity in the fresco by Masaccio in Santa Maria Novella in Florence, dated about 1427, is well known.[3] Indeed, the logic of Renaissance perspectival conventions entailed the creation of a monoptically consistent pictured world where the sizes of all objects in the painted space were convincingly proportioned according to how close they were supposed to be to the viewer.

Nevertheless, in terms of devout decorum, the donors or donor and his wife were required to be identified as different to the holy figures they accompanied, and painters were careful to distinguish them using incisively veristic portraiture, precisely depicted contemporary dress, and sometimes by using the fictive architecture in the painting to put the commissioners below the holy figures, to the sides, or separated, say, by a balustrade. The placing of the Lenzi couple as if kneeling on either side of the exterior of the painted chapel containing the Trinity was one ingenious solution suited to the fresco painter. Kocks pointed to other solutions, like the ones which Filippo Lippi found in two of his altarpieces painted in the 1440s and 1450s. In one the donors in an Annunciation scene kneel to honour the Virgin and the Angel, but are separated from the event by a low balustrade. In another the donor in the *Coronation of the Virgin* is shown kneeling on a pavement below the level of the floor on which the holy personages stand. Kocks also noted the motif, which he traced to the invention of Mantegna in his *Martyrdom of Saint Sebastian*, dated 1455, of dividing the donors from the divine figures by showing only their heads at the base of the window in the wall represented by the picture, while the figures they honour take centre stage. The donors are to be thought of as closer to the viewer than the holy figures, and possibly kneeling or standing on a level below them. Kocks showed that this convention spread during the second half of the fifteenth century and became very common in the sixteenth century.[4] However, he pointed out that the use of diminutive donor and donatrix figures was widely used throughout the peninsula in the late fifteenth century and is still found sporadically even in the 1540s, more than a century after the invention of scientific perspective constructions.[5]

It is significant that no sole donatrixes are known to have commissioned a realistically-sized portrait of themselves until the last quarter of the fifteenth century. It seems to have taken about fifty years for the logic of the new Florentine perspectival rules to reach the female commissioner. Even when it did do so, the donatrix very rarely had herself shown full-length, whereas many of her masculine predecessors and contemporaries did do so. Rather, she chose the convention of a votive portrait showing only head or head and shoulders, as if the frame of her altarpiece cut off from our view the rest of her figure, standing or kneeling on a floor level beneath the holy figures she honoured. Kocks followed Rudolf Wittkower in tracing this sort of donor portrait to the initiative of Mantegna in the 1450s, although André Chastel argued that the earliest certain instance of the truncated donor portrait is found in the 1470s in Viterbo.[6] The disagreement occurred because the truncated portrait of the man in the *Martyrdom* could arguably be intended as a bystander in the narrative, though there are sufficient indications of fifteenth-century costume in my view

to warrant the identification of this figure as a donor. In contrast, the example on which Chastel relied cannot be other than a donor portrait, because of its clerical dress; it was identified by Chastel as Bishop Settala. In fact, the earliest example Chastel cited of such a truncated portrait in the case of a donatrix was of an altarpiece dated 1484 from Verona.

When women commissioners felt able to employ a more realistic size for their portraits is very much an open question, dependent on scant data. For example, Kocks assumes that the fresco attributed to Andrea Vanni, painted in the last quarter of the fourteenth century at San Domenico in Siena, representing Saint Catherine of Siena, shows a donatrix kissing the hand of her patron saint (Plate 32). She is represented on the same scale as Saint Catherine. There are also a few examples of donatrixes being shown on a scale of about three-quarters of that of their saintly intercessors. Kocks cited the portraits of a Benedictine nun and a young richly dressed woman, protected by Saints Benedict, Remigius and Mary Magdalene, with the *Entombment* from San Remigio in Florence, but now in the Uffizi, dated 1365–70, and attributed to Giottino.[7] Neither of these examples is documented, and in both cases the clothing seems insufficiently subdued to denote widows. The representation of the donatrix as three-quarters the scale of her intercessors compares with examples documented as representing the consorts of rulers: for instance, the donatrix portrait of Fina Buzzacarini, wife of Francesco da Carrara, made about 1375, in the Baptistry, Padua (Plate 33), and the representation of Queen Sancia of Naples with her husband King Robert, painted for the refectory of Santa Chiara in Naples about 1340.[8] It may be that in the fourteenth century a larger-sized donatrix portrait could have signalled the highest possible social status.

However, it should be noted that because of the habit in some fourteenth- and fifteenth-century images of subdividing the pictorial field (with the largest-sized figures in the centre to represent the most important persons to be honoured, and smaller scenes arranged around or below) a sole donatrix could be shown as on the same scale as the divine figures she accompanied, where she and they belonged to one of the small subordinate scenes in the image. This occurs, for example, on a late fourteenth-century frescoed altarpiece at Sant'Agostino, Montalcino. Here a woman is represented on the same scale as the holy figures at the *Entombment*. She wears a striped coloured veil, and kneels to the right, beside the *Entombment* which is painted over the altar table, while the area above is devoted to the narration of the life of Saint Antony Abbot.[9] However, the scheme uses a variety of scales, with the tall figure of Antony Abbot dominating the centre of the chapel and the donatrix shown on the much smaller scale of the scene from Christ's Passion. A similar situation may be found on a large crucifix at the church of San Quirico at

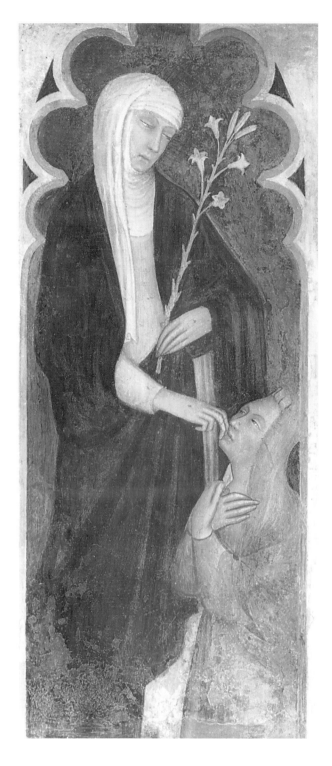

32 Andrea Vanni, *Saint Catherine of Siena with donatrix*, 1375–98, San Domenico, Siena.

132

Ruballa near Florence, dating from the early fourteenth century and attributed to the circle of the Master of Saint Cecilia (Plates 34–5).[10] Here the giant figure of Christ on the cross fills the picture space, but at his feet are three equally small figures on whom his blood is shed: the donatrix flanked by John the Evangelist and the Virgin Mary. So it is only in the example of the donatrix with Saint Catherine attributed to Andrea Vanni that there is a situation in which a full-scale donatrix with her patron saint seems to be the centre of attention. And even here too we may be looking at a part of a larger scheme, which once formed part of a complex, compartmented mural in San Domenico at Siena.

As analysed by Kocks, from the early fourteenth century onwards votive portraits showed both male and female commissioners kneeling with hands joined in prayer, or sometimes crossed in front of the breast in a gesture of adoration.[11] And whereas in the early Middle Ages donor portraits were usually of male clerics, during the fourteenth century it became increasingly common for lay people to have votive portraits, thus creating more opportunities

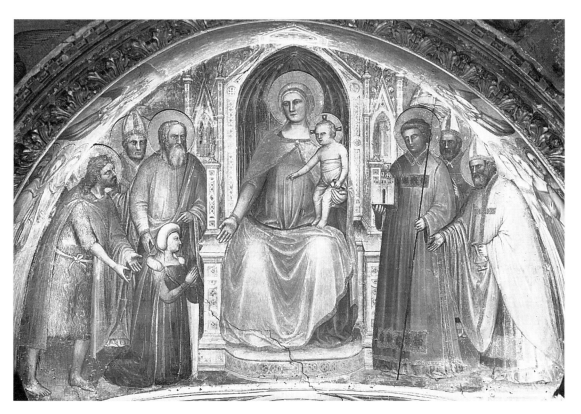

33 Giusto de' Menabuoi, *Virgin and Child with saints and the donatrix Fina Buzzacarini*,
c. 1375, fresco, Baptistry, Padua.

134

for the widow. The donor and the donatrix could be shown offering a candle or holding a scroll. However, poses were also gendered, since donatrixes were often represented as holding their rosary between their hands, while donors were pictured as bending their bared heads to honour their intercessors. They were also gendered in the sense that during the fifteenth century some donors – but never donatrixes – were shown kneeling on one knee, in a pose analogous to that of feudal homage. However, portrayals of both donor and donatrix were normally accompanied by a dedicatory inscription and a heraldic shield.

Kocks showed that the hopes of the donors and donatrixes for the intercession of their patron saints or of Christ or his mother with God as Judge were pictured by representing the suppliant in a variety of ways. Commissioners were put at the feet of their intercessors, gazing up at them, and liked to be portrayed as touching the clothing, the hand or the foot of the holy figure with

34, 35 Follower of the Master of Saint Cecilia, *Crucifixion with the donatrix*, *c.* 1300–30, large panel (*facing*) and detail, San Quirico, Ruballa, near Florence.

135

their own lips or hands. Kocks suggested that these were touches of homage similar to those given by lay people when kissing the hand of their bishop, or by clerics in kissing the foot of the pope. The devotrix or devout man might also be shown as being introduced to the mercy of God by the imagery of the intercessor holding his or her shoulder or hand, and sometimes commissioners might in turn present their children to the attention of a patron saint.[12]

Votive images were displayed in a variety of locations. Kocks highlighted the clusters of votive portraits to be found in favoured pilgrimage sites like San Francesco at Assisi, Sant'Antonio at Padua, Santa Croce in Florence and Sant'Anastasia in Verona. He also listed the placing of images on the pillars and columns of churches, on tabernacles by roads and on streets, in funerary chapels, and from the early fourteenth century onwards in the form of small household altars. It is not clear whether donatrixes felt able to appear in all these locations – some of which were more public than others. They seem to have favoured church locations and to have commissioned some small house-hold altars including their portraits.[13]

The most common votive image was that of the enthroned Madonna and Child, since believers conceived of the mother of Christ as a merciful figure who could intercede on their behalf with her Son, with or without intermediaries in the form of attendant saints. Until the fourteenth century Kocks found that this was overwhelmingly the votive theme. In the fourteenth century a few other types developed, featuring events in the life of the Virgin, with the Annunciation, Coronation and Assumption of the Virgin as particularly common choices. During the thirteenth and fourteenth centuries the Crucifixion was also quite favoured, in the conviction that the commissioner could appeal to God the Father through his Son. As with images of the Virgin Mary, a variety of other scenes in the life of Christ were occasionally chosen by votaries, like the scenes of the Passion and burial of Christ, the Nativity and the Resurrection. Donors or donatrixes also sometimes commissioned votive images of their patron saint.[14]

Donatrix portraits are of great interest because they presented interesting disturbances of conventional viewing expectations. Donatrixes tended to have themselves placed in the position of honour normally reserved for the man, to the left or in the centre of their altarpiece. Kocks noted in his survey of portraits of donors and donatrixes in Italian painting between the thirteenth and the fifteenth centuries that the men were usually positioned to the left and the women to the right, when a married couple was depicted.[15] This position was favoured because of the biblical statements that at the Last Judgement the blessed sheep would be placed on the right hand of God, that is, to the viewers' left as they faced God as Judge, and that the damned (who were identified as goats in the parables) would be on the right – an explanation given, for example, in the

gospel of Saint Matthew (25.33). In addition, where commissioners repres-
ented the heraldry of the husband and the wife, they usually placed the man's
shield to the left and the woman's to the right.

Most votive images showing a portrait were of a single male donor. Viewers
were therefore used to seeing only a small number of donatrix portraits. In
Kocks' survey, only about 3 per cent of votive portraits were of sole laywomen.
Where the viewer was accustomed to finding a male figure as entry-point into
the pictorial world, altarpieces with the portrait of the donatrix alone offered
the surprise of a female as mental stepping-stone, and as the person in the rep-
resentation directing the spectator how to look at it.[16] John Berger pointed to
the way that conventional Western European viewing expectations assume that
the image of the female (and indeed the woman herself) is a passive object to
be adjudged by the gauging masculine eye – a regime of representation which
is supported in the analysis of the handbooks of conduct produced in the
period.[17] Where portrayals of women often denoted the quality of the passive
feminine as to-be-looked-atness, the portraits of the donatrix drew viewers to
observe her watchfulness – in this case, to look at her looking intently at the
holy figures she revered, and they guided the spectator to imitate her devotion.
Female spectators were being offered an abnormally privileged viewing posi-
tion here.

In some instances the donatrix was portrayed with youthful looks, either
without a veil or wearing a transparent one revealing an elaborate *coiffure*,
and with a dress displaying her neck (Plates 32, 34). But such examples are in a
minority on inscribed commissions (see Plate 36). More often donatrixes were
represented with signs of ageing or abstinence in their faces and figures. In the
fourteenth and early fifteenth century their haggard and attenuated portraits
are painted on a diminutive scale (Plate 38). But from the late fifteenth century
more realistically-sized images began to be used occasionally by these well-off
widows, showing the donatrix on the same scale as the holy figures in the nar-
rative she had commissioned. At the same time, painters' skills in representing
the signs of ageing in a woman's face and pose were being developed, and seem
to have been considered appropriate by widows for their donatrix portrayals
(Plate 46). However, it is important to stress that the choice of veristic portrait-
ure was also made by many sole donors, and by male commissioners when com-
missioning votive images of themselves and their wives. All these portrayals
of men and women were presumably intended to assert concern for eternal life
in heaven, rather than the vanities of this world. All could be interpreted as
representing hopes for personal salvation for the individual soul. And highly
individualised portraits could in addition have had the function of clearly dif-
ferentiating the donor and donatrix from their spiritual superiors – the saints

and other holy figures included with them in the picture, who might be shown in a more idealised manner. But when a woman was portrayed alone on an altarpiece, the meaning of a warts-and-all portrait may also have included other messages. In Italian society, men remarried into old age, and signs of wear and tear on the face were no statement of intentions of sexual abstinence for a layman. However, the widow who had reached middle age would not be expected to remarry, and her modestly dressed and ageing figure could denote her conformity to the moderate life and the memory of her dead husband which the handbooks of conduct praised in widows.

Conformist in some ways, the votive portrait of the donatrix nevertheless demanded a specific mode of looking which was not called on when viewing the other types of portraits of women which developed from the fifteenth century onwards. In discussing fifteenth-century profile portraits of women, which were painted from the 1440s onwards, for example, Patricia Simons has argued that these images were produced as signs of the wealth and honour of fathers and husbands.[18] In contrast, the portrait of herself commissioned by the donatrix claimed more or less social prestige for the woman herself. In analysing the way in which male poets viewed independent portraits of men and women in the sixteenth century in Italy, for instance, Mary Rogers showed that the poet assumed an intimate relationship with the painted lady, whom he imagined responsively speaking to him, whereas he saw the painted gentleman as heroically aloof and incommunicative. Furthermore, the poet interpreted the portrait of the woman as an image of ideal beauty and grace, without implying an individual biography, but, in contrast, appreciated the portrait of the man as a celebration of personal achievement and a specific character.[19] It seems likely that the images of the donatrix which were emphatically not idealising, but strongly individualised, and which often portrayed her as gazing with dignified abstraction away from the viewer, could rebuff such viewing routines. In his treatise *On Painting* published in 1435 Alberti testified to the high value placed both on the inclusion in a painting of a figure which shows the viewer how to look, and on the arresting power of recognisable portraits. He advised the artist to include the figure of 'someone who points to some remarkable thing in the picture', and stated that in any picture a well-executed portrait will steal the scene – 'the face that is known draws the eyes of all spectators'.[20] Alberti assumed that the guide and the portrait which drew the eye would both be masculine. But as realistic pictorial skills developed during this period, a few wealthy widows eventually came to adapt these roles for themselves.

Of the widows commissioning votive self-portraits about whom we know something of their standing, the loftiest were from the minor nobility, like the Contessa Penthesilea Baglioni – wife of a *condottiere* who had been rewarded

by the Venetians with the title of Count, and members of the Venetian and the Neapolitan patriciate like Marietta Dandolo and Cecilia Ursini. At the more modest end of the scale were the female relatives of doctors of law or medicine in the Veneto, like Lucrezia del Min and Antonia di Bartolomeo da Urbino.

Diminutive votive portraits

What appears to be the earliest inscribed female votive portrait in the fourteenth century is on an elaborate version of the theme of the enthroned Madonna and Child with eighteen saints (Plate 36). This painting is an altar dossal at Santa Maria in Cesi near Terni, and is inscribed along the border at its base, 'In the name of the Lord, amen. In the year of the Lord 1308, the sixth indiction of Pope Clement V, Donna Elena had this work made.'[21] The panel has been attributed to the Master of Cesi, considered to have been active

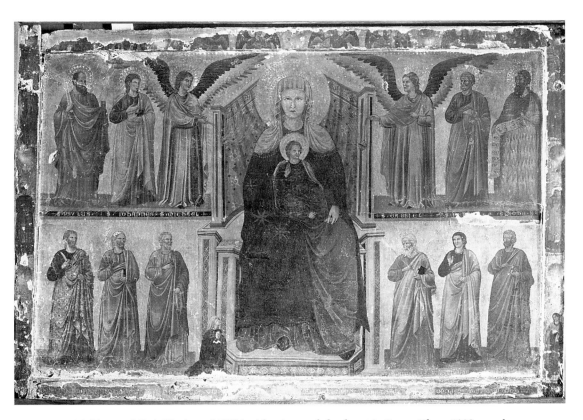

36 Master of Cesi, *Virgin and Child with saints and the donatrix Donna Elena*, 1308, wood, 105 × 156 cm., Santa Maria, Cesi.

in Spoleto at the beginning of the fourteenth century. The centre is filled with a representation of the Virgin seated on a throne, with the Child on her lap. At her feet to the left kneels the diminutive donatrix Donna Elena, dressed in a dark cloak and a white veil and under the protection of Saint Mark. Reading from top left, eleven other saints and angels are shown in two tiers on either side of the throne in a diagrammatic way, being labelled at their feet as Paul, John, Michael, Gabriel, Peter, the Baptist, Bartholomew, Luke, Andrew, Thomas and Matthew. On the borders at the side are six more saints, while on the apex are seraphim and the symbols of the Evangelists. The altarpiece of Donna Elena was extremely elaborate in its panoply of advocates, which suggests that her image stood for more than her singular hopes of salvation – perhaps even being addressed to the congregation of Santa Maria as the dossal for the high altar.

The more common votive form, as outlined by Kocks, appealed directly to the Madonna and Child enthroned. It was this imagery which was chosen, for example, by a widow who inscribed herself as 'Madonna Muccia, wife of the former Guerino Ciantari' on a large panel originally in San Francesco at Lucignano in Valdichiana (Plate 37). Madonna Muccia is portrayed kneeling in prayer to the right in diminutive scale, wearing the veil of a matron and a dress with a scoop neck. The inscription is written as if on the base of the Virgin's throne, and the patron's figure is positioned over the name of her dead husband. The panel has been grouped with others as having been made by a Sienese artist about 1320.[22]

Whereas the altarpiece of Madonna Muccia seems to refer to her personal salvation alone, some images which included the portrait of the donatrix were provided with inscriptions which made clear that they were intended to benefit a wider community of worshippers. This seems to be the case with the very large crucifix from San Francesco, Bassano, about 13 feet high, which asked for the prayers of her fellow-citizens on behalf of the donatrix, in acknowledgement of her gift (Plates 38–9).[23] It seems likely that this huge painting, inscribed as having been made by Maria Bovolini, was a widow's commission, because wives' patronage is so rare, but also because she stated that she imitated the life of Saint Helen, Dowager Empress and the mother of Constantine. She probably belonged to one of the ruling families in Bassano, since she placed the shield of the Bovolini base right, while she had Guariento portray her kneeling to the left in the place of honour. She is shown wearing the white veil and black garb appropriate to the widow (and indeed a tertiary) and holding a rosary. Maria's choice of painter from her local capital city (Bassano was then under the rule of Padua) and the large size of the work made it a spectacular gift to the people of Bassano, in a church which opened off the central piazza of the city. In the Latin inscription at the base of the cross Maria stated her identity and

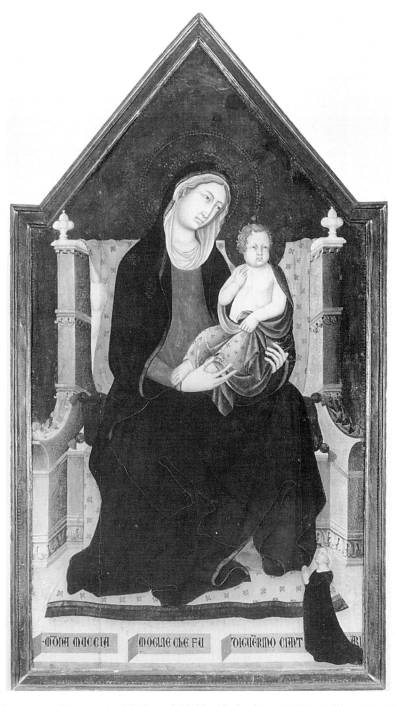

37 Anonymous Sienese artist, *Virgin and Child with the donatrix Muccia Ciantari*, c. 1320, panel, 167 × 90 cm., Museo Civico, Lucignano, Valdichiana.

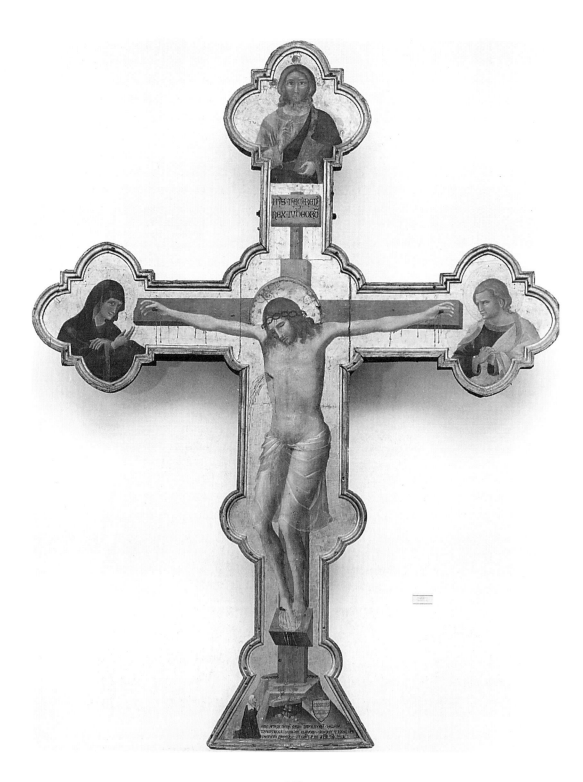

142

her hopes: 'Bona Maria de' Bovolini, imitator of Saint Helen who found the cross and the nails, dedicated this herself to the piety of the people of Bassano, that they might pray for her to Christ our Lord.'[24] There seems to be some sort of funerary commemoration here, but the public appeal for prayers for her soul removes this image from the conventions of the family chapel, and suggests that Bona Maria (Good Maria) sought recognition for her own devoutness and that she wanted to encourage admiration of her heroine, the outward-bound Helen, who had travelled to the Holy Land and had found the Cross buried in Jerusalem and had then built the church of the Holy Sepulchre.[25] Although her commission was very grand, it was not without precedent on a smaller scale, as shown by the example dated 1257, inscribed as having been made for another Donna Maria by two artists from Spoleto – Simone and his brother Machilone (Plate 40). Here the donatrix also kneels in prayer on the left at the base of the crucifix and wears a white veil, a dark underdress and a black or grey mantle. It seems likely that she too was a widow.[26]

A large crucifix attributed to a follower of the Master of Saint Cecilia in the church of San Quirico at Ruballa near Florence, painted about 1330, offers further evidence of a tradition of associating the donatrix portrait with Christ crucified (Plates 34–5). The image shows a donatrix at the centre base of the

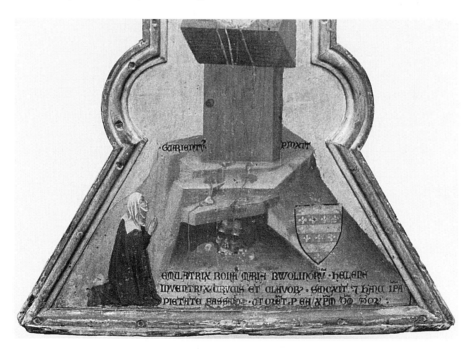

38, 39 Guariento, *Crucifixion with the donatrix Bona Maria Bovolini*, c. 1360, wood, 360 × 280 cm. (*facing*) and detail, Museo Civico, Bassano.

143

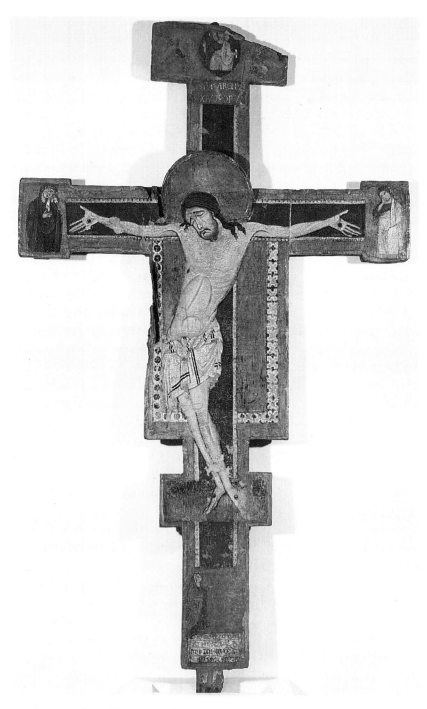

40 Simone and Machilone, *Crucifixion with the donatrix Donna Maria*, 1257, panel,
160 × 101 cm., Galleria dell'Arte Antica, Palazzo Barberini, Rome.

crucifix between the Virgin and Saint John the Evangelist. Since the base of the panel has been sawn off, evidence of her pose – and perhaps an inscription – has been removed. Although she is shown on the same scale as the Evangelist and the Virgin, she is placed lower, indicating that she kneels, while they stand.[27] The donatrix appears to take the Evangelist as her protector, for she looks to him and he points to her. This woman is represented without a veil, with a scoop-neck dress and with elaborately plaited hair bound round her head. The painter has imagined drops of blood spurting from the side of Christ, and this saving blood first reaches the images of Saints Laurence and Francis, which have been placed half-way up the support of the crucifix on either side of the body of Christ, but then falls further to reach the donatrix and her saintly companions. The way she is shown as of equal size to them is noteworthy, but all three are tiny by comparison with the central figure of the Saviour.

As well as the themes of the enthroned Virgin with Child and the Crucifixion, donatrixes – like donors – favoured the imagery of the Coronation of the Virgin too. Thus the remains of a tryptych dated 1375 and inscribed as having been made for Madonna Tora di Nardo, now at San Donato in Poggio near Tavernelle, Val di Pesa, Tuscany, represent the donatrix with Saints Antony Abbot and Louis of Toulouse below a high platform on which are seated Christ crowning Mary (Plate 41). The accompanying right-hand panel shows Saint Thomas Aquinas, and it has been suggested that the missing left-hand panel could have represented Saint Donatus, in honour of the community of the village of San Donato. The triptych has been attributed to Giovanni del Biondo, and is inscribed along the base of the centre panel below her figure in the vernacular: 'This panel was made with the goods and for the salvation of the soul of Madonna Tora di Nardo in the year 1375.'[28] Originally in the church of Santa Maria della Neve in the village of San Donato, the panels are now in the baptistry of the parish church of San Donato, and are quite large, with the tall centre panel measuring over 5 feet high. The painter has represented Madonna Tora – presumably Theodora – as kneeling slightly to the left of centre at the base of the panel and facing up towards the right in order to look up at Christ and Louis of Toulouse. She is shown underneath the figures of Mary and Antony to our left, as if under their protection. The painter has ingeniously focused our eye on the diminutive figure of Madonna Tora by arranging the staffs of her patron saints so that they cross over her head. Perhaps this cross, made by the Tau cross staff held by one of the founders of monasticism, Antony, and the episcopal staff of Louis of Toulouse, refers up to the cross of Christ as Saviour above them. The painter has clearly represented the hierarchy of the suppliant, her advocates and her judge, yet unified the three levels in a satisfactory way. The world of Christ and Mary is the most richly adorned, with

angels' heads depicted round the arch above their heads, and the illusion that they are dressed in brocade robes. The intermediary world of the saints is represented as partly austere in the clothing of Antony, the hermit of the desert, but Louis wears a bishop's regalia. At the lowest level are the donatrix in a plain black cloak and white or grey veil, and the naked pig of Saint Antony. The divine figures are seated. The next in rank stand like courtiers below the throne, and the humble suppliant kneels at their feet. Only the pig is smaller or lower in the scale of the universe than the donatrix, yet her presence as the giver of the painting is made clear by the way her dark figure is outlined against the pale stone of the throne. The triptych is described as having belonged to the 'Oratorio o Compagnia di Santa Maria della Neve', and this would suggest it could have been a gift to the local confraternity chapel. The association of the Dominican Aquinas and the Franciscan Louis of Toulouse awaits explanation.

Renaissance conventions of realistically consistent figural sizes for all the persons represented in a picture space were adopted late by women patrons having themselves portrayed alone on an altar-panel. Possibly small self-portraits seemed decorous to women commissioners when feminine modesty was so consistently advised. This applied to relatively isolated areas like Fabriano as well as to the centres like Florence where the new perspectival and proportional theories were being most intensively explored, and where there could be no question of a woman being ignorant of the latest artistic developments.

An emphatically diminutive size was chosen by the Florentine patrician widow Donna Smeralda Nelli when she commissioned her altarpiece in about 1480 from Domenico di Michelino (Plate 42). This panel was dedicated to Saint Laurence, who is shown standing, while Smeralda, with a lined face, kneels to the left, wearing the white veil and dark dress associated with the female relict. Donna Smeralda had predella scenes painted to narrate key episodes in the life of Saint Laurence, placing his martyrdom at the centre, his ministry as deacon of the early Church when he was himself imprisoned to the right, and beneath her own figure, the story of Laurence visiting Purgatory. This scene represented the belief that because his martyrdom had taken place on Good Friday, he had the privilege of descending to Purgatory every Friday to redeem a soul.[29] (The choice of an altarpiece honouring one saint was, according to Kocks, quite common.) As the wife of Francesco Neroni, who was exiled for his part in the conspiracy of 1466 against the Medici, she had unusual independence, since her husband died some time between 1478 and 1483 in exile and she survived him by at least two years. (She was married in 1429 and probably born about 1415, so she may have been about 70 at her death.) Given the role of the exile's wife, she may well have initiated the commission before she was widowed,

146

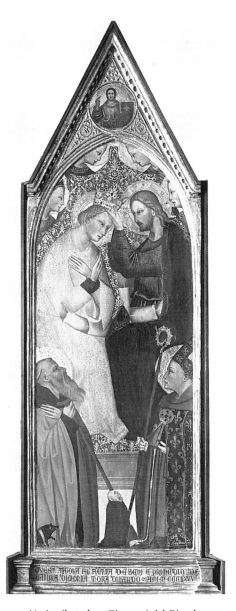

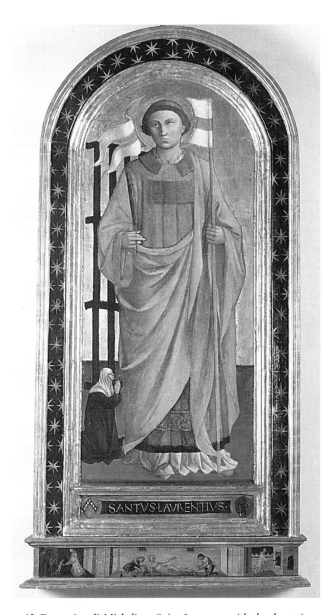

41 Attributed to Giovanni del Biondo,
*Coronation of the Virgin with Saints Antony
Abbot and Louis of Toulouse with the
donatrix Donna Tora di Nardo*, 1375, panel,
159 × 51.5 cm., San Donato in Poggio,
near Tavarnelle, Val di Pesa.

42 Domenico di Michelino, *Saint Laurence with the donatrix
Smeralda Nelli*, 1483, panel, San Lorenzo, Porciano.

with his spiritual needs in mind as well as her own. As identified by Annamaria Bernacchioni, the arms to the left on the altar-panel frame are those of his family – the Neroni – while those to the right are her family's.[30] Donna Smeralda could have been representing her views on her husband's treatment both in her choice of dedication and her location of their funerary altar. The family chapels of her and his family were at San Lorenzo, the parish church of the Medici. But understandably Donna Smeralda had transferred her allegiance to another church – the Badia in Florence – by at least 1477, when she is recorded as having given a large sum of money for a silver cross made by Antonio Pollaiuolo for the sacristy. Since she asked to be buried at the Badia, and the provenance of the altarpiece is this church, it seems likely that she founded a new chapel there. The dedication to Saint Laurence would recall the parish from which she had been driven, and indeed bring him to her new place of worship, while the predella scenes had resonances concerning the mercifulness of Saint Laurence to those who have been cast out and are being punished. Donna Smeralda was a well-connected woman in social terms, with one brother-in-law who was Bishop of Volterra and another – Dietisalvi Neroni – who was *Gonfaloniere* (a chief standard-bearer). The altarpiece seems to be something of a defence of the honour of her husband, since she put her husband's heraldry in the privileged position to the left and made veiled references to the plight of those who have been shut out or shut away in the predella themes.

About a decade later a similar-scale portrayal was still being made – for Oradea Becchetti of Fabriano. In 1491 the Venetian artist Carlo Crivelli inscribed an altarpiece commissioned by Oradea for her chapel dedicated to Santa Maria della Consolazione in her local church of San Francesco (Plate 43).[31] This altarpiece showed the Virgin and Child enthroned between Saints Francis – as patron saint of the church – and Sebastian – a saint often invoked against plague – with the kneeling Oradea sheltering at the feet of Francis. Oradea is depicted as veiled, as wearing black and holding rosary beads as if to represent her prayers. Like Donna Maria, Donna Smeralda and Bona Maria, she took the position of honour to the left. Whereas the inscription for the panel of Madonna Muccia had been painted as if written along the base of the Virgin's throne, Crivelli has painted the statement of Oradea's intentions as if the words were chiselled on the edge of the pavement on which the figures stand. Her aims are incisively put: 'Oradea of Giovanni dedicated this in compassion for her forebears and descendants, with not a little of her own money, to bountiful Mary, source of all consolation.'[32] In this way Oradea spoke to those who came after her, reminding them of her generosity on behalf of their spiritual welfare, so that while the small portrait represented the desire for her personal salvation, her inscription stressed her bountifulness to her family.[33] Some of

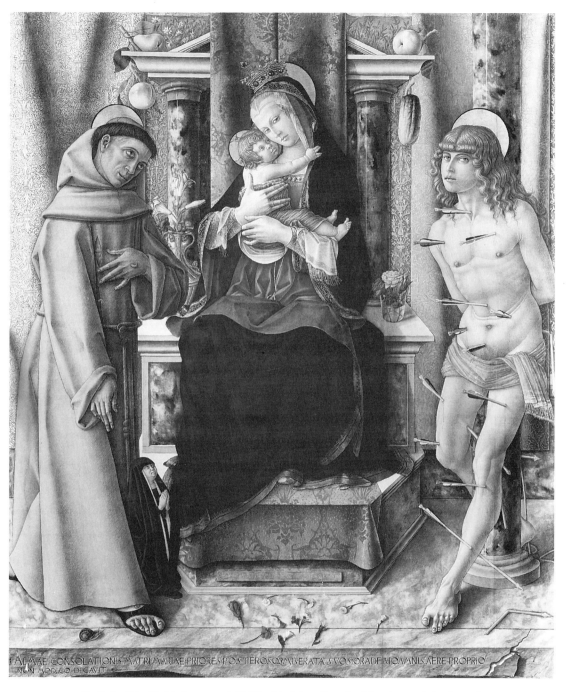

43 Carlo Crivelli, *Madonna and Child with Saints Francis, Sebastian and the donatrix Oradea Becchetti*, 1491, panel, 175 × 151 cm. Reproduced by courtesy of the Trustees of the National Gallery, London.

the detailing in the painting may be intended to represent the qualities of the Virgin. The fruit and vegetables on the throne could show the fruitfulness of the Virgin's womb ('Blessed is the fruit of thy womb, Mary'). The snail prominently painted at the feet of Saint Francis seems to be a sign of virgin birth, since in the bestiaries the way the snail was supposed to be made pregnant by the dew or rain was given as proof of the way the Virgin Mary was impregnated through the action of the Holy Spirit.[34]

From the inventory of San Francesco dated 1637, we learn that her descendants would also have been able to use the lavish altar furnishings she commissioned for her family chapel. This inventory described her silver-gilt chalice adorned with three enamelled medallions, one of which showed the arms of the Becchetti family, another her name, 'Domina Oradea', while on the third medallion was the name of the guardian of the church: 'in the time of Fra Giacomo' (*in tempore Fratris Jacobi*). On the lid of the chalice were the words 'Jesus Ave Maria'.[35] Like Bona Maria Bovolini, Oradea Becchetti was intent on making a public gift to the townspeople of Fabriano. For beside the altar was a tablet stating the indulgences which she had obtained from the Legate of the Marches. The original grant survives in the archives at Fabriano, and offers an indulgence of 140 days for those who pray before the image on the feast-days which she had chosen to highlight in her altarpiece.[36] She had dedicated the altar with the title of the Blessed Mary of Consolation, and selected as feasts for honour those of Christ and Mary and also those of Peter and Paul (for Fabriano was under papal dominion), those of John the Baptist (possibly for Giovanni, her husband), of Francis (as patron of the church) and Sebastian (perhaps indicating that he was her patron). The position of her altar was a prominent one, immediately to the right of the high altar in the apse of the church, and the church itself was in the centre of the city. Such a project may have been a way for a woman to encourage a particular regime of prayer in a manner which imitates the exhortatory and instructional powers of the clergy. The grant itself addressed her as 'Venerable Oradea of Giovanni Becchetti'.

Where the handbooks of conduct advised widows not to draw attention to themselves, let alone in the public arena, these votive self-portraits rather surprisingly often seem to have had an eye to an audience outside the woman's family. Thus Donna Elena intended her panel to be used by a congregation with its company of saints, Donna Maria de' Bovolini expected the prayers of her fellow-citizens in gratitude for the magnificent image she was providing for them to share, Donna Oradea offered indulgences to all according to a programme she had selected, Donna Tora probably endowed a confraternity and Donna Smeralda made not very guarded statements in defence of a husband who had been exiled. Even though these self-portraits were modest in size, they did guide

the viewer to worship the spiritual figures revered by the donatrix, by means of the poses and appearance of the widow herself. However, the eventual adoption of realistically-sized self-portraits by donatrixes, to which we now turn, were associated with enhanced opportunities for the widow, not only in having how they felt conveyed, but also in conducting viewers round their pictures and in establishing a new rapport with the spectator.

Realistically-sized funerary portraits

Previous to the 1480s there is only tenuous evidence of the existence of realistically-sized donatrix portraits. In contrast, it was quite common for male patrons to order realistically-proportioned effigies of themselves and their spouses from the 1430s onwards, and they were also often shown full-length. When women commissioners did begin to follow Renaissance principles for the correct depiction of scale, however, they did not often show themselves full-figure. Indeed, I have found only three instances of a widow having a painted portrait of herself full-size and full-length (Plates 18, 47–8). Instead, they imitated a format invented for donors a little earlier, of a votive portrait showing only head or head and shoulders, as if the frame of the altarpiece cut off from our view the rest of the figure standing or kneeling on a floor level beneath the holy figures she honoured. It was also rare for a widow to be portrayed as a result of her own commission on a sculpted tomb. Again, I can cite only three instances of this occurring. All of them showed the women as full-length, full-size effigies, alluding to the body interred beneath the relief (Plates 12, 44–5).

Presumably a few widows did commission full-length effigies for their tombs, like the carved floor slab of realistic size ordered by Donna Lucretia, widow of Giacomo Andreotti, for her burial-place at Santi Simeone e Giuda in Rome (Plate 44). This is now to be seen in the portico of San Silvestro in Capite, Rome. As explained in the inscription running around the full-length portrayal, she commissioned it during her lifetime in 1484. The effigy employed veristic effects and emphasised wrinkles and folds of sagging flesh. She had herself represented as wearing a mantle over a scoop-neck dress, and with her arms crossed over her stomach. The inscription begins over her head: 'Lucretia, relict of Giacomo Andreotti, placed this for herself, while she was living, in the year of salvation 1484.'[37] Such veristic floor-monuments of women were being made for male commissioners from the early fifteenth century onwards to commemorate women who were from the families of lawyers and of wealthy merchants, such as Bettina di Giovanni d'Andrea of Padua in 1370.[38] The

example in Rome discussed here is joined by the tomb memorial chosen by Sibilia Cetto during her widowhood as a memorial for herself and her husband on the chancel floor of the church of San Francesco in Padua (see Chapter 2 and Plate 10).

It seems likely that it was a mark of even higher status for a woman to commission a full-size effigy of herself or a female relative to be placed on the side of a tomb chest – raised off the floor. Such a monument does survive, for instance, in San Lorenzo in Naples, commissioned by Cecilia, who was from the Ursini family of Rome and was wife of the Neapolitan patrician Aurelio Pignone (Plate 45). Perhaps the fact that she came from a line of marquises and counts on her father's side enabled her to claim such a mark of status. The inscription accompanying her effigy announces, just as with Lucretia Andreotti, that she put up the monument while she was still living. She added that she did it as a token of the human condition ('humanae conditionis memor').[39] Although no date of her death has been inscribed, the effigy is placed on the side of a tomb chest which acts as the support for the tomb of her son who, the inscription tells us, died aged 14, and which was installed by Cecilia and her husband in 1548. The effigy of this teenager dwells on blighted promise through the motifs of the empty gauntlet on which the boy's hand rests and the empty helmet beneath his head.

Following the death of her husband, Cecilia Ursini seems to have reorganised the monument to her son. She inserted a burial-place for herself beneath his tomb chest and had an image made of her body, wearing a Franciscan habit, presumably in imitation of the dress of her cadaver within the chest. The exquisitely subtle style of carving adopted for her effigy relates it to the workshop of Merliano – one of the most sought-after sculptors of the period in Naples.[40] She had her coffin adorned with the united arms of herself and her husband placed together on a single shield on either side. With great delicacy the sculptor represented the mother and wife who waits devoutly to be reunited with her dead son and husband, perhaps actually living as a Franciscan tertiary associated with the Franciscan community who looked after the church of San Lorenzo. Her large right hand holds a book placed directly over her sex, while her left arm is bent so as to prop up her head in a way which recalls the pose favoured for dead Neapolitan noblemen, and indeed that used for her son above. Donna Cecilia fitted her valedictory commission into her husband's family chapel – the Cappella Pignone – taking the lowliest position on the left-hand wall opposite the tomb which her husband had made for his father in 1516. Tombs with a husband's effigy on the lid of the tomb and the wife's subordinated below in low relief on the side were quite common for the commemoration of Neapolitan patrician couples from the fifteenth century onwards, but

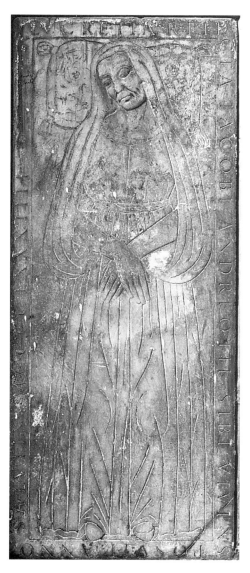

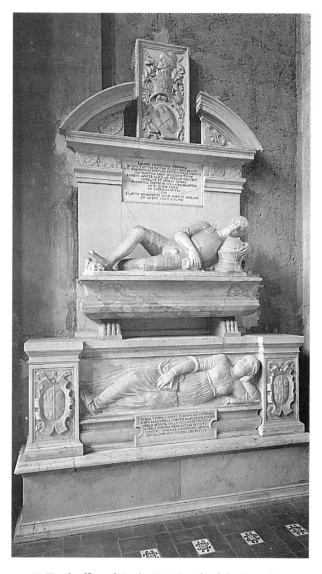

44 Tomb slab of Donna Lucretia, widow of Giacomo Andreotti, 1484, San Silvestro in Capite, Rome.

45 Tomb effigy of Cecilia Ursini, wife of the Neapolitan patrician Aurelio Pignone, *c.* 1549–61, Cappella della famiglia Pignone, San Lorenzo Maggiore, Naples.

no examples are inscribed as having been commissioned by the widow. As the chapel had passed into the control of Pietro Pignone by 1561, it seems that the tomb of Donna Cecilia would have been made in the 1550s.[41]

No widows seem to have considered themselves worthy to be commemorated with an effigy laid along the summit of a tomb chest attached to a wall,

of the sort that they had made for their husbands, and none commissioned free-standing tombs with effigies of themselves. These forms of tombs seem to have been reserved for men who had, or might have, been distinguished in civic, military or ecclesiastical office. Only women of exceptional spiritual distinction (see Chapter 9) were accorded such wall monuments. Sculpted effigies were rarely commissioned by widows for themselves, and even then widows bought only modest portrayals, placed on or near the ground, in low relief, not high, and never of bronze. However, widows were slightly more relaxed about having painted portraits of themselves.

The earliest of these realistically-sized portrait-busts made for a female commissioner was that by Francesco Buonsignori, a Veronese painter. The truncated portrait appears on an altarpiece made for Donna Altabella Avogaro in her funerary chapel at San Fermo Maggiore, Verona. It is signed by Francesco Buonsignori and dated 1484 on a *cartellino* on the front of the Virgin's throne (Plate 46).[42] Like the majority of votive images, it depicts the Madonna and Child enthroned with attendant saints. Following the male precedent identified by Chastel, the votive portrait of Altabella Avogaro is placed at the centre base in profile, and she is shown head-and-shoulders, with her praying hands raised to the level of her chin. She looks to the right towards Saint Christopher, who is standing in front of a bishop saint. To our left are Saints Onuphrius and Jerome. Presumably one of the saints in the foreground was intended to stand for the advocate of her husband, Donato dal Bovo, but it is not clear which, for Altabella is portrayed below the praying hands of Onuphrius, yet she looks in the direction of Christopher. The original frame has survived and shows on its base her husband's arms to the left and those of her natal family to the right. Perhaps this indicates that her husband's patron is to the left, and therefore Onuphrius. On the top corners of this frame appear the Virgin and Gabriel, to represent the Annunciation.[43] According to Biancolini, reporting in the eighteenth century, the panel was positioned in the chapel second from the right as one entered San Fermo Maggiore. This bay has at present an elaborate sculpted and painted frame which probably dates from the late fifteenth century and would indicate a lavish setting for the austere painting commissioned to be its centrepiece.[44]

Altabella had herself portrayed as if standing or kneeling just behind the pictured window-frame of her altarpiece. Her painter has presented her as demonstrating her own devotion to Saint Christopher, as well as suggesting that we pray for her soul. Unusually for a woman in an image, she guides the spectator as to what to look at, and acts as a visual stepping-stone into the divine and contemplative space of the picture. Both Saint Jerome and the Christ child who is held on the shoulders of Saint Christopher look out to make eye

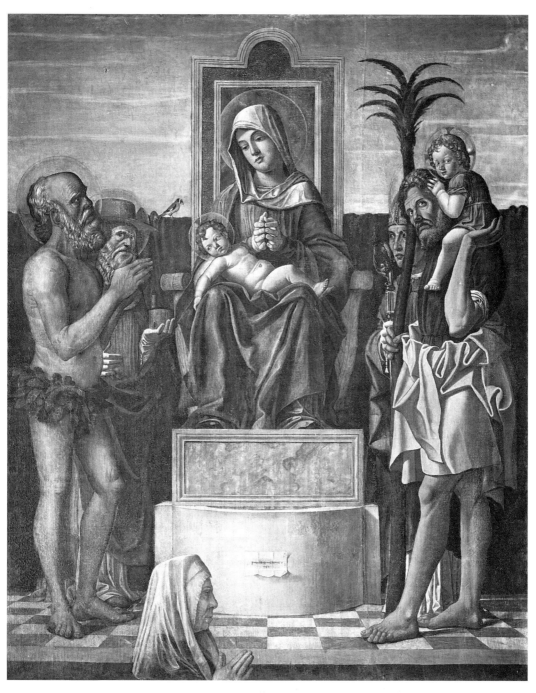

46 Francesco Buonsignori, *Virgin and Child with saints and the donatrix Altabella Avogaro, widow of Donato dal Bovo*, 1484, canvas, 206 × 174 cm., in original frame, Museo Civico, Verona.

155

contact with the viewer. The painter has been careful to show Altabella as below the level of the enthroned Virgin. However, she has been placed centrally over the altar where the host would be put, and therefore in symbolically powerful proximity to the rites of the priest, whose duties in saying and singing funerary masses she would have paid for at her altar. In this way the patron could make herself present after death to her priest. Altabella had herself portrayed wearing her widow's veil and with an apparently unflinching verism, which emphasises her thin lips, the folds of flesh under her eyes and chin and the craggy profile of age. For a woman called *Altabella* (which means 'superlative beauty' in Italian) such merciless demonstration of her physical deterioration could have had special emphasis in proclaiming her rejection of worldly vanity and her hopes of spiritual improvement. Although nothing is known of her family origins, the word *Avogaro* means 'a legal advocate'.

During the first half of the sixteenth century we can cite two women – the widow of a *condottiere* and the widow of a Paduan doctor of medicine – who felt able to take more picture space than Altabella and who commissioned full-size votive portraits showing their whole body. (One further woman was accorded the honour in about 1559 of a full-size, full-length donatrix portrait in recognition of her endowment of the monastery of Porziuncula; she was Donna Finalteria da Bevagna, discussed in Chapter 4.) The widow of the *condottiere* was of high rank, for her husband had been awarded the two territories of Pordenone and Alviano, and after his death she ruled them as countess during the minority of her son, between 1515 and 1529. These territories were far-flung, since Alviano is in the province of Terni, south of Orvieto, and had been granted to her husband in 1503 by the Pope, while he had received Pordenone – north-east of Venice – in 1508, after he had conquered it. Penthesilea Baglioni's husband was Bartolomeo d'Alviano – a *condottiere* who had been made Captain-General of the Venetian forces in 1513.[45] She was the sister of Giovanni Paolo Baglioni, who fought beside Bartolomeo, and had married in 1495. She had therefore been his wife for twenty years at his death in 1515. Since Bartolomeo died intestate and left one son aged 1 and three older daughters, she had much responsibilty as a widow, which she seems to to have shouldered with acumen. Since he was intestate, it was her choice to bury her husband in Venice, and she placed his body over the door of Santo Stefano in that city – presumably to keep the memory of his heroism in fighting the Austrians alive in the hearts of the Venetians. Between 1515 and 1517 she returned to Alviano and launched a successful correspondence campaign to get a pension for herself from the Venetians, as well as dowries for her daughters.

In the church of Santi Pietro e Paolo at Alviano, in the second bay on the right as you enter, is a frescoed altarpiece, which is attributed to Pordenone

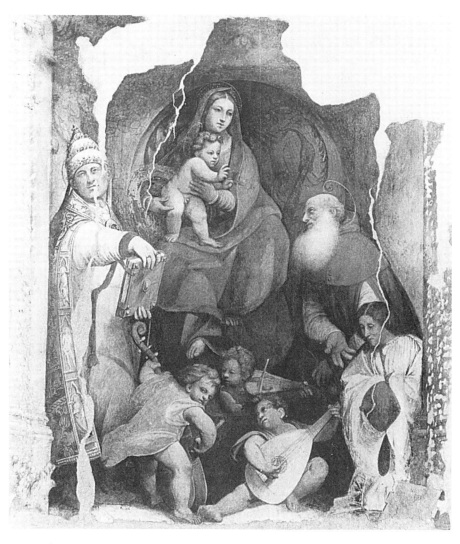

47 Pordenone, *Virgin and Child with saints and the donatrix Countess Penthesilea Baglioni,*
c. 1517, fresco, Santi Pietro e Paolo, Alviano.

(Plate 47).[46] He was an up-and-coming painter imported from Pordenone at a
considerable distance from Alviano, but which was the other territory over which
she had feudal control. He was in contact with her, according to the corres-
pondence documented between 1518 and 1526, in order to gain her favour.
Indeed, his patroness described him appreciatively as the painter 'whom we love'
(*quem diligimus*).[47] This altarpiece shows the Madonna and Child enthroned
with a saint to the left, identified as Pope by his triple tiara, and Saint Jerome
to the right. Jerome introduces the countess kneeling to receive the blessing of

157

the Christ child, while below his feet three boisterous putti saw and pluck away at a range of stringed instruments to make vigorous celestial music. The architectural setting which Pordenone has imagined is grand, with a coffered ceiling and Ionic columns and with a gilded mosaic apse decorated with peacocks and foliage behind the Madonna.

Penthesilea is portrayed as shrouded in a crimped white cloak over a grey dress, and she is differentiated from the brilliantly tinted holy figures through the drabness of her clothing, her lowly position and her apparent nearness to the spectator. It has been argued that stylistically the altarpiece was made quite early in Pordenone's career, and that he could have painted it in about 1520, following a visit to Rome, since the composition of the Virgin and Child appears to be a variation on that by Raphael then on the high altar at Santa Maria in Aracoeli. Penthesilea was, according to her letters to the Doge, penniless and in no position to commission anything between 1515 and 1517.

As analysed by Giordana Benazzi, the restoration examination of the fresco suggests that the painter made the portrait of Penthesilea from life. The fresco was made in five sections, corresponding to five days' work. All figures show the incision marks impressed into the wet plaster when the designs which had been prepared beforehand on the cartoon drawings were transferred to the fresco surface, except for the figure of the donatrix. It therefore seems likely that Penthesilea knelt for her portrait by her mural to be painted in a single day.[48] Penthesilea probably married as a teenager, so she would have been in her mid-thirties when her husband died, and possibly around 40 at the time when she commissioned the altarpiece, around 1520. The identity of the papal saint is an open question. Following the change of dedication of the church to Saints Peter and Paul, we might expect Saint Peter to be shown, although his attribute of keys is not present. A possibility suggested by Benazzi is that he is Saint Sylvester, a pope who was patron saint of the local monastery of Alviano, San Silvestro.

Despite Penthesilea's modestly downcast gaze, her decision to have herself shown full-size and full-length, albeit kneeling, was a bold one. There might have been a princely parallel for this in the altarpiece in Mantua made about 1519 showing the *Veneration of Beata Osanna*, which is thought to have represented Isabella d'Este as widow, and which shows the woman full-size, full-length and kneeling.[49] Penthesilea may perhaps have considered her status high enough to imitate the example of a marchioness. However, the second example I consider was made for a widow of lower rank, being the wife of a doctor of medicine in Padua.

The full-length portrait of Donna Lucrezia del Min of Padua is on a funerary altarpiece she commissioned for herself, her parents, her first husband and her daughter at Sant'Agostino in Padua. Some time between 1529 and

1531 she commissioned an altarpiece of the *Adoration of the Shepherds* for her chapel, which was situated on the entrance wall to the left as you entered the important Dominican church (demolished by the Austrians in 1819).[50] While earlier critics considered this painting to be by Domenico Campagnuola, the latest attribution by Caterina Furlan has been to Stefano dall'Arzere (Plate 48). She also argued that the altarpiece was inspired by an *Adoration of the Shepherds* painted by Titian about 1532–33.[51] However, such a date seems untenable, given the statements in two of Lucrezia's early wills to which Furlan did not refer. In Lucrezia's will of 1532 she already spoke of having had the chapel made, making none of the usual stipulations that her heirs should complete the altar-panel.[52] The 1534 testament repeated the statement, and emphasised that the dedication of her chapel was to the Nativity.[53]

The large panel shows the Adoration of the Shepherds, with a realistically-sized portrait of the donatrix in the foreground kneeling slightly to the left, as if adoring the new-born child with the humble shepherds and Joseph. Like Altabella Avogaro, Donna Lucrezia seems to have asked the painter to portray her without idealising away the signs of middle age, for she is depicted with a lined face, the beginnings of a dowager's hump, narrow lips and a sagging chin. She is portrayed in plain clothes, wearing a black dress with padded sleeves and a plain white camisole beneath. She displays her right hand with her wedding ring, while a white snood covers her hair almost entirely. Lucrezia's austere dress and rigid profile contrasts with the lively *contrapposto* and brightly coloured clothing of the divine world she contemplates. This black and white dress would have matched the robes of the Dominicans whose church this was. The atmosphere is of total concentration on the birth of the Saviour, since all eyes are fixed on the Christ child. The painter provided the illusion of a wide landscape vista to our right, containing the announcement of the Angel Gabriel, while to the left appears a massive column and broken arch beside the humble stable – a familiar convention, setting the scene in Roman Imperial times and perhaps suggesting the crumbling of paganism before the victory of Christianity. Over the stable float cherubs raining down olive-branches and roses to signify the peace granted to all men of good will at Christ's birth. In the foreground, close to the spectator, are the spring flowers – wood anemones, cyclamen and violets – with their hopeful promise, and in the centre are a pair of birds with red beaks and legs, grey bodies and white throats. This painting was installed in a white marble frame consisting of two fluted and gilded columns supporting an entablature with a frieze of black stone on which were carved the words 'Gloria in excelsis deo' ('Glory to God in the heavens'), to match the inscription painted on the scroll brought down by Gabriel to the shepherds, 'Adnuntio vobis gaudium magnum' ('I bring news to you of great joy').

159

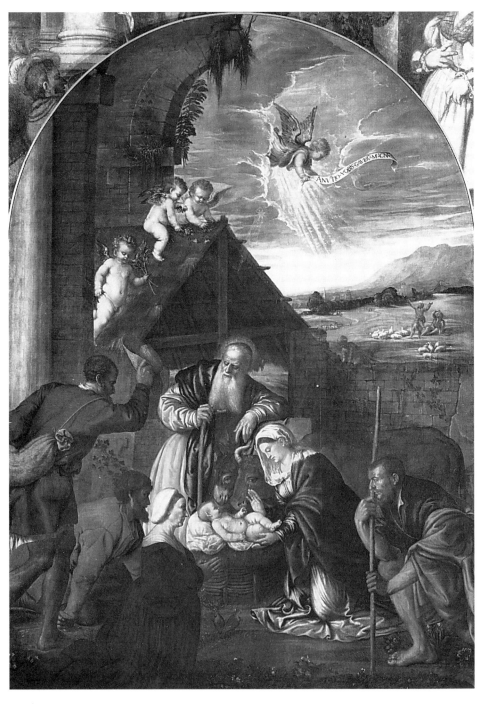

48 Attributed to Stefano dall'Arzere, *Adoration of the Shepherds, with the donatrix Donna Lucrezia del Min*, 320 × 230 cm., canvas, *c.* 1529 – *c.* 1531, Museo Civico, Padua.

Donna Lucrezia was the daughter of the Paduan jurist Stefano del Min, and her first husband was Vincenzo Moschetta, a doctor of medicine and a well-known orator, who died in 1529. She had already planned a chapel, since the obituary at Sant'Agostino recorded that she had constructed an altar dedicated to the Nativity of Christ in 1526 and had endowed it with 15 ducats a year for funerary masses.[54] It seems likely that the project to found the chapel was prompted by the death of her parents, and perhaps furthered by the death of her daughter Cassandra. According to the sixteenth-century accounts of the appearance of her chapel, Lucrezia had an epitaph carved for her husband in Greek and Latin on the family tomb which was situated on the floor before the altar: 'Vincenzo the famous practitioner of the Apollonian arts who is buried [here] carried along with him to the river Styx the healing remedies (what a misfortune). The god who rules over the sombre court was jealous of those living on earth. Alas, the wretched condition of mankind.'[55]

Although it seems likely that the mason made some slight mistake in the Greek, this is nevertheless the first time we have come across a female commissioner of a lower status than that of the relative of a ruler paying for a display of such erudition. (Obviously the Marchionness Isabella d'Este had achieved this earlier with her Mantegna commissions.) Presumably one of Vincenzo's erudite colleagues composed this verse with its sentiment of loss for such a skilled doctor and its mythological allusion to the god of the underworld, Pluto, who, wanting the benefit of Vincenzo's medicines for himself, has taken the good doctor from this upper world. As if in counterweight to the arch image of her husband as medical expert in hell, Lucrezia had herself portrayed above the epitaph in unimpeachably orthodox veneration of the birth of Christ.

There is no evidence that Lucrezia commemorated her husband with an effigy, so that the decision to have herself portrayed full-length was not balanced by any portrait of her spouse. That Lucrezia del Min had herself represented in this way, where others hid partly behind the frame, suggests that she was perhaps unusual in other ways. There is a sense of her erudite contacts, given the subtle classical allusions in the epitaph. She also showed a rare confidence in her own legal knowledge and command of the vernacular in writing her own wills from 1534 onwards. That she owned books is revealed in her will of 1538, in which she bequeathed them to her second husband.[56] She seems to have valued the feminine too, in the way she made careful provisions in her 1534 will, ensuring that her only granddaughter Cassandra could receive all her grandmother's household effects by succession through her daughter Laura (mother of this Cassandra), which were on no account to be absorbed into the household of Lucrezia's son-in-law and perhaps be lost to his relatives.

In her will of 1534 she wrote that she wished to be buried 'in our sepulchre along with my dearest husband and my sweetest little daughter Cassandra'. She endowed the chapel for a daily mass for herself and for the souls of all her dead, naming especially her mother, her father, Vincenzo and her own daughter Cassandra. It is clear that she was particularly close to a group of Dominican tertiaries (she calls them *pinzochere*) since she gave each of her sisters in the order money to pray for her and to accompany her corpse to the church of Sant'Agostino.[57] In 1537 she was married again, this time to a Venetian doctor of law, Angelo Alessandri, and consequently made another will in 1538. Whereas the 1532 will was written by the notary in Latin, the other wills were composed by Lucrezia herself and written in Italian. As the original of the 1538 testament displays, she used a rounded humanist hand. These wills seem to swing into the first person ('of my will of all that I desire') with gusto, after the reported speech of the notary.[58] Each testament runs to about 5,000 words in length and suggests how well the intelligent daughter of a lawyer could have learned to conduct her affairs. In her 1538 will she wrote that she wished to be buried 'in my chapel made and endowed by me'. And in this will she provided a fervent preamble: 'Before all, I recommend my soul to my maker who has created us in His own image and similitude, whose goodness and mercy are incomprehensible, and to His most glorious mother the Virgin Mary, and to my most lucid mirror of penitence Saint Jerome, and to all the saints.'[59]

Her possession of books is documented in her bequest of them to her second husband. After having given all her movable goods to her granddaughter, Lucrezia kept back one of her two large beds and half the bed-linen for him, as well as excepting the books which she left to him, 'in token of my love and that he may have a memento of me'. For Lucrezia, the books seem to have been highly personal to her, and to have been tokens of love.[60]

In her 1534 will she stated that her household effects were to go to her daughter Laura, and an inventory was to be made so that Laura could in her turn will the goods to *her* daughter Cassandra.[61] Lucrezia stipulated that a very detailed inventory would have to be taken following her death, and that if Laura's husband, her son-in-law, refused to allow the inventory, the nuns of San Prosdocimo would store everything until Cassandra was old enough (Lucrezia termed this her *età perfecta*, that is, her majority) to possess her inheritance. It seems likely that this granddaughter was named after Lucrezia's dead child.

Lucrezia's steady piety is evident in her request in her 1538 will to be buried in the Dominican habit, as is her readiness for death, since she explained where the habit was kept, along with her apostolic concessions of plenary absolution, the candles for the death chamber, and all the things necessary for her last journey. She ended with an invocation to 'the Virgin and Saint Jerome my

protector'.[62] Although, in practice, women of child-bearing age were often urged to marry to make useful alliances for the patriarchy, in spiritual advice handed out by male moralists, especially the more theologically minded, women were advised to stay loyal to the memory of one man. Moralists like Saint Jerome had advised that the most chaste and honourable thing was to marry once, and remain a widow, rather than becoming a pawn of male dynastic ambitions.[63] In his treatise the *Libro della vita viduale,* for instance, Savonarola quoted the choice of the Prophet Hannah not to take a second husband.[64] The Venetian Lodovico Dolce, in his treatise on the government of ladies written about 1550, even provided a bestiary of animal exemplars to the widow of faithfulness to the one mate, citing the loyalty of the pigeon and the turtle-dove to one partner.[65] While Donna Lucrezia did eventually remarry, the pair of birds which are featured so prominently in the centre foreground of her painting may have signified her earlier intention to remain a widow. Archival research suggests something of the qualities of a woman who could order one of the few full-length votive self-portraits for a woman of lesser rank: her education, in loving books and writing her wills; her value of the feminine, in her love of her dead daughter and her care for her granddaughter; her piety; and her self-confidence in possessing wealth in her own right.

Although also rare, the truncated portrait of a donatrix was more common, and was used for instance by Donna Giulia Muzzarelli of Ferrara in the altarpiece she commissioned from Girolamo da Carpi showing the Assumption (Plate 49). Donna Giulia's altar-panel exemplifies the way realistic skills in depicting facial expression and the subtle effects of lighting and landscape could represent the donatrix's beliefs and hopes. The painter was working for the Prior of the new church of San Francesco at Ferrara during the period 1526–9 to make a grand decoration representing the apostles on a frieze around the interior of the nave and decorating the dome over the high altar. It therefore seems possible that this commission was made soon after this period, and that Donna Giulia's altarpiece could have been viewed in connection with the overall scheme above.[66] The altarpiece shows the donatrix with widow's veil in a head-and-shoulders portrait, positioned base left. She appears gazing raptly up to the Virgin, in the pose used for the personification of Hope, and holding a rosary. Her pointing fingers indicate the figure of Saint Thomas, who is receiving the girdle which the Virgin had, according to legend, thrown down from heaven to prove her assumption to the doubting apostle. Saint Thomas is represented on a small scale, as if far away in the wild landscape, though he takes the central position in the visual field. To the right, as if in the background, is a hill-town, painted as if lit by low shafts of sunset or sunrise which pick out the details of a fortified gate. The Virgin is lifted into the heavens by angels,

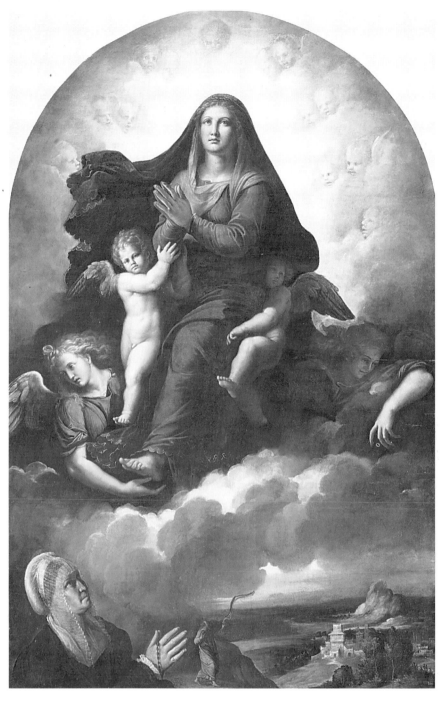

49 Girolamo da Carpi, *Virgin in Glory throwing her girdle to Saint Thomas*, 1530–40, panel, 199 × 131 cm., National Gallery, Washington.

one of whom looks out at the spectator. The Virgin herself gazes upwards with her hands joined in prayer, like the donatrix, as if to plead for her protégée. The altar-panel was admired by Vasari, who stated that the commissioner was Donna Giulia Muzzarelli, but was removed early in the 1570s by Cardinal Luigi d'Este when Ferrara became a Papal State. At this point a copy of the altarpiece was made by Scarsellino, which is still in the church. Serafini described the original location as 'a little chapel now adapted as a cupboard beneath the organ to the right of the high altar'.[67] In this position it could logically receive light from the left where the high altar stood at the liturgical east end of the church.

In comparison with the first truncated votive portrait – of Altabella Avogaro, made in the 1480s – Girolamo da Carpi gave Giulia Muzzarelli something new in the sense of offering a woman a portrait caught as if in a tempestuous vision of belief and hope, happening in a instant of specific lighting and weather. Where the writers of handbooks on the conduct of the widow pictured her normally housebound and performing everything, even her devotions, in a moderate way, this woman's personal faith is represented as entailing exalted possibilities of spiritual excitement, in a world beyond the ordinary confines of domestic and city walls.

The realistically-sized portraits we have looked at so far have all concentrated entirely on the one woman. However, votive portraits for a woman patron could be made in conjunction with another for a male relative. Thus Donna Antonia, daughter of Bartolomeo da Urbino, had a painted votive portrait-bust of herself made which she placed in a funerary chapel beside a sculpted bust of her father which she had commissioned earlier. The portraits of daughter and father now appear on the family monument in the bay immediately to the right on the transept wall as one views the high altar of San Francesco in Padua. The altarpiece is dated 1565 and was inscribed by the painter Paolo Pino in the *cartellino* centre base: 'Paolus Pinus Venetianus P[inxit] MDLXV'. The marble image of Bartolomeo, by a so far unidentified sculptor, was made soon after her father's death in 1528: 'To Dominus Bartolomeo of Urbino, nobleman of Padua, who with highest praise was for a long time teacher of Canon and Civil Law, and who lived 65 years, 4 months and 20 [or 22] days, Antonia, daughter of the best and most deserving father, made this during her lifetime.'[68] It shows him in the robes of a lawyer with idiosyncratic features which suggest realism, though with the pupils of the eyes uncarved, in the manner of some Roman Republican and Imperial funerary busts, and with relatively unlined skin, suggesting a younger man than one who lived to 65, as stated in the inscription below. As Sandra Faccini points out, the church was a favoured burial-place for lawyers, since the associated hospital was under the patronage of the College of Jurists in Padua (see Chapter 2, p. 70).[69]

The funerary chapel commissioned by Donna Antonia was dedicated to her father's name-saint, and employed four Ionic columns supporting an entablature whose frieze is decorated with crisply incised bucrania and swags. This carries a canopy adorned with the arms of Bartolomeo da Urbino. The imposing structure, which makes a bold impression from the entrance of the church, shelters the altarpiece. The portrait-bust of Bartolomeo da Urbino has been attached to the right-hand wall of the chapel. Antonia's chapel seems to have been designed as a pendant to the funerary chapel of Bartolomeo Sanvito, 'arciprete di Barbarano', dated 1527, employing a similar design for the architectural framing, including a full-length effigy of the dead man kneeling in prayer, positioned on a ledge to the left of the altar table.[70] It seems possible therefore that the elements in Antonia's chapel were made in two stages, with the bust of her father being completed just after his death in 1528. A portrait-bust tailored for the present position in the 1560s would *not* have had the head turned slightly to the right and down, but rather up and to the left, so as to look at his own and his daughter's funerary altarpiece and towards the high altar and presbytery of the church. It seems likely, then, that in the 1560s the bust was integrated with some difficulty into Antonia's funerary chapel, to make an ensemble matching that of Sanvito.

Paolo Pino designed a composition for the altarpiece which placed Antonia base right, so that she is below her father's portrait-bust (Plate 50). The subject-matter chosen was the most common theme for a votive image in depicting the Virgin and Child enthroned in the centre, with four saints. To the left, in the foreground, she placed Saint Bartholomew, with the knife with which he was flayed, as the patron of her father and the saint to whom the altar was dedicated. Behind him she had painted Saint Antony of Padua holding a lily, as patron of the Franciscans who tended the church. Both he and the Christ child look out at the viewer. To the right she had the representations of Saint Joseph with his flowering staff and, behind him, a martyr-saint in Dominican dress, probably Peter Martyr. Below Saint Joseph, in the position so often taken by a donor or donatrix, in proximity to their advocate's robe, Donna Antonia is portrayed in a brown dress and a black cap. This may be a reference to the dress of the female Franciscan community of San Bernardino in Padua, in whose habit she requested she be buried in her will.[71]

When she composed her will in 1566, Donna Antonia da Urbino was living in her own house in the *contrada* of San Biagio. She stated that she had completed the altar and that she was in the act of finishing the tomb at its foot for her body to lie in. Should she die without completing it, her executors were instructed to see to its completion. As we would expect, she paid for her funerary masses, for prayers on behalf of her relatives, and slightly more

166

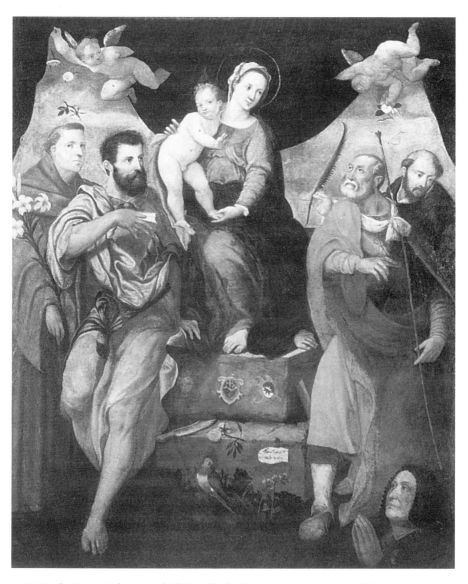

50 Paolo Pino, *Madonna and Child with the donatrix Donna Antonia di Bartolomeo da Urbino and Saints Antony of Padua, Bartholomew, Joseph and Peter Martyr*, 1565, canvas, San Francesco, Padua.

unusually, she willed a sum for a member of the community at San Francesco to go in the August following her death on pilgrimage to Assisi to collect an indulgence for her soul (see p. 188 for the Indulgence of the Perdono). Antonia had been married firstly to Don Raffaello Montagnana and secondly to Don Alessandro Capodivacca. Her daughter Justina was now dead but had had one

167

daughter, Samaritana, and it was this Samaritana, Antonia's granddaughter, who was named as universal heir. Samaritana was married to a member of the family of her grandmother's second husband, Don Gerolamo Capodivacca. Antonia made the Reverend Guardians of Sant'Antonio and San Francesco her executors.[72] These facts provide some clues as to why Donna Antonia placed the arms of the family of her first husband (the Montagnana) on the right, over her portrait, and those of her second husband (the Capodivacca) on the left. The arms in the centre, below the Virgin's foot, are those of the Franciscans who tended the church, and are found on the capitals of some of the columns. They consist of a cross and before it two linked arms, one naked and one in the Franciscan habit, to signify the charity of the order. Laura Sesler argued that Antonia wished to commemorate herself as the spouse of Raffaello Montagnana and Alessandro Capodivacca.[73] But perhaps such an unusual reference to two husbands could have been prompted rather by the way it tailored the altar for her heiress, Samaritana, descended from the Montagnana and wife of Gerolamo Capodivacca. In Salomonio's survey of the inscriptions in the church he recorded this inscription on the pavement in front of the altar of Saint Bartholomew: 'For her father Bartolomeo and for herself and her descendants, Antonia his daughter constructed this tomb as a resting-place until the dawning of the New Day.'[74]

Where Bartolomeo Sanvito, a cleric, had ordered an expensive sculpted altarpiece and a full-length effigy of himself, Donna Antonia commissioned the marble monument for her father, while she took the cheaper medium of oil on canvas and a truncated portrait of herself as donatrix. Recalling the legal connections of commissioners like Donna Lucrezia del Min and Sibilia Cetto, it may be surmised that this commission developed in another intellectually astute Paduan family, where the commissioner was the daughter of a teacher of law and her daughter Justina had married the Jurisconsulate Prosdocimo Placiola.[75] In these households, daughters may have helped their fathers and husbands by reading or acting as amanuenses, and have become well-informed through daily contact with educated and articulate men.

Most of the votive portraits considered were made for a mixed audience. The widows are shown more or less in profile, leading viewers to look at the persons they honoured. These expectations were overturned in the final example to be considered – the high altar commissioned by Donna Marietta Dandolo, between 1547 and 1556, from Domenico Campagnuola, for the choir of Sant'Agostino in Padua. While this image was probably visible at a distance to a general audience, it was most used by the Dominican friars seated in the choir surrounding it. It shows the donatrix, with eyes downcast, but turned so as to be visible full-face to this male audience. The portrait is of a kneeling woman, whose body is masked at the sides by her companions, and at the knees by a low hillock (Plate 51).

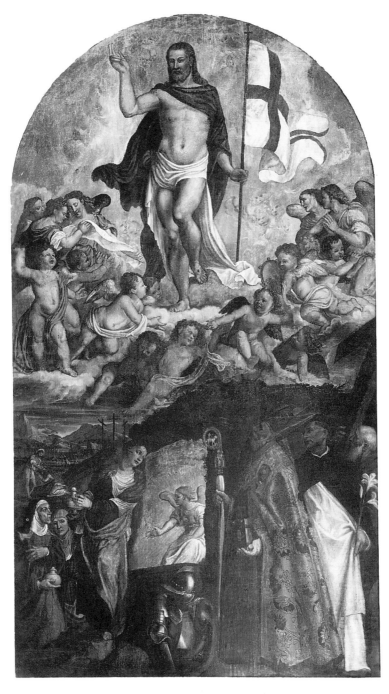

51 Domenico Campagnuola, the *Resurrection with Saint Mary Magdalene, a member of a sodality, the donatrix Donna Marietta Dandolo, and Saints Augustine, Dominic and Andrew*, c. 1550, canvas, 490 × 277 cm., Museo Civico, Padua.

The memorial written in 1596 by the Prior of Sant'Agostino at Padua stated that a certain Andrea Bragadin had benefited the community by funding choir stalls. However, the Prior, Vincenzo Moschetta, explained that the gifts of Andrea's wife, Donna Marietta Dandolo, had been more and greater ('plura et maiora'). She had lived on after her husband for a further seven years, from 1547 to 1554.[76] It was she who had restored the campanile when it was struck by lightning in 1550, and it was she who had paid for the high altar. Donna Marietta's spouse was a Venetian patrician with prestigious connections.[77] Perhaps his commitment to the choir stalls enabled her to make her contributions in a way that might not have been possible for a widow without the foothold obtained through her husband's initial involvement. But Marietta was also very well connected in her own right, having as brother-in-law Lorenzo Priuli, who became doge, and a brother who acted as ambassador for the Venetian Republic and the papacy, as well as being appointed *riformatore* of the University of Padua. She was the daughter of the Venetian patricians Niccolosa Loredan and Marco di Andrea Dandolo.[78] She was presumably childless.

Her high-altar commission was fully integrated into the choir-stall design, as recorded in a seventeenth-century drawing of the whole ensemble.[79] The altarpiece was framed in an elaborate aedicule of white stone, consisting of a tall base supporting Corinthian columns, which carried a triangular pediment. An inner frame of half-pilasters and capitals formed the setting for the arch-topped canvas, and the choir stalls, which were put in place in 1566, lapped up to the altarpiece on either side.[80] The subject of this votive picture was the Resurrected Christ, who was shown surrounded by angels against a radiant dawn sky of gold and pink in the upper half of the canvas. Below, the painter created the scene just before dawn when the Magdalene had come to the tomb of Christ and found it empty, guarded only by an angel while the Roman soldiers slept. The altarpiece emphasises that it was a woman who was the first witness that Christ had been resurrected. In the landscape, background left, the Magdalene is shown again, this time in her encounter with Christ in the garden of Gethsemane, when she at first failed to recognise him. The light streaks of sky over the mountains in the distance presage the sunrise of Easter Day, and link the lower with the upper world convincingly. The Magdalene is accompanied by two other women, and because of the way they move towards the empty tomb and the sense of sympathy which the painter suggests they are sharing with the Magdalene, it might seem at first sight that what we see are the three women who, according to Mark and Luke, found the tomb empty on the first Easter Sunday morning. According to the gospel of Saint Mark, these

women were Mary Magdalene, Mary the mother of James, and Mary Salome (Mark 16.1). According to the gospel of Luke, they were Mary Magdalene, Joanna and Mary the mother of James (Luke 24.10). However, according to Matthew (28.1) there were only two women who found the tomb empty, Mary Magdalene and the 'other Mary'; while for John, the Magdalene alone encountered the angel at the tomb (20.11), and it was his gospel which dwelt on the meeting of the Magdalene and Christ (John 20.14–18).

In the altarpiece the Magdalene is clearly identified, with a blue cloak and a red dress, wearing a white veil over her long, loose golden hair, and first to look into the brightly lit tomb-chamber at the centre base of the composition, where an angel is represented speaking with her. In the background left the Magdalene, in her pink dress, kneels to Christ in the garden. In the earliest description of the painting (the *Memorial* of 1586) Vincenzo Moschetta described both the companions of the Magdalene as 'portraits of the sodality'. Presumably he meant the members of the Dominican sodality or Dominican tertiaries associated with the church. He wrote that the high altar showed 'a Resurrection of Christ with Saints Augustine, Dominic, Andrew the Apostle, the Magdalene, and with images of the sodality – the work of Domenico Campagnola'.[81]

Given his report, only about thirty years after it was painted, and the gospel version of Saint John, it seems sensible to identify these figures as two devout women, rather than biblical companions of the Magdalene. However, they are not shown wearing the same clothing, as if members of a group of tertiaries. Both these women are represented as if behind and below the Magdalene. The one closest to the Magdalene is shown with her face turned to look up at her, and is carrying an ointment jar like hers. She wears a black crimped veil and a white wimple, which might be the appropriate headdress for a Dominican sodality. Since her red dress and blue cloak would be unseemly for a respectable woman, it may indicate her reverence for the Magdalene. Furthest back of the three women, and placed lower, we see a woman shown as facing the viewer, though with an unfocused gaze and reserved expression. She is shown wearing a buff veil and wimple with a white border, and a brown dress. This looks like the plain, undyed fabric recommended for tertiary groups. Since the woman in the yellow veil is wearing contemporary dress and is placed lower and further away from the sepulchre, it is suggested that she portrays the donatrix Marietta, even though she faces the spectator, which is unusual. The identity of the woman in the black crimped veil is a puzzle. She seems to be someone who honours the Magdalene and also someone whose devoutness the commissioner admired, but the strange combination of the red dress and blue cloak with the black veil awaits explanation.

171

To the right, three male saints look up to the resurrected Christ, who stares challengingly out at the viewer. They are the elaborately dressed Bishop and Doctor of the Church, Saint Augustine (to whom the church was dedicated) and Saint Dominic, in austere black and white, but holding the sweetly scented white lily (for the order tending the church), and far right, in red, with his cross of martyrdom, the apostle Andrew, for Marietta's husband, Andrea Bragadin. His position, furthest away on the right from the sepulchre, could match the placing of the portrait of his wife furthest from the Magdalene to the left. As her Christian name was Maria, Marietta could have embraced Mary Magdalene as her advocate. The dedication inscription on the facade of Sant'Agostino did not mention the Magdalene, though it did mention some other saints who were represented on the altarpiece. It stated that it had been founded by the commune of Padua in 1275 'in honour of Christ, his Blessed mother Mary, the Blessed Confessors Augustine, Dominic, John the Baptist and the Evangelist, Peter and Paul, Stephen and Peter Martyr and all the others whose altars it contained'.[82] Therefore the elements in the design whose inclusion the commissioner may have suggested comprise her own portrait, the representation of the second member of the sodality, and the images of Saints Mary Magdalene and Andrew.

The altarpiece was designed to make a splendid impact on the most important day in the church calendar, Easter Sunday, with its depiction of the sun of the first Easter Day. The composition not only placed emphasis on a woman as a leader in faith, but also gave the place of honour to humble members of a female sodality, whose arresting portraits draw the eye. While the male saints standing to the right have passive roles in the narrative, with their faces shown in near-profile, averted, and in shadow, it was the Magdalene and her female companions who were highlit as the more active participants, in varied and dramatically expressive poses, all three with their faces and bodies turned towards the viewer. According to this analysis, the altarpiece is a most unusual and innovative image. And yet, in practice, when we read the description of it by the Prior Vincenzo Moschetta, we notice that he still listed – and perhaps looked at – the males first and the females second (see p. 171).

Donna Marietta Dandolo had earned the respect of the Dominican monastery through her extensive generosity, and the obituary of Sant'Agostino recorded that 'the Magnificent Madonna Marietta Bragadin [*sic*], consort of the Magnificent Meser Andrea (now dead), at various times has given to our sacristy many good things, has restored the great crucifix, and has commissioned the tabernacle where we place the sacrament for communion'. It went on to list the other precious things she had provided to adorn the ceremonies at the high altar below her picture:

three surplices bordered with gold and the maniples and stoles to go with them; two large cloths, one furnished with a gold rim and the other of crimson silk; one chalice, valued at 30 ducats; one gilded pouch adorned with precious stones and pearls, valued at 50 ducats; a canopy of crimson satin with the Passion of Christ and four angels worked in gold thread and precious stones (that is, fine rubies), and with gold and silken tassels on its hangings; and a most beautiful altar-cloth for the high altar, and many other things.[83]

Prior Vincenzo Moschetta termed her 'a religious and famous woman'.[84] Desiderio del Legname, in his description of the church in 1561, when she was still alive, called her the 'venerable and pious Donna Marietta Dandolo'.[85] These epithets – 'magnificent', 'venerable' and 'famous' – were more customarily applied to the deeds of men, but were presumably earned through her lavish giving.

From these accounts it seems that Donna Marietta Dandolo was something of a stage-manager in providing for the richest visual effects at the great festivals of the church year enacted beneath her image. Like Donna Lucrezia del Min, she had herself portrayed as participating in the religious drama depicted in her votive image. Unlike Donna Lucrezia, she was portrayed full-face and for an audience mostly consisting of men. Nevertheless, she chose to be shown with a somewhat impassive expression, perhaps to indicate her solemn contemplation of the resurrection. Indeed, her downcast eyes suggest the suppressed gaze advised for women of standing in the few public spaces – like the church – which they were expected to occupy.

Votive portraits commissioned by women and men during the fourteenth century were usually diminutive in comparison with the size of the divine figures they thanked or sought help from. However, when new perspectival rules were developed from the 1420s onwards, male commissioners took the new full-size portraits as normal (whether for themselves or for portraits of themselves with their wives), but sole women commissioners did not do so for more than half a century. Furthermore, lone donatrixes did not take realistically-sized portraits until truncated donor images had been employed, for men, between the 1450s and the 1470s. It seems that for most widows, only the partial portrait could represent the retiring and modest mien fitting the position of the female relict. In only three cases so far noted – those of Penthesilea Baglioni, Lucrezia del Min and Finalteria da Bevagna, was the widow portrayed full-size as well as fully visible.

Another way of obeying Renaissance perspectival rules while retaining the humble size suited to a widow was to have her portrait painted as if in the background of the picture, some way away from the foreground group and therefore logically smaller than her holy companions, but it seems that this option

was rarely taken up. Conservation reports, for instance, relate that the altarpiece commissioned by Donna Briseide Colla from Antonio Correggio in 1523 contained just such a portrait, but cleaning campaigns have rendered this a mere shadow of a kneeling figure in the centre background (Plate 52). This altarpiece was for her funerary chapel in Sant'Antonio, Parma, and depicted the *Virgin and Child with Saints Jerome and Mary Magdalene*.[86] The composition interpreted the formulae of the votive image with unprecedented tenderness. Jerome and an angel companion to the left are shown with the codex and scroll of the Hebrew and Greek Bible whose translation into Latin he was responsible for, and which recorded the life of Christ and the prophecies of the coming of a saviour. Correggio raised the emotional and the sensuous tone of his image very high, depicting the Christ child in an animated pose, and using the convention of showing a patron saint touching the Virgin and Child, with the tender gesture of the Magdalene leaning to caress the baby's foot. With this gesture Correggio could also recall the events associating the Magdalene with her attribute – the jar of spikenard – which is held for her by her companion angel on the right. According to the New Testament, the Magdalene had washed the feet of Christ with a jar of expensive perfume, and after His crucifixion she had come to the tomb to help lay out the body with her jar of scented salve. Only the lion of Saint Jerome and the angel holding the Magdalene's jar look out at the spectator. Cecil Gould noted 'traces of a small kneeling figure in the middle distance between the Virgin's face and the angel's wing', which could have represented the donatrix Donna Briseide.

Donatrixes – like donors – had their hopes for advocacy represented by painters depicting their diminutive effigies in close contact with the bodies or clothing of their saintly protectors. This comforting proximity tended to be forfeited, however, when widows took over the realistically-scaled but truncated portrait, because this convention assumed that the donor or donatrix was placed well in front of, and below, the level of the holy figures they contemplated. The same formula applied to the use of the votive portrait seen as if in the distance, behind the holy figures. There were, nevertheless, some antidotes to these distancing conventions. One method of uniting the donatrix with the saintly persons she honoured is shown in the way Girolamo da Carpi used the potential of oil-painting techniques to represent specific weather and lighting conditions so as to give the impression of the donatrix Donna Giulia Muzzarelli being caught up in a vision of the Assumption (Plate 49). Another way of depicting the donatrix in intimate contact with the holy figures whose intercession she begged became available with the development of the half-length *sacra conversazione* in the circle of Mantegna and Bellini, in which all the figures are seen as if very close to the spectator, because we seem to see them from the

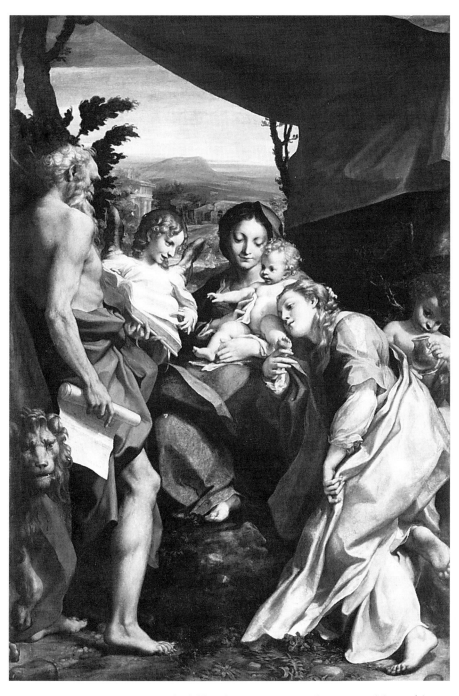

52 Antonio Correggio, *Virgin and Child with Saints Jerome and Mary Magdalene, perhaps
with the donatrix Donna Briseide Colla*, between 1523 and 1528, canvas, 205 × 141 cm.,
Galleria Nazionale, Parma.

waist upwards as we would do if we stood beside them, and also as very close to one another. There are some early sixteenth-century examples of such close-up *sacre conversazione* containing sole donatrixes – all from the Veneto, in terms of the attributions. However, none that I have found so far are inscribed.[87] In the rare cases when the donatrix was given a realistically-scaled portrait the whole of her figure could be shown in close proximity to her spiritual advocates (as in the images of Donna Penthesilea and Donna Lucrezia).

The intimacies of veneration which the donatrix had shared with the donor when the convention was still to represent the votive portrait on a reduced scale were not easily renegotiated in the new stylistic language of Renaissance art on behalf of the sole female patron. In addition, while some male votive portraits followed the devout mien of female counterparts in being shown with a lowered or diverted gaze (for example, the votive portraits of Bishop Ferry Carondelet by Fra Bartolomeo and of Canon Broccardo Malchiostro by Titian), other men took a bolder pose in portraits which faced round to stare at the viewer as with, for instance, the votive portrait of Niccolò Bonghi by Lorenzo Lotto.[88] Such looks do not seem to have been decorous for the votive portraits of the woman commissioner. As in other areas of representation, this analysis shows that donatrixes had a distinctively different relationship to the new opportunities of Renaissance artistic styles to that experienced by donors.

The documented examples of well-off widows commissioning a realistically-sized votive portrait seem to derive from a relatively restricted group of communities – being, except for Alviano, in the north of the peninsula, in the Veneto, Ferrara and Verona. In the case of Alviano, of course, the patron was the Countess of Pordenone, in the north, whence she obtained her painter. This grouping could relate to the spread of the invention of the truncated portrait from the circle of Mantegna, and could arise from the legal status of widows in areas which did not require a *mundualdus*, since they followed Roman Law. It would be very helpful to know whether there are other examples from this period from a wider geographical range, which have simply not yet come to light.[89]

Most female votive portraits appeared in the relatively private context of the family funerary chapel. However, even here their images were usually viewable by anyone, and they might have a positively public facet, such as having indulgences attached to them (Oradea Becchetti), or a political double meaning (Smeralda Nelli). On other occasions female votive portraits were placed on altar-panels for communal use of some sort (for a confraternity, say, or a community of friars). Even though most widows' votive portraits were modestly small or truncated and the face was only shown in profile or three-quarters, rather than full-face, they did usually assume the prime positions in the centre or at the left of the image. Most of them also required portraits of themselves

which claimed the recognition of personal character and individual experience in a woman, as a token of her spiritual biography, and rejecting any attempt to appear attractive as temporal vanity. Moreover, in deciding to have themselves represented as commissioners on their votive image at all, all these women took the didactic role, so unusual for women, of showing spectators how to look at what they had chosen for them to see. The emphasis on the initiative of individual women in all these altarpieces containing votive self-portraits means that they represent the strongest evidence for women commissioners stepping out of the humble obscurity prescribed by the handbooks of conduct. In Chapter 7 we turn to look at a group of widows who valued themselves only a little less boldly, in the sense that they did put their own spiritual needs first, but they used inscriptions rather than portraits to announce a woman's commemoration or her gift.

Notes

1 Ingo Herklotz, *Sepulcra e monumenta del medioevo: studi sull'arte sepolcrale in Italia*, Rome, 1985, pp. 191–2, lists pagan examples of the representation of donatrixes in votive images.

2 Kocks, *Die Stifterdarstellung in der italienischen Malerei*, p. 133.

3 *Ibid.*, pp. 165–6.

4 *Ibid.*, p. 209.

5 Kocks lists painters in Florence like Gozzoli and Neri di Bicci, in Siena like Andrea di Niccola, and in the Veneto like Crivelli, Jacopo Bassano and Pordenone as providing diminutive votive portraits in the late fifteenth and early sixteenth centuries (*ibid.*, pp. 196–201).

6 Kocks (*ibid.*, p. 209) quoted Wittkower's study of Veronese painting (Rudolf Wittkower, 'Studien zur Geschichte der Malerei', *Jahrbuch für Kunstwissenschaft*, IV, 1927, pp. 185–221, especially p. 187); André Chastel, 'Le donateur "in abysso" dans les "Pale"', *Festschrift für Otto von Simson*, ed. L. Grisebach and K. Renger, Frankfurt am Main, 1977, pp. 273–83.

7 Kocks, *Die Stifterdarstellung in der italienischen Malerei*, pp. 20, 27. For the *Entombment* attributed to Giottino (Uffizi no. 454, wood, 195 × 134 cm., *c.* 1365–70) see Uffizi Gallery, *Catalogo generale*, Florence, 1979, p. 295.

8 Ferdinando Bologna, *I pittori alla corte angioina di Napoli 1266–1414*, Rome, 1969, Plates 47–52 (pages unnumbered).

9 See Catherine E. King, 'Women as patrons: nuns, widows and rulers', in *Siena, Florence, and Padua*, II, pp. 243–66, especially pp. 245–6, Plate 295. This fresco is neither inscribed nor dated, but since the general design of the painted frame resembles the tracery of the windows inserted into Orsanmichele, Florence, in the late fourteenth century the fresco could also be dated in the 1390s.

10 Richard Offner, *A Critical and Historical Corpus of Florentine Painting, Section 3, Volume 1, The Fourteenth Century*, New York, 1931, p. 96, Plate XXXI.

11 Kocks, *Die Stifterdarstellung in der italienischen Malerei*, p. 20, noted five examples of the commissioner with hands crossed in this way. This observation suggests that the figure kneeling at the feet of Saint Catherine of Siena in the fresco attributed to Andrea Vanni is likely to be a donatrix portrait.

12 *Ibid.*, pp. 21–8.

13 *Ibid.*, pp. 108, 234–8; and Pietro Torriti, *La Pinacoteca Nazionale di Siena: i dipinti*, Geneva, 1990, p. 96, no. 35.

14 Kocks, *Die Stifterdarstellung in der italienischen Malerei*, pp. 244–53.

15 *Ibid.*, p. 33.

16 *Ibid.*, p. 30.

17 John Berger, *Ways of Seeing*, London, 1972, pp. 45–64.

18 Patricia Simons, 'Women in frames: the gaze, the eye, the profile in Renaissance portraiture', *History Workshop: A Journal of Socialist and Feminist Historians*, XXV, 1988, pp. 4–30. The profile portrait represented women as 'an ordered, chaste and decorous piece of property' (p. 7). The male gaze continued 'in its triumphant potency while the female gaze remained repressed' (p. 24).

19 Mary Rogers, 'Sonnets on female portraits from Renaissance North Italy', *Word and Image,* II, 1986, pp. 291–9, and Mary Rogers, 'The decorum of women's beauty: Trissino, Firenzuola, Luigini and the representation of women in sixteenth-century painting', *Renaissance Studies*, II, 1988, pp. 47–89.

20 Leon Battista Alberti, *On Painting,* trans C. Grayson, ed. M. Kemp, Harmondsworth, 1991, pp. 78, 91.

21 'In nomine Domini Amen. Anno Domini millesimo CCCVIII Clementis P[a]P[ae] V Indictione VI Domina Elena fecit fieri hoc opus.' See *L'arte in Terni: mostra fotografica*, ed. Piero Adorno, Rome, 1974, pp. 87–8, Fig. 55; Kocks, *Die Stifterdarstellung in der italienischen Malerei*, p. 397; F. Todini, *La pittura umbra dal Duecento al primo Cinquecento* (2 vols.), Milan, 1989, I, p. 114, no. 265.

22 L. Bellosi *et al.*, *Arte in Valdichiana dal XIII al XVIII secolo,* Cortona, 1970, p. 9. The dating and attribution are referred to in *Mostra di opere d'arte restaurate nelle provincie di Siena e Grosseto*, ed. M. Ciatti, L. Martini and F. Torchio, Genoa, 1983, pp. 37–40: 'moglie che fu di Guerino Ciantari'. 166 × 90 cm., Museo Civico, Lucignano Valdichiana, formerly San Francesco.

23 Francesca Flores D'Arcais, *Guariento: tutto la pittura*, Venice, 1965, Plates 1–5, p. 58. Tempera on wood, 360 × 280 cm., Museo Civico, Bassano del Grappa.

24 *Ibid.*: 'Emulatrix Bona Maria Bovolinorum Helen[a]e inventric[is] crucis et clavorum, sancxit hanc ipsa pietate Bassanorum ut orent pro ea Cristum Dominum nostrum.'

25 During the fourteenth century, altars dedicated to the Virgin (1331), Saint John the Evangelist (1328), Saint Peter (1347) and Saint Mary Magdalene (1347) are documented in San Francesco – see 'G. d. B.', 'Per il nostro san Francesco', *Bollettino del Museo Civico di Bassano*, II, 1905, pp. 1–6.

26 The painting is now on show at the Galleria Nazionale dell'Arte Antica, Palazzo Barberini, Rome, inventory no. 2465, tempera on wood, 160 × 101 cm.: 'Simone et Machilone pinserunt hoc opus anno domini MCCLVII Domina Maria fieri fecit.' This is the only inscribed piece by the two brothers from Spoleto. The provenance is the cathedral at Ancona. For a small example without an inscription see Kocks, *Die Stifterdarstellung in der italienischen Malerei*, p. 391, in the Fogg Art Museum, Cambridge, Massachusetts, described as Florentine and dated about 1290, 68 × 35 cm.

27 Offner, *Critical and Historical Corpus, Section 3, Vol. 1*, p. 96, Plate 31. No measurements are given. See also Kocks, *Die Stifterdarstellung in der italienischen Malerei*, p. 20, Plate 24.

28 Richard Offner and Klara Steinweg, *A Critical and Historical Corpus of Florentine Painting, Section 4, Volume 4, Giovanni del Biondo*, Part I, New York, 1967, pp. 156–7, Plate 34; 159 × 51.5 cm., inscribed: 'Questa tavola fu fatta de' beni e p[er] rimedio de l'anima di M[ad]onna Tora di Nardo Anni MCCCLXXV.'

29 George Kaftal, *Saints in Italian Art: Iconography of the Saints in Tuscan Painting*, Florence, 1952, cols. 619–20.

30 Annamaria Bernacchioni, in 'Documenti e precisazioni sull'attività tarda di Domenico di Michelino: la sua bottega di via delle Terme', *Antichità viva*, XXIX, 1990, pp. 5–14

178

(especially pp. 7–8), has done all the detective work on this example. According to Molho's list of the ruling class of Florence, Smeralda's family were powerful enough for inclusion in the elite, while the Neroni were not.

31 Martin Davies, *National Gallery Catalogues: The Early Italian Schools*, London, 1961, p. 165, inv. no. 807, wood, 175 × 151 cm., signed: 'Opus Caroli Crivelli Veneti Miles'.

32 'Almae consolationis matri Mariae priores posterosque miserata suos Oradea Ioamnis aere proprio non modico dedicavit.'

33 See Kocks, *Die Stifterdarstellung in der italienischen Malerei*, p. 277, for inscriptions by male donors emphasising that they had personally paid for the work.

34 Helen S. Ettlinger, 'The Virgin snail', *Journal of the Warburg and Courtauld Institutes*, XLI, 1978, p. 316, Plate 44d.

35 Romualdo Sassi, 'Arte e storia fra le rovine d'un antico tempo francescano', *Rassegna marchigiana*, XX, 1927, pp. 331–51. Oradea's commission was associated with another by Crivelli for the high altar of the church of San Francesco (now in the Brera, Milan), contracted by Fra Giacomo and Fra Giovanni as guardians in 1490 and delivered in 1493. The contract stated that Crivelli would be housed and fed for two years, and paid 250 ducats. Perhaps he made Oradea's panel while living with the friars.

36 Archivio Communale, Fabriano, Perg. XIV, 595.

37 Vincenzo Forcella, *Iscrizioni delle chiese e d'altri edifici di Roma* (12 vols.), Rome, 1869–84, II, p. 207: 'Lucretia relicta Jacobi Andreotti sibi vivens posuit anno salutis MCCCCLXXXIIII.' This tombstone was originally on the pavement of the church of Santi Simone e Giuda in the left-hand aisle, before the second pilaster. This church had been built by the Orsini and was situated among the houses owned by them; see Mariano Armellini, *Le chiese di Roma dal secolo IV al XIX*, Rome, 1982, p. 362.

38 For an example of a tomb slab with a full-length effigy for a woman who was the wife and daughter of a lawyer and taught law herself, see that of Bettina di Giovanni d'Andrea in Sant'Antonio, Padua, 1370, in Catherine E. King, 'Effigies human and divine', in *Siena, Florence, and Padua*, II, pp. 116–17, and Plate 139.

39 Filangieri, *Documenti per la storia*, II, pp. 111–12, describes the present Cappella della Circoncisione: 'CECILIA URSINA GENERE ROMANA ILLUSTR. PARDI URSINI MANUPELLI COMITIS MARCHIONIS GUARDIE GRELLIS SICULORUM VALLIS AC LARENI DOMINI FILIA AURELII PIGNONI NEAPOLITANI PATRITII CONIUNX HUMANAE CONDITIONIS MEMOR SEPULCRUM HOC VIVENS SIBI POSUIT.'

40 Roberto Pane, *Il Rinascimento nell'Italia Meridionale* (2 vols.), Milan, 1975–77, II, p. 184, Plate 195, discusses similar effigies of women made between about 1530 and 1550.

41 Filangieri, *Documenti per la storia*, III, pp. 111–12; and for the inscription on her son's tomb see Engenio Carracciolo, *Napoli sacra*, p. 118: 'IOVANNI FRANCISCO PIGNONO IN QUO TOT VIRTUTUM FLORES ENITEBANT UT IMMORTALES POSTERIS FRUCTUS POLLICERENTUR SED TANTAM HEU SPEM FUTURAM RAPIDUS AUSTER ILLICO AD TERRAM DECUSSIT AURELIUS ET CECILIA URSINA PARENTES CERTATIM COLLACHRIMANTES FILIO QUAM CARISSIMO OB EGREGIAS DOTES P.[IENTISSIMI] P.[OSUERUNT] ELATUS QUIESCENTI QUAM MORTUO SIMILITER ANN. AGENS QUATTUORDECIM MDXLVIII.'

42 Sergio Marinelli, *The Museum of Castelvecchio*, Verona, 1983, p. 58, no. 271, tempera on canvas, 206 × 174 cm. The cognomen also appears as *avogadro* or *avvogario*, and means 'legal advocate'.

43 E. Morando di Custoza, *Armoriale veronese*, Verona, 1976, Plate XVIII, no. 155 (the Avogaro arms), and Plate LV, no. 493 (the dal Bovo arms).

44 G. B. Biancolini, *Notizie storiche delle chiese di Verona* (8 vols.), Verona, 1749–71, II, pp. 349–50 (vols. I–IV have continuous pagination).

45 Caterina Furlan, *Il Pordenone*, Milan, 1988, pp. 168–73.

46 *Dizionario biografico degli Italiani*, II, Rome, 1960, pp. 587–91; Luciano Canonici, *Alviano: una rocca, una famiglia, un popolo*, Assisi, 1974, pp. 59–71. When he took over the territory

of Alviano in 1503, Bartolomeo had rebuilt the fortress called the Rocca at Alviano and had carried out urban improvements, including the enlargement of the parish church beside his fortress. He placed his arms on the church facade, inscribing the date 1508. This building was originally dedicated to the Assumption of Mary, but the dedication was at this point changed to that of Saints Peter and Paul.

47 Furlan, *Il Pordenone*, 1988, pp. 269–74.

48 Giordana Benazzi, 'Il Pordenone ad Alviano: un restauro e un poco noto gruppo di fregi', in *Il Pordenone 1984: Atti del convegno internationale di studio*, ed. Caterina Furlan, Pordenone, 1984, pp. 39–43. Canonici thinks that previous suggestions that the kneeling figure is to be identified as one of Bartolomeo's two brothers – Luigi d'Alviano or Bishop Bernardino d'Alviano – seem far-fetched, given that the only donors who appear dressed in a similar fashion in crimped surplices were canons, and the brother who was a bishop had died in 1511 (*Alviano*, p. 69).

49 Martineau and Chambers (eds.), *Splendours of the Gonzaga*, Figure 139, pp. 178–9.

50 *Da Bellini a Tintoretto: dipinti dei Musei Civici di Padova dalla metà del Quattrocento ai primi del Seicento*, ed. A. Ballarin and D. Banzato, Rome, 1991, pp. 164–6 (entry by Caterina Furlan).

51 *Ibid.*

52 ASP, Notaio Angelo da San Daniele, 1752, 12 February 1532, fos. 76 recto – 82 verso: 'capellam quam fabricari fecit'. Marginal notes to this will (on fo. 78 verso) refer to payments made to Sant'Agostino for funerary commemorations from 2 December 1528, possibly relating to the death of Cassandra. The parental deaths could relate to the setting up of the chapel in 1526.

53 *Ibid.*, 18 November 1534, fos. 334 recto – 343 verso.

54 Giuseppe Mazzatinti, 'L'obituario del convento di S. Agostino di Padova', *Miscellanea di storia veneta*, II, 1894, pp. 7–45, p. 7: 'Januar. IIII non. Dominae Lucretiae Mischetae quae reliquit conventui ducatos quindecim singulis annis. Haec altare nativitatis domini construxit anno 1526.'

55 This epitaph was kindly translated by Dr Jill Kraye of the Warburg Institute, London, who solved the problem of the corrupt Greek word. Of the several versions of the epitaph the most helpful – though still not quite correct – for the Greek term used in it is the Biblioteca Communale, Padua, Manuscript books, MS.B.C. 789; Desiderio dal Legname, *Inscriptiones quae passim variis in locis legantur in celeberrimo D. Augustini templo et coenobio*, Padua, 1561, fo. 20: 'Clarus Apollinea Vincentius arte sepultus ad Stygias miserum φάρμακα [pharmaka] traxit aquas invidit superis furvae deus arbiter aulae humani generis proh mala conditio.' According to Dr Kraye, masons often made mistakes when carving Greek words. It was probably a mason's mistake which gave rise to the puzzlingly varied readings of the epitaph, which was not preserved when the church was demolished.

56 ASP, Notaio Bartolomeo Zupponi, 1056, 2 March 1538, fos. 567 verso – 577 recto.

57 *Ibid.*, Notaio Angelo da San Daniele, 1752, 18 November 1534, fos. 334 recto – 343 verso: 'in la nostra sepultura donde e sepulto il mio carissimo consorte e la mia dolcissima fiolina casandra avanti la nostra capela qual ho facta edificare a laude e reverentia del nostro segnore e dela sua santissima nativita . . . in perpetuo a dire ogni zorno messa a la mia capela per l'anima mia e de tuti li mei morti e spezialmente del mio padre e madre e del mio carissimo consorte misser Vincenzo e de la mia dolzissima fiolina casandra'. She provided 3 lire to each of the 'pinzochere de l'orden de S. domenico le qual se retrovava al tempo de la mia morte sorele mie de l'ordine azo le abia causa di pregar dio per l'anima mia . . . e aconpagnarme ala chiesia'.

58 (1538) ASP, Notaio Bartolomeo Zupponi, 1056, 2 March 1538, fos. 567 verso – 576 recto: 'de la voluntate mia de tuto quelo desidero'.

59 *Ibid.*: 'mia capela pro me facta et adotata . . . aricomendata l'anima al mio factore che nel inmagine e similitudine sua la creata la cui pieta e misericordia e incomprensibile et ibi sua gloriosissima madre Virgine Maria e alo mio lucidissimo spechio di penitentia santo Gerolimo et a tuti li santi e sante de vita eterna amen'.

60 *Ibid.*, fo. 576 verso: 'uno delli miei dui leti grandi . . . Item libri che legasia decti, questi beni mobile li lasso accio li gabia pro amore mio e che de mi labia memoria.' (Lucrezia left her second husband the income from her land and houses for his lifetime, but her daughter Laura was her heir and her executors were her husband, daughter and son-in-law.)

61 *Ibid.*, Notaio Angelo da San Daniele, 1752, 18 November 1534, fo. 342 verso: 'volgio che de tuti ne sia facto uno inventario de ogni cosa e se abia afare una stima sopra tuti sti beni e per tanto quanto i sera estimati persone esperte . . . quando Laura venise a morta labia liberta . . . disponerne de dicti beni mobile che vero del qualuta de quelo che alei piasera'.

62 (1538) ASP, Notaio Bartolomeo Zupponi, 1056, 2 March 1538, fo. 569 recto: 'Lo abito del quale volgio essere vestita al tempo de la morte mia sie de sancto domenico el quale ho posto in una mia caseleta biancha con tute le altre cose da estremi poste intorno, in nela quale etiam sono alguni miei concesione apostolica ibi poteremi far absolevere pleniariamente . . . e le candele.' Lucrezia ended by invoking God the Father, the Virgin and 'hieronimo mio protetore'. She gave 1 ducat to Santa Maria della Grazie for mass on the feast of Saint Jerome.

63 Saint Jerome, *Select Letters of Saint Jerome*, trans. F. W. Wright, London, 1933, p. 231. In general the treatises of the early modern period follow the topoi proposed by the Church Fathers.

64 Savonarola, *Libro della vita viduale*, fo. a ii.

65 Dolce, *Ammaestramenti pregiatissimi*, p. 118.

66 Teodosio Lombardi, *I Francescani a Ferrara* (5 vols.), Bologna, 1974–5, I, p. 55. According to Lombardi the facade of the house of the Muzzarelli in Ferrara was decorated with fresco in the sixteenth century.

67 Vasari, *Lives*, VIII, p. 33; Amalia Mezzetti, *Girolamo da Ferrara, detto da Carpi, l'opere pittorica*, Milan, 1977, p. 103. (However, some critics have dated the altar-panel as early as *c.* 1523 or as late as *c.* 1540, on stylistic grounds.)

68 Laura Sesler, 'Significativi aspetti della pittura attraverso i secoli nella Chiesa di San Francesco Grande in Padova', in Associazione Culturale Francescana di Padova, *Il complesso*, pp. 133–4 and 147; Salomonio, *Urbis patavinae inscriptiones*, p. 333: 'D[O]M[INUS] BARTHOLOMAEO URBINO NOB.[ILI] PAT.[AVINI] CAESAREUM PONTIFICIUMQ.[UE] IUS MAX.[IME] LAUDE DIU PROFESSO ANTONIA FIL.[IA] PATRI OPT.[IMI] AC B.[ENE] M.[ERENTI] V.[IVENS] F.[ECIT] VIX.[IT] AN.[NI] LXV M.[ENSES] IV D.[IES] XIIX [*sic*].' Sandra Faccini, 'Lineamento della scultura nella chiesa di San Francesco Grande', in Associazione Culturale Francescana di Padova, *Il complesso*, p. 158, reported that he died in 1528, but without citing where she found the evidence for the death date.

69 Faccini, 'Lineamenti della scultura', pp. 149–64, especially pp. 156–8.

70 *Ibid.*, pp. 155–6.

71 ASP, Notaio Giordano Refatto, 4092, fos. 693–4, 30 June 1566.

72 *Ibid.*

73 Sesler, 'Significativi aspetti della pittura', p. 134. Sesler identified the bird centre base as a parrot, but it is more likely that is a pigeon.

74 Salomonio, *Urbis patavinae inscriptiones*, p. 336: 'Ante aram S. Bartholomaei BARTHOLOMAEO URBINO PATRI SIBIQUE, AC EIUS POSTERIS ANTONIA FILIA QUIETIS LOCUM IN NOVISS.[IMUM] USQ.[UE] DIEM P.[ONENDUM] C.[URAVIT].'

75 ASP, Notaio Giordano Refatto, 4092, fos. 693–4, 30 June 1566.

76 Quoted in Ballerin and Banzato (eds), *Da Bellini a Tintoretto* (entry by Elisabetta Saccomani, pp. 153–4).

77 The *Dizionario biografico degli Italiani*, XIII, Rome, 1971, p. 659, gives an Alvise Bragadin, who died in 1503 in Padua, who may have been Andrea's father. See also Schröder, *Repertorio genealogico*, I, p. 152.

78 *Dizionario biografico degli Italiani*, XXXII, Rome, 1986, pp. 492–4.

79 ASP, Monasteri città, Sant'Agostino, 317, fos. 35 verso – 36 recto: drawings of Andrea Minorello, showing the frame of the altarpiece in 1658 [Archivio di Stato Padova, Fotografato Ds2].

80 Ballerin and Banzato (eds), *Da Bellini a Tintoretto*, pp. 153–4.

81 *Ibid.*, p. 153: 'Resurrectio Christi, cum DD. Augusti, Dominici, Andreae apostoli, Magdalenae et sodalium simulacris, opus Dominici Campagnolae'. (The man who wrote this (Vincenzo Moschetta) was the nephew of Lucrezia del Min.)

82 Salomonio, *Urbis patavinae inscriptiones*, pp. 39–40: 'per commune Paduae ad honorem Domini Nostri Jesu Christi, Beatae Mariae Matris eiusdem, et Beatorum Confessorum Augustini, Dominici, Joannis Baptistae, Joannis Evangelistae, Apostolorum Petri et Pauli'.

83 Mazzatinti, 'L'obituario', p. 14: 'Nota che la magnifica madonna Marietta Bragadin consorte de quondam magnifico meser Andrea in diversi tempi ha dato alla nostra sacrestia multa bona, ha restaurata la croce grande, ha fatto el tabernaculo dove si ripone el sacramento in cena domini. Camici n. 3 con finimenti d'oro stole et manipoli, doi fazoli magni, uno fornito d'oro circumquaque l'altro di setta cremaxina. Uno del calice di valore duc. 30, una borsa deaurata fornita con pietre preciose et perle di valor ducati 50, un baldachino di raxo cremexino con Christo passo, quatro agnoli lavorado d'oro con pietre preciose cioè rubini fini con li suoi sguaciaroni con li fiochi d'oro et setta, et una tovaglia per lo altar grande bellissima.'

84 Ballerin and Banzato, *Da Bellini a Tintoretto*, p. 153: 'religiosae et clarae foeminae Dominae Marietae Bragadeno venetae'.

85 Desiderio dal Legname in 1561 recorded that the sacristy at Sant'Agostino had been robbed in 1454, but that the men and women of Padua had restored its treasures (Biblioteca Communale, Padua, MS. 789, fo. 10 recto). Marietta Dandolo, widow of Andrea, was here mentioned as especially important in the restoration of the contents of the sacristy ('veneranda et Pia Donna Marieta Dandulo'). He also says that 'their tomb was near the door of the bell-tower, not far from the sacristy' ('prope fores campanilis non longe a sacraria habentes sepulchrum') (fo. 12 recto).

86 Girolamo Tiraboschi, *Biblioteca Modenese*, VI, 1786, pp. 267–8. See Cecil Gould, *The Paintings of Correggio*, London, 1976, pp. 262–3.

87 See, for example, Filippo Trevisani, 'Osservazioni sulla mostra "Lorenzo Lotto nelle Marche: il suo tempo, il suo influsso"', *Arte veneta*, XXXV, 1981, pp. 275–88, especially pp. 275–6, Plate 1. This painting is attributed to Pier Maria Pennacchi (1464–1515 or 1528). It shows the Madonna and Child seated and enclosed within a high wall, over the top of which we glimpse a pink and white Venetian Gothic palace facade. Only the *piano nobile* is visible. The head and shoulders of a kneeling woman is to the right base in profile wearing a white veil with a black border and offering a brocaded cloth to the Christ child, who leans to bless her. As the Madonna is shown half-length, the impression is of intimacy and closeness. The commissioner might have been a Venetian patrician.
 See also an example in the Galleria Borghese, Rome, attributed to Jacopo Palma, il Vecchio, listed in Pergola, *Galleria Borghese*, I, Plate 226, pp. 124–5. The painting is in oil on panel, 71 × 108 cm. and dated about 1514–18, and shows the Virgin and Child with Saint Francis to the left and Saint Jerome to the right. The figures are half-length and the donatrix is portrayed as head-and-shoulders, lower left, dressed in red with pearls and a white veil, and has her hair drawn back (Photo Alinari 27506).
 Enrico Maria del Pozzolo, in 'Due proposte per Giovanni Buonconsiglio', *Venezia arti: Bollettino del Dipartimento di Storia e Critica delle Arti Giuseppe Mazzariol dell'Università di Venezia*, 7, 1993, pp. 157–8, illustrates and describes a painting (which appeared for sale in Milan in 1963) attributed to Giovanni Buonconsiglio (oil on panel, 86 × 123 cm.) which shows (Plate 2) the Holy Family with Saint Zachariah – all half-length – and the donatrix bottom left as a portrait-bust. Del Pozzolo does not offer a date, but the painter Buonconsiglio was working in Venice between about 1495 and 1535.

88 See the donor portrait of Bishop Ferry Carondelet by Fra Bartolomeo, 1511–12, in Saint Jean at Besançon, who kneels and points to the focus of his devotion but turns away from the

viewer (S. J. Freedberg, *Painting of the High Renaissance in Rome and Florence* (2 vols.), Cambridge, Mass., 1961, illustrations volume, Plate 261). See also Titian's *Annunciation* for the Cappella Malchiostro, Treviso, for Canon Broccardo Malchiostro of 1519, which shows the canon kneeling in the background looking downwards (see H. Wethey, *The Paintings of Titian* (3 vols.), London, 1969–71, I, Plates 56–7. Compare with Lorenzo Lotto, *The Mystic Marriage of Saint Catherine*, Pinacoteca dell'Accademia Carrara, Bergamo, dated 1523, commissioned by Niccolò Bonghi, who kneels behind the Virgin's chair and looks straight at the viewer; see Giorgio Mascherpa, *Invito a Lorenzo Lotto*, Milan, 1980, p. 87.

89 For instance we note that one Neapolitan example from just outside the period we are considering – in the 1570s – was commissioned by Donna Berardina Transo, in her Chapel of the Annunciation in the church of the Sapienza, Naples. Donna Berardina had obtained permission in 1556 to be buried in a simple floor tomb, but in 1570 she obtained rights over a chapel which she dedicated to the Annunciation. Having decorated it, she willed it to her heirs in 1573, at the time of her death. The altarpiece shows the Annunciation with a portrait of Donna Berardina bottom left depicting her to waist level and wearing a brown veil, a black dress and a white shirt. The painting has been attributed to Dirk Hendricksz, and it has been argued that he painted it in 1580–2, but it seems more likely that it was commissioned in about 1570, before the artist's arrival in Naples (Patrizia di Maggio, *Opera d'arte: Palazzo Arcivescovile di Napoli*, Naples, 1990, p. 51). For later examples see the altarpieces made by Lavinia Fontana and her father Prospero in Bologna: Prospero Fontana, altarpiece of the *Annunciation* for a widow, Bologna, *c.* 1585: *Pittura bolognese del '500*, ed. Vera Fortunati Pietrantonio (2 vols.), Bologna, 1986, I, p. 405; Lavinia Fontana, canvas showing a widow and her daughter with Saint Jerome and the crucifixion, from the church of San Bernardino delle Monache in Bologna, 1585, oil on canvas, 340 × 210 cm. (the figures larger than life), Pinacoteca Nazionale, deposited at the Palazzo Pepoli, Bologna (see Maria Teresa Cantaro, *Lavinia Fontana bolognese 'pittura singolare' 1552–1614*, Bologna, 1989, p. 140, no. 4a, 54).

ACTING FOR
THEMSELVES

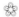

Some widows did not draw attention to themselves by including portraits on votive images, yet they did initiate commissions while they were still living which were intended for their own spiritual welfare, and which were marked as belonging to them in terms of inscriptions – if not on the work itself, then on adjacent epitaphs. The commissions of the five women in this chapter are less challenging to the male-defined feminine in some ways, because the widow did not appear as actor in her tableau. However, they probably represented a stronger feminine than the male moralists advised, because they still took up space in a prominent way to show the value of the personal salvation of an individual woman, and they often celebrated the female for her personal generosity and magnanimity to a religious or civic community as well. In commissioning a new sculpted portal for one of the largest churches in her city, Donna Agnese Nascimbene, for example, reached a big civic audience in Padua, while at Montefalco, Donna Griseide di Ser Sebastiano provided an equally important devotional amenity for her fellow-townspeople in having a chapel painted which explained how they could avoid the pains of Purgatory. Donna Finalteria da Bevagna also benefited a community in commissioning to help complete the decoration of the apse of the nuns' choir at Sant'Anna in Foligno – though her audience was restricted to the nuns and their visitors, by comparison with the open access to the works of Donna Agnese and Donna Griseide. The widow might, of course, act more narrowly for herself in having a personal funerary chapel made. She might, like Donna Fiordelise, a potter's widow from Padua, have an altarpiece with an iconographic programme focused on her own condition as lone woman. However, she could, like Donna Marsia de' Cagli of Perugia, commission an altarpiece which had both personal relevance

and wider significance for the monastic community in whose church she had her chapel made.

The opportunity to place her name on a large item of church embellishment, visible to all, was not often granted a widow. However, the occasion did arise in connection with the commissioning of the south portal for the church of the Eremitani in Padua in the 1440s. This impressive sculpted doorway was carved in the latest classicising style by the Florentine sculptor Niccolò Baroncelli for Donna Agnese, called Bianca, between 1441 and 1442, and displayed an inscription recording her gift on the transom (Plate 53).[1] Donna Agnese came

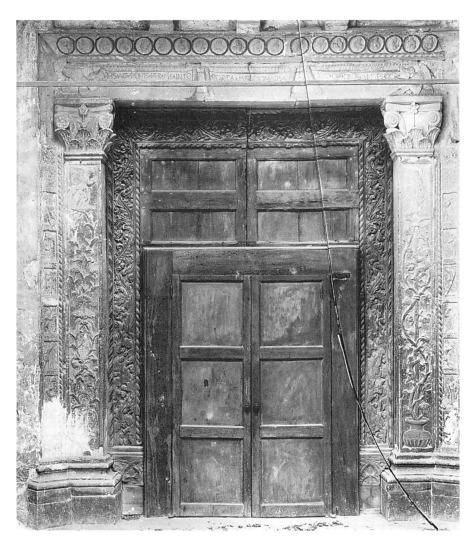

53 Niccolò Baroncelli, South Portal, Eremitani, Padua, 1442. Museo Civico, Padua.

185

from the Nascimbene family and was the widow of a notary, Dionisio da Montona. Donna Agnese had been widowed by 1415, since she agreed in May that year to take a house in the Androne de' Fabbri by the Piazza della Ragione from the heirs of her husband as her dowry.[2] Until the early spring of 1440 she seems to have had no thought of commissioning a work of art which would be so personally labelled as her gift to the church, for in her will of that year she mentioned the church to make general provision for the monastery to spend on upkeep, and she gave 50 ducats towards the building of its infirmary: just the sort of self-effacing alms which moralists like Giovanni Dominici approved for the retiring widow. But in August 1441 she wrote a codicil which stated that she had already concluded a contract with 'Niccolò da Firenze pittore e lapicida' and bound her executors to pay him the sum of 50 ducats at the conclusion of his work, which had previously been assigned to helping to build the infirmary. The Florentine sculptor was witness to the codicil.[3] Donna Agnese was dead six months later – by February 1442, when her executors sold her house – but the marble portal frame may well have been finished by her death, since it is dated as having been installed in that year, and she had signed the contract the summer before.

It is likely that the portal was under the overall control of the friars of the Eremitani, with particular responsibility being taken by Fra Alessandro and Fra Giovanni, two of her executors who witnessed the codicil at her house along with the sculptor. Nevertheless, it was she alone who had already signed the contract with the artist. Conceivably, the Prior, Fra Domenico, wished to act promptly to keep the Florentine sculptor in Padua (he seems to have left for Ferrara in 1442) and suggested the project to his wealthy benefactress, rather than waiting for her to die, and will his convent the funds for the maintenance of its buildings. On the other hand, the commission may have been her idea, to which the Prior would want to accede. He was well aware that the community stood to benefit from her 1440 will, which granted several houses including the dowry house in the Androne de' Fabbri to be sold for the *fabbrica* of the church, and gave many smaller sums for the role of executors and the conduct of the funeral and the masses for the dead.[4]

The portal probably had a version of the deep pointed canopy supported on corbels which presently shields it. Indeed, Lionello Puppi suggested that the doorway was already present in the fourteenth century.[5] If so, the shape contrasted with the classicising styles of the portal itself, which the sculptor had brought from Florence. The outer lateral bands of the frame consist of a strip of reliefs on either side representing the months, with January to June reading clockwise from base left, and the second half of the year, from July to December, on the right, reading top down. So the spectator stands between December

and January at his or her feet and looks up at the summer months when the sun is at its highest. These bands of reliefs meet that of the concave cornice belonging to the entablature forming the transom of the doorway, and this cornice is adorned with twenty gilded roundels representing male saints. The frieze is decorated with two naked putti who hold up a long pleated scroll on which three Latin inscriptions appear. The putti seem to be sitting on the composite capitals of the two pilasters supporting the entablature. The outer faces of these pilasters are carved in subtle relief with foliage. To the left, the fronds are of oak and support the figure of Gabriel. To the right is a grapevine which carries the Virgin Mary. The wooden frame within to hold the door-leaves is further decorated with foliage and edged with Venetian Gothic cable-pattern. In the overdoor are three statues of God the father, Saint Antony and a deacon saint. At the apex of the canopy is a small group of the Pietà.

The leftmost inscription gives the spiritual reason for making and using the door, quoting from the gospel of Saint John (10.7–10): 'Jesus says if any man enter by me he shall be saved and may go in and leave and shall find sustenance.' Agnes's door was therefore a symbol of Christ himself, being an image of the way to salvation. The passage in the gospel from which this was taken compared Christ to the Good Shepherd who lets his flock in to shelter and out to pasture through a gate. Although the image of the congregation as a flock of sheep was commonplace and therefore fitting for the general use of the portal, there could have been comforting personal meanings in the symbolism for Donna Agnese, called Bianca, because her given name derived from the Latin word for a ewe lamb, *agna* – a reference celebrated in the attribute of a white lamb for Saint Agnes. The combination of the familiar image of Christ as Good Shepherd in her portal with her own name meaning one of his lambs might have played some part in motivating her to fund the project. Indeed, the right-hand inscription tells us who had this door made in terms which connect her given name 'Agnese' with her acquired name 'Bianca', which means 'white': 'This work Donna Agnese called Bianca had made for her soul.' The inscription at the centre gives the practical information to the viewer that it is only open after midday: 'The south door shall not be open until midday.'[6]

This commission produced an unusually public gift, giving easy access to members of the congregation to the church, coming from the centre of Padua to this monastery outside the walls, and one which would draw countless eyes to note the name of the benefactress. The rather old-fashioned imagery of the months[7] recalls the Romanesque cycles on great churches like the cathedral at Ferrara or San Marco in Venice, and perhaps even granted something of the prestige of these comparisons to her portal. However, the novelty of the classicising style and details like the naked wind-god who represents March claimed

the patron's progressive acceptance of the re-creation of Antique art and architecture.[8] The iconographical programme of the door was chosen to express the idea of the entry through the portal into eternal salvation beyond the temporalities of the labours of the months, offered by Christ's sacrifice on the cross, and made possible through the incarnation of Christ announced by Gabriel to the Virgin Mary. At the same time the door could act as a funerary commemoration for the patron. In her will she said she wished to be buried 'in her own tomb', in the church of the Eremitani by the chapel of Saint Nicholas of Tolentino, to whose confraternity she left money for masses for her soul, while the inscription on the portal explained that it too was made 'for her soul'.[9]

The high public profile achieved by Donna Agnese, called Bianca, was very rare for a woman, and the remaining commissions we shall look at in this section were more modest, because they cost less and did not change the face of the city in quite the same way. Although two of the commissions – the Cappella delle Rose at San Fortunato in Montefalco, and the frescoes for the nun's choir of Sant'Anna in Foligno – were made, like the Eremitani portal, to benefit the wider community other than the woman's immediate family, the former was somewhat secluded in the courtyard of the church, and the latter was for a community of nuns. The other commissions (of Donna Fiordelise of Padua and Donna Marsia de' Cagli of Perugia) were for personal funerary chapels. All these schemes were cheaper than that of Donna Agnese because they were for paintings or for paintings and stucco.

The frescoed chapel decorated by Griseide di Ser Sebastiano in honour of the indulgence of the Perdono of Saint Francis and situated in the courtyard of San Fortunato in Montefalco must have represented a prominent gift to local worshippers in 1512 (Plate 54). Her chapel was inscribed with the information: 'Favoured by the Grace of God, this work was completed at the expense of Griseide di Ser Sebastiano for her soul and the souls of her relatives who are dead, on 20 May 1512. Tiberio d'Assisi painted it.'[10] Two years before she undertook this commission Griseide had commissioned a funerary altarpiece specifically for her husband (and perhaps her daughter), inscribing on it a dedication which did not mention her own salvation. This panel, which is still in the church of San Francesco at Montefalco, is attributed to Tiberio d'Assisi, and showed the *The Madonna del Soccorso*.[11] After this commission she seems to have turned her thoughts to her own funerary commemoration, in funding a more elaborate design comprising the complete fresco decoration of the chapel at San Fortunato, a Franciscan church situated a short way outside the town.

The mural decoration of the chapel illustrated one of the miraculous visions of Saint Francis which was believed to have taken place at Porziuncula – now

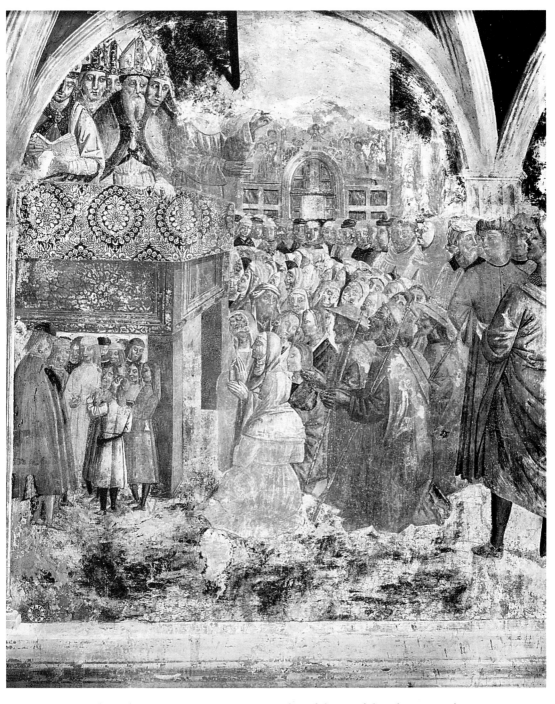

54 Tiberio d'Assisi, *Saint Francis announces the Indulgence of Il Perdono*, 1512, fresco, Cappella delle Rose, San Fortunato, Montefalco.

189

Santa Maria degli Angeli – in the plain below Assisi, and related the way Francis had himself obtained a plenary indulgence in honour of this miracle. It seems likely that the chapel of Griseide advertised the availability of this indulgence, which was thought to free one's soul from purgatory and which could be obtained either by making a pilgrimage giving thanks at Porziuncula on 2 August or by having a mass said at the altar at that church. Griseide's intention may well have been similar to that of Oradea Becchetti of Fabriano in seeking to encourage a particular devotional practice through her commission (see p. 150). In his pictorial narrative Tiberio d'Assisi closely followed scenes depicted on the altarpiece which had been made in 1393 by Ilaria da Viterbo at the site of the miracle at Porziuncula itself.[12] The story began with Saint Francis being tempted by the Devil even though he whipped himself with thorns to quell the temptations of the flesh, but being rescued by two angels who turned the thorn-bushes to thornless roses and banished the Devil. In the next frame Tiberio depicted the angels accompanying Francis to the church of the Porziuncula. Over the altar of the chapel he showed Saint Francis giving thanks for his rescue from sin at the altar of the church at Porziuncula and being granted the vision of the Coronation of the Virgin, when according to the legend, Christ gave him and others who followed him a plenary indulgence. The grace given is again symbolised by roses dropping on to the altar from heaven. The two final scenes represented Pope Honorius III validating the Indulgence of the Perdono – or general pardon of all one's sins – at the request of Saint Francis, on 1 August 1216, and its announcement by Saint Francis at Santa Maria degli Angeli, surrounded by seven bishops of Umbria. In this depiction (as in the original altarpiece of Ilaria da Viterbo) women are shown in the seated congregation listening to Saint Francis's words. Each scene was carefully labelled in Latin. Also included in the mural decoration were images of the key followers of Francis, Saints Bonaventure, Bernardine, Louis of Toulouse, Antony of Padua, Clare and Elizabeth. The representations of these women saints were placed on the right-hand wall, and beside them on a *cartellino* next to the window illuminating the chapel were inscribed the words of Griseide's dedication.[13] Through her gift Griseide attracted the gaze of the general congregation, because her chapel advertised the plenary indulgence available in August at Assisi through Saint Francis's revelation, and perhaps even because it encouraged the devout to pay for masses at Assisi for their souls. Like Donna Agnese called Bianca, therefore, she was producing much more than a personal funerary commemoration, private to the family.

The votive inscription of Donna Agnese called Bianca for the Eremitani in Padua had been aimed at the widest civic spectatorship possible, while that of Griseide di Ser Sebastiano would have been read by both men and women

visiting San Fortunato. However, in the following example a widow designed her gift for a community, since it benefited a group of nuns, but it was relatively exclusive, since it was for the decoration of the nuns' choir. As these nuns were of the Third Order, visitors were allowed, then, as now, but the choir was still normally confined to the community. The widow in question was the same Donna Finalteria da Bevagna whose votive portrait was later placed in the male refectory of the Franciscans in Santa Maria degli Angeli at Porziuncula (see Plate 18). She also commissioned a fresco for the female community of Franciscans of Sant'Anna at Foligno. This painting was for the altar-wall of the choir and was made during her lifetime, being inscribed: 'Donna Finalteria di Meneco [Domenico] di Calamo da Bevagna had this made 1544.'[14]

The nuns' choir, which was built in the fifteenth century, is placed over the public church of Sant'Anna and consists of a rectangular hall, six bays long and three bays wide, with a fine vaulted roof. This choir was decorated during the first half of the sixteenth century. The earliest surviving element in its adornment is the sculpted tabernacle for the Eucharist, placed in the left-hand bay on the altar-wall and dated 1522. Donna Finalteria provided the fresco for the bay on the other side of the altar, representing the Nativity of Christ accompanied by Saint Lucy (Plate 55). As Lucy is shown kneeling and presenting her eyes on a dish, it is possible that Donna Finalteria's votive gift related to help with her sight. This fresco has been attributed to the painter Dono Doni of Assisi. While Saint Lucy herself has an unfocused gaze, her disembodied eyes on the plate stare fixedly at the viewer. Antonio Cristofani argued on stylistic grounds that the commission entailed most of the decoration of the choir which included the scene of the Annunciation and Franciscan saints on the side wall to the left of the tabernacle.[15] Like Griseide di Ser Sebastiano, Donna Finalteria initiated more than one work of art. Where Griseide made one altarpiece for her husband and a large frescoed chapel for herself, Donna Finalteria donated this choir decoration to the nuns of Sant'Anna, gave another showing the Martyrdom of Saint Catherine to the female convent church of Santa Caterina, also in Foligno, and, of course, funded the refectory and other buildings for the Franciscans at Santa Maria degli Angeli (see p. 94).[16] Such extensive patronage must have made these women prestigious figures in their communities, treated with respect by the Franciscan groups they benefited.

In contrast with the three previous commissions, the Paduan funerary altarpiece inscribed by Fiordelise, wife of Bertolo (Plate 56), seems to have had a relatively personal function. However, this panel is of great interest because the inscription on a *cartellino* in the centre states that it was made by the spouse of a master potter: 'Donna Fiordelise, wife of the now dead Master Bertolo, potter, had this work made.' The much smaller *cartellino* beside this one states

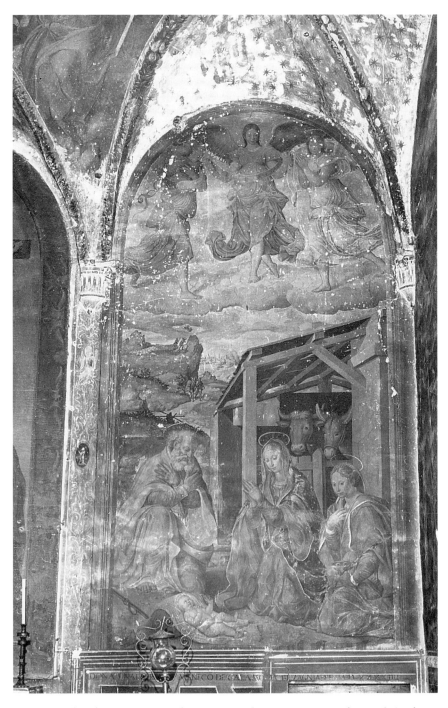

55 Attributed to Dono Doni, *The Nativity with Saint Lucy*, 1544, fresco, choir of Sant'Anna, Foligno.

192

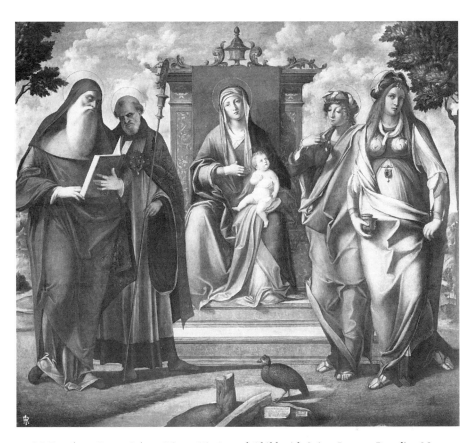

56 Benedetto Rusconi detto Diana, *Virgin and Child with Saints Jerome, Benedict, Mary Magdalene and a male saint with turban and sword*, before 1525, panel, 201 × 230 cm., Accademia, Venice.

that the picture was made by Benedetto Diana. While Donna Agnese was the wife of a notary and Griseide was the wife of *Ser* Sebastiano – indicating a man of power in Montefalco – this work was made for the wife of a craftsman.

The altarpiece of Fiordelise has been variously dated as an early or late work of Benedetto Rusconi, called Diana, who is recorded as working from 1482 onwards and who died in 1525.[17] The fact that the pottery industry in Padua became strong enough to have a district named after it from 1505 onwards – the *contrada* Boccalerie off the Piazza dei Frutti by Santa Lucia – might suggest a later date.[18] Although Edwards listed the panel as from the church of San Luca, other early guides more plausibly reported that it was from Santa Lucia, the church in the potter's district. The panel shows the Virgin and Child enthroned in a wide landscape, while four saints are standing at her side – to the left, Saints Jerome and Benedict, while to the right is a male saint with a

turban, who appears to be holding a sword-hilt with the blade hidden in his mantle, and Saint Mary Magdalene. While Jerome reads his book and the other male saints look down, the Magdalene turns to look at the spectator. She is portrayed with her jar of ointment for the anointing of the body of Christ in an overtly erotic way, with jewellery hanging over her brow and a rounded belly and with a bodice cut out to emphasise her breasts. The painter has created an ingenious group of metaphors in the foreground by the *cartellino* to express the survival of the widow following the death of her husband. A path curves from the left foreground to the feet of the turbaned saint and stops where a solitary mateless bird is standing over the *cartellino* giving the donatrix's name. Beside them is a tree which has been cut down and a piece of broken stone. This tree could be related to the two tall trees on either margin of the panel beside Jerome and the Magdalene, and might suggest the turn from the growthless temporal to the flourishing spiritual life which the Magdalene ex- emplified and which the widow was supposed to follow. Altarpieces produced later for Paduan widows also used birds to signify the widowed or married state (for example, the altarpieces of Donna Lucrezia and of Donna Antonia), and it is possible that Fiordelise's image set the precedent.

Like the altarpiece of Donna Fiordelise, the funerary chapel of the Immacu- late Conception by Dono Doni in San Francesco al Prato in Perugia was made for a woman, the widow Donna Marsia de' Cagli.[19] In choosing the subject of the Immaculate Conception, Donna Marsia was taking a theme which the order tending the church was particularly keen to propagate, and her painter took a particulary didactic tone, filling the pictorial field with learned scriptural and patristic inscriptions, as if for an audience of Franciscan priests. In 1558 Donna Marsia signed the contract for this chapel in the house of the heirs of her first husband, Geronimo Bevignati. One of the artists who agreed to work for her was a Florentine called Tommaso Danti, who contracted with her to build the chapel and to make an ornament of stucco to decorate it 'to the honour of the Omnipotent God and of his Most Glorious Mother and of All Saints'.[20] The other artist involved was the same painter from Assisi whom Donna Finalteria had used, Dono Doni, and he promised to complete the altarpiece by June 1559. In this altarpiece Dono Doni promised to 'paint the Conception of the Madonna and the other figures as shall please Madonna Marsia'.[21] The chapel was immediately to the right of the high-altar chapel.[22]

The altarpiece showed the Virgin Mary standing in glory at its apex before the sun and with her feet on the moon (Plate 57). She is surrounded by scrolls containing sentences from the Bible adduced by theologians to support the view that the Virgin Mary was free of sin at the moment of her conception, and consequently worthy of giving birth to the Son of God, who could free

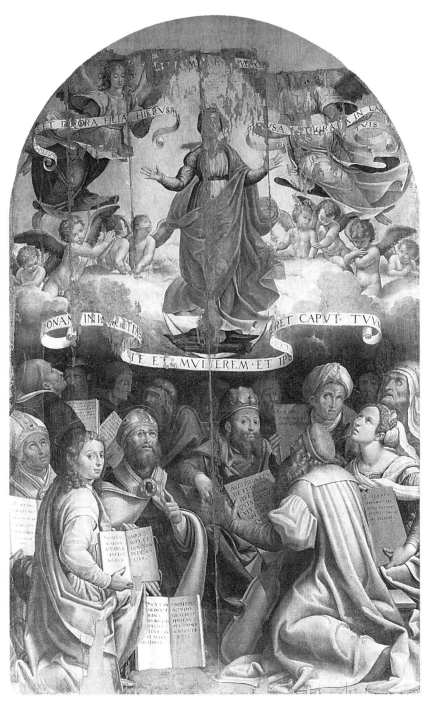

57 Dono Doni, *The Immaculate Conception*, 1558–59, panel, 260 × 180 cm.,
Galleria Nazionale, Perugia.

the whole of the human race from sin.[23] The topmost scroll is entitled 'Virgo Immaculata'. Given the theological complexity of the panel, it seems that a Franciscan scholar of the church would have provided detailed guidance to the painter. Since the Franciscan order had a reputation for defending the belief in the Immaculate Conception, Donna Marsia was taking part in something of a theological campaign in funding this pictorial statement, because the painting presents the key biblical texts held to refer to the concept. Above, to the right, are the words: 'Grace is poured into thy lips' ('Diffusa est gratia in labiis tuis'; Psalm 44.3). Beside it, to the left, are the words: 'Beautiful and decorous is the daughter of Jerusalem' ('Pulchritudo et decora filia Ierusalem'; Psalms 44.5), which suggests both the plenitude of grace given to Mary and compares her to the beloved bride of Christ. Below the feet of the Virgin is the inscription from Genesis 3.15, which was regarded as the first statement in the Bible referring to the coming of Mary and her special opposition to the Devil. This verse was thought to allude to a woman who would crush the serpent under her heel: 'I shall make enmity between you and the woman, and she shall crush thy head' ('Ponam inimicitias inter te et mulierem, et ipsa conteret caput tuum').

Below the Virgin are prophets and prophetesses of the Old and the New Testaments who had meditated on the role of the Virgin Mary and who hold tablets and books with their words, explaining the meaning of the symbols and sayings pictured above them. Prominent to the left, the youthful Saint John the Evangelist looks at the viewer, smiling, to show his prophecy (Revelation, 12.1) that the Virgin will appear at the end of time mantled with the sun and standing on the moon – 'Signum magnum apparuit in celo mulier amicta sole et luna sub pedibus eius.' King David, in the centre, also smiles at the viewer, and summarises the verses from Psalms 44.10–11, immediately following those quoted above him: 'Hear, daughter, and see. Incline thine ear, for the King has desired your loveliness' ('Audi filia et vide inclina aurem tuam quia concupivit rex speciam tuam'). He conveys the idea that Mary can be compared to the Church loved by Christ the King. Behind John the Evangelist are two doctors of the Church or bishops. The one to the left announces that 'She is the virgin in whom there was neither the knot of original nor the bark of venial sin' ('Haec est virgo in qua nec nodus originalis ni cortex venialis culpae fuit'). To the right of John is an open book with the words 'As much as sin abounded in the first woman, so in you, the full plenitude of grace superabounds' ('Sicut in prima femina abundavit delictu ita et in te superabundavit omnis plenitudo gratiae'). The statement is at the very centre base of the painting and emphasises that Mary, as the second Eve, was able to make possible the birth of Christ and thus save the world. Donna Marsia was therefore commissioning a panel which would provide her with personal spiritual comfort in representing the praise of a woman

who would be a specially powerful advocate on the Last Day, in an image which conveyed a sense of intimate rapport between the painted figures and the viewer, in glances and in smiles. In addition, Donna Marsia was providing the church with an attractive 'visual aid' which might even have been used for theological teaching for the Franciscan community who had charge of the church.

In most of these commissions the widow was making some contribution to the conduct of the public cult in her church and attracting the notice of a congregation. Indeed, the spiritual value for the woman might be expected to be enhanced, the greater the number of other souls her commission assisted. It appears, however, in general, that the greater the public benefit that might be produced by a woman's gift, the less likely it was for her to maintain full control over the project. Even widows who were in powerful positions socially, like Donna Maria Longo, widow of one of the three *reggente* appointed by the Spanish king to rule Naples, seem only to have been able to initiate a large scheme and hand it over to clusters of men controlling the ecclesiastical, the monastic and the secular government. In the case of Donna Maria Longo, for instance, she obtained permission from Leo X in 1519 to set up a confraternity of noble donors who funded the building of the Hospital of the Incurabili at Santa Maria del Popolo in Naples (Plate 58). Although she is recorded as

58 The Hospital of the Incurabili at Santa Maria del Popolo, numbered 38 on the map of A. Lafrery, *La nobile città di Napoli*, Rome, 1566.

197

buying the first parcels of land on which the hospital was being built from 1521 onwards, and she negotiated tax exemptions for the food and drink consumed by the patients and held the post of Governatrice Generale degli Incurabili, the creation of the hospital over the next decade or so was largely in the control of the committee of seven governors set up by her in 1523.[24] The commissioning powers of a widow often moved from the secular to the religious when the woman was encouraged to retreat from lay life and enter or create a religious order. In this way she might use her wealth to create large buildings like a convent and its church. Indeed, such a shift might be one of the strategies enabling the widow to conduct quite an elaborate commission or series of commissions, to change her life and those of others. For example, Donna Lucrezia Agliardi, widow of Francesco Cataneo of Vertova, had built the Carmelite convent and the convent church of Sant'Anna at Albino near Bergamo by 1525, having been widowed in 1516, and became its first Abbess. In honour of her achievement, her portrait was painted for her community in 1557, when she was 67, by Giovanni Battista Moroni, with a Latin inscription explaining what she had done.[25] If the more public-spirited commissions of individual widows were often taken over by powerful men, and powerful widows with public-spirited ideas often shifted from being laywomen into a religious regime, there was one other interesting option open to laywomen who wanted to act for their fellows. This avenue, which we examine in Chapter 8, was to join a group of like-minded laywomen in a sodality or sorority and commission on a joint basis, or to belong to a mixed lay confraternity of men and women and commission on their behalf.

Notes

1 E. Rigoni, 'Il soggiorno in Padova di Niccolò Baroncelli', in E. Rigoni, *L'arte rinascimentale in Padova: studi e documenti*, Padua, 1970, pp. 75 ff.

2 ASP, Archivi privati: pergamene diverse, miscellanea XXXVII, 789, 17 May 1415.

3 *Ibid.*, Notaio Giacomo di San Fermo, *Liber instrumentorum*, 3, fo. 196: 'voluit et ordinavit per presentem codicillum quod dicti ducati quinquaginta expendi debeant per comissarios suos in fabricha porte ecclesie heremitarum de padua pro qua fabricha dicta domina Agnese convenit cum magistro Nicolao de florentia pictore et lapicida'.

4 *Ibid.*, fos. 184–5, 14 February 1440. In addition to the proceeds from the houses, each brother from the Eremitani who was an executor would have 1 ducat while those brothers who carried her bier got 5 ducats and there was 1 ducat for every mass said for her soul.

5 Lionello Puppi and Sergio Bettini, *La chiesa degli Eremitani di Padova*, Vicenza, 1970, p. 70.

6 Rigoni, 'Il soggiorno', p. 85. The three texts are, from left to right: 'I[E]H[SU]S AIT SI QUIS PER ME INTR[O]IERIT SALVABITUR ET INGREDIETUR ET EGREDIETUR ET PASCUA INVENIET', then: 'PORTA MERIDIONALIS NON APERIATUR USQ[UE] AD CALOREM SOLIS', and finally: 'HOC OPUS D[OMI]NA ANG[N]ES D[I]C[T]A ALBA FIERI FECIT P[ER] A[N]I[M]A SUA MCCCCXXXXII.'

7 January defaced; February digging; March as a naked man with the wind blowing his garment; April with hunting horns; May with a woman crowned Queen of May; June cutting hay; July threshing corn; August making wine coops; September picking grapes; October defaced; November picking olives; December defaced.

8 Pietro d'Ancona, *Uomo e le sue opere nelle figurazioni del Medioevo*, Florence, 1924, pp. 108–13.

9 ASP, Notaio Giacomo di San Fermo, *Liber instrumentorum*, 3, fos. 184–5 (1440): 'in eius sepultura propria'.

10 Vasta, *Pittura in Umbria*, p. 133; Joseph Crowe and Giovanni Cavalcaselle, *Storia della pittura in Italia* (10 vols.), Florence, 1885–1908, X, pp. 134–5: 'GRATIA DEI BE[N]EFACTUM HOC OPUS A.D. MCCCCCXII XX DIE MAII IMPENSIS GRISEIDE DE SER SEBASTIANI PRO A[N]I[M]A SUA SUORUM ET DEFUNCTORUM TIBERIUS DE ASSISIS PINXIT.'

11 Festi, *Francesco Melanzio da Montefalco*, pp. 124–5. It is inscribed: 'GRISEYDA SER BASTIANI FECIT FIERI PRO ANIMABUS DICTI SER BASTIANI TARQUINI PERITEY [PERITEI] ET FRANCISHINE A.D. MDX.' The word 'francishin[a]e' is most likely to be the genitive of 'francishina'.

12 Kaftal, *Saints in Italian Art (Central and South Italian)*, cols. 473–94.

13 Michele Mattioli, *Montefalco*, Spoleto, 1953, pp. 65–7.

14 Giovanni Cecchini, *Guida del Foligno storico artistico, illustrata*, Milan, n.d., pp. 50–4: 'DONA FINALTERIA DE MENECO DE CALAMO DE BEVAGNIA FECIT FIERI MDXXXXIIII.'

15 Antonio Cristofani, *Delle storie d'Assisi* (6 vols.), Assisi, 1866, VI, pp. 474–5. (An *Adoration of the Kings* which is opposite this scene, to the right of the inscribed fresco by Donna Finalteria, is in fact dated 1567 and was made by a nun of the de' Conti family.)

16 Cecchini, *Foligno*, p. 54; Cristofani, *Delle storie d'Assisi*, VI, pp. 474–5, for the donation to the convent of Santa Caterina. The painting is *in situ*.

17 Moschini-Marconi, *Cataloghi dei musei*, I, p. 126: 'D[ONNA] FIORDELIXE MOGIER CHE FO DI MAISTRO BERTOLI BOCHALER FATO FAR QUESTA OP[ERA].'

18 Giovanni Saggiori, *Padova nella storia delle sue strade*, Padua, 1972, p. 48.

19 Santi, *Galleria Nazionale (secoli XV–XVI)*, p. 189; Vasta, *Pittura in Umbria*, pp. 96–7, who gives the archival refrence: Archivio di Stato, Perugia, Protocolli, 1351, Francesco Patrizi, 1558, fos. 998 verso – 1000 verso, signed in the house of the heirs of her first husband, Geronimo Bevignati.

20 Archivio di Stato, Perugia, Protocolli, 1351, Francesco Patrizi, 1558, fos. 998 verso – 1000 verso: 'ad honorem omnipotenti dei et eius gloriossime matris serenissimae virginis Mariae et omnium sanctorum'.

21 *Ibid.*, fo. 999 verso: 'depingere concessione di la Madonna et altre figure come piacera ala detta Madonna Marsia'.

22 Cristofani, *Delle storie d'Assisi*, VI, p. 471.

23 Hilda Graef, *Mary: A History of Doctrine and Devotion* (2 vols.), London, 1963–5, I (*passim*) surveys the general arguments.

24 S. Ravicini, *Sulla università dell'opera ospedaliera della Santa Casa degli Incurabili in Napoli*, Naples, 1899; Ciro Fiorillo, *Gli Incurabili: l'ospedale, la farmacia, il museo*, Udine, 1991.

25 *Giovan Battista Moroni, 1520–78*, ed. F. Rossi, Bergamo, 1979, pp. 112–13; New York, Metropolitan Museum, 90 × 60 cm.: 'LUCRETIA NOBILISS. ALEXIS ALARDI BERGOMENSIS FILIA HONORATISS. FRANCISCI CATANEI VERTUATIS UXOR DIVAE ANNAE ALBINENSE TEMPLUM CVRAVIT MDLVII.' See the visitation of Carlo Borromeo for a description of the now destroyed church: *Gli atti della visita apostolica di S. Carlo Borromeo a Bergamo*, ed. A. G. Roncalli and P. Forno (2 vols.), Milan, 1957, II, pp. 431–5.

CHAPTER EIGHT

ACTING TOGETHER

In this chapter we look at two commissions, both dating from the early sixteenth century: one by a group of women, and the other by one woman for a group of men and women who were Third Order Seculars. The former was contracted by several members of a sorority in Perugia for the altarpiece of their chapel, and had a programme aimed at assisting women wishing to marry, to conceive and to have a successful birth. The latter was funded by a woman who was a member of a group of Franciscan secular tertiaries in Verona for the altarpiece of their chapel, and gave prominence to the foundress of the female tertiaries, Saint Elizabeth. The Perugian example was made for an all-female audience and represented members of the sorority in the predella. The Veronese example contained small portrayals of female and male tertiaries in the predella, while the main scene above featured a prominent portrait of the donatrix in her tertiary dress, and represented in a way which prioritised the female spectator in the chapel.

These images are distinctive because they were made for groups with institutional continuity and therefore the possibility of a sequence of commissions over a long period, as well as having a public official face in the life of their parish. In the Perugian example a group of women were acting together in secular society for their group and their successors. In the Veronese example the donatrix was contributing to the devout life of a mixed-sex community, but again, one which would continue into the future, building on her design. Otherwise, of course, the only women who commissioned in groups were living in religious communities, following their regime of piety partly or completely secluded from the public. Commissioning as a sorority or commissioning for a tertiary group was a rare opportunity for women to see themselves acting in

200

public, to benefit an institution which they hoped would long outlive them, and which other women in the future could perhaps augment.

Members of the Third Order Secular might or might not be married, but they were living out in society and gathered regularly for their devotions at a local church.[1] Although various different orders promoted Third Order groups, one can get an idea of the aims of these men and women by looking at the regulations of the Third Order called the order of the Penitents, founded by Saint Francis in the early thirteenth century. This stipulated, for instance, that *sorelle della Penitenza* would wear simple and plain clothes and live in their own houses. Recalling the advice of the handbook writers considered in Chapter 1, these Sisters of Penitence were not to go to immodest gatherings or to the theatre or dances.[2] Except when they were pregnant, they were to abstain from meat on four days a week. Their programme of devotion included prayer at home, such as saying grace at their meals and observing the canonical hours of the Office during the day by reading the Psalms, or if they were illiterate, by saying the Lord's Prayer. Outside the house their piety was to be expressed in terms of confessing three times a year, at Christmas, Easter and Pentecost, and meeting together once a month in church to hear a sermon and make a collection of alms. Their mutual charity work was to include visiting the sick and attending the funerals of members. It was forbidden for married women to join without their husband's consent, and it was stipulated that members should not leave the Third Order Secular except to enter a Regular community.

Sororities and confraternities were similar to Third Order Secular organisations except that they were created to encourage devotion to different elements in religious cult. The objects of devotion tended to be gendered, with sororities concentrating on the life of the Virgin and mixed or all-male confraternities focusing on the life of Christ – the Trinity, the Name of Jesus, the Holy Cross. (In contrast, the tertiaries were aimed at encouraging general devoutness, especially in the family.) Most of these were male groups; a few were female and male. Very few seem to have been all-female. There were also confraternities enjoining specific types of penitence such as flagellation, and ones associated with deeds of mercy in the form of charitable acts towards the poor, the old, widows and orphans, as well as the sick. Evidence about the practices of sororities is scant, but we can perhaps get some indication of their rules by reference to a manuscript dated 1616, which lists the regulations of the Perugian sorority of Our Lady, which had commissioned the altarpiece we consider next, a century earlier. The sorority was under the control of the Vicar of the church of Sant'Antonio Abate in Perugia, where the sorority chapel was situated. This man was also the Bishop of Perugia.[3] Each sister was to honour God and his glorious Mother, and set a good example. She should confess three times a

year, at Easter, the Nativity and the Feast of the Annunciation. This emphasis signalled the sorority's dedication to encouraging reverence for Our Lady. At these three feasts the entire *compagnia* was to take communion together in their chapel. In addition, it was to celebrate mass there in praise of the Madonna every Saturday and Monday. An Abbess and a *Priora* were to be elected by the sisters, who would speak to the congregation when necessary, and keep the chest of the *compagnia*. They were charged with looking after the keys, the linen, the candles and the altar-cloths of the chapel – all wifely tasks, of course – and were given responsibility for keeping an account-book and reproving the conduct of members where necessary.

The altarpiece ordered by the sorority of Our Lady at Sant'Antonio Abate in Perugia is unique among the works considered in this book because it put the devout needs of living women in marriage and in childbirth to the forefront, rather than dwelling on death and funerary requirements. In 1510, a brother from the monastery of Sant'Antonio Abate in Perugia and four women of the Compagnia della Nostra Donna in the church of Sant'Antonio Abate contracted with Mariano di Ser Austerio to complete the panel with the *Nativity of Christ* already begun by Lo Spagno (Plate 59). Mariano agreed to provide the figure of God the Father for the apex of the altar-panel and a predella with the Virgin of the Misericordia in the centre, sheltering the women of the *compagnia*. On one side of the Virgin holding her cape in the predella was to be Saint Antony Abbot, and on the other Saint Leonard, 'or other figures that are pleasing to the above-mentioned *compagnia* of the women'. Significantly in the finished predella there were not two flanking saints but four, and Saint Anne, the mother of the Virgin, took the place of honour to the left, lifting the mantle over the women of the *compagnia*. This altar-panel has been split up; the Louvre in Paris now has the central *Nativity*, while the tondo and predella remain in Perugia. In addition, the predella was repainted and reshaped in the seventeenth century by being cut into three and reframed with borders of flowers edging the scenes (Plates 60, 61a, 61b).[4]

In choosing the Nativity for the main panel, the sorority were presumably thinking about its relevance to one of the major feasts when they gathered for joint worship in their chapel – and the scene also referred to the feasts of the Christmas period in general, by including images of the shepherds and the kings. In selecting the Madonna della Misericordia for the centre of the predella they had the opportunity to show themselves sheltered under the mantle of the Virgin's protection. The choice of Saint Antony Abbot related to the dedication of the church, but the other saints were selected for their relevance to women seeking marriage, conceiving a child and coming safely through childbirth. The saint who helps Saint Anne lift the Virgin's cloak is Saint Leonard, following

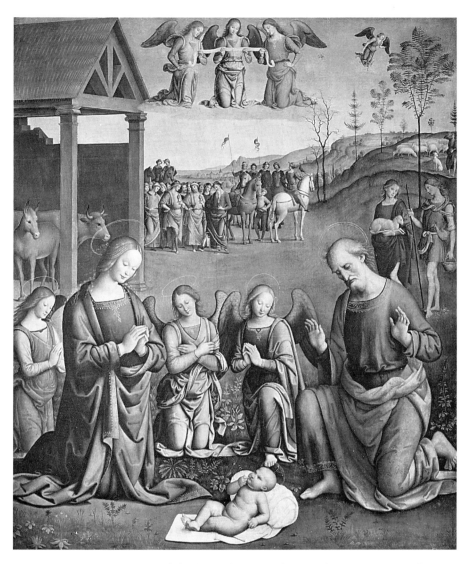

59 Lo Spagno, *Nativity*, panel, for the confraternity of Our Lady at Sant'Antonio Abate, Perugia. Musée du Louvre, Paris.

the stipulation of the contract. He is dressed in the habit of the Olivetan community (a reformed branch of the Benedictines), who looked after the church and one of whose brothers led the sorority. The invocation of Leonard was regarded as helpful in childbirth.[5] After the contract was signed the sorority decided to add Saint Anne, the mother of the Virgin Mary, and Saint Nicholas of Bari. Anne is shown wearing grey, white and violet, and was probably chosen because she was regarded as an advocate for women seeking pregnancy, for

203

60 Mariano di Ser Austerio, *Saint Anne with the Madonna della Misericordia and women of the confraternity*, central panel, tempera on wood, 29 × 54 cm., cut down in the seventeenth century and given a flower surround. Galleria Nazionale, Perugia.

women in labour and as a model mother. Saint Nicholas of Bari appears with the three golden balls recalling his payment of gold to a pimp to save young women from prostitution, and his assistance to them in enabling them to marry. Like Leonard, he has been given the habit of the Olivetan community. The scene of the Nativity of Christ chosen for the main panel could have been intended to stress the theme of the family and maternity. Under the cloak of the Madonna, following his instructions, the painter showed a large group of kneeling women of the sorority in brightly coloured clothing.[6] Their choice would have been made in light of the fact that confraternity images which showed the men and women of a company under the protection of the Madonna della Misericordia placed men in the place of honour to the left, and women on the right. The sorority's priest is not portrayed here, though the presence of his order is displayed in the use of the Olivetan habit worn by Saints Leonard and Nicholas.

The complete contract is worth quoting:

In the name of God, 19 November 1519. Let it be noted and manifest to any person who hears or reads this present writing that Mariano di ser Austerio of Perugia in Porta San Pietro promises Don Paolo of the monastery of Sant'Antonio at Porta Sole in Perugia and Donna Berardina di Teseo di Tei, Suriana di Angelo di

61a, *Saint Antony Abbot*, 61b, *Saint Nicholas of Bari*, by Mariano di Ser Austerio (details of the predella of Plate 59). Galleria Nazionale, Perugia.

Federigo, Maddalena di Pietro Angelo, Angelica in her own name, and all the ladies of the Compagnia della Nostra Donna of Sant'Antonio di Porta Sole, to finish an altarpiece, already begun by Lo Spagna [*sic*], on which is represented a Nativity of Christ and other figures, and in the centre tondo [he promises] to paint a God the Father, and on the predella, in the middle to paint Our Lady of Mercy with the ladies beneath her mantle, and on one side [of the mantle] Saint Antony, and on the other Saint Leonard, or other figures which shall be pleasing to the said *compagnia* of the said ladies, and where gold is required he will place ducat gold, and elsewhere he will use good and fine colours, and he will finish the landscape and the foliage, according to the judgement of two masters of the guild, at the end of ten and a half months, for the price of 45 florins in Perugian money, of which the said Mariano confesses that he has received 30 florins and 80 *soldi* partly in coin and partly in grain, according to Perugian prices, and the *compagnia* promises to give him the remainder of the sum by means of 7 *some* [loads or measures] of grain, according to the communal measure, and Mariano promises to wait for what is still owed him after that, until such time as the *compagnia* find the means to pay him.[7]

Clearly the group of women were advised and led by their priest. Significantly one woman – Angelica – contracted Mariano in her own name, but the other named women were specified as having husbands. Presumably only some of the women could read, because of the notarial reference to reading the document aloud to the group who were to agree to the contract. It may be because of the limited access of these women to funds that they paid the painter partly in kind, and that they had to get him to agree to wait for the final sum until such time as they could scrape together some more money.

In contrast with the chapel of Nostra Donna for this sorority, the altarpiece funded by Caterina de' Sacchi for her tertiary chapel in Verona did have some funerary functions, relating to the communal vault for its members beneath its floor. But like the sorority altarpiece, the tertiaries' chapel was for frequent use, to encourage a routine of devotion to help one to live well – though as a mixed-sex group its concerns were, of course, much wider than marriage, pregnancy and birth (Plate 62). Caterina's altarpiece, with its realistically scaled votive portrait at centre base, looks comparable to some of the funerary altarpieces for individual women considered in Chapter 6 (Plates 46–50). However, the fact that Caterina's picture was for the regular use of an institution rather than for occasional private masses for the dead means that her image had a public importance inviting fairer comparison with the votive portraits of donatrixes on paintings marking gifts to male and female religious communities by laywomen considered in Chapters 4 and 6 (Plates 18–19, 51).

In 1522 an altarpiece attributed to the local painter Pietro Cavazzola was completed for the chapel dedicated to Saint Francis belonging to the Third Order Seculars at San Bernardino in Verona (Plate 62). This large painting is now in the Museo Civico, Verona, although a copy is in place in the original chapel. The altarpiece provided a votive portrait of a woman wearing the habit of the Third Order Secular at centre base. She turns to our left to honour the patron saint of the female Franciscan Third Order, Saint Elizabeth of Hungary. Again, this votive portrait is in the tradition of Veronese female votive portraits begun by the commission of Altabella Avogaro in 1484. However, it has a grander presence, because the painter created a more complex design which gave the donatrix a greater directive role than that geared for a personal or family chapel.

The identity of this donatrix is uncertain, although it seems plausible that Vasari was right in reporting that it was a woman called Caterina de' Sacchi. Vasari also provided identities for some of the people on whom the saints in the altarpiece were modelled by the painter Pietro Cavazzola. For example, he related that the woman portrayed as Saint Elizabeth of Hungary was actually a gentlewoman who was a widow from the same de' Sacchi family.[8] Above, in

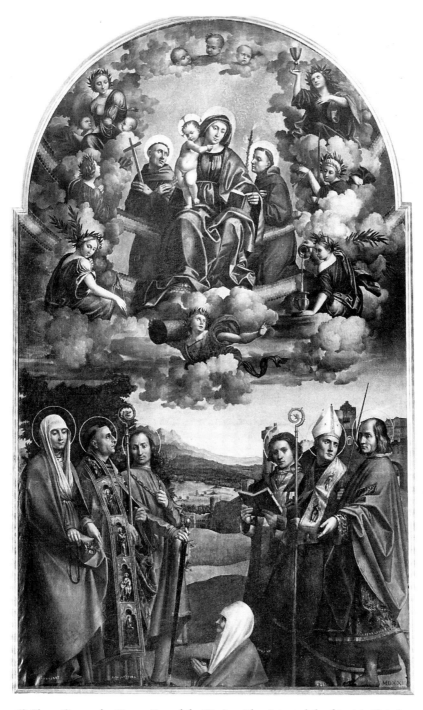

62 Pietro Cavazzola, *Coronation of the Virgin with saints and the donatrix Caterina de' Sacchi*, 1522, canvas, 440 × 267 cm., Museo Civico, Verona.

the heavens, sit the Virgin and Child with angels carrying the symbols of the Seven Virtues, flanked by the Franciscan saints Antony and Bernardine. Below them, in a landscape which seems to represent a particular place, are shown, from left to right, Saints Elizabeth of Hungary; Bonaventure; Louis of Anjou – the King; Ivo; Louis of Toulouse – the Bishop; and finally a key patron saint of the Franciscan male Third Order, Eleazer. Helpful gold labels on the hems of the saints' dresses provide the identifications. Except for Ivo, all are important Franciscan saints. It is to be assumed that the Franciscans running the tertiary organisation advised on this programme.

The management of the gaze by the painter is especially striking in this altarpiece, since he has given the donatrix the role of guiding us round the picture. She directs the viewer to honour Elizabeth first and then, reading round from left to right, to end with Eleazer – who completes the circle of viewing by pointing down towards the donatrix herself, as if to exhort us to follow her devotion. While the donatrix looks up at her exemplar and Elizabeth has her eyes demurely downcast, the only three women in the composition do in fact take the three prime places, at the centre top and bottom, and to the left. In this way the donatrix prioritised the female viewer and user of her picture. Saint Elizabeth was an interesting role-model for the devout wife, because her own life exemplified the duty of the pious woman to obey God if the commands of her husband or her father-in-law were, in her view and the view of her confessor, contrary to God's commands. Her attribute of the basket full of roses signified the miracle in which she was caught outside his palace by her father-in-law giving bread to the poor, after he had expressly forbidden such unladylike behaviour and public appearance. When he asked her to open her cloak and reveal her disobedience, God miraculously turned the bread into roses. In contrast, Eleazer was held up as a model of the good husband and head of the household, whose commands would always help his wife to follow a godly path. In fact, the altarpiece was only part of a large scheme of decoration for the chapel, which devoted scenes on the vault to the life of Saint Francis. However, the central position of the altar and its preference for Saint Elizabeth provides for an intriguing tension in what was, after all, a chapel dedicated to Saint Francis.

The chapel assigned to the Franciscan tertiaries at San Bernardino seems to have been built by 1512, according to the evidence of a will of that year which ordered that a chapel be made 'like the chapel of Saint Francis, newly constructed in the said church'.[9] It is immediately to the right as one enters the church, and has a lofty barrel-vault. It has its own portal in the facade of San Bernardino, as well as being open to the nave. The inscription on the frieze below the vault dates the fresco cycle to 1522, when it was dedicated by the

Franciscan Second Order, whose church this was, and its 'society' – presumably meaning the Third Order attached to it.[10] This vault sequence showing the life of Saint Francis is attributed to Nicola Giolfino, and according to Dianin the narratives here relied on the account of Bonaventura, providing a link with the altarpiece.[11] The refurbishment of the altar-frame in the seventeenth century destroyed evidence of its commissioning and date. However, the original appearance of the composition was recorded by Biancolini in his survey of the churches of Verona. He described an

> inscription placed on the altarpiece over the altar in gold letters in 1522, 'MDXXII TERTII ORDINIS SUMPTIBUS. 1522 With the money of the Third Order.' And a little below one saw several women of these tertiaries with other children [*figliuoli*] of Saint Francis, and the women were dressed in the habit that they always wear.[12]

In describing the predella Biancolini therefore referred to 'other children' of Saint Francis using the term *figliuoli* (or male children) painted on the base of the altarpiece, so it seems that there were images of men *and* women of the Third Order painted below the main panel. Presumably as main donatrix of the fund administered by the Third Order, however, Caterina de' Sacchi obtained the full-scale votive portrait.

Only the most limited suggestions can be made on the basis of these two examples. However, it is important to note that in commissions for a confraternity containing women and for a sorority, donatrixes unusually had both a guaranteed female audience and a public arena validated for their use by the veil of piety. The power of donatrixes to command the gaze was exercised, as we saw in Chapter 6, but the setting in a sorority or tertiary chapel could have more effect. The portrayals of the *compagnia* in Perugia show many women on either side of the Virgin, and are not differentiated in such a way as to suggest portraiture. However, the contract suggests that the women were expecting to see themselves represented in some way, and it is interesting that they had themselves placed over the centre of the altar, as did Caterina de' Sacchi, at the point in front of which the Host would have been elevated at the services all the women attended. Vasari's information and the possession of a large sum for the commission suggests that Caterina was a noblewoman. But the women who managed to have themselves painted by Mariano di Ser Austerio were of a humbler financial and, presumably, social position. For these women there would hardly have been any other commissioning opportunity allowing them to have themselves represented for their community to admire, except this sorority venture. Where the women of the *compagnia* chose the motif of the merciful cloak of the Virgin to shelter them in effigy, Pietro Cavazzola arranged the six saints above Caterina de' Sacchi so that their gestures and attributes hover

in a protective semi-circle over her head. It is notable that on such rare opportunities when women could command images as a group or for a group, they do seem to have enjoyed privileging women's hopes in the scheme of salvation. It may be significant too that the Perugian sorority altarpiece is the first picture we have looked at to emphasise votive help in childbirth. The colourful clothing of the women portrayed under the Virgin's cloak suggests that the altarpiece was aimed to appeal to younger women of child-bearing age, in contrast to the stress on widowhood and hopes for the afterlife which were otherwise more prominent in female commissions.

Notes

1 Gabriele Andreozzi, *Storia delle regole e delle constituzioni dell'ordine francescano secolare*, Milan, 1990, pp. 157–8.

2 *Ibid.*, pp. 35–8: 'non vadano a conviti disonesti o a spettacoli e danze'.

3 Biblioteca Augustina, Perugia, MS. 1471, *Capitoli et constitutione della venerabile compagnia della Madonna delle Donne posta al Sant'Antonio al Porta Sole*.

4 Vasta, *Pittura in Umbria*, p. 85; and Santi, *Galleria Nazionale (secoli XV–XVI)*, pp. 143–4.

5 Kaftal, *Saints in Italian Art (Central and South Italian)*, cols. 688–9. Leonard was a sixth-century saint who was thought to protect prisoners and women in labour.

6 Briganti, 'Un ignorato dipinto'. The church of Sant'Antonio Abate has recently been converted to housing. In shape it consisted of a square atrium at the entrance and a single nave.

7 *Ibid.*, p. 367, from the Archivio Giudizario di Perugia, III serie, Iuradiversa 1509–1510: 'Al nome di Dio amen. Al dì 19 de Novembre MDX. Sia noto et manifesto a qualunque persona odira [odire o] leggere questa presenta scripta comme mariano de ser Austerio de Peroscia Porta Sancto Pietro promete a domino Paulo de monisterio Sancto Antonio de Porta Sole de Peroscia et a donna Berardina de Teseo de Tei, la Suriana de Angelo de Foederigo, la Maddalena de Pietro Angelo, l'Angelica in nome loro, et de tucte le donne de la compagnia de la nostra donna de Sancto Antonio de Porta Sole, finire una tavola già comenzata per Spagna pentore dove sta penta una Natività de Christo, ed altre figure, et nel mezo tondo pengnere uno Dio padre, et nella predella inmezzo pengnere una nostra donna della Misericordia colle donne socto el manto et da uno de Capi sancto Antonio et de l'altro sancto Leonardo o altre figure che piacesse al supradicta compagnia de le dicte donne, et dove se recerca oro ponere oro de ducato et altrove mectere buoni colori et fini et finirla de paesi, et fogliami a judicio de doi maestri de tale arte in termene de dieci mesi et mezo per prezo de fiorini quarantacinque a moneta peruscina de' quali el dicto Mariano se chiama confesso et contento havere hauti et ricevuti fiorini trenta et soldi octanta in fra denarii et grano a moneta peroscina et del resto la dicta compagnia promecte darli queste state che verà septe some di grano a mesura communa et de quello restarà de suoi dicto Mariano promette aspectarle fin tanto che la dicta Compagnia havarà commodità a pagarlo' (my emendation).

8 Vasari, *Vite*, V, pp. 316–17.

9 G. M. Dianin, *S. Bernardino da Siena a Verona e nel Veneto*, Verona, 1981, p. 161, Will of Gaspare Rossi, 1512: 'similem capelle S. Franciscis noviter in dicta ecclesia constructa'.

10 *Ibid.*, p. 162: 'SERAPHICO FRANCISCO ALMI ORDINIS FRATRUM ET SOCIETATIS EIUS DEVOTIONE DICATUM MDXXII' ('Dedicated in 1522 by the bounty of the Order of the brothers and by the devotion of their society to the blessed Saint Francis').

11 *Ibid.*, p. 163.

12 Biancolini, *Notizie storiche*, VIII, p. 349: '[I Terziari] eran diretti da Frati Minori i quali perciò adunarsi, fu dagli istessi indi nobilmente ornata come dimostra la seguente iscrizione i caratteri d'oro sull'ancona riposta all'altare nell'anno 1522: "MDXXII TERTII ORDINIS SUMPTIBUS". E in poco più sotto veggonsi alcune di queste terziarie cogli altri figlioli di s. Francesco e vestite le donne coll'istesso abito che usano tuttavia.'

CHAPTER NINE

LIVING
SAINTS

Special privileges accrued to wives and widows who lived lives of such saint-
liness that they were able to gain the attention and support of powerful men
who believed in their spiritual gifts and who assisted them on occasion in
commissioning works of art and architecture. The research of Gabriella Zarri
has shown that most of the women in Italy between 1490 and 1550 who
were candidates for beatification were members of the Third Order Regulars.[1]
Perhaps the relatively more open and public mode of life provided by these
pious organisations, in comparison with the Second Order, licensed women to
some action, and meant that their saintly lives could be observed by fellow-
citizens. However, some women who were candidates for beatification lived as
Third Order Seculars, like the *beata* Margarita Bichi, and others lived a life of
sanctity in their own homes, like the *beata* Elena Duglioli. These women were
occasionally able to direct the making of art and architecture. Because of their
prestige, their female relatives sometimes had the opportunity to commission
to further their cult. For example, these circumstances allowed the Florentine
Villana delle Botte to fund an altarpiece, reliquary and tomb in honour of her
aunt – the *beata* Villana – at Santa Maria Novella between 1421 and 1451.
The *beata* Villana had not belonged to any tertiary organisation, but had at
her request been buried in the clothing of the Dominican Third Order. In this
way Antonia Rusca, the daughter of a beatified woman – Beatrice Casati, wife
of Franchino Rusca – who had belonged to the Franciscan Third Order in
Milan, made an impressive tomb for her mother in 1499.

Candidates for sainthood

Female candidates for beatification played a leading role, sometimes to design items otherwise outside the scope of the wives and widows surveyed in Chapters 2–7, whether in terms of the speed with which a large commission was effected, or in terms of the public and political status of the object created, or in terms of commanding the services of the leading painter of the papal court. When women made accurate prophecies, or had visions and performed feats of abstinence, powerful men and women could be anxious to have their advice and seek to please them as especially auspicious avenues to propitiating God and seeking His assistance for their plans. This phenomenon has been analysed by Gabriella Zarri in terms of the way governments all over Italy sought to obtain the support of such 'living saints'.[2] The situations in which the *sante vive* played some part in the making of art and architecture were, therefore, particular instances of a general pattern linking spiritual to political power and permitting the holy woman the experience of unusual public prominence. As stressed by Gabriella Zarri, these impressive laywomen saints tended to come from quite wealthy backgrounds. In the two commissions we consider one entailed the patronage of a lawyer's widow. This was the creation of a new chapel for the cult of Saint Cecilia by the *beata* Elena Duglioli of Bologna, with the help of the papal legate Antonio Pucci, between 1513 and 1517. The other commission was initiated in 1526 on the advice of the *beata* Margarita Bichi, daughter of a prominent Sienese magnate whose family had played a part in the government of the republic and also had a foot in the camp of the feudal hierarchy because they held the title of marquis through their ownership of land outside the city. These saintly patrons were drawn, therefore, from the ranks which also produced most of the women commissioners considered in Chapters 2–8.

The *beata* Elena's commission was distinguished as being one that was possible for a woman regarded as a saint in four respects. Firstly, she was able to command the services of the key papal painter, Raphael. Secondly, she could commission and complete a large new funerary chapel with a cupola for her husband and herself in a short space of time. Thirdly, she was able to provide for the public cult in placing a relic of Saint Cecilia in the altar of her funerary chapel. These activities were possible because clerics were in awe of her spiritual gifts and wished to please her. Fourthly, however, her commission was distinctively that of a saintly woman, because although the subject-matter of Raphael's altarpiece, in honouring Saint Cecilia, was certainly chosen to refer to the saint she emulated, the clerics close to her who wished to have her officially acknowledged as a saint by the Church saw her as a second Cecilia, reading the chapel as honouring both its dedicatrix and its dedicatee.

In September 1516 the Bolognese notary Vincenzo Budrioli recorded that Elena Duglioli had given land at Varignano to the canons of San Giovanni in Monte at Bologna 'for the endowment of a chapel which the said Donna Elena has founded and erected from the foundations and constructed in the said San Giovanni in Monte a year ago, which is beside the chapel of the Scarani family, on the upper side, and is dedicated to Saint Cecilia'.[3] Soon after, in April 1517, Donna Elena made her will, in which the same notary recorded that she left the chapel which she had had made 'a year ago' to her son-in-law, Count Andrea Bentivoglio, who had married her adopted daughter Pantasilea Monteceneri. The chapel made by Donna Elena seems, therefore, to have been completed in the autumn of 1515. Since the will did not charge her heirs with completing it if she should die untimely (which the testatrix would normally do if the project were unfinished), the chapel must have been complete, including the altarpiece designed for it by Raphael, in the spring of 1517.

The building of a large centrally-planned chapel with a dome and the hiring of the services of the painter of the papal court were not ordinarily to be expected for the funerary chapel of a lawyer's widow. In part the prestige of the architecture and the ability to call on the papal painter can be explained by her intention to encourage the honour of Saint Cecilia, a relic of whom she wished to house in proper dignity in the altar, rather than merely to make a family chapel. But, in addition, Donna Elena had especially high status because she was regarded as a candidate for canonisation by men who were themselves high in the Church hierarchy and in close contact with the papal court at Rome. As far as these men were concerned, Donna Elena's family chapel would soon be the chapel where the body of the *beata* Elena was interred.

According to the *Leggenda anonima*, composed between 1529 and 1531, the architect chosen to make the chapel was Arduino Arriguzzi, who was also working at one of the most important churches in Bologna, San Petronio, at the time. The *Leggenda* reported the visions of Elena as related by her confessor:

> In that time, and it was in the month of October 1513, many times at the sacrament, the Lord spoke these words to her, 'Daughter, I want you during your life, and not by the hands of your heirs, to build a chapel in San Giovanni in Monte with the dedication to Saint Cecilia, where you are to put the relic of her which you have, and if you do not have any other provision for the building, you may spend your own dowry on it, and I order you to to explain your intention to your son, Messer Antonio Pucci, the Florentine.[4]

The legend went on to explain that Antonio took on the task with a will and had the architect of San Petronio, Messer Arduino, make a wooden model of the chapel, and Raphael paint the altarpiece. The legend stated that 'all the

money was provided by Antonio Pucci because he wished to be the only one to give the satisfaction that would delight his mother [Elena]'.[5]

Whatever the financing situation, the chapel was endowed by Elena and willed to her heirs, who were still in control of it in 1695.[6] In June 1516 she had 'the new sepulchre' of her husband redug within this chapel.[7] For the new chapel the architect provided a design recalling elements of the Florentine new style, with a square plan and white plastered walls, articulated with pilasters and arches in *pietra serena*. The austerity is relieved by a richly gilded and azure frieze, which harmonises with the foliage carved on the gilded wooden frame of the altarpiece, the upper rectangular section of which is original. The chapel is lit from above via an octagonal drum and faceted cupola with a lantern and from one oculus situated at the apex of the right-hand arch. This system of lighting is assumed in the painting on the altar.

It seems likely that Raphael painted the altarpiece for this chapel during 1514 and 1515 (Plate 63). In the centre he was asked to celebrate the early Christian martyr Cecilia, who died for her faith and had lived as a virgin despite being married, having persuaded her husband Valerian on their wedding-night to forgo bodily pleasures and to turn towards the pleasures of the spirit. According to an early legend of her life she had offered her husband a vision of heavenly music on their wedding-night to turn his thoughts from human to divine love. It seems likely that it is for this reason that Raphael depicted a pile of discarded musical instruments at her feet and a portable organ slipping from her fingers, as she gazes up to heavenly musicians above. The central significance of the altarpiece was probably therefore that of admiration both for martyrdom and for virginity even in marriage.[8] In the background to the left, Raphael depicted Saint John the Evangelist as the patron saint of the church, while to the right he showed the patron saint of the Augustinian canons who were in charge of the church, Saint Augustine. In the foreground to right and left are Saint Mary Magdalene and Saint Paul. Stanislaus Mossakowski has suggested that their presence underlines the aspiration to live in chastity, recalling the words of Paul (1 Corinthians 13.1): 'If I have all the eloquence of men and of angels, but speak without love, I am simply a gong booming or a cymbal clashing.' Such an allusion would explain the rejection of human music which fills the centre foreground of the painting.[9] The three foreground saints may signify varieties of the celibate life. The Magdalene was reputed to have turned from a life of promiscuity to chastity, while Paul thought virginity superior to marriage. In contrast to both of them, Cecilia had practised celibacy in marriage.

Gabriella Zarri has shown the way in which Elena Duglioli attracted the attention of members of the papal government of Bologna which had taken power from the Bentivoglio dynasty in 1506, and suggested both the way in

215

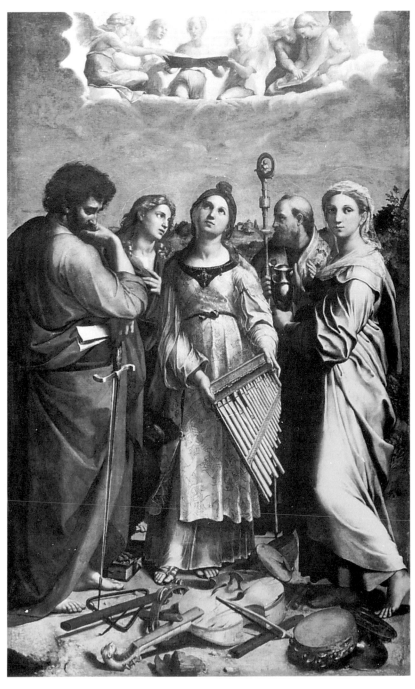

63 Raphael, *Saint Cecilia with Saints Paul, John the Evangelist, Augustine and Mary Magdalene, c.* 1514 or 1515, transferrred from wood to canvas, 238 × 130 cm., Pinacoteca Nazionale, Bologna.

which she was relied upon for her spiritual advice and support and also the political advantages they hoped to gain from promoting her reputation for sanctity. Elena, who was born in 1472, lived in a house beside the church of San Giovanni in Monte and was the daughter of a notary, Ser Silverio Duglioli, born in 1472. She had married another notary, Ser Benedetto Dall'Olio, with whom she lived for eighteen years.[10] Probably after his death around 1506 she revealed that they had lived in complete chastity throughout their marriage, following the example of the virgin martyr Saint Cecilia and her husband Valerian, and of course the Virgin Mary herself.[11]

From 1508 to 1511 Elena was sought out by the most powerful figure in Bologna, Cardinal Francesco Alidosi, who as papal legate governed Bologna on behalf of Julius II. According to the *Cronaca Bolognini* in 1510, for example, Alidosi frequented her house, asking for her prayers on his behalf, said mass with her, and gave her 600 ducats to spend as she thought fit. Since Alidosi as cardinal had been given the titular church of Santa Cecilia in Rome, which was the site of Saint Cecilia's martyrdom, he was primed to see Elena as a second Cecilia and to believe that she had a special significance for him, and at some point during this period Alidosi gave Elena a relic of the knuckle-bone of Saint Cecilia which he had acquired.[12] Although Alidosi was assassinated in 1511, Elena had found a new powerful adherent by 1513 in another papal legate, Antonio Pucci. It was this man who, according to the *Leggenda*, assisted Elena to house the relic in a new chapel. As papal legate he had the appropriate contacts in Rome to obtain the services of the papal court painter Raphael, and he had in addition the support there of his uncle Lorenzo Pucci, who was appointed cardinal in September 1513.[13] In October 1513, according to the *Leggenda*, God began to speak of the commission to Elena. Although Antonio Pucci's post took him away from Bologna – as papal legate to Switzerland in 1514, for example – it seems likely that he negotiated the commission for his spiritual 'mother'.

Zarri argued that it was to the advantage of the canons of Saint John Lateran at San Giovanni to have the new chapel for Saint Cecilia as well as to promote Elena as a future saint, because this might place them in a superior position to a rival group of Augustinian canons in Bologna – the *eremitani* – based at the church of San Giacomo.[14] Zarri showed that San Giovanni was a centre of support for the papacy during the difficult period of transition between the collapse of Bentivoglio rule in 1506 and the return of full papal statehood, pointing out that Elena's son-in-law Andrea was a member of the Bentivoglio clan who had always supported the papacy, and that Elena's chapel for *her* Bentivoglio heir would rival another chapel of Saint Cecilia at Via San Donato which had been commissioned by the erstwhile Bentivoglio rulers of the city.[15]

Various attempts have been made to disentangle different interests at work in the composition. For example, Regina Stefaniak has argued that the Magdalene was included to represent Antonio Pucci's desire for Church reform, expressed verbally in a sermon to the Fifth Lateran Council in 1514 and rendered by the figure of the Church as the penitent woman in need of a new life.[16] Probing another interest, Zarri has pointed to the engraved version of the altarpiece attributed to a pupil of Raphael as possible evidence for the development of the composition by Raphael. She argued that the way in which the engraving showed Saint Augustine with the attribute of the mitre, whereas in the final painting he carries a pastoral staff, might suggest an alteration at the behest of the canons of San Giovanni, in order to emphasise that their version of the Augustinian heritage was superior to that of the *eremitani*, in stressing a symbol of the pastoral care for which the Lateran canons supposedly stood.[17] However, in the complex situation in which Elena owned and endowed the chapel, the canons of San Giovanni housed it, and Antonio Pucci paid for it, it seems impossible to do more than guess at the patrons' differing intentions. Another difference between the engraving and the altarpiece relates to the gazes of three of the saints. In the engraving Saint Mary Magdalene and Saint John look to our left, while Paul and Augustine both look down. But in the painting the Magdalene has swung round to look directly out at the viewer. Cecilia still looks up and Paul down, while John and Augustine now look across, as if behind Cecilia, at each other. The behavioural strictures considered in Chapter 1 suggest how carefully weighed would have been the decision to give a female protagonist such a direct look, and allow the Magdalene to be the one who invited the spectator to admire the example of Cecilia and, by analogy, her imitatrix Elena.

The chapel of Saint Cecilia was an unusual amalgam of a family chapel, in which the commissioner and her husband were buried, and a reliquary chapel with a public face. A work of such grandeur was possible only because the commissioner was valued as possessing abnormal perfection in a woman – 'una vergine di grandissima perfetione', as Don Hieronimo Regino put it in 1518 – and was therefore justified in inhabiting the public sphere. The public presence of this extraordinary widow extended to her spiritual distinction being broadcast in the sermons of one of the canons (Pietro da Lucca) during her lifetime. It was he who wrote to Leo X following her death in 1520, summarising her life and pleading that her name become famous in all Christendom. Towards the end of her life in 1517 she seems to have begun to travel, in order to meet Leo X and the Duke of Savoy, according to the chronicle of Fileno dalle Tuate.[18] She may also have written letters and composed a book on spiritual living.[19]

At first sight the part played by the *beata* Margarita Bichi in designing a processional banner for public use in Siena seems very different to the role of the *beata* Elena in the chapel of Saint Cecilia at Bologna. However, as we have seen, recent research has identified the political undercurrents of the Bolognese commission in the presentation of a prestigious chapel associated with the papacy in a city recently won back as a papal state, and even the importance to the papal government of having obtained the allegiance of a revered Bolognese holy woman. Margarita Bichi was born in 1480, the daughter of Bernardino di Pietro Bichi and Antonia Tagliacci. The Bichi were patricians in the republic and had some claim to nobility through the marquisate derived from their ownership of Rocca Albegna and Vallerona. Margarita was married in 1497 at the age of 17 to Francesco Bonsignor Bonsignori, but was widowed childless in 1505. In her widowhood she became a Franciscan tertiary and was honoured for her piety with the name of the Venerable Emerenzia Bichi, taking for her special devotion the belief in the Immaculate Conception. It is arguable that as the daughter of a marquis, she should not be included in this chapter. However, I suggest that as the daughter of a Sienese burgher living in a republic, she may have held a similar status to the Florentine Andreuccia Acciaiuoli, who had married a count and then, at his death, the Marshal of Queen Joanna of Naples (see p. 101). It seems that she was a Third Order Secular, because she was buried in the public part of the church of San Francesco at Siena, rather than within the monastic cloister, and retained control of her possessions so that she was able to will her own funerary chapel there. In her widowhood she apparently gave away most of her possessions, keeping only a small household of servants, and concentrated on helping the sick through nursing. According to Lusini, when Margarita died she willed that a chapel for the Immaculate Conception should be made at San Francesco, and she desired to be buried in front of the altar. The decoration of the chapel was destroyed by fire in 1555, although the basic structure remains (it is the last chapel on the west side of the north transept). Here, Lusini reported, a confraternity was established called the Compagnia della Concezione, in honour of the Virgin, whom Margarita Bichi had invoked successfully to save Siena from invasion in 1526. According to the 1552 list of mass obligations in San Francesco which he cited, Margarita died in 1532.[20] It was not until 1535, however, that the chapter of the Franciscans agreed the fulfilment of her will with regard to her chapel.[21]

In 1526, at the age of 46, Margarita was asked to help the Sienese government authorities in the battle against the armies of the Medici Pope Clement VII and the Republic of Florence which were besieging the city. She had already impressed them by prophesying the death of her cousin Alessandro Bichi, the treachery of Lucio Aringhieri and the siege they were now suffering.

Through her confessor, Canon Giovanni Battista Pecci, she informed the twenty-one *padri della patria* that as a result of her invocation of the Virgin Mary, the protector of Siena, she had been given the heavenly advice that the people of Siena should honour the Immaculate Conception and should have a banner made to carry in a solemn religious procession. On one side of the banner should be an image of the Immaculate Conception. On the other side there should be a representation of the Virgin guarding Siena and shown as saying to the people of Siena: 'Donasti claves et moenia Seno: funde preces Nato libera facta meo' ('You have entrusted me with the keys and the fortifications of Siena: pray fervently to my Son to maintain your freedom').[22] That Margarita was suggesting an image which had literal currency for the people of Siena is supported by reference to the coinage of Siena, which frequently took the image of the Virgin protecting the city as a motif.[23] Some idea of the image suggested by the *beata* Margarita for her banner may be provided by the representation of the Virgin protecting Siena at San Martino in Siena, painted by Giovanni di Lorenzo Cini in 1527 to commemorate the Sienese victory.[24] It shows the Virgin standing over the city of Siena on her apocryphal symbol of the moon, with the light of the sun behind her. Margarita announced that the siege was a divine punishment, and that to do penance all the citizens of Siena should observe three days of fasting and prayer culminating in confession and communion and the carrying of the banner to the cathedral. There was to be re-enacted the giving of the keys of the city to the Virgin (as of course painted on the banner) – a ceremony which had been observed after the victory of Siena in the famous battle of Montaperti. Through these symbolic acts Siena might yet again vanquish its enemies. Following the carrying out of her instructions, she also directed the forces, instructing them to sally out from Siena in two groups from different gates in the city – a strategy which successfully routed the Florentine and papal armies. Her use of Latin, her sense of history and her leadership were, of course, all unfeminine capacities.

The use of processional banners was common, although their making was normally wholly in the control of masculine institutions and associated with the public display of religious fervour.[25] Nevertheless, there were precedents for the advice of saintly women being asked concerning the use and the design of such *gonfalone* by governments which felt that their cities were in peril. For example, the *beata* Colomba da Rieti had assisted the Perugian government in 1494 when the city was struck by plague and the threat of invasion. In this case the saintly woman was a Third Order Regular – a Dominican tertiary. She too had ordered the performance of religious processions and specified the design on a large banner to obtain divine assistance following the holy visions which were believed to have been given to her.[26] Her banner had included the

image of the city of Perugia and the representation of Saints Catherine and Dominic as its protectors.

Neither of these negotiations was a commission in the ordinary sense, for Colomba and Margarita were asked only to advise that an image should be made in the first place, what it should represent and how the imagery should be displayed. The task of Margarita Bichi was extraordinary in entailing the specification of a visual spectacle in which all citizens of her community were expected to take part, in the most public manner possible and on behalf of those matters of state with which the handbook writers advised her never to concern herself. The *gonfalone* designed by the *beata* Colomba was displayed in the main Dominican church of Perugia, where it may still be seen, and presumably that of Margarita Bichi survived on show at the cathedral, or at San Francesco, for some time. In the case of Margarita Bichi the success of her visual displays was recorded in contemporary printed publications which spread her fame throughout Italy.

Female relatives of candidates for beatification

Being a female relative of a woman who was regarded as worthy of canonisation could also entail some special privileges. A woman like the Florentine Donna Villana delle Botte, who was the niece of a saint, was able in about 1440 to commission a reliquary and an altarpiece from leading artists (Ghiberti and Fra Angelico) in connection with her aunt's veneration and then posthumously to fund her aunt's effigial tomb by making her aunt's grandson her heir. While ordinary laywomen might have feared to will their estate away from other expectant heirs, the relative of a saint would feel confident in earmarking her possessions for the honouring of such a special member of her family. (Indeed, in the case of Donna Villana, her descendants did go to law to try to rescind her will.) As shown in the sepulchre for her aunt, the *beata* Villana, and also in the equally grand effigial monument put up by the Milanese Antonia Rusca for her mother, the *beata* Beatrice, in 1499, the tomb of a female saint presented an unusual opportunity for a woman to fund a full-length, full-size, realistic, marble portrait of a woman actually resting on top of a sarcophagus. Both Villana delle Botte and Antonia Rusca were taking part in a kind of religious politics working to further the veneration of their relatives by commissioning art.

Between 1421 and 1444 Donna Villana delle Botte funded the making of a magnificent reliquary casket by Lorenzo Ghiberti for relics relating to her aunt and namesake, the *beata* Villana, to be placed in the church where her

221

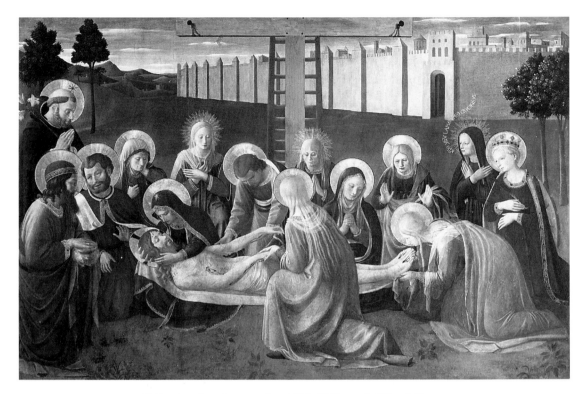

64 Fra Angelico, *Lamentation*, 1436–4[1?], panel, 104 × 164 cm.,
Museo di San Marco, Florence.

aunt was buried, Santa Maria Novella in Florence. It is likely that she also paid
Fra Angelico to paint an altarpiece which gave some prominence to the *beata*
Villana for the Confraternità della Santa Croce del Tempio in the same church.
The casket has not been identified and was probably melted down in 1530, but
what is probably the altarpiece survives in the museum of San Marco, Flor-
ence, and shows the *Lamentation* with attendant Dominican saints (Plate 64).
The saints of post-biblical times have been placed in the outer circle, cluster-
ing round the dead Christ at the base of the cross. At the left margin stands
Dominic, and to the right kneels Saint Catherine. Beside her, also kneeling, is
the *beata* Villana. Fra Angelico has carefully differentiated the status of these
saints, giving Villana a halo of golden rays, whereas the saints who already had
full canonical status have full golden discs over their heads. The *beata* Villana
has been further distinguished with a gilded inscription on her halo: 'B. Villana',
and the words 'Christo Iesu lamor mio crucifisso' ('Jesus Christ my love cruci-
fied') issuing from her lips. Two other women with similar haloes but without
identifying labels also kneel in the outer circle.

222

The *beata* Villana was the daughter of Andrea di Lapo delle Botte, and she married into the Benintendi family (her husband was Rosso Benintendi, the son of Piero). After a short life of impressive prayer and abstinence (between 1332 and 1360), she had asked to be buried at Santa Maria Novella, wearing a Dominican habit. The *beata* Villana had observed a special reverence for Christ crucified, and her own crucifix had been placed on the wall over her tomb slab in Santa Maria Novella in the fifth bay in the nave on the north wall of the aisle.[27] In this painting it seems that Fra Angelico has been asked to emphasise her veneration of the Holy Cross, with special reference to the the dedication of the confraternity chapel of the Santa Croce for which it was commissioned, and also in allusion to her grave nearby. The great-nephew of Donna Villana, Fra Sebastiano, had contracted what was probably this altarpiece from Fra Angelico for the confraternity chapel in 1436, although it seems that it may have taken some time to complete, since Castelfranchi Vegas noted the date 144[?] inscribed on the Virgin's robe.[28] In 1444 Donna Villana willed most of her estate to her cousin's son Sebastiano, and made special mention of the Confraternity of the Holy Cross, giving it a house in the Chiasso dei Velluti on the condition that it celebrated the feast day of *beata* Villana annually. By the ingenious strategy of providing the confraternity with an altarpiece and an endowment, Donna Villana could further the cult of her relative.

The rather background part played by Donna Villana is documented in 1441 when she had commissioned her cousin's son Sebastiano, who was a Dominican friar living at Santa Maria Novella, to erect an altar or chapel at the tomb of the *beata* Villana herself. She endowed the chapel of the *beata* Villana with a house and loggia in the Via Valfonda in the parish of Santa Maria Novella. As we have come to expect, Donna Villana and her cousin's son came from the elite of rich families in Florence.[29] The role of Donna Villana is confirmed in the testimonies of Ghiberti and Sebastiano at a hearing in the convent of Santa Maria Novella in 1445, which was forced by her other relatives, who contested the will. Fra Sebastiano was, not surprisingly, supported in his statements by twenty-four fellow-Dominicans attending the hearing.[30] At this hearing Ghiberti swore that the reliquary had cost 182 florins, and Sebastiano affirmed that 'he had never squandered, nor was he now squandering, the said goods of Donna Villana, but on the contrary *he had always done the will of the said Donna Villana* concerning them' (my italics).[31] He explained that he had already spent money on the reliquary from Ghiberti and the altarpiece by Fra Angelico. Having been vindicated, Fra Sebastiano went on in 1451 to commission a fine sculpted tomb for the *beata* Villana from Bernardo Rossellino, presumably using Donna Villana's money and fulfilling her will.[32] The tomb he chose was a wall tomb and it represented the *beata* by means of a full-length

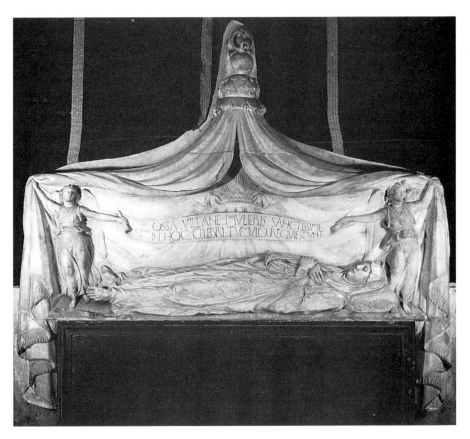

65 Bernardo Rossellino, Tomb of the *beata* Villana, 1451, Santa Maria Novella, Florence.

effigy reclining on top of an elaborately draped bier carved as if with a canopy of drapery, whose swathes two angels lift away to reveal the body (Plate 65). The tomb was carved from white marble, though the effigy rests on a slab of red marble, and the white marble was gilded. The richness of the materials used and the full-size portrayal on *top* of the bier were marks of great distinction; it will be recalled that no female commissioner considered in Chapter 6 accorded herself such a monument.

Because Donna Villana was placed in a position where she needed to use her cousin's son to fulfil her patronage, she might be thought of as playing a merely financial role in these three commissions. Nevertheless, the rebuttal of her relatives' attempts to overturn her bequest had rested on Sebastiano testifying that he spent her money to fulfil her will. Clearly both Sebastiano and Donna Villana would take pride in celebrating their pious relative and encouraging her cult, and the commissioning sequence produced by their partnership

224

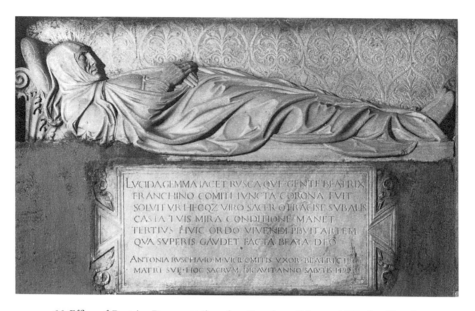

66 Effigy of Beatrice Rusca, attributed to Benedetto Briosco, 1499, Sant'Angelo de' Frari, Milan.

emphasises that having a holy woman for a relation might create an unusual family alliance. While Donna Villana was a member of the *beata* Villana's paternal family (the delle Botte), Sebastiano was a grandson of the Benintendi – the family the *beata* had married into.

The prestigious effigial commemoration which Sebastiano had commissioned to mark the burial-place of the *beata* Villana bears some resemblance to the sepulchre in Milan commissioned by Antonia Rusca to honour her mother, the *beata* Beatrice, in 1499 and attributed to Benedetto Briosco (Plate 66). Again the woman lies in an austere habit, as if on a bier draped with the most precious cloth, though this time the treatment of the face is more realistic. As explained in the epitaph, the woman who put this monument up in the Franciscan church of Sant'Angelo was the wife of Giovanni Maria Visconti. As the wife of a count, she was of lofty rank, and her mother also was a countess – Beatrice Casati, spouse of Franchino Rusca, Count of Locarno. Beatrice's husband had died in 1465, and she had lived as a devout widow and tertiary under the guidance of the Franciscans of Sant'Angelo for the remainder of her life.[33] The inscription on her tomb made a tactful claim to her status as a *beata*:

> Here lies Beatrix, the shining jewel of the Rusca family, who was married to Count Francino. When she was left a widow, the sacred Franciscan Order sustained her in wonderful chastity under the shelter of your wings, and the Third Order provided her with a regime for living such that she rejoices with God among those on high

now that her deeds have been blessed. Antonia Rusca, wife of Giovanni Maria Visconti, dedicated this to her mother Beatrice in 1499.[34]

According to Vincenzo Forcella, Beatrice was listed in the *Menologio Francescano* of Como as a *beata*, having died after twenty-five years of widowhood on 16 March 1490. He reported that she lived in her husband's house in the *contrada* of Brera, and was buried in the church of Sant'Angelo de' Frati Minori, in the chapel that her son Count Giovanni made for her. (Presumably Forcella was referring to her son-in-law.) The original church where Beatrice had worshipped was just outside the Porta Comacina, but it was pulled down and relocated in 1552, although the tomb was brought to the new church.[35]

The patronage by and for women who were especially saintly is quite distinctive. While holy women needed to collaborate with men to achieve their commissions, just like their spiritually less distinguished sisters, their projects were unusual in being in the public eye, just as they themselves were famous for their perfection in piety. In concluding this chapter with the two case-studies of tombs funded for saintly women by their female relatives, it is possible to suggest that the common aim of celebrating a holy woman could produce designs which were very similar, despite the fact that one was commissioned for a well-off Florentine mercantile family, and the other for a noble Milanese family. Both Villana and Beatrice were honoured by female relatives with tombs commemorating their personal perfection as candidates for canonisation. Because this was so, it was possible for them both to be accorded a wall tomb with a full-size sculpted effigy on its lid and inscriptions praising their lives, which would otherwise have been restricted to men. Both Elena and Margarita were also specially licensed in being helped and obeyed by authoritative men. In this sense the commissioning by and for female saints is insulated from that of ordinary laywomen.

Notes

1 Zarri, *Le sante vive*, pp. 52–6.

2 *Ibid.*, p. 128.

3 For the text of the document see Angelo Mazza, 'La chiesa, la cappella, il dipinto', in Carla Bernardini, Gabriella Zarri and Andrea Emiliani (eds.), *L'Estasi di Santa Cecilia di Raffaello da Urbino nella Pinacoteca Nazionale di Bologna*, Bologna, 1983 (which covers the whole commission), pp. 50–103 (p. 68): 'in dotem et pro dote unius capellae quam p[redic]ta Domina Helena iam est annus fundavit, et de novo erexit, ac fundari erigi et construi fecit in ecclesia sancti Johannis in monte predicto iuxta cappella illorum Scarinis, a latere desuper, sub titulo sancta Ceciliae'.

4 Mazza, 'La chiesa', p. 67: 'In tal tempo, et fu nel mese di ottobre del 1513, più volte al sacramento li furon dal Signore dette queste parole. "Figliola io voglio che in vita tua, et non

per mano de tuoi heredi, edifichi una cappella in san Gioani in monte sotto il titolo di Santa Cecilia, dove riporrai le reliquie di quella che sono appresso di te, et se non haverai altra provisione per la fabricha, li spenderai la tua propria dote et comettoti che tu exponi tal intentione al tuo figliuolo Messer Antonio Pucci fiorentino." '

5 *Ibid.*: 'ogni cosa de denari dil sopradetto, qual volse esser il solo, che tal contento desse alla diletta sua madre'.

6 *Ibid.*, pp. 54, 57 (the arms of the Copardi family on the present altarpiece frame come from another chapel).

7 *Ibid.*, p. 74.

8 Stanislaus Mossakowski, 'Raphael's Saint Cecilia: an iconographical study', *Zeitschrift für Kunstgeschichte*, XXXI, 1968, pp. 1–24, especially p. 4.

9 *Ibid.*, p. 6.

10 Regina Stefaniak, 'Raphael's *Santa Cecilia*: a fine and private vision of virginity', *Art History*, XIV, 3, 1991, pp. 358–71.

11 Gabriella Zarri, 'Storia di una committenza', in Bernardini, Zarri and Emiliani (eds.), *L'Estasi*, pp. 20–37, who quotes (p. 33) Giovanni Battista Fregoso, who in his *Collectanea de dictis et factis memorabilibus*, Milan, 1509 (composed about 1506), tells an anecdote of a Bolognese couple who lived in chastity for eighteen years.

12 Josephine Jungić, 'Raphael at Bologna and Savonarola's prophecies of a *Renovatio ecclesiae*', *Art History*, XVI, 4, 1993, pp. 580–99, especially pp. 588–90.

13 Zarri, 'Storia', p. 31.

14 *Ibid.*, p. 37.

15 *Ibid.*, p. 21.

16 Stefaniak, 'Raphael's *Santa Cecilia*', p. 353.

17 Zarri, 'Storia', pp. 26–7, 37: 'significa affermare contro gli agostiniani eremitani la superiorità canonicale', and see Plate 179 for the engraving.

18 *Ibid.*, p. 29.

19 *Ibid.*, p. 34.

20 V. Lusini, *Storia della basilica di San Francesco in Siena*, Siena, 1894, pp. 153–5, 177, 260–1.

21 *Dizionario biografico degli Italiani*, X, pp. 351–3.

22 G. Olmi, *I Senesi d'una volta*, Siena, 1889, p. 94.

23 Beatrice Paolezzi Strozzi, Giuseppe Toderi and Fiorenza Vannel Toderi (eds.), *Le monete della repubblica senese*, Siena, 1992, p. 150, no. 820, Fig. 3.

24 *Ibid.*, p. 143, Fig. 86, and Touring Club Italiano, *Toscana: guida di Touring Club Italiano*, Milan, 1974, pp. 529–30.

25 Francesco Santi, *I gonfaloni umbri del Rinascimento*, Perugia, 1976, *passim*.

26 Giovanna Casagrande and Enrico Menesto (eds.), *Una santa, una città: Atti del Convegno Storico nel V Centenario della Venuta di Colomba da Rieti, Perugia 1989*, Spoleto, 1991, pp. 247–55.

27 Kaftal, *Saints in Italian Art (Tuscan)*, cols. 1017–18.

28 U. Baldini and E. Morante, *L'opera completa di Angelico*, Milan, 1970, p. 83; and L. Castelfranchi Vegas, *L'Angelico e l'humanismo*, Milan, 1989, pp. 86, 105.

29 Molho, *Marriage Alliance*, pp. 365 ff.

30 S. Orlandi, *Necrologia di Santa Maria Novella*, Florence, 1955, pp. 228–41, 482–4.

31 *Ibid.*, p. 482: 'respondetur quod ipse dicta bona domine Villane numquam dissipavit neque dissipat quin ymo de illis semper fecit voluntatem dicte domine Villane'.

32 Anne Markham-Schulz, *The Sculpture of Bernardo Rossellino*, Princeton, 1977, pp. 59–63, 108–10.

33 Maria Teresa Fiorio, *Le chiese di Milano*, Milan, 1985, p. 143.

34 Vincenzo Forcella, *Iscrizioni delle chiese e degli altri edifici di Milano* (12 vols.), Milan, 1889–93, V, p. 8: 'Lucida gemma iacet Rusca qu[a]e gente beatrix / Franchino comiti iuncta corona fuit / solvitur h[a]ecq[ue] viro sacer o[rdo] fra[n]cis[cina]e sub alis / casta tuis mira conditione manet / tertius huic ordo vivendi p[rae]buit artem / qua superis gaudet facta beata deo. ANTONIA RUSCA IO[ANNIS] M[ARIAE] VICECOMITIS UXOR BEATRICI / MATRI SU[A]E HOC SACRUM DICAVIT ANNO SALUTIS 1499.'

35 *Ibid.*

CHAPTER TEN

MARGARITA
PELLEGRINI

What kind of patronage could give laywomen the most prestige – and therefore the most unconventional powers for the feminine? It seems to me that the key factors here were the extent of the project itself and its costliness, the extent to which the commission attracted public notice and the extent to which the woman herself managed to control the enterprise. It seems from the case-studies examined so far that the more a commission was in the public eye and the larger it was, the more likely it was to slip from the sole power of a laywoman, because public importance usually meant being linked with the institutions of Church, monastery or government, and here masculine influence would be needed to ensure success. Consequently, it appears so far from this study that the most elaborate object which a wife or widow could commission according to her individual will would be a lavish family chapel. The Pellegrini chapel in Verona was a commission which is sufficiently well documented to demonstrate the personal control of its patron, Margarita Pellegrini, over nearly three decades. It was extremely expensive because it employed lavish sculpted, rather than painted, decoration. It was built new from the foundations and was a prominent addition to the church, visible from the outside as a virtually free-standing entity. Funerary chapels could attract public attention for a variety of reasons, such as housing a relic, or doubling as a sacristy for the church, or having indulgences attached to prayer before its altar. In the case of the Pellegrini chapel factors attracting public interest were the prestige of the architect Michele Sanmichele, who later worked for the most powerful families and institutions in Verona, the central-plan form which was employed for the commemoration of great men and the classicising erudition demonstrated in the design.

229

We have looked at four somewhat similar chapels: the Cavalcanti chapel at Santa Maria Novella (*c.* 1380); the chapel of the Badoer at San Francesco della Vigna in Venice (*c.* 1490–1508); the Duglioli chapel at San Giovanni in Monte at Bologna (1513–17); and the chapel of the del Doce in San Domenico, Naples (*c.* 1519). It is instructive to compare these examples with the Pellegrini chapel, which is the sole case-study considered in this final chapter. All these chapels were private because their upkeep was the responsibility of a woman and those she designated. But they were also viewable by the public. In addition, the Cavalcanti chapel doubled as the sacristy of the church and the Duglioli chapel held an important relic which any might wish to pray beside. The Cavalcanti and the Duglioli chapel were actually built new from the foundations, but while the former seems to have been under the control of Andreuccia Acciaiuoli, the latter was at least partly supervised by the cleric Antonio Pucci, and was not the sole responsibility of Elena Duglioli. The Badoer chapel had to be created twice, because of the rebuilding of San Francesco della Vigna, and while Agnesina Badoer was assisted by her husband in the first phase, she had a son to deputise for her during the second phase of chapel-building. The del Doce chapel made an impressively classicising effect, but the new order of semi-columns was only applied to the original Gothic structure by Antonina Tomacelli. The closest to the Pellegrini chapel, because it was erected new from the foundations and entailed an elaborate decoration apparently controlled by the commissioner herself, is the Cavalcanti chapel. Whereas the latter had entailed funding a painted polyptych and an elaborate stained-glass window, both placed under a Gothic cross-vault, the latter concentrated almost entirely on the very expensive splendour of the architectural structure itself and its elegant sculpted adornment for its effect.

The Pellegrini chapel in Verona was designed by the local architect Michele Sanmichele, and consists of a large cylindrical *cella* crowned by a dome and lantern, attached to the south side of San Bernardino (Plates 67–70). It was built between about 1529 and 1557 for 'the Noble and Most Honourable Margarita, widow of Benedetto Raimundi' as a funerary chapel for her son and for herself.[1] In hiring him, Donna Margarita provided Sanmichele with an opportunity to demonstrate the latest architectural ideas, which favoured central plans. Sanmichele had returned to Verona only two years previously, after a long absence during which he seems to have studied in the rest of the Veneto and in Rome, and was presumably glad of the opportunity to show what he had learnt. The chapel was something of a showcase displaying antiquarian zeal for re-creating the classical orders. In fact the rendering of ancient Roman architectural ornament here is so exact that the effect has been compared to the neoclassical styles of the eighteenth century.[2] The creation of elaborate

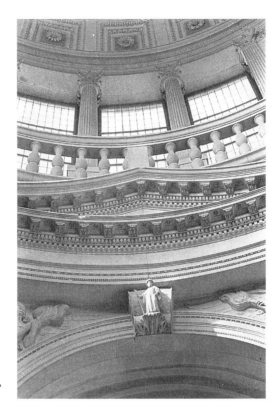

67, 68
Michele Sanmichele, Pellegrini Chapel,
San Bernardino, Verona, 1529–57.

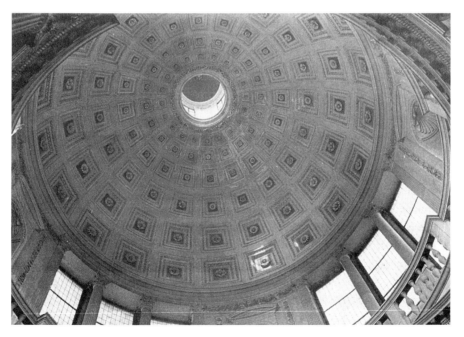

centrally-planned chapels was conventionally the act of rich and powerful men – men like Julius II, the banker Agostino Chigi or Cardinal Giulio de' Medici. The fact that this centrally-planned chapel was commissioned by a woman meant that it was designed differently; and because it was so innovative and perfectionist, it threatened to disrupt contemporary notions of women as passive rather than leading in thought, and as imperfect rather than capable of initiating an exquisite design.[3]

Any idea that Donna Margarita mechanically ordered a funerary chapel to fulfil social expectations and just chanced on Sanmichele is dispelled when one reads her wills. In her 1534 will, for example, she spoke of her desire to see the chapel brought to 'its most perfect and most dignified beauty'.[4] In her 1554 will she justified making the College of Notaries the patron of the chapel and endowing it for its upkeep 'so that a work of such superlative beauty may be maintained in its laudable state and be decorously conserved'.[5] That she considered herself to understand the design thoroughly and have responsibility for it is documented in her lawsuit of 1538 with the mason whom Sanmichele had left with the task of executing the scheme. Margarita appealed to the *podestà* of Verona to be allowed to dismiss Master Paolo the mason, because of his insolence. The *podestà* 'declared that she could choose a capable stonecutter who would complete the chapel and that with regard to the difference there is between the parties, Master Paolo would have to give her recompense'.[6] Her personal concern for the execution of this chapel is suggested in her last will, of 1557. With the chapel still not quite complete, two of her witnesses were stonecarvers, arguably working on the chapel at that time.[7]

The floor of the chapel is raised above the level of the nave, presumably to provide for the burial-vault. The chapel is also secluded by means of the vestibule, which allowed the cylindrical *cella* of the chapel to be placed at a distance from the wall of the nave (Plates 69–70). This was required because the design of the chapel needed thick lower walling to support a balcony, and because the further away the cylinder could be placed from the nave, the better the lighting would be for the windows in its drum. The entrance to the chapel from the nave is a relatively simple portal, but the doorway leading from the vestibule to the *cella is* exquisitely elaborate, and arguably takes its design from the main door of the Late Antique church of San Salvatore at Spoleto – a church which Sanmichele is thought to have visited on his journey to Rome.[8] Leading from the west side of the vestibule a stair was built, rising to the balcony running round the inside of the drum and to a room placed directly over the vestibule, perhaps designed to keep the things used for the funerary masses prescribed by Margarita, for which no storage space was available below. The geometric simplicity of the design with cylinders and hemispheres is echoed in

the rationality of the proportions in which the height of the chapel up to the entablature is twice the diameter of the *cella*.

The lower order comprises eight bays – wider bays containing arches alternating with narrow bays decorated with shell-vaulted niches. Fluted Corinthian columns support the entablature, while the wider bays are crowned with triangular pediments. The design alludes to the motif of Roman triumphal arches to frame the three altars and the door. Since the Corinthian order was used, the decoration could be as ornate as possible. The semi-columns are all fluted, but those framing the main altar and the door are distinguished with spiral fluting. Swags are carved between the capitals, and plaques of veined marble have been placed over the shell-vaulted niches. The imagery of the Roman triumph is sustained in the Victories carved in the spandrels, except that they have been Christianised to hold the symbols of the Passion, and therefore to signify the triumph over death. The chapel is lit by four large windows in the drum, sustained by pairs of fluted columns. The balcony provided a private position for viewing the chapel as well as a visually rich transition from the first to the second order of decoration for the spectator below. The interior of the dome was coffered and was topped by an elegant lantern. Throughout, the ornamentation is of the most varied beauty and interest, inviting, for example, close inspection of crisply carved flora and fauna, or naked satyrs and sea-nymphs sharing a pilaster, and visual pleasures on every side.

Margarita came to have the money and the social approval to commission this magnificent chapel only after the death of her husband and son. She was in her mid-thirties when she commissioned the chapel as the funerary chapel of her only son Niccolò, who had died at the age of 18, leaving her as heir to his fortune, in 1528. She was from the *contrada* of Mercato Nuovo, situated in the centre of Verona, by the cathedral. The Pellegrini were a family who were eligible for a seat in the *consiglio* or council of the city, and, as one can tell from the existence of the Pellegrini chapel in Sant'Anastasia, had been powerful in the community for more than a century.[9] In 1509, when she was 15, she had married Benedetto Raimundi de' Guareschi – a man from a *nouveau-riche* family – who was only the first of his line to be listed in the *consiglio*. However, he died in 1522, leaving their only son as heir.[10] Margarita was an extremely wealthy woman, whose large household is recorded in the censuses of Verona as on a par with those of rich merchants and lawyers of the city. In 1529, for example, when she launched her project for the chapel and was living in the *contrada* of San Benedetto, near the cathedral, the household she was head of consisted of her daughter Anna, two of her brothers, the illegitimate brother of her husband and a chaplain, all waited on by nine menservants and eight maidservants.[11]

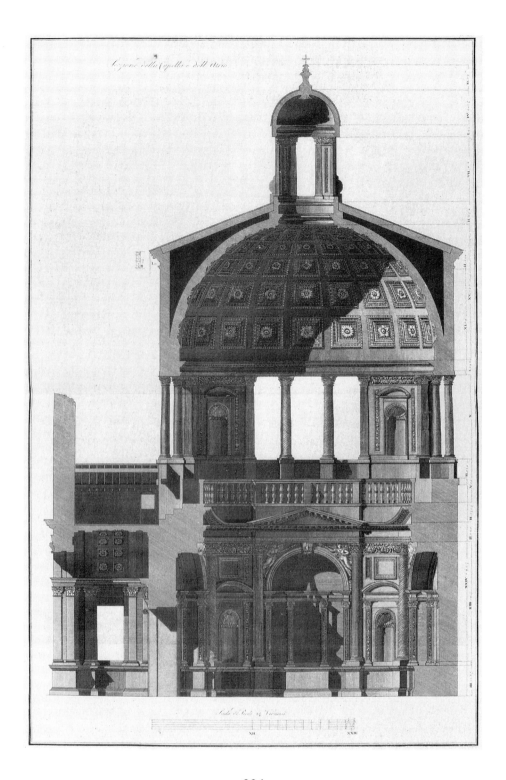

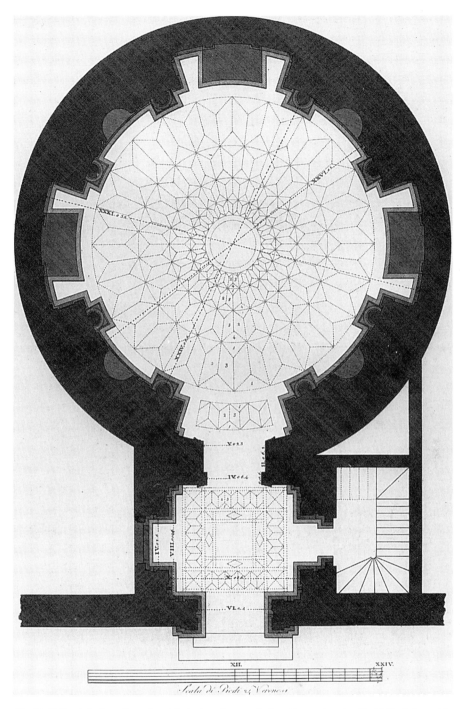

69, 70 Pellegrini Chapel, section (*facing*) and ground plan. Engravings by B. Giuliari, from his
La cappella della famiglia Pellegrini, Verona, 1816.

235

In planning her chapel Margarita had the precedent of the elaborate funerary chapel placed by the Pellegrini family in the church of Sant'Anastasia, near her home, decorated by Pisanello (1433–35) and containing the tomb of her fore-bears.[12] In contrast, her husband's family grave was much more plainly marked with an inscription in the graveyard of San Bernardino, a church recently built by the Franciscans on the outskirts of the city. It was in this grave that her husband asked to be buried with his father and grandfather, and so it was there that she built the funerary chapel for her son.[13] In 1529 she made her first will, in which she asked 'to be buried in the monument that she has ordered to be constructed [*construi statuit*] for the body of the noble Niccolò, her most beloved son, in a chapel which she has at this time begun [*iam per eam inchoati*] at San Bernardino, dedicated to Saint Anne'. She named her architect as Michele Sanmichele, and desired that 'he should be satisfactorily paid for his work and his industry for completing the chapel, and if necessary the matter should be judged by her executors, in case, while still living, she should have been at all remiss in her sense of rightness and her discrimination'.[14] The fact that Sanmichele's family came from the *contrada* of her married home at San Benedetto may have informed her choice. (There were forty-seven *contrade* in Verona.)[15] The clause was repeated in all her four wills and suggests that she was keen that her architect should have his due.

In her two early wills, of 1529 and 1534, the chapel is spoken of as 'for her son'. But by the 1554 and 1557 wills, it was called 'her chapel' ('eius capella' and 'sua capella').[16] The 1554 will suggests her view of her chapel, since

> she ordered that her body be buried in her chapel of Sant'Anna, which Donna Margarita has herself had built, and erected at great expense (although not yet quite perfected), in the church of San Bernardino, so that she may rest in the monument that she has decreed to be made in the said chapel, united with her most beloved children, who were snatched from her, at their premature deaths.[17]

Because there were no legitimate male heirs to the Raimundi fortune, Margarita's family stood to inherit this wealth at her death. In order to allow her to make him heir to her fortune, her father emancipated her, making her free in law from his paternal control, so that she could have a full independent legal persona. Consequently in her 1529 will she was able to make her father her heir, while in the later wills her brothers were her heirs. In 1534 she had five brothers, and she made further wills in 1554 and 1557, when Giacomo and Guglielmo, respectively, died. It is suggested that they would have approved of her expensive building plans for at least two reasons. Firstly, the lavish expenditure on the chapel was a public statement by the Pellegrini family that a decent amount of the massive Raimundi windfall was spent on the dead Niccolò Raimundi. And

secondly, the commitment throughout the rest of her life to the slow building of the chapel emphasised Margarita's social, and even emotional, identity as the Raimundi widow, not as someone who might marry again. From the information given in the civic censuses, it appears that four of her brothers (Giacomo, Vicenzo, Teodoro and Guglielmo) were younger than she was, while the age of her other brother, Marcantonio, is not known. These men could expect to outlive her and benefit personally from the windfall of the Raimundi fortune. It is important to emphasise that although she was head of her household, first in the *contrada* of San Benedetto near the Piazza del Bo and later in the 1540s in the *contrada* of San Vitale over the river Adige, she was surrounded by her family. In 1529 her brothers Guglielmo and Teodoro were living with her.[18] In 1545 and 1553 their places had been taken by her brothers Giacomo and Vincenzo.[19] In 1557 Giacomo was dead but Vincenzo was still with her, and was joined by his wife Cassandra.[20] Like any other widow, Margarita moved back into the orbit of her father's family. The tax censuses show that as a widow, the large household she headed always contained several members of the Pellegrini family (brothers, nieces or nephews). The chapel prioritised the Pellegrini arms – placing the eagle of the Raimundi on the keystones of the side arches and giving the little pilgrim of the Pellegrini shield more prominence over the doorway and main altar. Had she wished the chapel to be devoted solely to the memory of her son, she should have given precedence to the Raimundi shield, or possibly represented his arms alone. Other commissioning widows provided ample precedents for Margarita in employing the arms of their father as well as that of their husband. But these women placed their husband's arms in the commanding position to the left, while they had their own shield to the right, or they put his above theirs.

The duality of familial allegiances in this chapel is one sign that it was a feminine commission, although Margarita's prioritising of her natal coat of arms was unusual. Secondly, the chapel was distinctive of female patronage because it was only for a boy, and his mother created conditions that were especially favourable for Sanmichele to design what was regarded as the best kind of centrally-planned building, the perfectly circular kind. Tomb portraiture for women, as we know from Chapters 6 and 9, was very uncommon, as it was for males who died young. The chapel, with its central burial-vault and the three equal-sized altars, can be contrasted with the square plans which were favoured by male patrons to accommodate their full-size tombs, often with effigies. The Chigi chapel at Santa Maria del Popolo in Rome, for example, provided on its side-walls for commemorations of Sigismondo and Agostino, employing bronze portrait profiles placed on tall pyramids.[21] Such requirements acted against the non-axiality characteristic of the most perfect central plans. In

the Pellegrini chapel only the slab closing the vault gave the names of Margarita, Niccolò and his sister Anna. As argued by Wittkower on the basis of contemporary texts, a circular chapel was so prized because the circle and sphere were regarded as the most perfect geometric figures, best suited to honouring God, and in mystic terms reaching out to the spiritual, because they most closely imitated God's perfection and that of his spherical cosmos.[22] Because of the notion that the feminine and the young had lower temporal status, Margarita could commission Sanmichele to create a chapel regarded as stronger in spiritual terms, and perhaps in artistic attainment too. Through this paradoxical route, Margarita's acceptance of the ordinary social conventions for the modest entombment of women and boys enabled Sanmichele to allude in his design on her behalf to the latest scholarly and philosophical discussions which saw the purest central plans as the most elevated representations of holiness and as having a talismanic character in drawing down the power of God to the devout.

Thirdly, the chapel was also marked as feminine because she chose to dedicate it, not to a male patron saint for her son, but to the patron saint of childbirth and mothers, Saint Anne.[23] The altarpiece shows Saint Anne with the Virgin and Child. On either side are their husbands, Joseph and Joachim, while God the Father is represented above. This was made after Margarita's death, with Bernardino d'India painting the centrepiece in 1579 and Pasquale Ottimo providing the other elements soon after. It seems significant that Anna was the name of her only daughter, aged 8 when Margarita began building (and probably born close to the time of her father's death).[24] In her wills of 1529 and 1534 Margarita provided for a large dowry for her daughter Anna. In 1534, for example, she assigned 450 ducats of her own and also 1,000 ducats from the money belonging to Benedetto's estate for Anna's dowry.[25] But Anna died soon after, in her teens. By the 1554 will there was no longer any sum set aside for Anna and instead Margarita contributed to the dowry of her niece Livia, whose upbringing she had been put in charge of – 'quae ad haec sub regimine et cura eius domina testatrix est'.[26] Margarita could never have planned that her daughter would be buried in the chapel, because a woman had the right to choose her place of burial, and could well have chosen to be buried with her husband. However, the choice of name might indicate the veneration of Saint Anne by Margarita. In her wills she ordered that a mass be celebrated for the Feast of Saint Anne. The reading from the Old Testament for the Feast in the contemporary missal was from Proverbs 31, which praised the prudent housewife and the virtuous woman, of 'strength and honour'. The New Testament reading was from Matthew 13, which compared the Kingdom of Heaven to 'a pearl of great price'. This reading might have had special resonance for the patron, because *margarita* is the Italian for 'pearl'. This was

a socially acceptable decision, and yet, as with the prioritisation of the Pellegrini coat of arms, it is interesting that she chose to emphasise a woman saint.[27]

Fourthly, the commission was feminine because she could rely on no one in her family to complete it, since she could not hand her chapel on to a single line of heirs. So she placed the patronage in the hands of another institution, in this case the College of Notaries of Verona. She endowed them so that they would maintain it and make her brothers complete the chapel if it were unfinished at her death. In her will of 1554, for example, she made the College of Notaries responsible for spending 200 scudi a year on the chapel (exacted from her remaining four brothers at the rate of 50 scudi each) until her chapel was brought 'to its perfect beauty' ('ad suam perfectam formam'). She also paid the College of Notaries to visit the chapel annually after its completion with one of her heirs, to decide on any repairs required and to ensure that the friars at San Bernardino performed the annual funerary commemoration of herself and her children, lighting two candles each weighing 3 pounds at her sepulchre.[28]

In some ways Margarita behaved according to the precepts of the male moralists who told widows how they should live. As they instructed, she always had one or more brothers living in her household. As a guarantee of her piety, she always had a household chaplain. (In 1529, for example, she had a chaplain called Don Gregorio – who was aged 34.)[29] And in her wills she put her father and brothers first, making tiny bequests only to female convents.[30] But the writers of books on the behaviour of widows asked for something more. If they were tough, like Savonarola (1491), they asked for abstemiousness in spending and in the pleasures of the senses. If they were more indulgent, like Trissino (1524), they still demanded moderation.[31] Furthermore, they required either total self-effacement or at least a retiring attitude. The upper-class widow was supposed to confine herself to the private sphere of the home. This is where Margarita's commission broke the rules. The chapel was very obviously not abstemious, and as it developed into what she called 'her chapel' it was clear that it drew attention to her personally – to her natal family and to the honour of a female saint. Indeed, when her three surviving brothers, Vincenzo, Teodoro and Marcantonio, came to place the only inscription there is in the chapel from the sixteenth century – on the burial-vault – they dedicated it to her, explaining that she had had the chapel made to bury herself and her son and daughter:

To Margarita Pellegrina, a woman distinguished by her probity and prudence. After the death of her husband, Benedetto Raimundi (who would have chosen the place of burial had he lived), she built this chapel for herself and for her most obedient children Niccolò and Anna, who left her heir to the entire estate when they died of disease in the flower of their youth. She lived 64 years, and was a

widow for 35 of those years. She died in the year of our salvation 1557, leaving her brothers as her heirs.[32]

Perhaps most important of all, the chapel gradually gained a reputation as a demonstration of artistic inventiveness by Sanmichele. It began as a private monument, suited to a widow's patronage. When it became, in the words of Vasari in 1568, 'a most beautiful and most ornate chapel'[33] which he marked down as a significant work of contemporary architecture, it left the local family domain and entered the public arena as a building regarded as one which any architect or patron should visit as a model of good style and practice. Although Margarita died in 1557, eight years before Vasari visited Verona, the fact that she called her chapel 'a most beautiful and laudable work' ('pulcherrimum opus in suo laudabili esse') in her will of 1554 suggests that she had already begun to consider it as a work of art to be looked at, judged and praised.[34] The superlatives that she, and later Vasari, used about her chapel suggest that she had strayed from the moderation widows were advised to observe. It may be recalled, for example, that Trissino had advised: 'In your dress, it is praiseworthy to look well turned out, but not excessively fashionable' ('Ne l'habito vostro poi, lodo *l'essere ornata*, ma non sfoggiata') (my italics; see Chapter 1, p. 36).[35] But Margarita Pellegrini made a chapel which Vasari termed 'the *most* ornate' ('ornatissima').

It is suggested that the threat of this symbolic slippage is conveyed in the bizarre diatribe which Vasari launched against her 'avarice' and her 'poor judgement', after he had praised Sanmichele:

> this work, after having been left unfinished by Michele, I know not for what reason, was given either from avarice or from lack of judgement [*poco giudizio*] to certain others to be finished, who spoiled it, to the infinite vexation of Michele, who in his lifetime saw it ruined before his very eyes, without being able to prevent it; wherefore he used to complain at times to his friends, but only on this account, that he had not thousands of ducats wherewith to buy it from the avaricious hands of a woman who by spending less than she was able, was shamefully spoiling it [*vilmente guastava*].[36]

That the specific form which Vasari's criticism took was not arbitrary is suggested by Ian Maclean's survey of concepts about women in the connected discourses of law, theology and medicine. Maclean stated that in law, according to the *Digest*, women's

> debarment from succession, office and privilege, is justified by her *levitas, fragilitas, imbecillitas, infirmitas* [fickleness, weakness, feebleness, inconstancy]. These words recur often in the *Digest*, and in legal texts of the Renaissance; they are often linked with a recital of female vices, grouped according to their relationship to avarice, ambition and sensuality.[37]

240

There were, then, good reasons why Vasari would have associated avarice with poor judgement in a woman, and seen them as markers of feminine difference. In the same passage Vasari presented this chapel as a canonical work in which Sanmichele had demonstrated the solution to the problem of creating a perfectly circular liturgical space, following similar experiments like Brunelleschi's octagonal ground plan for the church of Santa Maria degli Angeli in Florence. It seems possible that Vasari's diatribe carries traces of the views of Paolo da Porlezza, the cousin of Sanmichele, who had been put in charge of the execution of the chapel but had been dismissed by Margarita in 1538 and made to pay her for his mistakes. That the dismissal had been acrimonious is documented in the deposition on behalf of Margarita to the *podestà* – which described Paolo as having treated her with insolence ('contumacia').[38] Vasari's statement certainly does not square with Margarita's attentiveness to her architect in all her wills. And it is significant that Giuliari, who performed the first restoration, in the late eighteenth century, expressed surprise at the assertion.[39] The lack of swags on the upper order and the disproportion of the blind niches at this level were the only things he felt it appropriate to correct.

It is suggested that, for Vasari, this feminine patron challenged the idea that knowledge of the art of antiquity and appreciation of the erudite and rational interpretation of ancient texts on architecture and ancient buildings should be confined to men. The kind of perfection which Sanmichele had produced for Margarita Pellegrini threatened contemporary notions of gender difference, inviting the collapse of the binary divisions supposed to separate male from female and always used to represent the woman as inferior.[40] While the feminine was supposedly private, imperfect, ignorant and poor, Margarita had slipped across the gender divide to achieve a perfect, learned and tremendously expensive building, which belonged to the admiring public gaze as a Great Work in the History of Art. The modern art historian will want to extend the comparisons well beyond the example of Brunelleschi and consider among others the ancient precedent of the Pantheon and the modern exemplar of the martyrium of Saint Peter by Bramante at San Pietro in Montorio.[41]

Given the conscious artistic importance of this chapel, it is intriguing to consider how a noble widow of Verona could have gained the intellectual breadth, confidence and daring to commission it. There is no proof that the patron could read or write. Margarita's wills were spoken, not written, wills, and they list houses, land, shop-rents and furniture – but not books, statues or pictures. All the wills are copies, so no signatures are recorded. But Margarita could at least see ancient Roman architecture, simply as an inhabitant of Verona. The Arena was the largest surviving ruin, but the city was so rich in Roman remains that Caroto, in his archaeological survey of Verona printed in

1540, claimed that it was second only to Rome.[42] Perhaps most important for her knowledge was the survival of four Roman portals in Verona from whose detailing and forms Sanmichele drew freely. For instance, the Arco de' Gavi demonstrated the motif of the tall central archway flanked by narrower bays containing niches. The Arco di Giove Ammone would have offered models of Corinthian columns decorated with twisted fluting.[43] This no longer survives, but is shown in the engraving by Caroto published in 1540. The upper order of the Arco de' Leoni could provide a visual preparation for the treatment of the upper order in the chapel. Here she could see free-standing columns with spiral fluting, raised on a base to create the effect of benches. The wealth of classical exemplars close at hand had added significance for Margarita because she was a disabled woman. In her first will of 1529, when she was 35 years old, she was described as suffering from 'debilitatio', which means weakness in the upper or lower limbs. Since the lawyer went on to describe her as seated in a 'cathedra' to speak her will, she was probably disabled in her legs. (A 'cathedra' is a chair with arms and a backrest, or a litter.) The lawyer wrote that she had suffered from this disability for many years. In her other wills she was described as being well, except for her long-standing disability.[44]

With male patrons we might expect to study some printed and written sources to understand their motives, but with women of Margarita's status, it seems wiser to concentrate on the visual material available to her. And with special reference to her disability, the more local ones seem to be the more useful. At San Fermo, for instance, the Torello Saraina altar, dated 1523, could have made a strong impression. It employed the form of the Arco de' Gavi, and it was commissioned by a Veronese family with antiquarian interests. A member of the family was one of the speakers in the Latin treatise 'On the Origin and Enlargement of the City of Verona' published by Caroto in 1540. Another important model – in this case to demonstrate the splendid effects provided by a coffered dome – could be found in the chapel of San Biagio at Santi Nazaro e Celso. The chapel was square in plan and had a polygonal apse, but it sustained a hemispherical dome which was painted with fictive coffering. The chapel was being built from 1488 onwards, and the pendentive paintings are inscribed by Falconetto.[45] However, this was an important reliquary chapel for the use of the general congregation, and Margarita was taking a bold step in providing a dome for a family chapel.

It seems likely that she would have had some male advice. The commissioners of the tomb of Girolamo and Marcantonio della Torre at San Fermo are strong candidates as her advisers. They were Giulio and Raimondo della Torre, who probably planned the tomb to hold the bodies of their father and their uncle. This monument is attributed to Andrea Riccio, the Paduan bronze

sculptor, and was commissioned about 1510. The family of the patrons of this erudite and expensive work was mentioned in Margarita's wills. In 1529 she sat in the house of Giulio della Torre, doctor of law, to declare her will in front of all her witnesses, and she listed him and Raimondo among her executors. In 1557 Giulio's son, Girolamo, was one of her witnesses.[46] This family had chosen in their sepulchre to commemorate their dead with Christian adaptations of a wealth of Antique motifs and pagan Roman funerary themes.[47] These social connections suggest ways in which Margarita could have acquired the taste to commission such a learned work by Sanmichele.

When Margarita commissioned the chapel, Sanmichele was a mature architect in his late forties, but a man who had not yet established his reputation in his native Verona, where he had not spent much time. Margarita made a leap in taste when she hired him, and presumably gave him an important opportunity to demonstrate his skill to other, more powerful patrons. During the long period of building, I think we can infer that she would have taken pleasure in the affirmation of her taste as she saw her architect being asked to redesign the city gates, adorn civic buildings, create a new circular choir for the cathedral, build palaces for the most powerful families – one of which, the Palazzo Bevilacqua, used similar articulation to that in her chapel – and plan a massive dome for the new church of San Giorgio in Braida.

Notes

1 For further illustrations see L. Puppi, *Michele Sanmichele: architetto da Verona*, Padua, 1971, pp. 41–5.

2 Pierpaolo Brugnoli, *Architettura sacra a Verona dal secolo X al secolo XVIII*, Verona, n.d., p. 405: 'ellenistica raffinatezza . . . sottile e vibrante'.

3 Alison A. Smith, in her 'Locating power and influence within the provincial elite of Verona: aristocratic wives and widows', *Renaissance Studies*, VIII, 4, 1994, pp. 439–48, analyses the control by women of the ruling families in Verona of amounts smaller than the estate owned by Margarita Pellegrini, but which were nevertheless substantial, in the form of their dowries.

4 ASV, Notaio Geronimo Piacentini, Massa 126, will no. 177, 19 August 1534: 'ad eius perfectissima et dignissima forma'.

5 *Ibid.*, Massa 146, will no. 490, 22 December 1554: 'ut tale pulcherrimum opus in suo laudabili esse, et decore conservari et manuteneri possit'.

6 R. Brenzoni, 'La sanmicheliana cappella Pellegrini in S. Bernardino di Verona: retrodatazione del progetto e dell'inizio della fabbrica all'anno 1527c', *Atti dell'Istituto Veneto di Scienze, Lettere ed Arti*, CXV, 1956–57, pp. 119–31. G. da Re, in 'La cappella Pellegrini di S. Bernardino', *Madonna Verona, Bollettino del Museo Civico di Verona*, VIII, January–March 1914, pp. 52–4, analysed the lawsuit which Margarita undertook in 1538 with Paolo da Porlezza (quoting the Antichi Archivi Veronesi, Atti dei Rettori Veneti, no. 51, 8 July 1538: 'declaravit ipsam Dominam Margaritam posse eligere unum idoneum lapicidam qui habeat perficere assertam capella, de qua est differentia inter partes et hoc damno et expensis et interesse dicti magistri Pauli'.)

7 ASV, Notaio Geronimo Piacentini, Massa 149, will no. 455, 24 September 1557: 'Jacobo lapicidi filium Cristoforo et Antonio lapicidi'.

8 L. Magagnato, *Arte e civiltà a Verona*, Verona, 1991, Fig. 98.

9 Paola Lanaro, in 'Essere famiglia di consiglio: social closure and economic change in the Veronese patriciate of the sixteenth century', *Renaissance Studies*, VIII, 4, 1994, pp. 428–38 (especially p. 432), pointed out that the Pellegrini were members of an inner ring of ruling families who held on to conciliar office over a long period. Antonio Cartolari, in his *Famiglie già ascritte al nobile consiglio di Verona*, Verona, 1854, pp. 198–205, shows that the Pellegrini were listed as belonging to the council between 1405 and 1682; while on p. 226 Margarita's husband Benedetto appears as the first Raimundi to belong to the council in 1517.

10 B. Giuliari, in *La cappella della famiglia Pellegrini*, Verona, 1816, p. 7, affirms that Benedetto was the sole heir of his father and Niccolò was the sole heir of Benedetto, while Niccolò made his mother sole heir in 1528.

11 ASV, Anagrafe della contrada di San Benedetto, 1529, II, 65. Listed as Erede di Benedetto Raimundi.

12 G. Benini, *Le chiese di Verona*, Verona, 1988, p. 74. The chapel was elaborately decorated with terracotta reliefs by Michele da Firenze and murals by Pisanello.

13 Dianin, *San Bernardino da Siena*, pp. 171–82. The tomb in the cloister bore an inscription stating that Francesco Guaresco de' Raimundi had had the tomb made for his father Raimundo in 1481.

14 ASV, Notaio Geronimo Piacentini, Massa 121, will no. 455, 15 October 1529: 'Volens et mandans satisfieri debere Magistro Michaeli de Proletio eius architecto pro opere et industria sua ut arbitrabatur per infrascriptos commissarios casu quo ipsa Domina vivente, cuius conscientiae et discretioni remissum est non efficiat.'

15 Puppi, *Michele Sanmichele*, p. 11. For information on the forty-seven *contrade* see M. Lecce, *Gli antichi estimi veronesi: condizioni economico-social di Verona a metà del secolo XVI*, Verona, 1953, pp. 17–35.

16 ASV, Massa 146, will no. 490, 22 December 1554: 'eius capella'; and Massa 149, will no. 455, 24 September 1557: 'sua capella'.

17 ASV, Notaio Geronimo Piacentini, Massa 146, will no. 490, 22 December 1554: 'sepeliri iussit in eius capella sub vocabulo Sanctae Annae. Quam capellam ipsa Domina erigi, et construi fecit non sine magna impensa, licet nondum perfecta sit, in ecclesia Sancti Bernardini apud dilectissimos filios ipsius Dominae ut una secum conquiescat, postquam praematura morte sibi fuerint erepti in monumento, quod ibi in dicta Capella statuit fieri facere'.

18 ASV, Anagrafe di San Benedetto, 1529, II, 65, listed under 'E' for Erede di Benedetto Raimundi.

19 *Ibid.*, Anagrafe di San Vitale, 1545, XXIX, 1182 and 1553, XXIX, 1183, listed under 'M' for Madonna Margarita de' Raimundi.

20 *Ibid.*, 1557, XXIX, 1190, listed under 'M' for Madonna Margarita de' Raimundi.

21 J. Pope-Hennessy, *Italian High Renaissance and Baroque Sculpture* (3 vols.), London, 1963, catalogue volume, pp. 43–5.

22 Rudolf Wittkower, *Architectural Principles in the Age of Humanism*, London, 1949, pp. 1–28.

23 *Bibliotheca sanctorum*, I, Rome, 1961, cols. 1269–76 (especially col. 1271).

24 ASV, the Anagrafe for the *contrada* of San Benedetto, III, 81 for 1527 lists Margarita as aged 36, Niccolò as aged 17 and Anna as aged 7. The Anagrafe for the same *contrada* in 1529, II, 65 listed Margarita as 35, Anna as 8, and does not mention Niccolò. Discrepancies in the information about the ages of different members of the household recur.

25 *Ibid.*, Notaio Geronimo Piacentini, Massa 126, will no. 177, 19 August 1534.

26 *Ibid.*, Massa 146, will no. 490, 22 December 1554. Livia's dowry was, at 600 ducats, significantly less than the one planned for Anna of 1,450 ducats in 1534.

27 *Missale romanum noviter impressam ordine quodam miro*, Venice, 1519, fos. 286 verso – 287 verso: 'fortitudo et decor' (Proverbs 31) and 'preciosa margarita' (Matthew 13).

28 ASV, Notaio Geronimo Piacentini, Massa 146, will no. 490, 22 December 1554. The reliance on the College of Notaries may suggest that she could not trust the promises of her brothers to complete or maintain her chapel.

29 *Ibid.*, Anagrafe of the *contrada* di San Benedetto, 1529, II, 65. This chaplain was still with her in 1545 (Anagrafe of the *contrada* di San Vitale, XXIX, 1182), but had been replaced by 1557 with another – Jacopo, aged 32 (*ibid.*, 1190).

30 In 1529, for example, she willed 20 ducats to the nuns of Santa Chiara and the same sum to the nuns at Santa Caterina for prayers for her soul, while giving 5 ducats each to her servants and singling out her personal maid (300 ducats) and the nursemaid of her daughter Anna (200 ducats) for generous legacies. The modest religious bequests are repeated in the subsequent wills (ASV, Notaio Geronimo Piacentini, Massa 121, will no. 455, 15 October 1529).

31 Savonarola, *Libro della vita viduale*, fos. cii–ciiii, and Trissino, *De la vita che die tenere una donna vedova*, fos. B iv verso and cii recto.

32 G. B. da Persico, *Verona e la sua Provincia*, Verona, 1838, p. 147: 'Margaritae Peregrinae, insigni probitate ac prudentia foeminae, quae extructum a se post Benedicti Raymundi coniugis mortem sacellum, locum sepulturae hic vivens optaret, sibi Nicolaoque et Annae filiis obsequentiss. a quibus in ipso aetatis flore morbo consumptis testamento haeres ex asse relicta fuerat vixit ann. LXIIII, vidua XXXV, obiit vero anno a salute nostra MDLVII, relictis fratribus haeredibus.'

33 Vasari, *Vite*, VI, pp. 353–4: 'bellissima ed ornatissima cappella de' Guareschi in San Bernardino'.

34 ASV, Notaio Geronimo Piacentini, Massa 146, will no. 490, 22 December 1554.

35 Trissino, *De la vita che die tenere una donna vedova*, fo. B iv verso.

36 Vasari, *Lives*, VII, pp. 225–6. The original text is in Vasari, *Vite*, VI, pp. 353–4.

37 Ian Maclean, *The Renaissance Notion of Woman: A Study of the Fortunes of Scholasticism and Medical Science in European Life*, Cambridge, 1980, p. 78.

38 Re, 'La cappella Pellegrini', pp. 52–4.

39 Giuliari, 'La cappella', p. 4, lists all the minor repairs which he thought necessary.

40 Maclean, *The Renaissance Notion of Woman*, *passim*, and more recently, Ben Lowe, 'Body images and the politics of beauty: formation of the feminine ideal in medieval and early modern Europe', pp. 21–36, in Karen A. Callaghan (ed.), *Ideals of Feminine Beauty: Philosophical, Social and Cultural Dimensions*, Westport, Conn., 1994. Women were construed as inferior versions of men, and the dyads outlined by Aristotle, such as reason versus emotion, limited versus unlimited, light versus darkness, straight versus curved and so on, to characterise men versus women, were reiterated.

41 See, for instance, E. Langenskiöld, *Michele Sanmichele, the Architect of Verona: His Life and Works*, Uppsala, 1938, pp. 110–14.

42 L. Magagnato, 'L'interpretazione dell'architettura classica di Michele Sanmichele', in *Studi raccolti dall'Accademia Agricoltura, Scienze e Lettere di Verona, per la celebrazione del IV centenario della morte*, Verona, 1960, pp. 44–5; Torello Saraina, *De origine et amplitudine civitatis Veronae*, Verona, 1540, p. 3: 'Everyone agrees that Verona possesses of antiquity among all the other cities in Italy an abundance to display, some of it still extant and as if still active, and some of it although buried, yet in the pages of history and the memory of men still alive' ('omnia Veronam urbem abunde inter alias Italiae civitates habuisse videre quidem licet, partim ex iis, quae adhuc extant, et quasi vivunt, partim ex iis quae quodammodo interiere, in historiis autem, et memoriis hominum adhuc vivunt').

43 Torello Saraina, *De origine*, p. 20: 'non mirum hunc exactissime arcum constructum, quum Vitruvius ipse celeberrimus fuerit architectus'.

245

44 ASV, Notaio Geronimo Piacentini, Massa 121, will no. 455: 'debilitate'; Massa 126, will no. 127, 19 August 1534: 'excepta in solita eius debilitationis egritudine quivi praeteritis annis multorum' ('except for the weakness of her customary lameness which she has suffered from for many long years').

45 Benini, *Le chiese di Verona*, p. 167.

46 ASV, Notaio Geronimo Piacentini, Massa 121, will no. 455, 15 October 1529; Massa 126, will no. 177, 19 August 1534; Massa 146, will no. 490, 22 December 1554; Massa 149, will no. 455, 24 September 1557.

47 John Pope-Hennessy, *Italian Renaissance Sculpture*, London, 1973, pp. 332–4, where it is suggested that the commissioners were Giulio, son of Girolamo della Torre, and Giovanni Battista della Torre.

CONCLUSION

It seems likely that a laywoman would have thought carefully about the implications of her actions in ordering works of art and architecture to be made, whether she was acting in the safer private sphere for a woman in patronising on behalf of a man, or whether she was taking a less conformist route in buying art for her own spiritual salvation or for the public good. To be a successful and confident patron, she herself would have needed to believe her own actions to be both appropriate and respectable. As the range of advice offered in the handbooks made clear, there was some leeway where the behaviour of a widow was concerned, allowing the woman to take some moral and spiritual lead and to do good beyond the scope of the family, in the community. Religious devoutness could provide a female commissioner with the justification to give generously to charity or to an ecclesiastical or monastic foundation. Nevertheless, the handbook-writers insisted that a woman should never draw attention to herself, whether in intense devoutness or in immoderate social behaviour and dress. Indeed, these writers never even considered the possibility that she might order her own altarpiece or tomb. In this sense the commissions which entailed the commemoration of devout and generous women in portrayals or inscriptions that precisely recorded their identities on public gifts or personal votive objects were pushing against the prescriptions of the treatises on proper feminine conduct, to offer their own definitions of the woman who desired to do good. Such redefinitions entailed the possibility that the feminine could be safely recognised for her magnaminity in the public sphere, and could honourably show concern for her own commemoration in a devout context.

I conclude by suggesting some comparisons between the patronage of these laywomen and that, on the one hand, of women rulers, and on the other hand, of courtesans. While the commissioning power of female rulers and female consorts of rulers is richly documented, that of the courtesan can only be inferred.

Unlike laywomen, ruling women could be responsible for large defensive and governmental or civic projects. The erstwhile Queen of Cyprus, for example, built a fortified palace in the Veneto in the late fifteenth century, complete with her own private chapel.[1] The queens of Naples, Joanna I and Joanna II, both maintained and rebuilt the fortresses and palaces in their realm, as well as erecting massive tombs for the men from whom they had inherited the throne, which were placed over the high altars of major churches (Santa Chiara and

247

San Giovanni Carbonara) in the city. Ruling women could build large churches in their cities. Joanna I and II built churches with adjacent hospitals, while the consorts of Neapolitan kings, Sancia of Naples and Mary of Hungary, built churches with associated convents.[2] Such grand ecclesiastical patronage by individual ruling women was common. Thus the Marchesa Paola Malatesta built the convent of San Paola in Mantua in the middle of the fifteenth century, Contessa Lodovica Torelli built the church of San Barnaba in Milan in the middle of the sixteenth century and Contessa Lucrezia Pico della Mirandola endowed the rebuilding of San Benedetto Po in Mantua in 1503.[3]

Ruling women had the power and the wealth to secure the services of artists of note. Where there was a court, court painters and architects could be called on by a woman and paid out of a general salary through her husband or her son, but working at her behest. Rather than having a contractual relationship with an artist of limited duration, the ruling patron might negotiate with her court servant over a long period on various tasks; these relationships are sometimes documented, as with the correspondence of the Marchioness of Mantua, Isabella d'Este, and her daughter, the Duchess of Urbino, Eleanora Gonzaga.[4]

Some ruling women were able to take a leading role in exploring Renaissance styles and themes. Isabella d'Este was able to collect contemporary bronzes by Antico and have bronze medallion portraits made of herself. She could plan a free-standing life-size marble statue of the poet Virgil to place in a public location in Mantua, with an inscription announcing that she had restored it. She could create a small study adorned with paintings by those whom she considered the best contemporary artists. She could commission independent secular (not votive) portraits to decorate her apartment. She was able to collect Antique sculptures expressing her scholarly knowledge in such prize pieces redolent of Roman Imperial history as the portrait-bust of the Roman Empress Faustina, and images of ancient myths like the relief of Hermes seeking out Persephone in the kingdom of Pluto, which she placed in her *studiolo*. In other words, a ruling woman could enjoy many of the facets of Renaissance art presumably not appropriate to laywomen of lower rank. Ruling women commissioned church furniture, and funerary chapels too, but they were also able to move outside the sphere of pious patronage to some extent. Isabella d'Este's daughter Eleanora Gonzaga commissioned portraits, for instance, and also planned interior decorations with some secular and classicising subject-matter in her husband's villa at Pesaro. Items from these interiors have been quite well curated and can sometimes be married to relatively good archival evidence to record the kinds of household expenditure on books, tapestries, plate and ceramics which had their more modest (but now vanished) equivalents in the houses of lesser women.

Ruling women were likely to be relatively well educated, as, for example, was Lucrezia Tornabuoni, wife of Piero de' Medici, who was an accomplished poet. Her taste and personal piety have been discerned in some of the decisions made about the subjects depicted in the private chapel of the Medici palace in Florence. It has been argued that the theme chosen for the wall-paintings, the Journey of the Magi, had special significance for the men of the Medici family who belonged to the Confraternity of the Magi. However, it is probable that Lucrezia advised on the treatment of the Nativity on the altar-panel by Filippo Lippi, which illustrated features, in the presence of Saint Bernard and the youthful John the Baptist, traceable to themes in her own poetry.[5]

Whereas laywomen acted in the public sphere with temerity or the special licence of spiritual distinction, ruling women were in a quite different position where the 'private' concerns of their family and household merged into or were sometimes identical with the public matters of state connected with the dynasty and court. As a sovereign by inheritance such a woman could be seen as keeping the throne safe for the next heir, while as ruler by marriage she might support her husband while he lived and govern as regent while he was at war, or at his death until her son attained majority. The ruling woman would need to show her dignity and her power in her dress, her comportment and in all that she had made to comprise her visual and physical surroundings. While the laywoman was advised to efface herself and avoid attention, the ruling woman might need to hold the gaze – in a decorous way.

Perhaps even when the ruler to whom the woman was related was elected – as in the case of popes and doges – patronage could have carried the kinds of institutional prestige not associated with the commissioning of, say, a family palace or a funerary chapel for a more ordinary lineage. For instance, the Palazzo Piccoluomini in Siena was built by Bernardo Rossellino for Caterina Piccoluomini with the funds and influence of her brother Aeneas Sylvius Piccoluomini, Pius II.[6] As Pope he had enabled her husband to take the Piccoluomini name and intended her grandson Silvio – his great-nephew – to inherit a patrimony from his great-uncle the Pope.

Although ruling women had greater scope in patronage than women of lesser rank, there seem to have been some restrictions on them in comparison to men of their own rank. In this sense ruling women operated under the same rules of confinement as their female subjects. In commissioning designs for their own burial, they were likely to award themselves a lower status. For example, when Fina Buzzacarini, who was consort of Francesco I da Carrara of Padua, played a key role in commissioning the mural decoration of the baptistry as a dynastic funerary chapel in about 1375, she placed her husband's tomb on the floor of the baptistry, and relegated her own to a marginal position, high up on

one wall over the door.[7] Ruling women also had to obey what may be called 'the iconographical double standard'. In order to guard her reputation for chastity, a ruling woman needed to commission images which represented the path to Christian virtue. Isabella d'Este might acquire the most erudite and scholarly works for her apartments, but she needed to be seen to use them to signify her role as educator of her children and guardian of the notion of wifely chastity. It seems likely that works of Antique sculpture needed to be interpreted as having honourable meanings in order to find a place in her collection. For example, her relief of the search for Persephone could represent the attempt by the good mother Demeter to rescue her child from captivity. In contrast, men of her rank included within the scope of their commissioning works which took a relaxed attitude to vices like drunkenness and celebrated the enjoyment of leisure. While her brother Alfonso could have Titian show the pleasures of Dionysus in music, sleep, love-making and dance without censure in the canvas of the Andrians (in the Prado, Madrid), Isabella's pictures illustrated the dangers of leisure in Mantegna's *Minerva driving the Vices from the Garden of Virtue* and the need to avoid sensuous pleasure in the paintings she commissioned from Correggio. To be seen as prudent women, women patrons needed to be prudish. To take a final example, ruling women also had to be careful as to the location and the viewers of their works. When the Duchess Eleanora Gonzaga had Girolamo Genga design a new villa for her husband during the 1530s at Pesaro, next to the Villa Imperiale belonging to her husband's family, she had him employ classicising articulation similar to that used by Giulio Romano for her brother at the Palazzo del Tè in Mantua. However, her brother used this facade, with its open central entrance on the ground floor of his villa, for anyone to enter or leave. By contrast, Eleanora's concern to emphasise her chastity as a wife entailed designing a villa which could only be reached via a narrow passage leading from the *piano nobile* of the Villa Imperiale. Only when the carefully vetted visitors had traversed this plain corridor did they find the enclosed courtyard in front of the entrance facade of her secluded new house. Eleanora might, therefore, have a classicising villa which looked like her brother's in some ways, but its access was much more private.[8]

Tantalising glimpses of the taste permitted to courtesans suggest that they were really laywomen who flouted the rules for the respectable feminine because of their profession. Rather than being confined to the home, the courtesan was associated with the public streets. Indeed, in token of their use of the public way to ply their trade, the papacy made courtesans pay taxes specifically for the upkeep of bridges and streets in Rome. While other women were told by the writers of handbooks of conduct not to attract attention to themselves by

spectacular looks, wit or behaviour, the courtesan earned her living by doing the opposite. She attempted to command an audience by her wit, and she benefited from being learned, skilled in poetry and music, and by drawing all eyes with her dress and figure.

Because of the research of Georgina Masson we know that courtesans were quite conspicuous consumers.[9] Indeed, in terms of their legal rights they owned their own earnings, because they were unmarried, and if they were illegitimate they were outside the legal control of a father, too. Furthermore, courtesans living under Roman law in Rome or Venice did not even require a *mundualdus*. Such women could have had an unusual degree of autonomy in commissioning. While no direct evidence of their patronage seems to have survived, there are records of courtesans commissioning tombs and funerary chapels for themselves, as well as having beautiful houses. For example, the courtesan Imperia had a Venus painted on the front of her house in the Borgo near the Vatican in about 1506, while Bandello described her house as furnished with the finest carpets and brocades, and the best room as having cornices decorated in gold and blue. On the cornices were vases of alabaster, porphyry and serpentine. There were also many books in Latin and Italian, richly bound, and books of music and musical instruments. Later she became the lover of Agostino Chigi. In 1512 she committed suicide, leaving money and instructions to Agostino Chigi as her executor to build her tomb at San Gregorio. This tomb may be the one reused by Canon Guidiccioni in the seventeenth century in the portico at San Gregorio. At Sant'Agostino there were monuments commemorating courtesans. Fiammetta, for instance, who had been given a house and vineyard by Sixtus IV, funded the making of a funerary chapel for herself – by Jacopo L'Indaco – at Sant'Agostino in 1512. Her altarpiece, according to Vasari, showed the Virgin holding the crucified Christ on her knees (a *Pietà*). However, all traces of such monuments were removed during the Catholic Reformation.

If courtesans wished to have dignified tombs just like other laywomen, it seems possible that in other respects, unlike any other laywomen, either humble or powerful, their taste mimicked that of their rich male clients. Following the lead given by the information about Imperia's bold choice of the pleasures of Venus for her facade and contemporary descriptions of the erudition of successful courtesans, it seems possible that these very special laywomen could have commissioned images for the interiors of their houses which explored the themes of pleasure without censure in a learned and amusing way.

How women acted as spectators and used buildings and the townscape, as well as what they were able to commission, depended on their prescribed roles – social ones, which they had to act up to in order to be allowed on to the stage at all, but within which there was usually some leeway for individual

role-development. This book forms an introductory study of the patronage of respectable wives and widows of men of upper-, middle- and even some lower-class positions, which will benefit from further research within this particular field, and from the more precise comparisons which may be possible when more secure generalisations can be made about the commissioning scope of other laywomen. At present it would seem that the patronage of women rulers was more public, secular and erudite than that of their respectable female subjects – but just as moralising and virtuous. As with women rulers, it seems likely that courtesans were less confined to the private sphere in their consumption, and would have found it appropriate to purchase secular and erudite items, too. And although courtesans might have wanted pious entombment, it is probable that their choice of representations for their houses was neither virtuous nor moralising.

Looking at the commissioning powers of the tiny number of women who operated on the margins of the powerful masculine institutions of family, religion and state entails highlighting a group of buyers who were politically and economically weak, as well as restricted in what they could command. Such a study may appear at first sight to have a marginal and slight significance in itself. However, a study of women's artistic purchases and modes of looking can provide data for a discussion as to how every aspect of the creation and consumption of art and architecture was gendered, and underline the fact that the ostensibly 'neuter' townscapes of the Italian peninsula at this time, with their public buildings and squares, their palaces and their impressive tombs for great men, were largely marked out as masculine in their making, meanings and use. (For example, if no laywoman of a rank below that of rulers can be shown to have commissioned a sculpture in bronze, it begins to look as if bronze sculpture represented masculinity as well as wealth, taste and knowledge of antique art.) Students coming to the study of women as patrons are apt to ask whether such women ever managed to purchase art or architecture by artists of note. The answer is twofold. Laywomen did indeed find artists at the beginning of a successful career, as did Margarita Pellegrini with Michele Sanmichele or Briseide Colla with Antonio Correggio, and have them make works of art which attracted the admiration of contemparary critics and other artists. When artists such as Raphael were very successful, they were pulled into the orbit of powerful men and would work for a woman commissioner only in special circumstances (as in the case of Elena Duglioli). The second part of the answer, however, is that the scope of art history is much wider than the biographies of the artists as written by Giorgio Vasari and his followers. The study of the lives of artists, their association in geographical schools and in stylistic periods, has its importance, but so too do such fields as the study of the institutions of

patronage and the way images and buildings were used, the study of the education and business practices of artists, the study of iconography, of historiography and of the history of art criticism. Within this broad definition of an art history which attends to the roles of contemporary makers, buyers and users of art, as well as to those of later conservationists, collectors and cultural consumers, the study of women as patrons has an importance which may be related to, but which does not have to depend on, Vasarian listings of the leaders and the also-rans.

Notes

1 Piovesan, 'Il barco della regina Cornaro'.

2 The patronage of the Angevin queens of southern Italy is covered in (for example) *Storia di Napoli* (11 vols.), Naples, 1969–78, III.

3 Catherine E. King, 'Medieval and Renaissance matrons, Italian-style', *Zeitschrift für Kunstgeschichte*, LXI, 1992, p. 388.

4 The patronage of Isabella d'Este is discussed in (for example) *Splendours of the Gonzaga*, ed. Martineau and Chambers. The patronage of her daughter Eleanora di Gonzaga is traced in the correspondence published by Georg Gronau in his *Documenti artistici urbinati*, Florence, 1935. I am grateful to Dr Deborah Howard for information on the patronage of the Villa Imperiale.

5 Marilyn Aronberg Lavin, 'Giovannino Battista: a study in Renaissance religious symbolism', *Art Bulletin*, XXXVII, no. 2, June 1955, pp. 85–101, especially pp. 92–5 and pp. 100–1 for the manuscript poem. I am grateful to Dr Diana Norman for telling me about this example.

6 Gaetano Milanesi, *Documenti per la storia dell'arte senese* (3 vols.), Siena, 1854–56, II, pp. 323, 348, documents dated 1463 and 1472, and R. J. Mitchell, *The Laurels and the Tiara*, London, 1962, pp. 92–4.

7 See Catherine King, 'Women as patrons', pp. 250–4.

8 Giuseppe Marchini, *La Villa Imperiale di Pesaro*, Rome, 1968.

9 Georgina Masson, *Courtesans of the Italian Renaissance*, London, 1975.

BIBLIOGRAPHY

Manuscripts

Archivio Communale, Fabriano.

Archivio di Stato, Padua (cited as ASP).

Archivio di Stato, Perugia.

Archivio di Stato, Verona (cited as ASV).

Biblioteca Augustina, Perugia.

Biblioteca Communale, Padua.

Printed sources

Adorno, Piero (ed.), *L'arte in Terni: mostra fotografica*, Rome, 1974.

Affò, Ireneo, *Ragionamento sopra una stanza dipinta dal celeberrimo Antonio Allegri da Correggio nel monistero di San Paolo alle Monache in Parma*, Parma, 1794.

Alberti, Leon Battista, *I libri della famiglia*, ed. G. Mancini, Florence, 1908.

Alberti, Leon Battista, *On Painting*, trans. C. Grayson, ed. M. Kemp, Harmondsworth, 1991.

Ancona, Pietro d', *Uomo e le sue opere nelle figurazioni del Medioevo*, Florence, 1924.

Anderson, Jaynie, 'Rewriting the history of art patronage', *Renaissance Studies: Journal of the Society for Renaissance Studies*, X, 1996, pp. 129–38.

Andreozzi, Gabriele, *Storia delle regole e delle constituzioni dell'ordine francescano secolare*, Milan, 1990.

Ansidei, Vincenzo, *Ricordi nuziali di Casa Baglioni*, Perugia, 1908.

Antonino, Archbishop of Florence, Saint, *Tractatus de sponsalibus*, Lyons, 1511.

Armellini, Mariano, *Le chiese di Roma dal secolo IV al XIX*, Rome, 1982.

Aronberg Lavin, Marilyn, 'Giovannino Battista: a study in Renaissance religious symbolism', *Art Bulletin*, XXXVII, no. 2, June 1955, pp. 85–101.

Associazione Culturale Francescana di Padova, *Il complesso di San Francesco Grande in Padova: storia e arte*, Padua, 1983.

Astur, Baleoneus (Pseud.), *I Baglioni*, Prato, 1964.

B., G. da, 'G. d. B.', 'Per il nostro San Francesco', *Bollettino del Museo Civico di Bassano*, II, 1905, pp. 1–6.

Bagemihl, Rolf, 'Francesco Botticini's Palmieri altarpiece', *Burlington Magazine*, CXXXVIII, no. 1118, May 1996, pp. 308–14.

Baldini, Umberto (ed.), *Pinacoteca Vaticana*, Milan, 1992.

Baldini, Umberto and Morante, E., *L'opera completa di Angelico*, Milan, 1970.

Ballerin, Alessandro and Banzato, Davide (eds.), *Da Bellini a Tintoretto: dipinti dei Musei Civici di Padova della metà del Quattrocento ai primi dei Seicento*, Rome, 1991.

Barbaro, Francesco, *De re uxoria*, Paris, 1513.

Barbaro, Francesco, *Prudentissimi et gravi documenti circa la elettion della moglie*, Venice, 1548.

254

Barberino, Francesco da, *Reggimento e costumi di donna*, ed. G. E. Sansoni, Turin, 1957.

Bellinati, Claudio, 'Ospitale Sancti Francisci. Contributo alla storia della carità e dell'assistenza religiosa nell'ospedale di San Francesco a Padova (xv–xvii secolo)', in Associazione Culturale Francescana di Padova, *Il complesso*, pp. 13–30.

Bellosi, L. *et al.*, *Arte in Valdichiana dal XIII al XVIII secolo*, Cortona, 1970.

Benazzi, Giordana, 'Il Pordenone ad Alviano: un restauro e un poco noto gruppo di fregi', in *Il Pordenone 1984, Atti del Convegno Internationale di Studio*, ed. Caterina Furlan, Pordenone, 1984, pp. 39–43.

Benini, G., *Le chiese di Verona*, Verona, 1988.

Berger, John, *Ways of Seeing*, London, 1972.

Bernacchioni, Annamaria, 'Documenti e precisazioni sull'attività tarda di Domenico di Michelino: la sua bottega di via delle Terme', *Antichità viva*, XXIX, 1990, pp. 5–14.

Bernardini, Carla, Zarri, Gabriella and Emiliani, Andrea (eds.), *L'Estasi di Santa Cecilia di Raffaello da Urbino nella Pinacoteca Nazionale di Bologna*, Bologna, 1983.

Besta, Enrico, *La famiglia nella storia del diritto italiano*, Milan, 1962.

Biancolini, Giovanni Battista, *Notizie storiche delle chiese di Verona* (8 vols.), Verona, 1749–71.

Bibliotheca sanctorum (12 vols.), Rome, 1961–69.

Bologna, Ferdinando, *I pittori alla corte angioina di Napoli 1266–1414*, Rome, 1969.

Brenzoni, R., 'La sanmicheliana cappella Pellegrini in S. Bernardino di Verona: retrodatazione del progetto e dell'inizio della fabbrica all'anno 1527c', *Atti dèll'Istituto Veneto di Scienze, Lettere ed Arti*, CXV, 1956–57, pp. 119–31.

Bresciani Alvarez, Giulio, 'Il cantiere dell'ospedale, del convento e chiesa di San Francesco in Padova. Note sulla scuola della Carità e l'oratorio di Santa Margherita', in Associazione Culturale Francescana di Padova, *Il complesso*, pp. 59–108.

Briganti, F., 'Un ignorato dipinto di Mariano di Ser Austerio', *Bollettino della Deputazione di Storia Patria per l'Umbria*, XV, 1909, pp. 365–72.

Brugnoli, Pierpaolo, *Architettura sacra a Verona dal secolo X al secolo XVIII*, Verona, n.d.

Canonici, Luciano, *Alviano: una rocca, una famiglia, un popolo*, Assisi, 1974.

Cantaro, Maria Teresa, *Lavinia Fontana bolognese 'pittura singolare' 1552–1614*, Bologna, 1989.

Canuti, Fiorenzo, *Il Perugino* (2 vols.), Siena, 1931.

Capra, Giovanni Francesco, *Della eccellenza e dignità delle donne*, ed. Maria Luisa Doglio, Rome, 1988.

Cartolari, Antonio, *Famiglie già ascritte al nobile consiglio di Verona*, Verona, 1854.

Casagrande, Giovanna and Menesto, Enrico (eds.), *Una santa, una città: Atti del Convegno Storico nel V Centenario della Venuta di Colomba da Rieti, Perugia, 1989*, Spoleto, 1991.

Castelfranchi Vegas, L., *L'Angelico e l'humanismo*, Milan, 1989.

Cecchini, Giovanni, *Guida del Foligno storico artistico, illustrata*, Milan, n.d.

Celano, Carlo, *Notizie del bello, dell'antico, e del curioso della città di Napoli*, ed. Atanasio Mozzello, Alfredo Profeta and Francesco Paolo Macchia, Naples, 1970.

Certaldo, Paolo da, *Libro di buoni costumi*, ed. Alfredo Schiaffini, Florence, 1945.

Chastel, André, 'Le donateur "in abysso" dans les "Pale"', *Festschrift für Otto von Simson*, ed. L. Grisebach and K. Renger, Frankfurt am Main, 1977, pp. 273–83.

Cherubino da Siena, Fra, *Regole della vita matrimoniale*, in G. Carducci, *Scelta di curiosità letterarie inedite o rare dal secolo XIII al XVII*, ed. C. Negroni and F. Zambrini, Bologna, 1888.

Chojnacki, Stanley J., 'Patrician women in early Renaissance Venice', *Studies in the Renaissance*, XXI, 1974, pp. 176–203.

Ciampi, S., *Vita e poesia di Messer Cino da Pistoia*, Pisa, 1813.

Ciatti, M., Martini, L. and Torchio, F. (eds.), *Mostra di opere d'arte restaurate nelle province di Siena e Grosseto*, Genoa, 1983.

Coleschi, Lorenzo, *Storia della città di Sansepolcro*, Città di Castello, 1886.

Collodo Sylvana, 'Religiosità e assistenza a Padova nel Quattrocento. L'ospedale e il convento di San Francesco dell'Osservanza', in Associazione Culturale Francescana di Padova, *Il complesso*, pp. 31–58.

Corner, Flaminio, *Notizie storiche dalle chiese e monasteri di Venezia e di Torcello tratte dalle chiese veneziane e torcellane*, Padua, 1758.

Corradini, Sandro, 'Parmigianino's contract for the Caccialupi Chapel in S. Salvatore in Lauro', *Burlington Magazine*, CXXXV, no. 1078, January 1993, pp. 27–31.

Cristofani, Antonio, *Delle storie d'Assisi* (6 vols.), Assisi, 1866.

Crowe, Joseph and Cavalcaselle, Giovanni, *Storia della pittura in Italia* (10 vols.), Florence, 1885–1908.

Davies, Martin, *National Gallery Catalogues: The Early Italian Schools*, London, 1961.

Delille, Gérard, *Famille et propriété dans le royaume de Naples XV–XIX siècle*, Paris, 1985.

Dianin, G. M., *San Bernardino da Siena a Verona e nel Veneto*, Verona, 1981.

Dizionario biografico degli Italiani, I–XXXII, Rome, 1960–86 (in progress).

Dolce, Lodovico, *Ammaestramenti pregiatissimi che appartengono alla educatione e honorevole e virtuosa vita virginale, maritale e vedovile*, Venice, 1622.

Dominici, Giovanni, *Regola del governo di cura familiare*, ed. D. Salvi, Florence, 1860.

Engenio Caracciolo, Cesare d', *Napoli sacra*, Naples, 1623.

Ettlinger, Helen S., 'The Virgin snail', *Journal of the Warburg and Courtauld Institutes*, XLI, 1978, p. 316.

Faccini, Sandra, 'Lineamenti della scultura nella chiesa di San Francesco Grande', in Associazione Culturale Francescana di Padova, *Il complesso*, pp. 149–64.

Festi, C. B., *Francesco Melanzio da Montefalco*, Milan, 1973.

Filangieri, Gaetano, *Documenti per la storia, le arti e le industrie delle provincie napoletane*, (6 vols.), Naples, 1883–91.

Fiorelli-Malesci, Francesca, *La chiesa di santa Felicità*, Florence, 1986.

Fiorillo, Ciro, *Gli Incurabili: l'ospedale, la farmacia, il museo*, Udine, 1991.

Fiorio, Maria Teresa, *Le chiese di Milano*, Milan, 1985.

Flores D'Arcais, Francesca, *Guariento: tutto la pittura*, Venice, 1965.

Forcella, Vincenzo, *Iscrizioni delle chiese e degli altri edifici di Roma* (14 vols.), Rome, 1869–84.

Forcella, Vincenzo, *Iscrizioni delle chiese e degli altri edifici di Milano* (12 vols.), Milan, 1889–93.

Fortunati Pietrantonio, Vera (ed.), *Pittura bolognese del '500* (2 vols.), Bologna, 1986.

Foster-Baxendale, Susannah, 'Exile in practice: the Alberti family in fifteenth-century Florence, 1401–1428', *Renaissance Quarterly*, XLIV, 1991, pp. 720–56.

Franklin, David, 'Ridolfo Ghirlandaio's altarpieces for Leonardo Buonafé and the hospital of S. Maria Nuova in Florence', *Burlington Magazine*, CXXXV, no. 1078, January 1993, pp. 4–16.

Franklin, David, 'Rosso, Leonardo Buonafé and the Francesca de Ripoi altarpiece', *Burlington Magazine*, CXXIX, no. 1015, October 1987, pp. 652–62.

Franzoi, Umberto and Stefano, Dina di, *Le chiese di Venezia*, Venice, 1976.

Freedberg, S. J., *Painting of the High Renaissance in Rome and Florence* (2 vols.), Cambridge, Mass., 1961.

Furlan, Caterina, *Il Pordenone*, Milan, 1988.

Gallo, Rodolfo, 'La chiesa di Sant'Elena', *Rivista mensile della città di Venezia*, V, 1926, pp. 421–90.

Gamurrini, Giovanni Francesco, *Istoria genealogica delle famiglie nobili toscane et umbre* (5 vols.), Bologna, 1972 (first published 1668–85).

Giuliari, B., *La cappella della famiglia Pellegrini*, Verona, 1816.

Gnoli, Umberto, *Pittori e miniatori nell'Umbria*, Spoleto, 1923.

Golzio, V., *Raffaello nei documenti nelle testimonianze dei contemporanei e nella letteratura del suo secolo*, Vatican City, 1936 (1971 reprint).

Gothein, Everardo, *Rinascimento nell'Italia Meridionale*, trans. Tommaso Persico, Florence, [1915] 1985.

Gould, Cecil, *The Paintings of Correggio*, London, 1976.

Graef, Hilda, *Mary: A History of Doctrine and Devotion* (2 vols.), London, 1963–65.

Grandi, Renzo, *I monumenti dei dottori e la scultura a Bologna (1267–1348)*, Bologna, 1982.

Gronau, Georg, *Documenti artistici urbinati*, Florence, 1935.

Haines, Margaret, 'The sacristy of Santa Maria Novella in Florence: the history of its functions and furnishings', in *Santa Maria Novella: un convento nella città: studi e fonti, Memorie domenicane*, XI, 1980, pp. 575–626.

Herklotz, Ingo, *Sepulcra e monumenta del medioevo: studi sull'arte sepolcrale in Italia*, Rome, 1985.

Jerome, Saint, *Select Letters of Saint Jerome*, trans. F. W. Wright, London, 1933.

Jungić, Josephine, 'Raphael at Bologna and Savonarola's prophecies of a *Renovatio ecclesiae*', *Art History*, XVI, 4, 1993, pp. 580–99.

Kaftal, George, *Saints in Italian Art: Iconography of the Saints in Central and South Italian Schools of Painting*, Florence, 1965.

Kaftal, George, *Saints in Italian Art: Iconography of the Saints in Tuscan Painting*, Florence, 1952.

King, Catherine E., 'The arts of casting and carving', in *Siena, Florence, and Padua: Art, Society, and Religion, 1280–1400*, ed. Diana Norman (2 vols.), New Haven and London, 1995, I, pp. 97–121.

King, Catherine E., 'The dowry farms of Niccolosa Serragli and the altarpiece of the Assumption in the National Gallery (1126) London ascribed to Francesco Botticini', *Zeitschrift für Kunstgeschichte*, L, 1987, pp. 275–8.

King, Catherine E., 'Effigies human and divine', in *Siena, Florence, and Padua: Art, Society, and Religion, 1280–1400*, ed. Diana Norman (2 vols.), New Haven and London, 1995, II, pp. 104–27.

King, Catherine E., 'Medieval and Renaissance matrons, Italian-style', *Zeitschrift für Kunstgeschichte*, LXI, 1992, pp. 372–93.

King, Catherine E., 'Women as patrons: nuns, widows and rulers', in *Siena, Florence, and Padua: Art, Society, and Religion, 1280–1400*, ed. Diana Norman (2 vols.), New Haven and London, 1995, II, pp. 243–66.

King, Margaret L., *Le donne nel Rinascimento*, Bari, 1991.

King, Margaret L., 'Goddess and captive: Antonio Loschi's epistolary tribute to Maddalena Scrovegni', *Medievalia et humanistica*, X, 1988, pp. 103–27.

Kirshner, Julius, 'Wives' claims against insolvent husbands in late medieval Italy', in *Women of the Medieval World*, ed. Julius Kirshner and Suzanne F. Wemple, Oxford, 1985.

Klapisch-Zuber, Christiane, *Women, Family and Ritual in Renaissance Italy*, Chicago, 1985.

Klapisch-Zuber, Christiane and Herlihy, D., *Les Toscans et leurs familles*, Paris, 1978.

Kocks, Dirk, *Die Stifterdarstellung in der italienischen Malerei des 13–15 Jahrhunderts*, Ph.D. thesis, University of Cologne, 1971.

Kolb-Lewis, Carolyn, *The Villa Giustinian at Roncade*, Ph.D. thesis, New York University, 1977.

Kuehn, Thomas, 'Cum consensu mundualdi: legal guardianship of women in Quattrocento Florence', *Viator*, XIII, 1982, pp. 309–33.

Kuehn, Thomas, *Law, Family and Women: Towards a Legal Anthropology of Renaissance Italy*, Chicago, 1991.

Lanaro, Paola, 'Essere famiglia di consiglio: social closure and economic change in the Veronese patriciate of the sixteenth century', *Renaissance Studies*, VIII, 4, 1994, pp. 428–38.

Langenskiöld, E., *Michele Sanmichele, the Architect of Verona: His Life and Works*, Uppsala, 1938.

Lazzarini, Vittorio, 'Il mausoleo di Raffaelle Fulgosio nella Basilica del Santo', *Archivio veneto-tridentino*, IV, 1923, pp. 147–56.

Lecce, M., *Gli antichi estimi veronesi: condizioni economico-social di Verona a metà del secolo XVI*, Verona, 1953.

Lewis, Douglas, 'The sculptures in the chapel of the Villa Giustinian at Roncade and their relation to those in the Giustinian chapel at San Francesco della Vigna', *Mitteilungen des Kunsthistorischen Institutes in Florenz*, XXVII, 1983, pp. 307–52.

Lombardi, Teodosio, *I Francescani a Ferrara* (5 vols.), Bologna, 1974–75.

Lowe, Ben, 'Body images and the politics of beauty: formation of the feminine ideal in medieval and early modern Europe', in Karen A. Callaghan (ed.), *Ideals of Feminine Beauty: Philosophical, Social and Cultural Dimensions*, Westport, Conn., 1994.

Ludwig, Gustav, 'Archivälische Beitrage zur Geschichte der venezianischen Malerei', *Jahrbuch der preussischen Kunstsammlungen*, XXVI, 1905, Beiheft.

Lunghi, E., 'Osservazioni su Dono Doni', in *Arte e musica in Umbria tra Cinquecento e Seicento. Atti del XII Convegno di Studi Umbri, 1979*, Gubbio, 1981.

Lusini, V., *Storia della basilica di San Francesco in Siena*, Siena, 1894.

Maclean, Ian, *The Renaissance Notion of Woman: A Study of the Fortunes of Scholasticism and Medical Science in European Life*, Cambridge, 1980.

Maetzke, A. M. and Galoppi Nappini, D., *Il Museo Civico di Sansepolcro*, Florence, 1988.

Magagnato, L., *Arte e civiltà a Verona*, Verona, 1991.

Magagnato, L., 'L'interpretazione dell'architettura classica di Michele Sanmichele', in *Studi raccolti dall'Accademia Agricoltura, Scienze e Lettere di Verona, per la celebrazione del IV centenario della morte*, Verona, 1960.

Maggio, Patrizia di, *Opera d'arte: Palazzo Arcivescovile di Napoli*, Naples, 1990.

Mancini, F. F., *La basilica di Santa Maria degli Angeli* (3 vols.), Perugia, 1990.

Marinelli, Sergio, *The Museum of Castelvecchio*, Verona, 1983.

Marchini, Giuseppe, *La Villa Imperiale di Pesaro*, Rome, 1968.

Markham-Schulz, Anne, 'The Giustiniani chapel and the art of the Lombardi', *Antichità viva*, XVI, 1977, pp. 27–44.

Markham-Schulz, Anne, 'A new Venetian project by Verrocchio: the altar of the Virgin in SS. Giovanni e Paolo', in *Festschrift für Otto von Simson*, ed. Lucius Grisebach and Konrad Renger, Frankfurt am Main, 1977, pp. 197–208.

Markham-Schulz, Anne, 'Reversing the history of Venetian Renaissance sculpture: Niccolò and Pietro Lamberti', *Saggi e memorie di storia dell'arte*, XV, 1986, pp. 9–61.

Markham-Schulz, Anne, *The Sculpture of Bernardo Rossellino*, Princeton, 1977.

Martineau, Jane and Chambers, David (eds.), *Splendours of the Gonzaga*, London, 1982.

Mascherpa, Giorgio, *Invito a Lorenzo Lotto*, Milan, 1980.

Masson, Georgina, *Courtesans of the Italian Renaissance*, London, 1975.

Mattioli, Michele, *Montefalco*, Spoleto, 1953.

Mazza, Angelo, 'La chiesa, la cappella, il dipinto', in Bernardini, Zarri and Emiliani (eds.), *L'Estasi*, pp. 50–103.

Mazzatinti, Giuseppe, 'L'obituario del convento di S. Agostino di Padova', *Miscellanea di storia veneta*, II, 1894, pp. 7–45.

Mazzei, ser Lapo, *Ser Lapo Mazzei, lettere di un notaro a un mercante del secolo XIV, con altre lettere e documenti*, ed. Claudio Guasti (2 vols.), Florence, 1880.

Meneghin, Vittorino, *San Michele in Isola di Venezia* (2 vols.), Venice, 1962.

Mezzetti, Amalia, *Girolamo da Ferrara, detto da Carpi, l'opere pittorica*, Milan, 1977.

Milanesi, Gaetano, *Documenti per la storia dell'arte senese* (3 vols.), Siena, 1854–56.

Missale romanum noviter impressam ordine quodam miro, Venice, 1519.

Mitchell, R. J., *The Laurels and the Tiara*, London, 1962.

Molho, Anthony, *Marriage Alliance in Late Medieval Florence*, Cambridge, Mass., 1994.

Morando di Custoza, E., *Armoriale veronese*, Verona, 1976.

Moschini-Marconi, Sandra, *Cataloghi dei musei e gallerie d'Italia: Gallerie dell'Accademia di Venezia* (2 vols.), Rome, 1955–62.

Mossakowski, Stanislaus, 'Raphael's Saint Cecilia: an iconographical study', *Zeitschrift für Kunstgeschichte*, XXXI, 1968, pp. 1–24.

Moureyre-Gavoty, F. de la, *Musée Jacquemart-André: sculpture italienne*, Paris, 1975.

Nevizzano, Giovanni, *Sylvae nuptualis libri sex*, Venice, 1573.

Offner, Richard, *A Critical and Historical Corpus of Florentine Painting, Section 3, Volume 1, The Fourteenth Century*, New York, 1931.

Offner, Richard and Steinweg, Klara, *A Critical and Historical Corpus of Florentine Painting, Section 4, Volume 4, Giovanni del Biondo*, Part I, New York, 1967.

Offner, Richard and Steinweg, Klara, *A Critical and Historical Corpus of Florentine Painting, Section 4, Volume 5, Giovanni del Biondo*, Part II, New York, 1969.

Olmi, G., *I Senesi d'una volta*, Siena, 1889.

Origo, Iris, *The Merchant of Prato: Francesco di Marco Datini*, London, 1957.

Orlandi, S., *Necrologia di Santa Maria Novella*, Florence, 1955.

Ortner, Sherry B. and Whitehead, Harriet, *Sexual Meanings*, London, 1981.

Pane, Roberto, *Il Rinascimento nell'Italia Meridionale* (2 vols.), Milan, 1975–77.

Panofsky, Erwin, *The Iconography of Correggio's Camera di San Paolo*, London, 1961.

Paolezzi Strozzi, Beatrice, Toderi, Giuseppe and Vannel Toderi, Fiorenza (eds.), *Le monete della repubblica senese*, Siena, 1992.

Pergola, Paola della, *Galleria Borghese: i dipinti* (2 vols.), Rome, 1955–59.

Persico, G. B. da, *Verona e la sua Provincia*, Verona, 1838.

Pertile, Antonio, *Storia del diritto italiano dalla caduta dell'Impero Romano alla codificazione* (6 vols.), Turin, 1896–1903.

Piccolomini Adami, Tommaso, *Guida storico-artistica della città di Orvieto*, Siena, 1883.

Pinelli, A. and Rossi, O., *Genga architetto, aspetti della cultura urbinate del primo '500*, Rome, 1971.

Piovesan, Luciana, 'Il barco della regina Cornaro', *Storia di Asolo*, XVI, 1980, pp. 36–198.

Pope-Hennessy, John, *Catalogue of Italian Sculpture in the Victoria and Albert Museum*, London, 1964.

Pope-Hennessy, John, *Italian High Renaissance and Baroque Sculpture* (3 vols.), London, 1963.

Pope-Hennessy, John, *Italian Renaissance Sculpture*, London, 1973.

Pozzolo, Enrico Maria del, 'Due proposte per Giovanni Buonconsiglio', *Venezia arti: Bollettino del Dipartimento di Storia e Critica delle Arti Giuseppe Mazzariol dell'Università di Venezia*, VII, 1993, pp. 157–8.

Puppi, Lionello, *Michele Sanmichele: architetto da Verona*, Padua, 1971.

Puppi, Lionello and Bettini, Sergio, *La chiesa degli Eremitani di Padova*, Vicenza, 1970.

Quintavalle, Augustina, 'Alessandro Araldi', *Rivista dell'Istituto Nazionale d'Archeologia e Storia dell'Arte*, VII, 1958, pp. 292–333.

Ravicini, S., *Sulla universilità dell'opera ospedaliera della Santa Casa degli Incurabili in Napoli*, Naples, 1899.

Re, G. da, 'La cappella Pellegrini di S. Bernardino', *Madonna Verona, Bollettino del Museo Civico di Verona*, VIII, January–March 1914, pp. 52–4.

Rigoni, E., 'Il soggiorno in Padova di Niccolò Baroncelli', in E. Rigoni, *L'arte rinascimentale in Padova: studi e documenti*, Padua, 1970.

Rogers, Mary, 'The decorum of women's beauty: Trissino, Firenzuola, Luigini and the representation of women in sixteenth-century painting', *Renaissance Studies*, II, 1988, pp. 47–89.

Rogers, Mary, 'Sonnets on female portraits from Renaissance North Italy', *Word and Image*, II, 1986, pp. 291–9.

Roncalli, A. G. and Forno, P. (eds.), *Gli atti della visita apostolica di S. Carlo Borromeo a Bergamo* (2 vols.), Milan, 1957.

Ronchi, O., 'Notizie da documenti inediti del secolo XV intorno alla chiesa dei Santa Maria dei Servi', in *La chiesa e il convento di Santa Maria dei Servi*, Padua, 1937.

Rosenthal, Elaine G., 'The position of women in Renaissance Florence: neither autonomy nor subjection', in *Florence and Italy: Renaissance Studies in Honour of Nicolai Rubenstein*, ed. P. Denley and C. Elam, London, 1988.

Rossi, F. (ed.), *Giovan Battista Moroni, 1520–78*, Bergamo, 1979.

Sabatini, Fausta G., *Giovanni di Pietro, detto Lo Spagno*, Spoleto, 1984.

Saggiori, Giovanni, *Padova nella storia delle sue strade*, Padua, 1972.

Salomonio, Giacopo, *Urbis patavinae inscriptiones sacrae et prophanae*, Padua, 1701.

Santi, Francesco, *Galleria Nazionale dell'Umbria: dipinti, sculture e oggetti d'arte di età romanica e gotica*, Rome, 1969.

Santi, Francesco, *Galleria Nazionale dell'Umbria: dipinti, sculture e oggetti dei secoli XV–XVI*, Rome, 1985.

Santi, Francesco, *I gonfaloni umbri del Rinascimento*, Perugia, 1976.

Saraina, Torello, *De origine et amplitudine civitatis Veronae*, Verona, 1540.

Sassi, Romualdo, 'Arte e storia fra le rovine d'un antico tempo francescano', *Rassegna marchigiana*, XX, 1927, pp. 331–51.

Savonarola, Girolamo, *Libro della vita viduale*, Florence, 1491.

Schröder, F., *Repertorio genealogico delle famiglie confermate nobili nelle provincie venete*, (2 vols.), Bologna, 1972.

Schütz-Rautenberg, Gesa, *Künstlergrabmäler des 15 und 16 Jahrhunderts in Italien* (Ph.D. thesis, University of Munich), Cologne, 1978.

Sensi, M., 'Nuovi documenti per Niccolò di Liberatore detto L'Alunno', *Paragone*, XXXII, 389, 1982, pp. 77–107.

Sesler, Laura, 'Significativi aspetti della pittura attraverso i secoli nella chiesa di San Francesco Grande', in Associazione Culturale Francescana di Padova, *Il complesso di San Francesco Grande in Padova: storia e arte*, pp. 125–48.

Simoni, P., *Antica mappa di San Michele Extra*, Verona, 1981.

Simons, Patricia, 'Women in frames: the gaze, the eye, the profile in Renaissance portraiture', *History Workshop: A Journal of Socialist and Feminist Historians*, XXV, 1988, pp. 4–30.

Smith, Alison A., 'Locating power and influence within the provincial elite of Verona: aristocratic wives and widows', *Renaissance Studies*, VIII, 4, 1994, pp. 439–48.

Solberg, Gail E., *Taddeo di Bartolo: His Life and Work*, Ph.D. thesis, University of New York, 1991.

Spiazzi, Anna Maria (ed.), *Giusto de' Menabuoi nel battistero di Padova*, Trieste, 1989.

Stefaniak, Regina, 'Raphael's *Santa Cecilia*: a fine and private vision of virginity', *Art History*, XIV, 3, 1991, pp. 358–71.

Storia di Napoli (11 vols.), Naples, 1969–78.

Strobel, Anna Maria and Mancinelli, Fabrizio, 'The Cinquecento', in Baldini (ed.), *Pinacoteca Vaticana*, pp. 253–310.

Tamassia, Nino, *La famiglia italiana*, Milan, 1911.

Tiraboschi, Girolamo, *Biblioteca Modenese, o notizie della vita e delle opere degli scrittori, natii [sic] degli stati del Serenissimo Signor Duca di Modena* (6 vols.), Modena, 1781–86.

Todini, Filippo, *La pittura umbra dal Duecento al primo Cinquecento* (2 vols.), Milan, 1989.

Todini, Filippo and Lunghi, Elvio, *Niccolò di Liberatore detto L'Alunno*, Foligno, 1987.

Torriti, Pietro, *La Pinacoteca Nazionale di Siena: i dipinti*, Geneva, 1990.

Touring Club Italiano, *Toscana: guida di Touring Club Italiano*, Milan, 1974.

Trevisani, Filippo, 'Osservazioni sulla mostra "Lorenzo Lotto nelle Marche: il suo tempo, il suo influsso"', *Arte veneta*, XXXV, 1981, pp. 275–88.

Trissino, Giovanni Giorgio, *De la vita che die tenere una donna vedova*, Rome, 1524.

Tutini, Camillo, *Dell'origine e fundazione de' seggi di Napoli*, Naples, 1754.

Uffizi Gallery, *Catologo generale*, Florence, 1979.

Vaccaro, Mary, 'Documents for Parmigianino's Vision of Saint Jerome', *Burlington Magazine*, CXXXV, no. 1078, January 1993, pp. 22–7.

Valle, Raffaele Maria and Minichini, Benedetto, *Descrizione storica, artistica, letteraria della chiesa convento e religiosi illustri di S. Domenico di Napoli dal 1216 al 1854*, Naples, 1854.

Vasari, G., *Lives of the Most Eminent Painters, Sculptors and Architects*, translated by Gaston du C. de Vere (10 vols.), London, 1912–14.

Vasari, G., *Le vite de' più eccellenti pittori, scultori ed architettori*, ed. G. Milanesi (10 vols.), Florence, 1878–85.

Vasta, Laura (ed.), *Pittura in Umbria tra il 1480 e il 1540, premesse e sviluppi nei tempi di Perugino e Raffaello (guida catologo)*, Milan, 1983.

Visceglia, Maria Antonietta, 'Corpo e sepoltura nei testamenti della nobiltà napoletana: XVI–XVII secolo', *Quaderni storici*, L, 1982, pp. 583–614.

Vitale, Giuliana, 'Modelli-culturale nobiliari a Napoli', *Archivio storico per le provincie napoletane*, CV, 1987, pp. 27–103.

Volpe, C., *Pietro Lorenzetti*, ed. M. Lucco, Milan, 1989.

Wethey, H., *The Paintings of Titian* (3 vols.), London, 1969–71.

Wittkower, Rudolf, *Architectural Principles in the Age of Humanism*, London, 1949.

Wittkower, Rudolf, 'Studien zur Geschichte der Malerei', *Jahrbuch für Kunstwissenschaft*, IV, 1927, pp. 185–221.

Wolters, Wolfgang, *La scultura veneziana gotica 1300–1460* (2 vols.), Venice, 1976.

Wood Brown, J., *The Dominican Church of Santa Maria Novella at Florence*, Edinburgh, 1902.

Zarri, Gabriella, 'Storia di una committenza', in Bernardini, Zarri and Emiliani (eds.), *L'Estasi*, pp. 20–37.

Zarri, Gabriella, *Le sante vive: profezie di corte e devozione femminile*, Turin, 1990.

INDEX

Men known by nicknames (such as Rosso Fiorentino) or whose names are usually anglicised (such as Raphael or Titian) are listed under those names. Those called after their place of origin (Cherubino da Siena) or according to their job (Francesco Muraro) are listed under their Christain name. Names, however, which only derive from a place of origin such as Lombardo are treated as family names, as in 'Lombardo, Tullio'. Men and women known by their Christian name and their father's Christian name, such as Antonia di Bartolomeo, are also listed under their Christian name. (It may not be clear, from an inscription alone, whether a woman is called after her father or her husband – e.g. Griseide di Ser Sebastiano, or Tora di Nardo.) Where known, the woman's paternal family name is given, followed by her Christian name, as in 'Pellegrini, Margarita'. In cases where a woman's father's family name is not known, but that of her husband is recorded, she is listed under the husband's family name and her marital relationship to that name is noted, as in 'Bechetti, Oradea, wife of Giovanni Becchetti'. Occasionally too little is known – through having to rely on scanty evidence of epitaphs or other inscriptions – to be certain of the spelling of the paternal family name (e.g. Antonia Rusca) or whether it was a paternal rather than a marital family name (e.g. Maria Bovolini). I decided to list these under the family name. In the case of Francesca de Ripoi I decided to use this name even though the name of her father is known (as Benedetto Falchone) because the key previous publication on her commissioning had named her in this way. Given these variations, the reader is advised to try searching under the Christian name if the second name does not appear in this index. In any case, note that female patrons are listed as sub-entries under 'women associated with commissions'. Page numbers given in *italic* refer to illustrations.

271